WHITE STAR PUBLISHERS

VANISHING ANIMALS

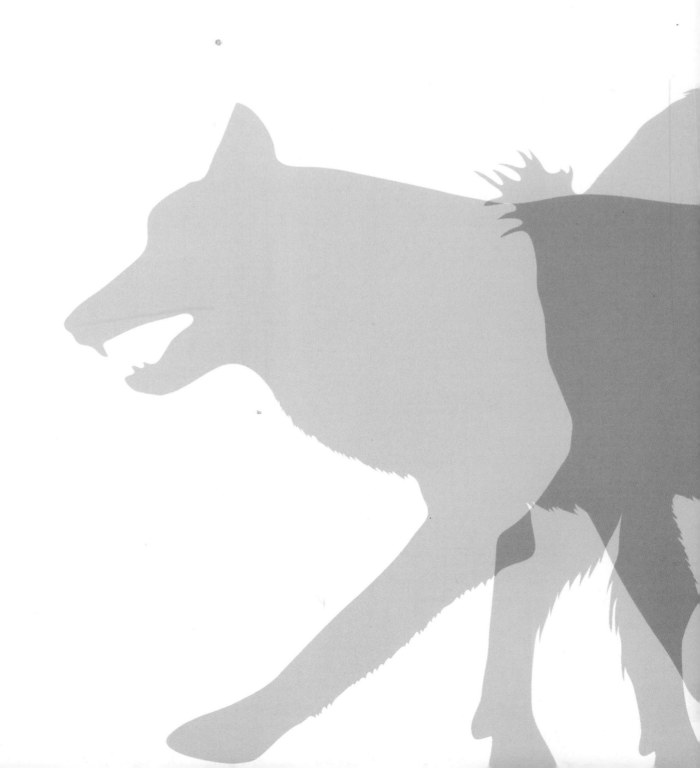

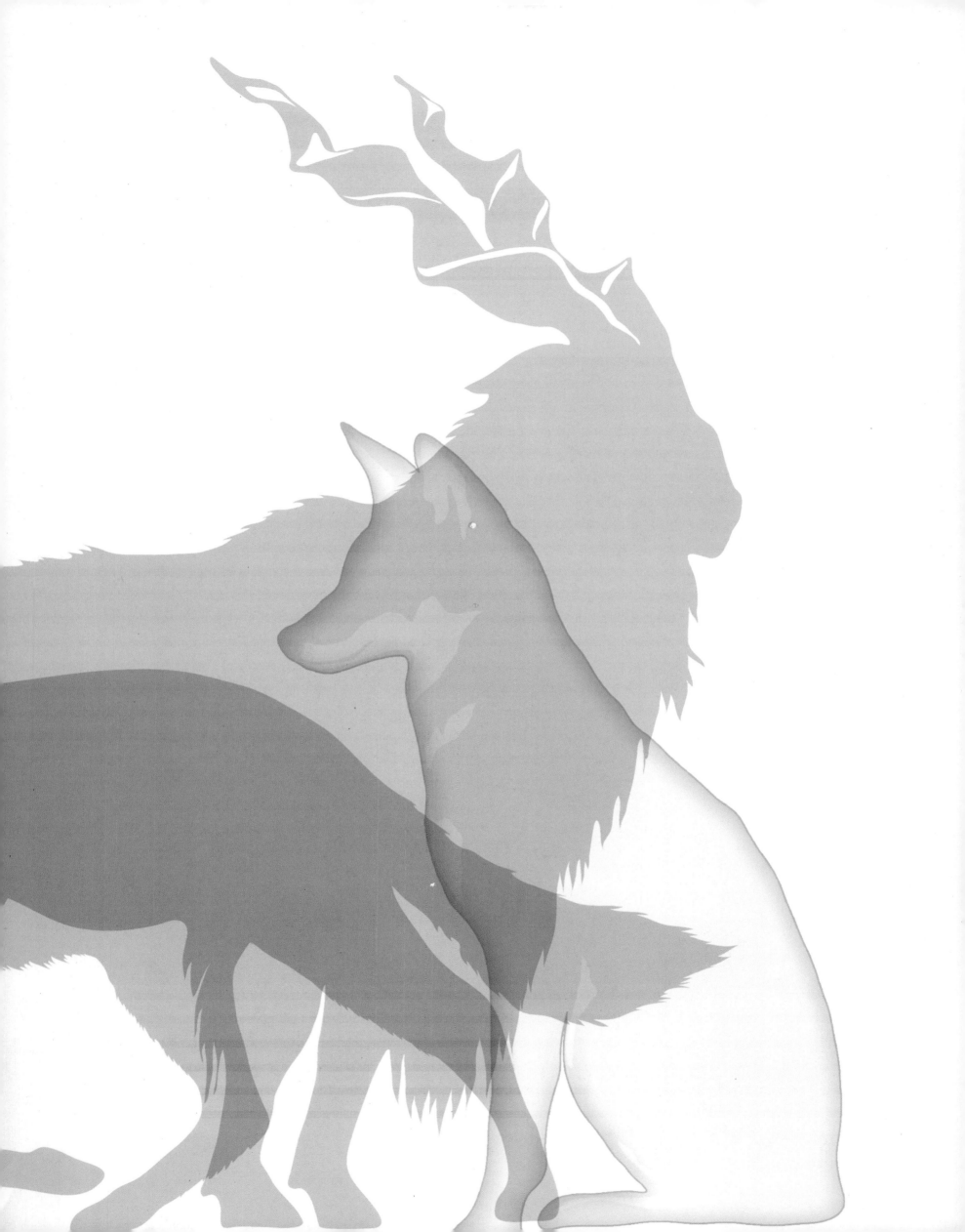

VANISHING ANIMALS

Preface

Fulco Pratesi

Editorial coordination WWF-Italy

Edoardo Maria Massimi

Texts

Gianfranco Bologna, Paolo Casale, Gianluca Catullo, Francesca Conti, Claudia De Rosa, Lavinia Fochesato, Ilaria Guj, Edoardo Isnenghi, Massimiliano Rocco

4

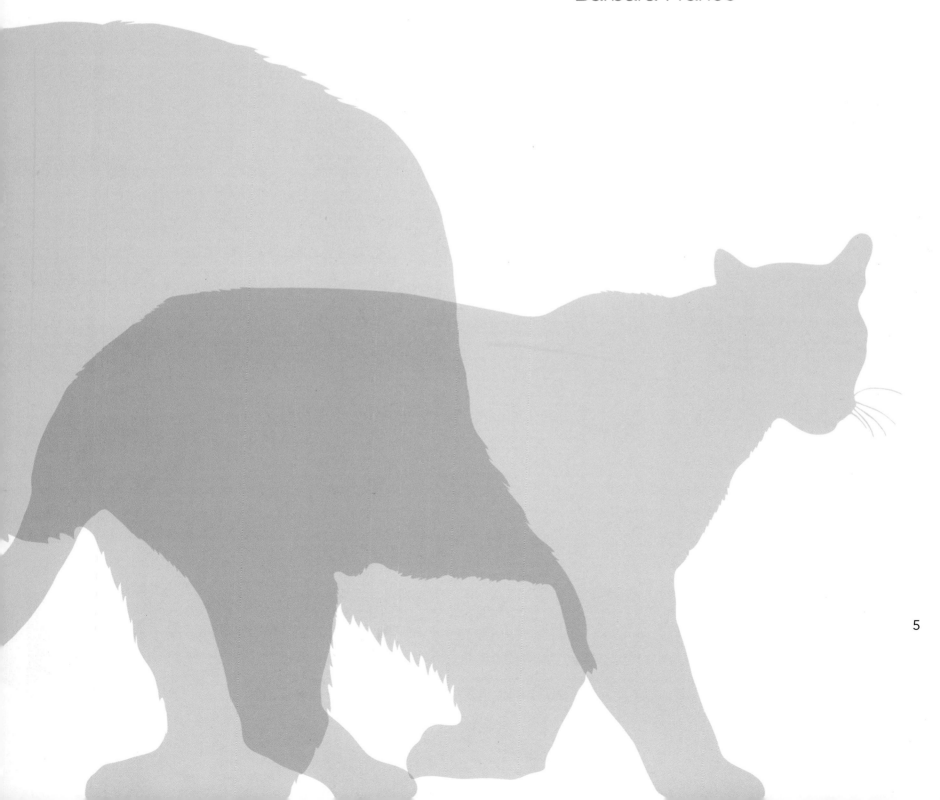

Project editor

Valeria Manferto De Fabianis

Graphic designer

Patrizia Balocco Lovisetti

Collaborating editors

Marcello Libra, Giorgia Raineri

Coordination for WWF-Italia Ong - Onlus

Barbara Franco

VANISHING ANIMALS

contents

6

8-9 Its imposing stature, flattened frontal cranium, long trunk, and very large tusks (which are its upper incisor teeth) are the characteristic traits of the African elephant, whose Latin name, *Loxodonta africana*, derives from the Greek for "slanted teeth," referring to its tusks.

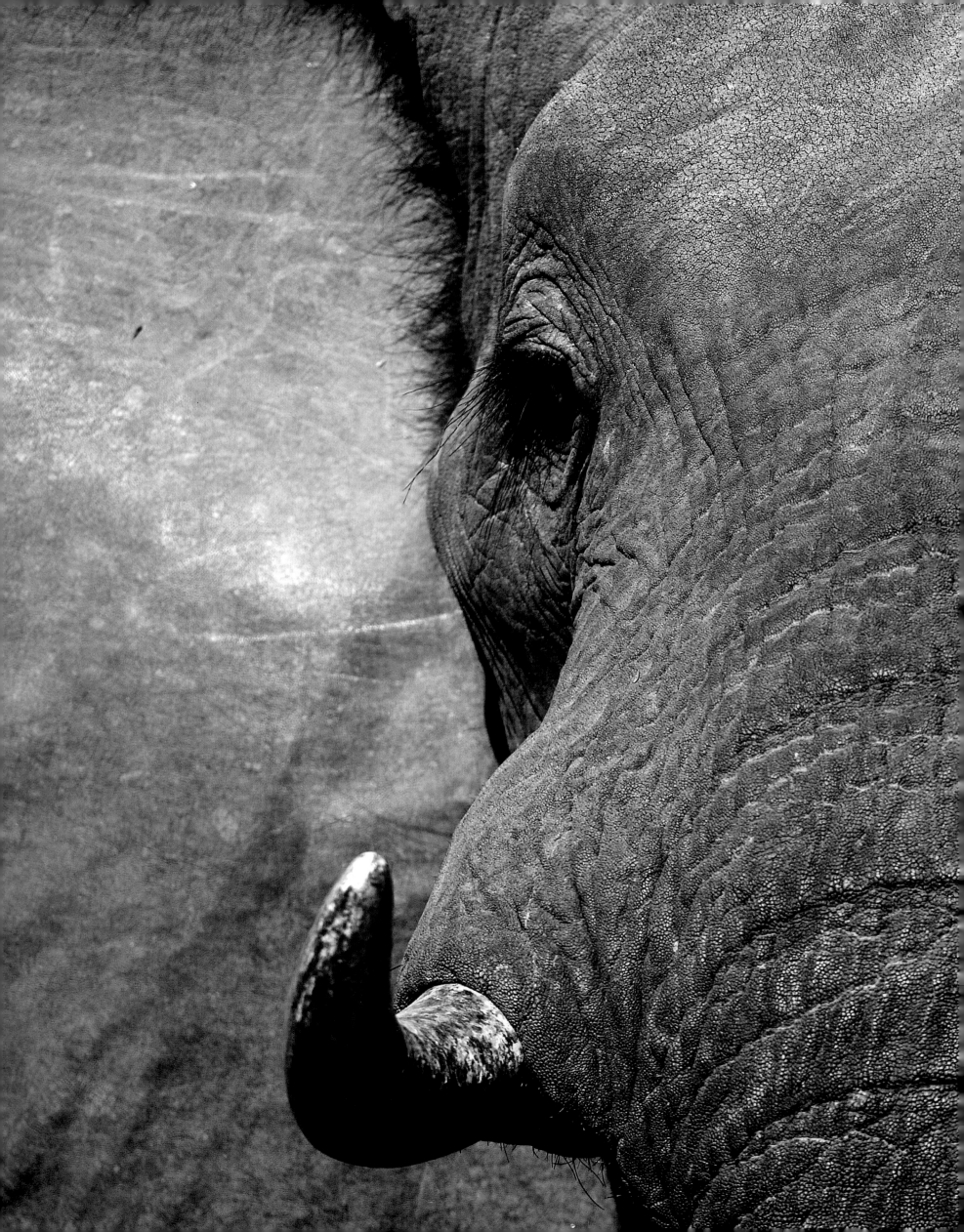

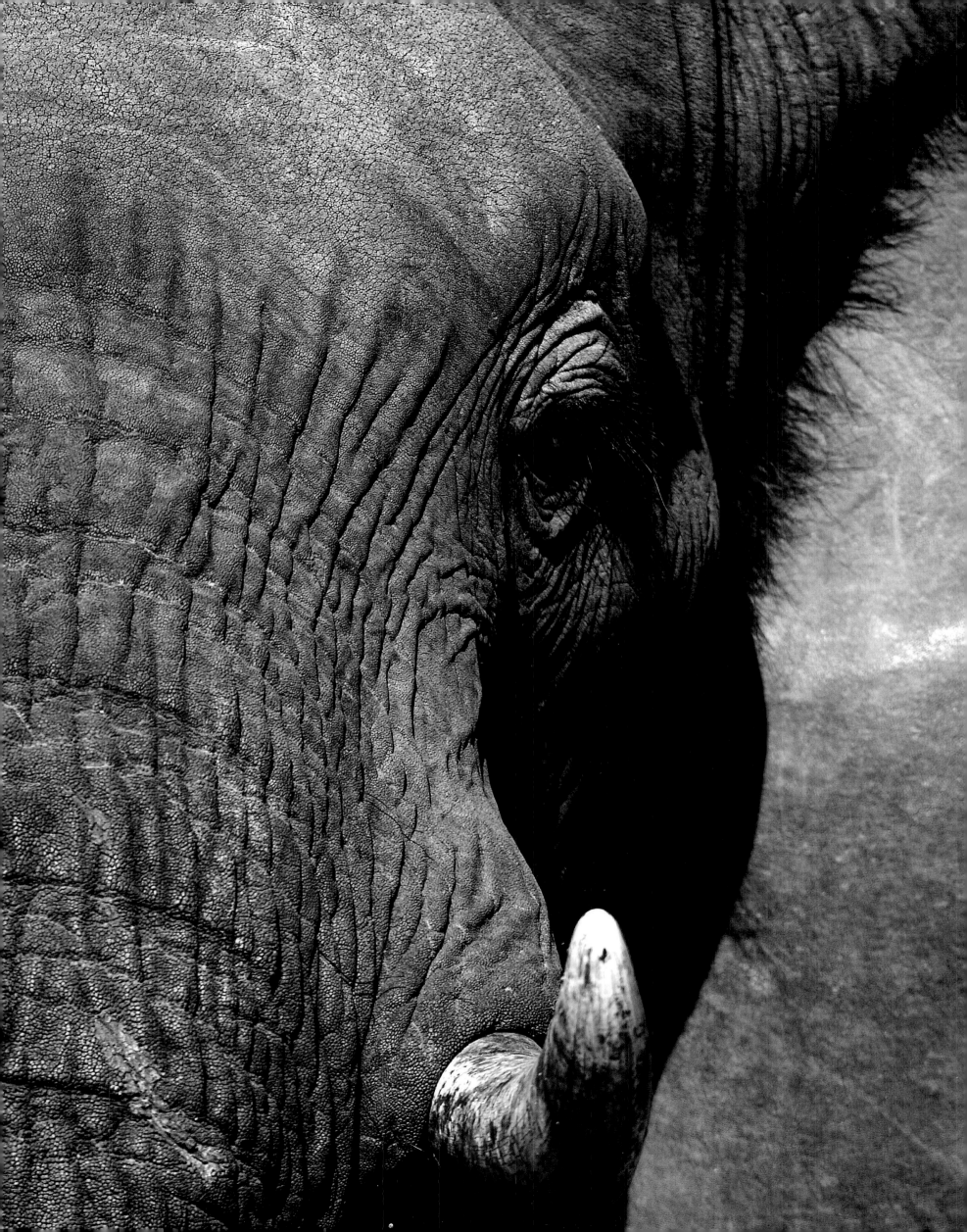

Prince Philip, Duke of Edinburgh and former president of the WWF, wrote one day that if the Coliseum were destroyed, reconstruction would still be possible through use of photos and drawings. But, if the Indian rhinoceros species becomes extinct, nothing in the world could bring it back to life. Take a moment to think about an Africa without the rhinoceros, an Asia without the tiger, an Australia without the platypus, or a Latin America without the jaguar. Or, even an Arctic without the polar bear, an ocean without the enormous blue whale. It would be a horrible nightmare.

And yet, we are dealing with a bad dream that could rapidly become a reality. However fascinating the magnificent landscapes of the Sahara or sequoia redwood forests, the Grand Canyon or the glaciers in Patagonia, no environment, no landscape, no scenery can captivate and charm us as much as wild animal life does.

Placed at the top of the huge food pyramids and at the center of complex ecological equilibria, wild animals represent some of Nature's most beautiful and perfect gifts, the result of millions of years of evolution, from the first living cells lost in the viscous and steamy soup of swamps in the Archaic Age, to the perfect living sculpture of today's mountain gorilla or Asiatic lion. Nevertheless, each of these animal species I've cited thus far do not amount to more than a few thousand specimens.

Even the jaguar, a stupendous feline that once populated the American continent from the southern United States to Patagonia, has a population of only some 50,000 specimens worldwide, equal to the audience at a rock concert or a stadium full of football fans of the most popular NFL team.

Not to mention animals that are genetically closer to us, such as the mountain gorilla, a species whose population could fit into a theater showing an unpopular short run B movie.

The WWF and other environmental protection organizations must work tirelessly in order to safeguard the future of these vulnerable populations. And thanks to their efforts there is still some hope of conserving our planet's precious and essential biodiversity. As you read this book and admire these wonderful photos, tens of thousands of people are taking action, carrying the panda symbol with them throughout the world in defense of animals endangered by extinction and human populations that share their environments. They are in the Congo, aiding the last 600 mountain gorillas, in the Brazilian Pantanal, defending the jaguar and the hyacinth macaw, in Sumatra, fighting against poachers decimating the last tigers, and in the Himalayas, searching for any remaining snow leopards.

The text and incredible images in this volume shall contribute to the courageous battle fought on every continent, ensuring a sustainable future for the most celebrated symbols of our endangered biodiversity. Only by saving the so-called "umbrella species," such as the bear or the elephant, the condor, or the great white shark, and all of the habitats in which they live, from the jungles to the savannahs, from the pack ice to the oceans, from the tundra to the deserts, can we ever hope to escape the environmentally impoverished future that will result from the lack of human foresight and irresponsible behavior.

Fulco Pratesi
Honorary President, WWF Italy

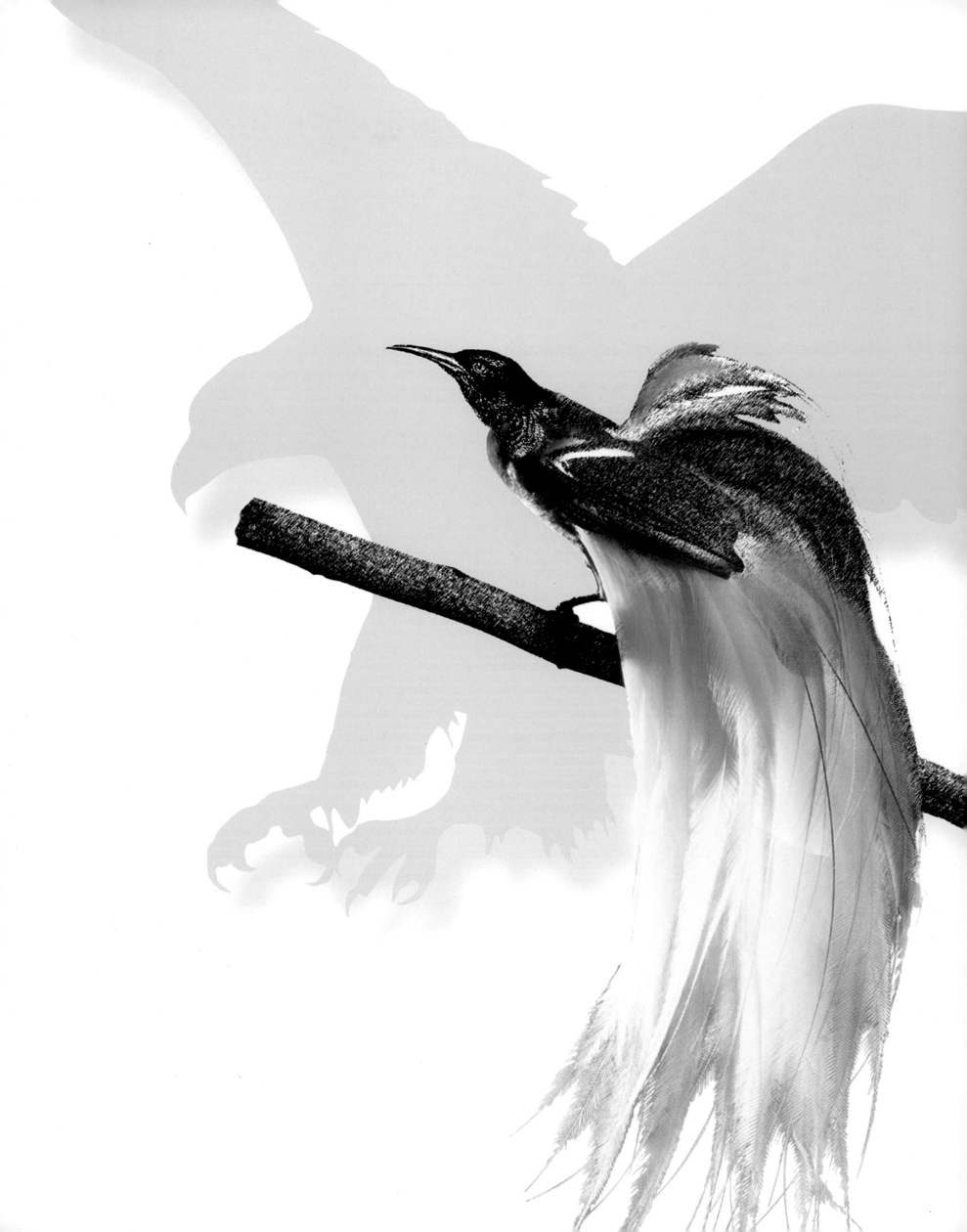

The Tragedy of the Extinction of the Species

Endangered animals and international cooperation:
the role of local communities and indigenous populations

INTRODUCTION

The influence of human intervention on natural ecosystems has reached a level that no other species has ever achieved in such an oppressive way and in such a short period of time in the history of life on this planet. The enormous growth of the human population in the last few centuries corresponds directly to the increasing extinction rate of plant and animal species, an incontrovertible indication that human communities and their profit-based economies constitute the gravest threat to biodiversity and the harmonious balance and functioning of the planet's ecology.

Exploration of and knowledge about our planet has led us to recognize about two million species and many others yet to be categorized: the diversity of life forms is incredible. Many scholars consider that the number of evolved species existing in nature today exceed 10 million. Others even estimate 30 million, but for many species these assessments will not be completed in time because they have already disappeared or are nearing extinction along with their environments. During the four billion years that life has evolved on the Earth, at least five mass extinctions have been documented, natural and quite diverse events that are still occurring before our very eyes today. The scientific world still maintains that the true rate of extinction is much higher than its current pace due to heavy human intervention of ecosystems, at least 100 to 1,000 times higher than the natural rate of extinction documented in the last few centuries "referenced" by fossils. In the IUCN's (World Conservation Union) latest *Global Species Assessment* published in 2004, factual reality even far exceeds the worst forecasts. The Red List is filling with thousands of new species at each revision but that is not enough to open our eyes. Recent data show that our planet is suffering and the success achieved even after decades of effort spent on countless conservation projects still seems meager. More than 41,000 species are counted on the latest IUCN Red List (2007) and a good 16,306 of these are at risk of extinction, including most recently all types of coral.

An example of a truly tragic situation is that of the large anthropoid monkeys. All of the species comprising this group are considered endangered, such as the two orangutan species in the forests of the islands of Sumatra and Borneo, whose habitats humans continue to destroy. Luxuriant forests are modified at a frenetic pace in order to satisfy our demand for wood, transforming a natural habitat into oil palm tree plantations and monoculture farms, which in Borneo alone have increased from 772 square miles (2,000 sq km) in 1984 to more than 10,425 square miles (27,000 sq km) in 2003. In the Congo, the western plains gorilla population was decimated by diseases, such as the ebola virus, and by direct persecution to acquire food sources. The gorilla population has been reduced by 60 percent in the last 20 to 25 years and this negative trend seems unstoppable. The mountain gorilla also deserves mention because, after years of effort with conservation projects involving local communities and authorities of the countries concerned, this gorilla is now safe within the confines of the Virunga Mountains National Park. In recent times, however, guerrilla warfare due to political instability in the area has

also claimed the lives of many animals, violently recalling the world's attention to the conservation of a species that was beginning to show a slight but consistent increase in number.

Many of our smaller cousins are also seriously endangered – the agile douc langur and the tightrope-walking gibbons – in the Asiatic forests between Thailand and Vietnam. This is an area of superb biodiversity that until now still offered many unexplored areas. This region's biodiversity is of global significance and its conservation has been given the highest priority. The border between Laos, Cambodia, and Vietnam is also of particular importance in terms of biodiversity, but only 13 percent of this entire territory has been designated for protection, too small a percentage to guarantee the survival of the many species that require large, undisturbed spaces, such as the tiger, elephant, clouded leopard, gibbons, douc langur, and many others that are defenseless against attacks by poachers that decimate their populations without regard. The same can also be said about the great Asiatic vultures. In the last decades, the sudden death of thousands of specimens from Pakistan to Bhutan has been traced to the drugs administered to cattle, such as Diclofenac. Poisons, drugs, and disease have completely eradicated entire vulture populations once present in Africa and Asia, as well as in Europe, where thousands have also been killed by electrical lines or windmill blades every year. Dams, reservoirs for flood retention, and water removal for agricultural use are all increasingly altering entire hydrographic basins, modifying the course and load capacity of our rivers. This is the very thing that has resulted in the extinction of the Yangtze River dolphin while the gavial (or gharial) has been reduced to not more than 200 adult specimens, a truly meager population. Thousands of other reptiles and fish are at risk because they are victims of illegal sale and uncontrolled collecting. Every year, 900,000 small cardinal fish specimens from the Banggai archipelago in Indonesia end up in aquariums.

The destruction of natural habitats, introduction of foreign species, continuous development, emission of pollutants into ecosystems, direct persecution by humans, excessive hunting, and the climatic change of the last few decades are the great threats to biodiversity. In many areas, bio-geochemical and hydro-geological cycles have been modified, progressively larger parcels of territory are completely stripped of their forest resources, wetlands are reclaimed, and rivers are dammed and over-exploited, altering their delicate natural balance and promoting soil erosion processes that trigger desertification. How do we remedy the situation? We must all commit to altering our industrialized and consumer-oriented lifestyles if the detrimental effects of human activities on the natural ecosystems are to be rectified. Paul Crutzen has proposed a definition of the current geological period starting with the Industrial Revolution as "Anthropocene," witnessing the decisive role of the human species in altering natural balances, habitats, and individual plant and animal species. The destiny of the most endangered species, especially guaranteeing sufficient living space to support viable populations, thus depends entirely on the actions of humans. In an effort to begin the

process, the international community has actively proposed appropriate conventions, protocols, agreements, initiatives, and whatever else they could to motivate people, governments, and organizations to redress these destructive processes, because the loss of biodiversity, essential supplies, and genetic resources will endanger the future of humanity as well as animal species. The Convention on Biological Diversity (CBD), the Washington Convention on International Trade in Endangered Species of Wild Fauna and Flora, the Convention on Migratory Species, the Convention of Ramsar, and the Convention on Global Heritage are international political instruments, which various governments are promoting in order to protect our biodiversity. CITES, the Convention on International Trade in Endangered Species of Wild Fauna and Flora, aims to prohibit or at least strictly control the trade of endangered species and promotes monitoring and suitable sustainable management plans. For all of the species registered in Appendix I of CITES, such as the large anthropoid monkeys, tigers, snow and clouded leopards, whales, sea turtles, pandas, rhinoceros, elephants, and many more, trade is prohibited with only limited imports or exports allowed for scientific purposes or with special dispensation.

In the last 20 years, the number of protected areas recognized by the IUCN have increased from 22,000 to more than 115,000. Unfortunately, many of these areas have not been a great success because they are not properly managed and continue to suffer from various destructive human activities. In 2002, the member countries of the CBD agreed to the common commitment that by 2010 the current biodiversity rate of loss would be halted on a global, regional, and national level, having the added effect of promoting the fight against poverty. This was an important step forward, recognizing the fact that there can be no social development without environmental protection. From then on, the CBD's commitment for the conservation of biodiversity was included in the Development Plan for the New Millennium, reflecting a turning point in the way the global community confronts the urgent need to pursue sustainability. By making links between the issues of poverty, hunger, and environmental protection, concrete and attainable objectives within definite timelines were established, connecting the health and well-being of humanity to environmental quality and the safeguarding of biodiversity. It is the very poorest and most vulnerable populations who share the vital habitats with most of the animals that are at risk of extinction. Both the animals and the people need an intact and productive ecosystem in order to provide a foundation for their survival. For this reason, international cooperation must progressively be oriented toward conservation programs that guide governments towards a model of development that provides for the protection of their natural heritage as an essential condition for guaranteeing food supplies and economic resources to local communities, who will be capable of developing new sources of income from the conservation of the species and their habitats. These are programs that must be carried forward with the help of local and indigenous populations.

Humans depend on nature and only by integrating traditional wisdom with scientific knowledge will it be possible to halt the loss of biodiversity and ensure a sustainable environment for less fortunate populations. We will only prosper by sensibly exploiting and managing our natural resources without compromising the planet's capacity for regeneration and renewal.

ANIMAL THREAT CATEGORIES

Among animals and plants, more than 16,000 species are threatened with extinction, according to the latest Red List compiled by the IUCN – World Conservation Union, a worldwide organization uniting many countries and other regional bodies, hundreds of government agencies and non-governmental organizations, and more than 10,000 scientists and experts from 160 countries throughout the world. To be exact, of the 41,415 species on the Red List published in 2007, a good 16,306 are at risk of extinction. This number has increased from the previous year. In fact, there were 16,118 endangered species on the Red List in 2006. Mammals, birds, and amphibians are the most endangered animals. The most recent scientific definition of threat categories provided by the IUCN Red List is as follows:

• Extinct (EX = Extinct): a species is "extinct" when it is certain that the last specimen is dead. Accurate research recurring over the range where the species was definitely present has demonstrated that there is no individual living specimen remaining.

• Extinct in Nature (EW = Extinct in the Wild): a species is extinct "in the wild" (or "in nature") when only specimens in captivity and/or in naturalized populations outside of their original range survive. Following recurring research, no single specimen has been found in the historical range where its presence was definitely previously identified.

• Critically Endangered (CR = Critically Endangered): a species is "critically endangered" when it faces a very high risk of extinction in nature in the immediate future. Species whose populations have endured an intense recent reduction in size, a rapid decrease over their range, include very few specimens, or have a very small chance of surviving in the immediate future are included in this category.

• Endangered (EN = Endangered): a species is "endangered" when it faces a high risk of extinction in nature in the immediate future and could become critically endangered.

• Vulnerable (VU = Vulnerable): a species is "vulnerable" when it faces a high risk of extinction in nature in the mid- to long-term future and could become endangered.

• Dependent on Conservation Action (CD = Conservation Dependent): a species is "conservation dependent" when the suspension of current conservation measures for that species or its habitat could put it in a higher risk category.

• Almost at Risk (NT = Near Threatened): a species is "almost at risk" when it is not currently at risk but could re-enter the "vulnerable" category in the future.

• At Low Risk (LC = Least Concern): a species is at "low risk" when it is not at risk or close to becoming so. Species re-entering this category are widely distributed and not subject to any threat.

• Insufficient Data (DD = Data Deficient): species re-enter this category when information available to evaluate their level of risk is insufficient. A species may also be well known from a biological and ecological viewpoint but data on its distribution and conservation status is unavailable, requiring its re-entry into this category. Therefore, this is not a threat-level category.

• Not Evaluated (NE = Not Evaluated): a species is "not evaluated" when it is has not been evaluated according to the IUCN criteria.

The acronyms (EX, EW, CR, etc.) at the end of each report indicate the IUCN threat category relative to the species in question.

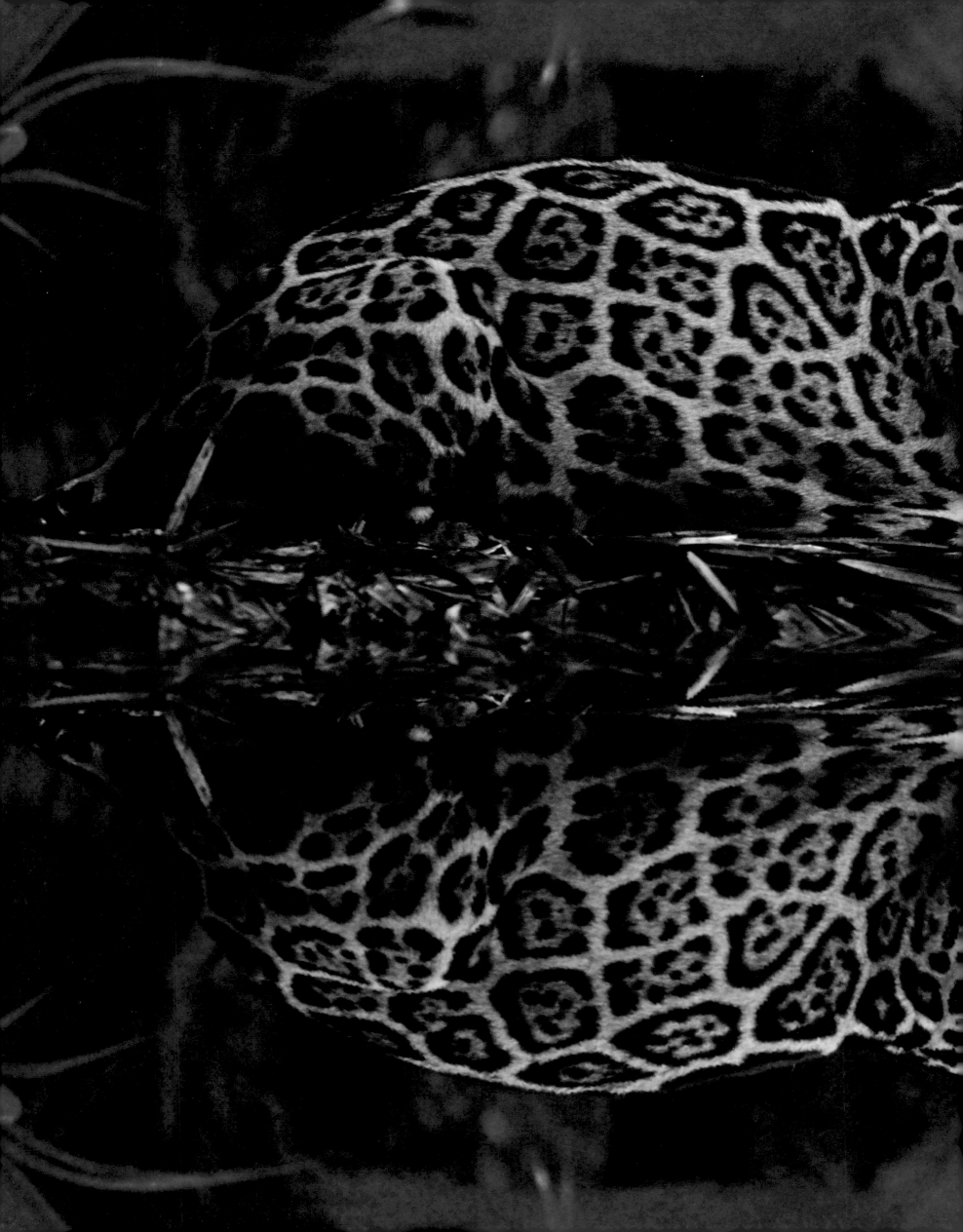

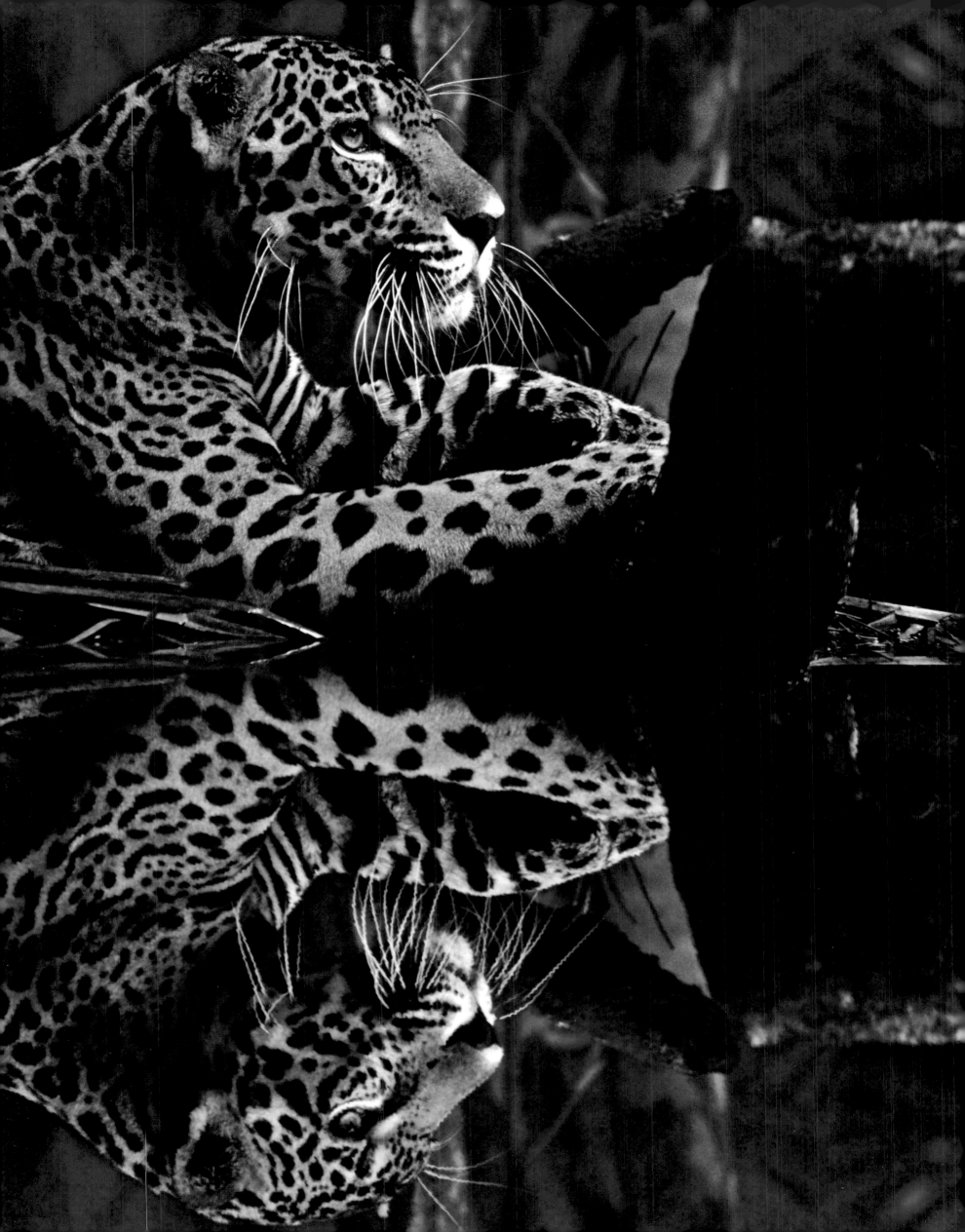

EUROPE

The European continent, though profoundly altered over thousands of years by humankind, still offers a rich and complex variety of habitats – from the forests of Scandinavia, to the mountain chains of the Alps and Carpathians, and the coastal regions of the Mediterranean. This extraordinary and unique mosaic of natural and semi-natural habitats accommodates innumerable plant and animal species. The survival of these myriad species is seriously threatened, however, by the rapacious lifestyle of just one animal – human beings. Europe is a densely populated and highly developed continent, with a complex, often conflicting, sometimes benevolent relationship with nature. Indeed, in Europe the concept of conservation, of preserving wildlife and unspoilt landscapes, is rather old. Nature parks and natural preserves may even date back to the Sacred Woods of the ancient Romans, which were protected as much for their holiness as for their natural beauty. Even in the establishment of medieval royal parks and hunting preserves there can be discerned an early sensitivity towards safeguarding an environment from rapid and unexpected transformation tied to deforestation and conversion to agriculture. Once covered by vast stretches of forest, Europe saw a radical environmental change over the course of centuries as a result of population expansion and the development of industry and agriculture which disfigured if not irreversibly altered the original landscapes, some of which may only be admired today in paintings.

The institution of protected areas is only the first step towards the conservation of a species at risk of extinction, and is quite often fundamentally important to the maintenance of a level of biodiversity necessary for the survival of an entire ecosystem. Europe now offers a complex and extensive system of protected areas. According to the latest research there are 43,018 of these areas, covering more than 290,000 square miles (750,000 sq km), equal to almost 15% of continental Europe. This is an impressively high number, but there are dramatic differences between the various European countries. Legal initiatives

and measures addressing environmental conservation established by a single or a few countries are still not yet completely integrated into a wide-ranging program that takes into consideration the actual distribution of habitats and species, which are rarely neatly located within national boundaries. A perfect example of this are the Pyrenees, Alps, and Carpathian mountains that all extend over several national borders and have precious ecosystems, rich in endemic species of flora and fauna. One success story is the Alpine ibex (*Capra ibex*) which has been reintroduced to the Alps. After studies showed that it was on the threshold of extinction, this beautiful animal has finally repopulated a large part of its original European range.

The European Union, however, has provided alarming data on the continuing reduction and loss of biodiversity throughout Europe despite having already adopted a "strategy to anticipate, prevent, and combat the basic causes for the significant reduction or loss of biodiversity" in 1998. The urgent revitalization of the populations of cerain species should be added to the now irreversible extinctions of others. In fact, it is estimated that there are at least 335 vertebrate animal species at risk of extinction, and the survival of 42% of endemic mammals, 45% of butterflies, 30% of amphibians, 45% of reptiles, and 52% of freshwater fish are still seriously compromised. Many human activities have a devastating impact on the environment and serious threats that could endanger all types of European habitat are increasingly evident, from uncontrolled exploitation of natural resources to the release and discharge of pollutants which can suffocate an already almost saturated environment. Additionally, climatic change will also increase the rate of environmental disruption and the loss of biological diversity, changes that plant and animal species cannot successfully cope with when they are already dealing with a state of extreme vulnerability.

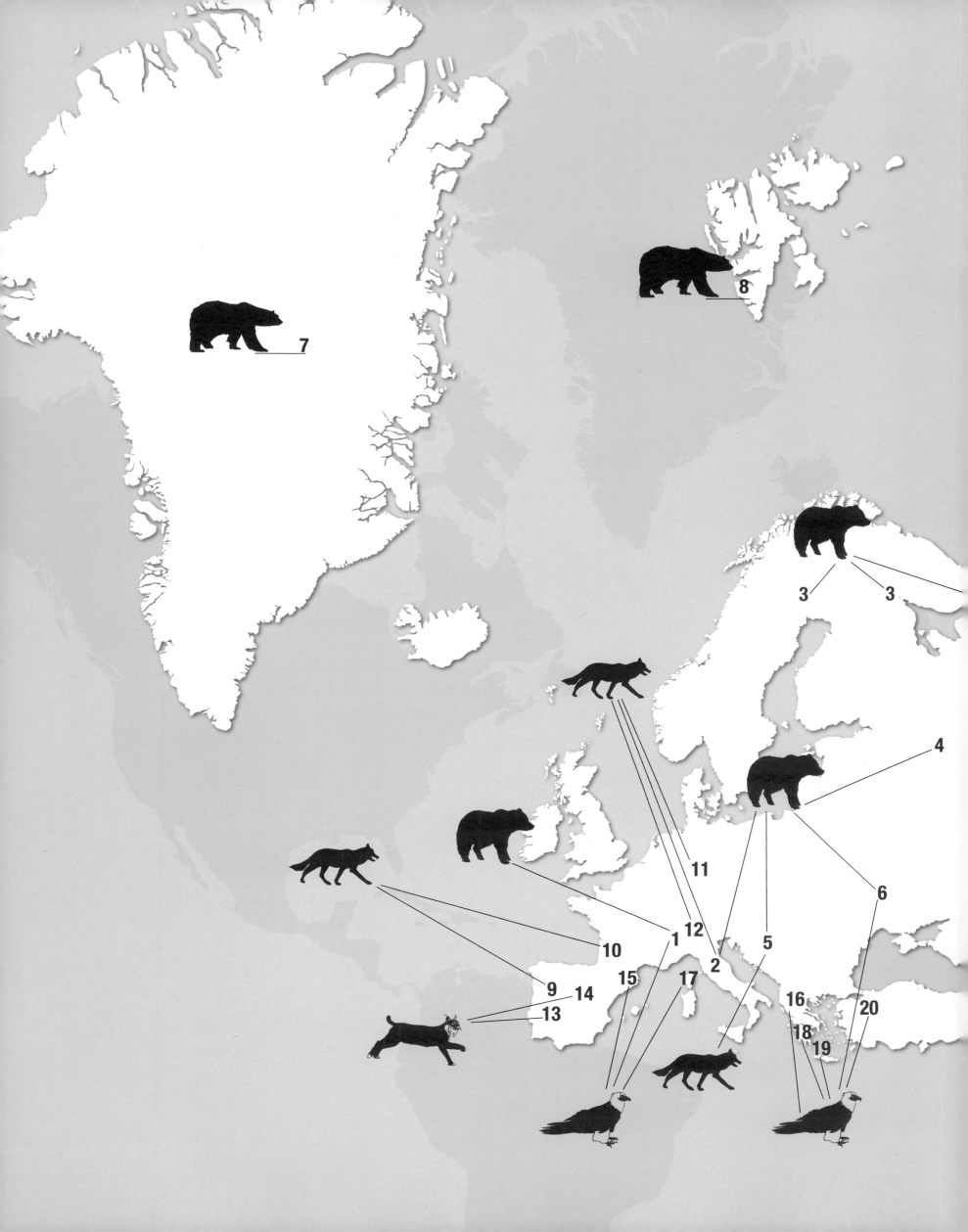

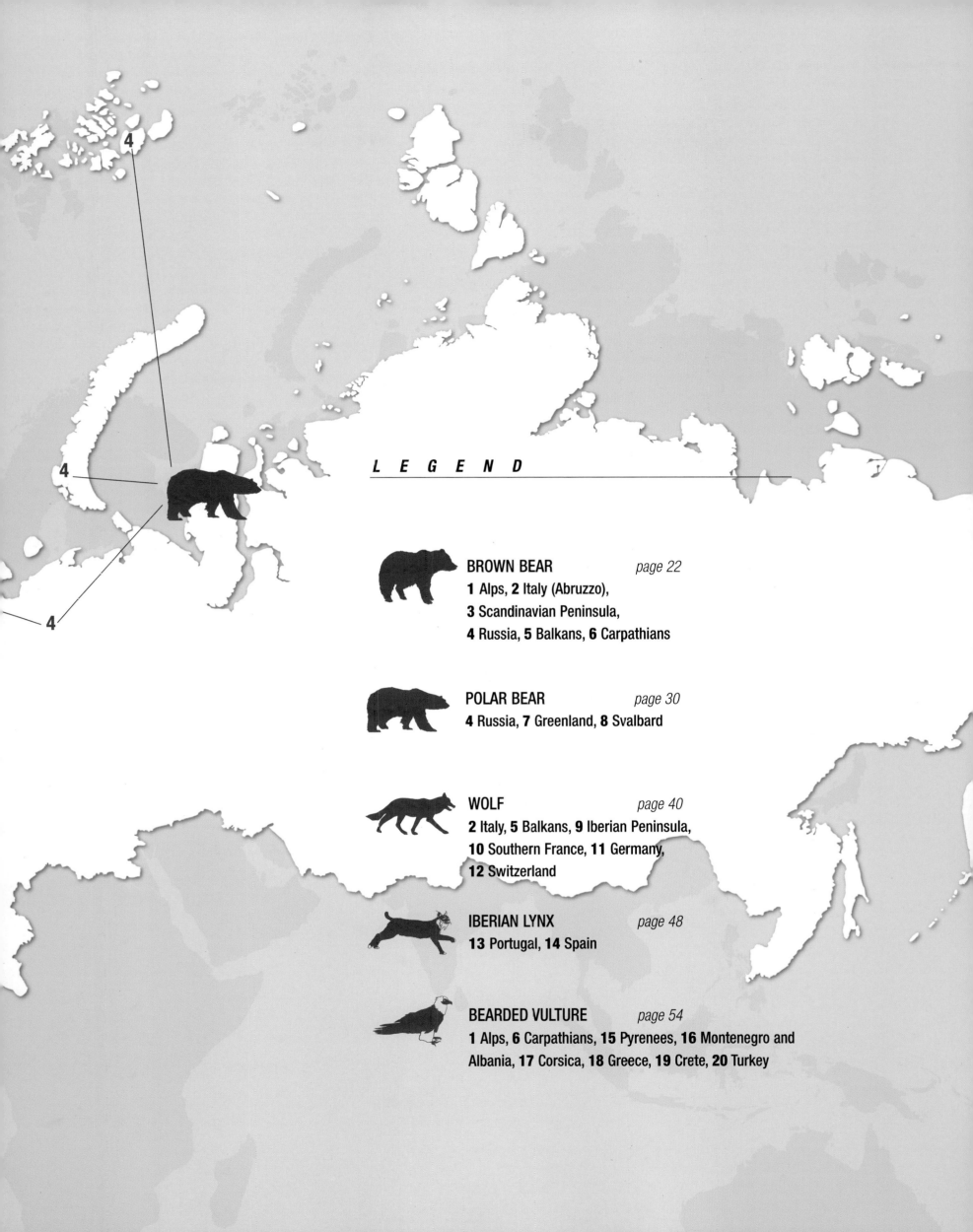

LEGEND

BROWN BEAR page 22
1 Alps, 2 Italy (Abruzzo),
3 Scandinavian Peninsula,
4 Russia, 5 Balkans, 6 Carpathians

POLAR BEAR page 30
4 Russia, 7 Greenland, 8 Svalbard

WOLF page 40
2 Italy, 5 Balkans, 9 Iberian Peninsula,
10 Southern France, 11 Germany,
12 Switzerland

IBERIAN LYNX page 48
13 Portugal, 14 Spain

BEARDED VULTURE page 54
1 Alps, 6 Carpathians, 15 Pyrenees, 16 Montenegro and
Albania, 17 Corsica, 18 Greece, 19 Crete, 20 Turkey

BROWN BEAR

Ursus arctos

An animal both loved and feared, the brown bear (*Ursus arctos*) in many ways symbolizes the contradictory relationship humans have with nature. In the Holocene epoch about 8,000 years ago, the brown bear was the most powerful predator in Europe. It was found throughout the temperate forests along with the wolf, Iberian lynx, and the various members of the Mustelidae family (weasels, badgers, and skunks). Thousands of years later, Latin poets and historians of the Christian era described the forests as being so dense and immense that a squirrel could have traveled across the continent without ever descending from the trees. This was the ideal environment for an animal such as the brown bear which requires extensive hunting territories. Over time, however, the spread of agriculture and the resulting need for increasingly larger areas of cleared land for cultivation, as well as the rising density of the human populations and their ever-increasing demand for timber, brought about the progressive reduction of the bear's forest environment. Today, brown bears live in confined forested areas that are protected, but these woods are often too small and they will leave them in their search for food and travel into areas that are unsafe. In particular, they run the risk of being hit by vehicles or entering inhabited areas to prey on livestock or even beekeepers' hives. Along with the fragmentation of its natural environment, there are other threats putting the survival of this species at risk in Europe, such as poaching, the presence of traps spread throughout the mountains for illegal capture of game, accidental killing during wild boar hunts, and use of poisoned bait put out to "defend" livestock. The brown bear population in Europe is now extremely reduced, to such an extent that it is close to the point of no return. Its future is entirely in our hands. We have now reached the moment where we have to choose between taking a step backward, guaranteeing a vital environment for the brown bear, or accepting its final disappearance from the continent.

LC

23 The male brown bear is a solitary animal and will only accept the presence of other bears during the mating season or if food sources are abundant, for instance, when salmon swim upstream from the sea.

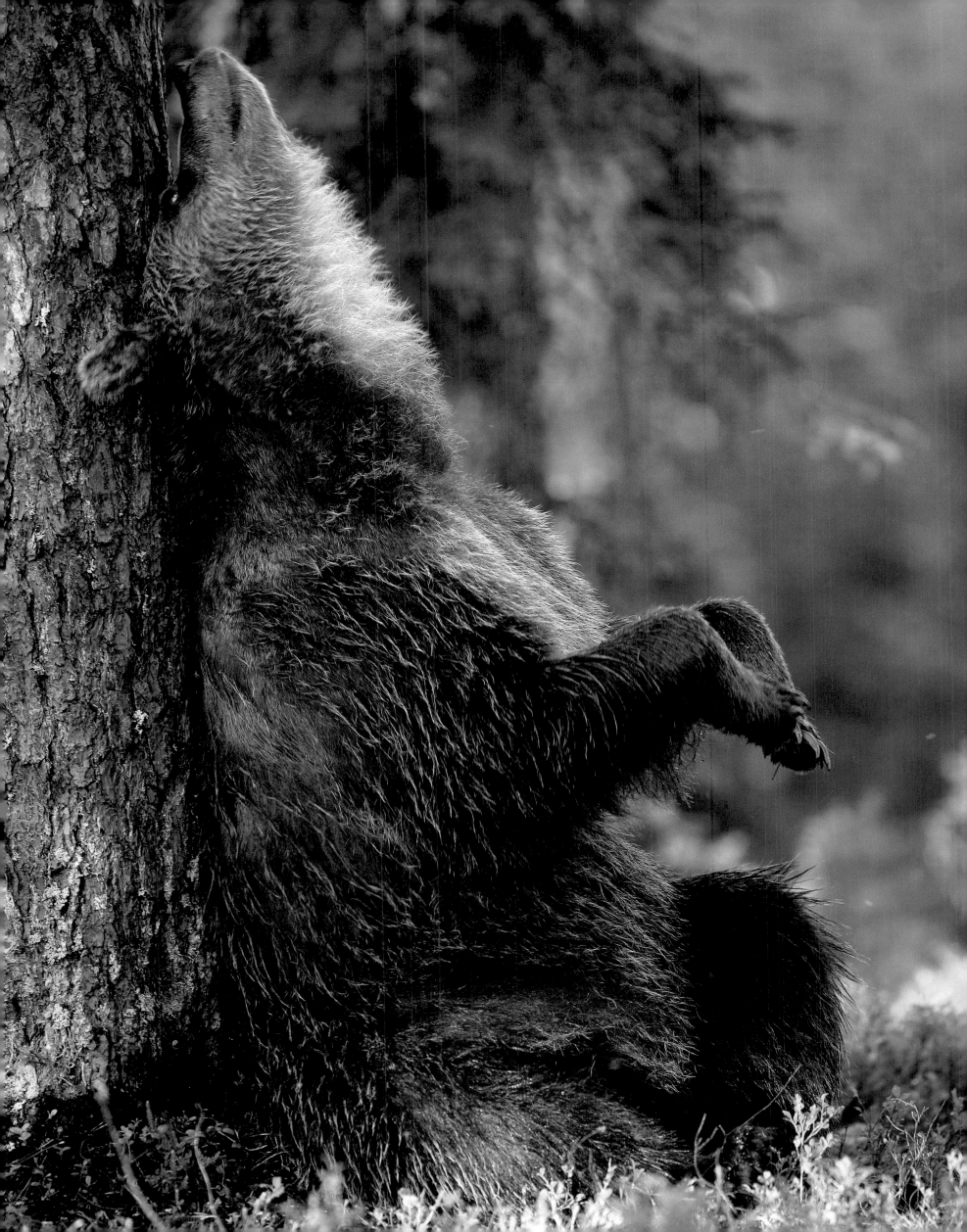

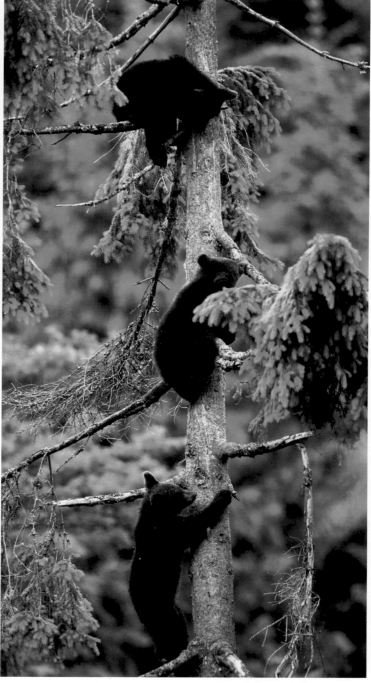

24 top left When the brown bear gallops or runs, it can reach speeds of up to 30 mph (48 km/h) and maintain this top speed for almost 105 ft (32 m). An accomplished walker, the brown bear may travel up to 25 miles in one day.

24 bottom left After giving birth, female brown bears spend at least a couple of years with their cubs. Over the course of its entire life, a female brown bear may give birth to a total of six to eight cubs.

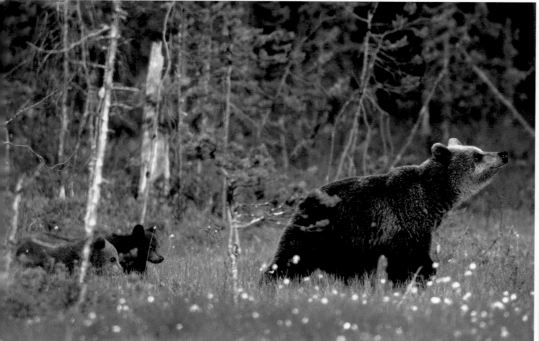

24 right From birth to adulthood, the brown bear gains 600 times its birth weight, from almost 18 oz (510 g) to more than 660 lb (300 kgs).

25 The brown bear has a very varied diet, with insects, such as ants, wasps, and beetles, constituting an important part of its nutritional requirements.

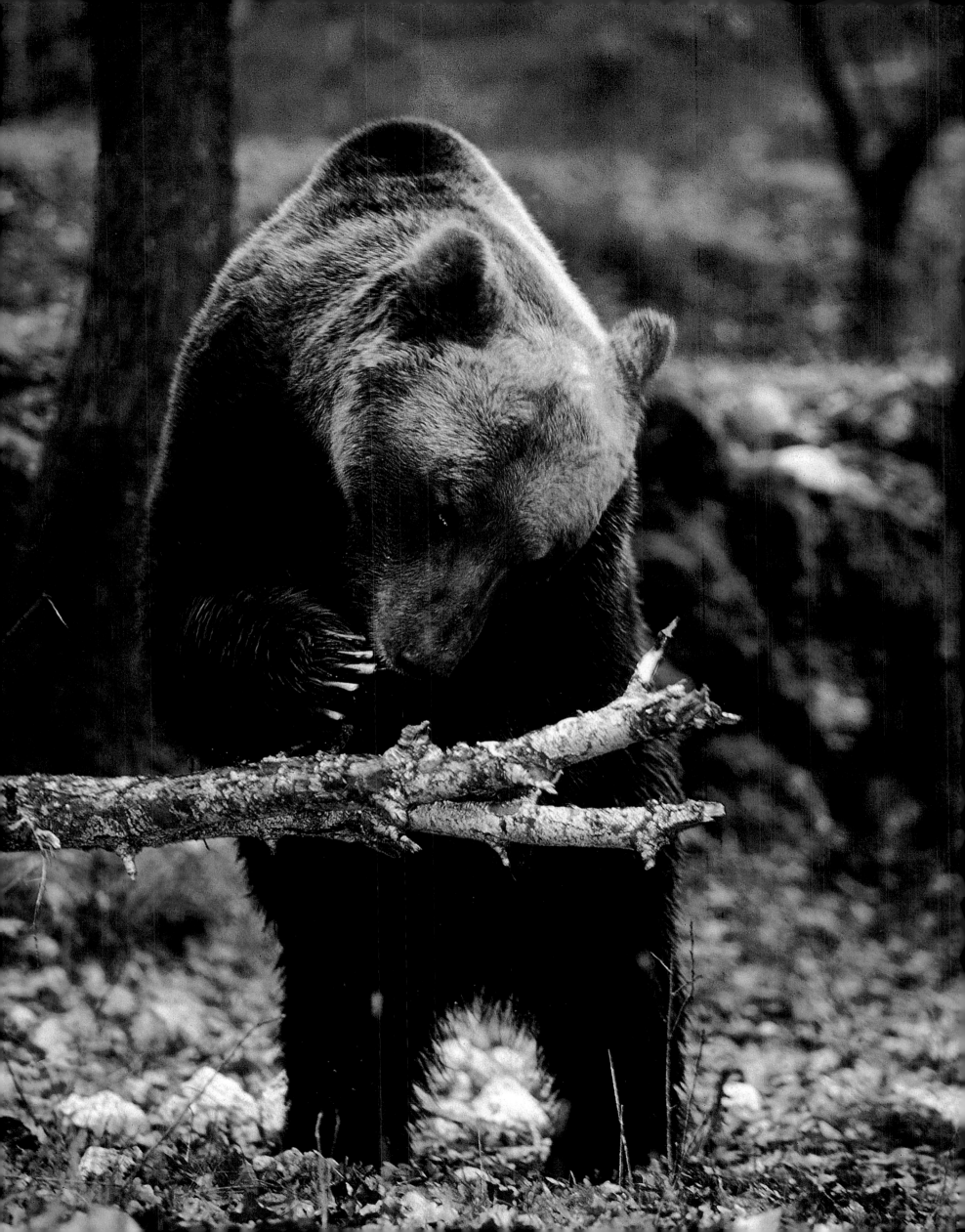

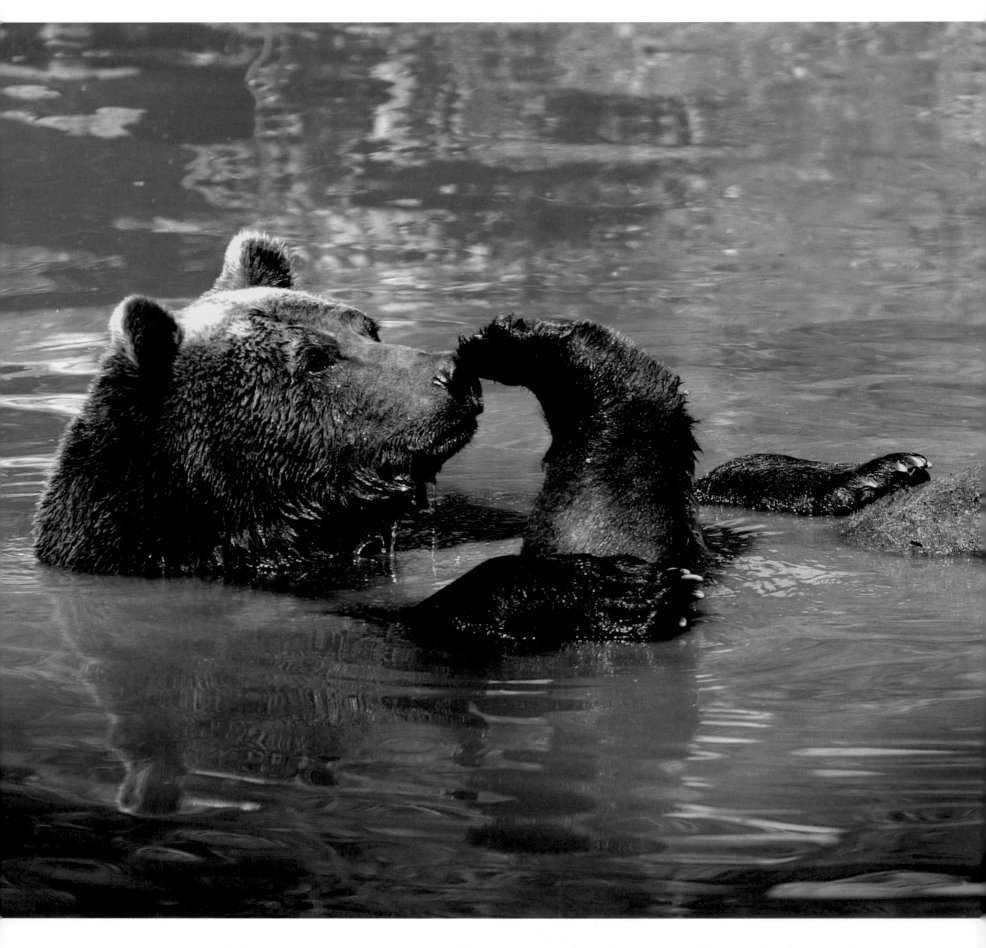

26-27 The brown bear's paws are made up of a smooth black sole, divided by a row of furry pads that grow five powerful non-retractable nails.

27 top The brown bear walks with the soles of its hind paws flat on the ground (plantigrade). This ability allows it to maintain an upright posture for brief periods of time so that it can change position.

27 center The brown bear has a massive physique and its coat is dark brown with lighter shades to darker greys. It can live up to 15 years in the wild, while in captivity it can reach up to 40 years of age.

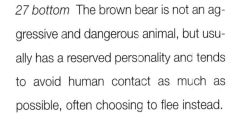

27 bottom The brown bear is not an aggressive and dangerous animal, but usually has a reserved personality and tends to avoid human contact as much as possible, often choosing to flee instead.

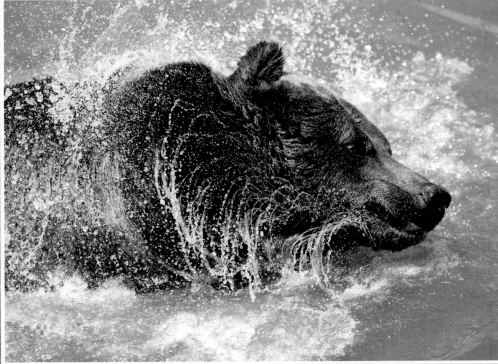

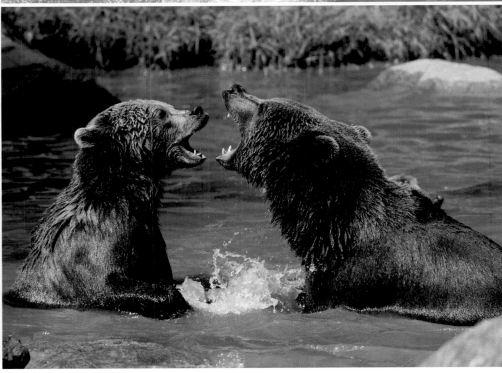

B R O W N B E A R

28 The brown bear is not an endangered species as a whole, but certain sub-species are: for example, in the Apennines in Italy the Alpine brown bear is critically endangered and the Marsican brown bear is endangered. In an area centering around the Abruzzo, Lazio, and Molise National Park, there is a surviving brown bear population of about 50 to 80.

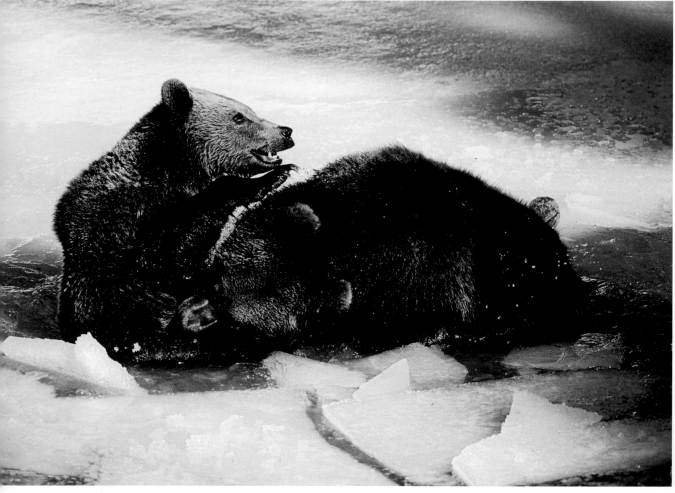

28-29 Currently, the brown bear's distribution throughout Europe has reduced to sizeable populations only in Russia and the Scandinavian peninsula, with smaller populations in the Balkans and the Carpathians, and still smaller ones in the Alps.

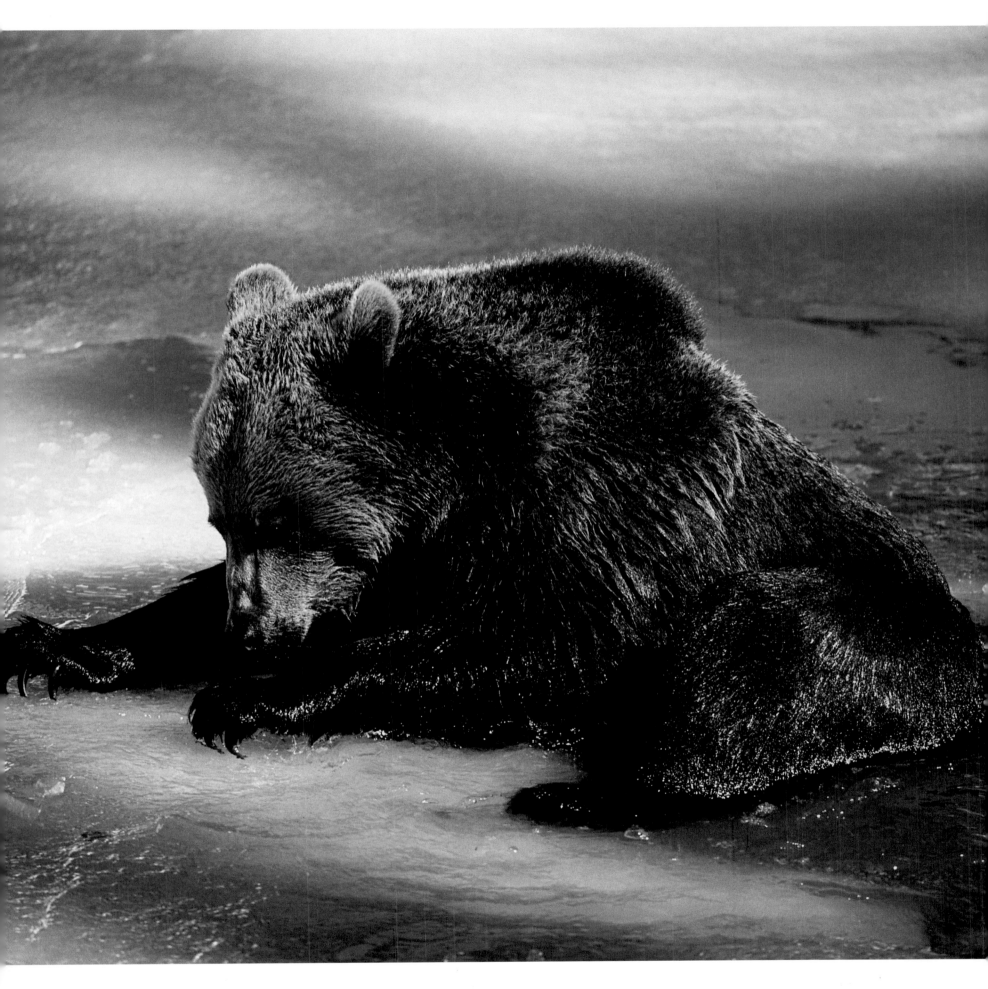

POLAR BEAR

Ursus maritimus

A polar bear (*Ursus maritimus*) trapped on a floating iceberg fragment not much larger than itself has become one of the most compelling images of the impact of climate change. The largest predator in the Arctic marine ecosystem since the Pleistocene epoch is now threatened by the climatic alterations to its environment. The 19 populations of polar bears that inhabit the Arctic from Canada to Alaska, from Russia to Norway, and on to Greenland, spend a great part of their time near or on the edges of the ice pack searching for food. However, the effects of global warming, caused by the constantly growing levels of greenhouse gases in the atmosphere, mean that the Arctic is becoming increasingly ice-free. Polar bears share this beleagured habitat with other endangered animals, such as ringed seals, Arctic wolves, narwhals, beluga whales, and millions of migratory birds. Most polar bears spend winter and spring on the ice where it is easier for them to get nearer to their prey, but the shorter and less-cold winters and consequent diminishing size of the ice pack mean that they now have less and less time available to obtain food. When the ice begins to melt and break up some bears remain on isolated fragments, with the risk of becoming floating prisoners, while others spend the summer on land, taking advantage of their reserves of body fat accumulated over the spring and winter hunting seasons. At the current rate of climate warming, experts anticipate that by the year 2080, there will no longer be any ice in Canada's Hudson Bay and more than 60 percent of the 20,000 to 25,000 polar bears in the world live in Canada. According to the IUCN's (World Conservation Union) estimates, in the next ten years five of the polar bear populations will run a high to very high risk of decline, six will have a low risk, while there is not enough data to make accurate evaluations for the remaining eight.

VU

31 The top predator in the Arctic marine ecosystem, the polar bear is among the largest land carnivores in the world, although its Latin name, *Ursus maritimus*, reminds us that it spends most of its life in and around the sea.

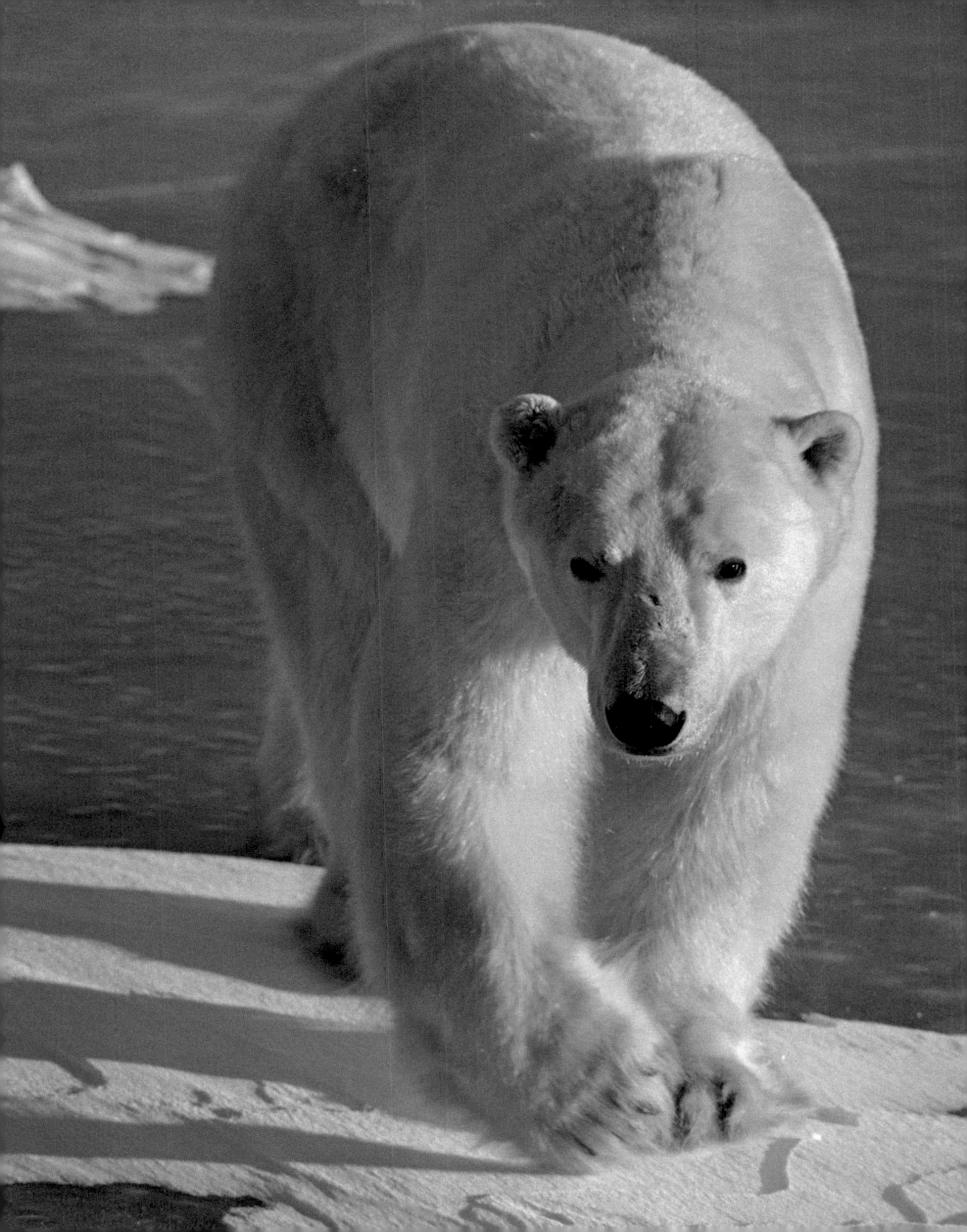

32-33 The polar bear's thick coat is composed of water-repellent fur, camouflaging black skin, which is ideal for absorbing the rays of the Arctic sun.

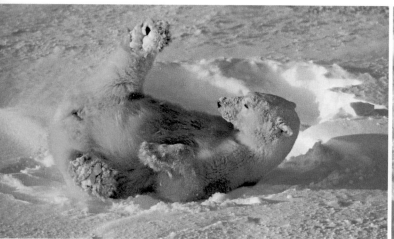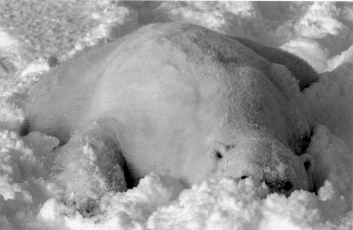

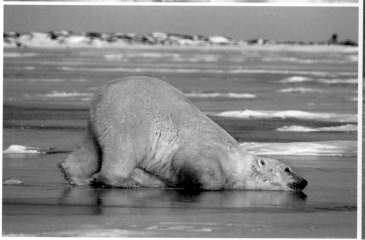

32 left and top right The polar bear's preferred habitat is ice, particularly the ice covering the Arctic seas for most of the year. That is where the polar bear spends most of its time, both hunting and reproducing.

32 center and bottom right The polar bear has adapted to a life in the far north where temperatures can plunge to -22°F (-30°C) during the long winter and often not exceeding 50°F (10°C) during the summer.

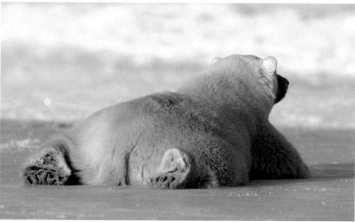

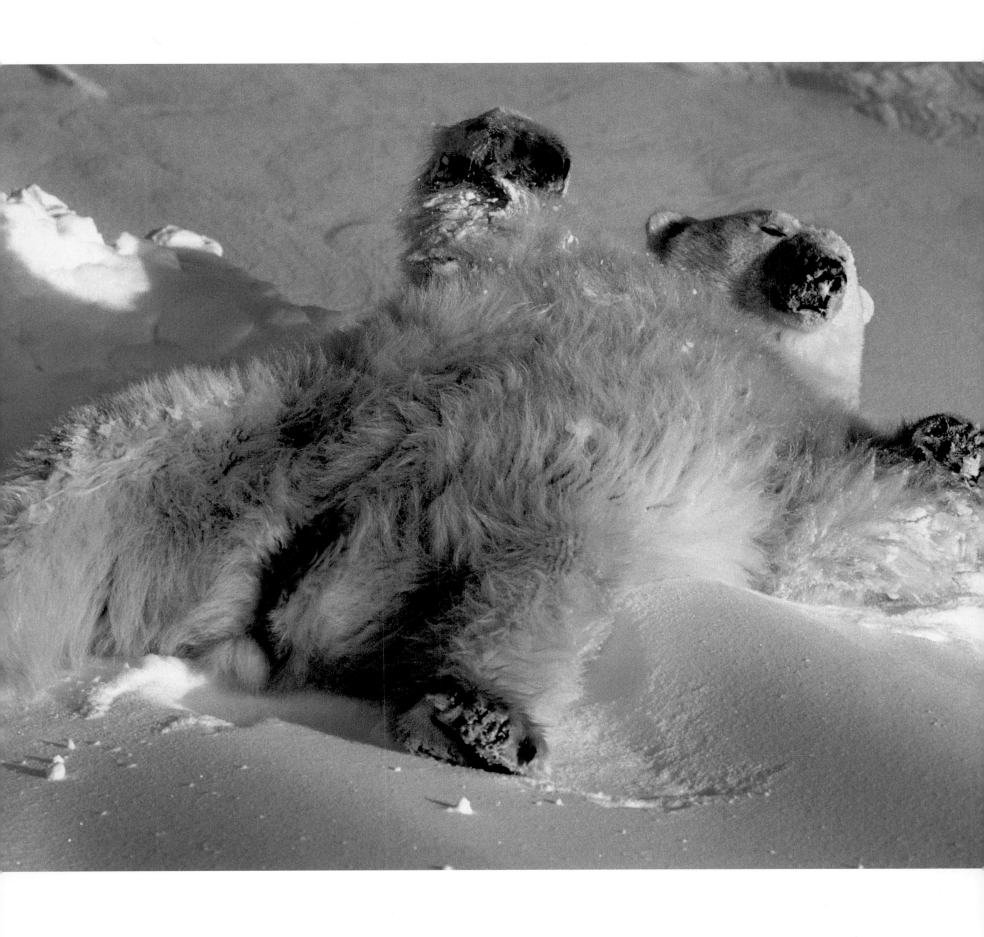

P O L A R B E A R

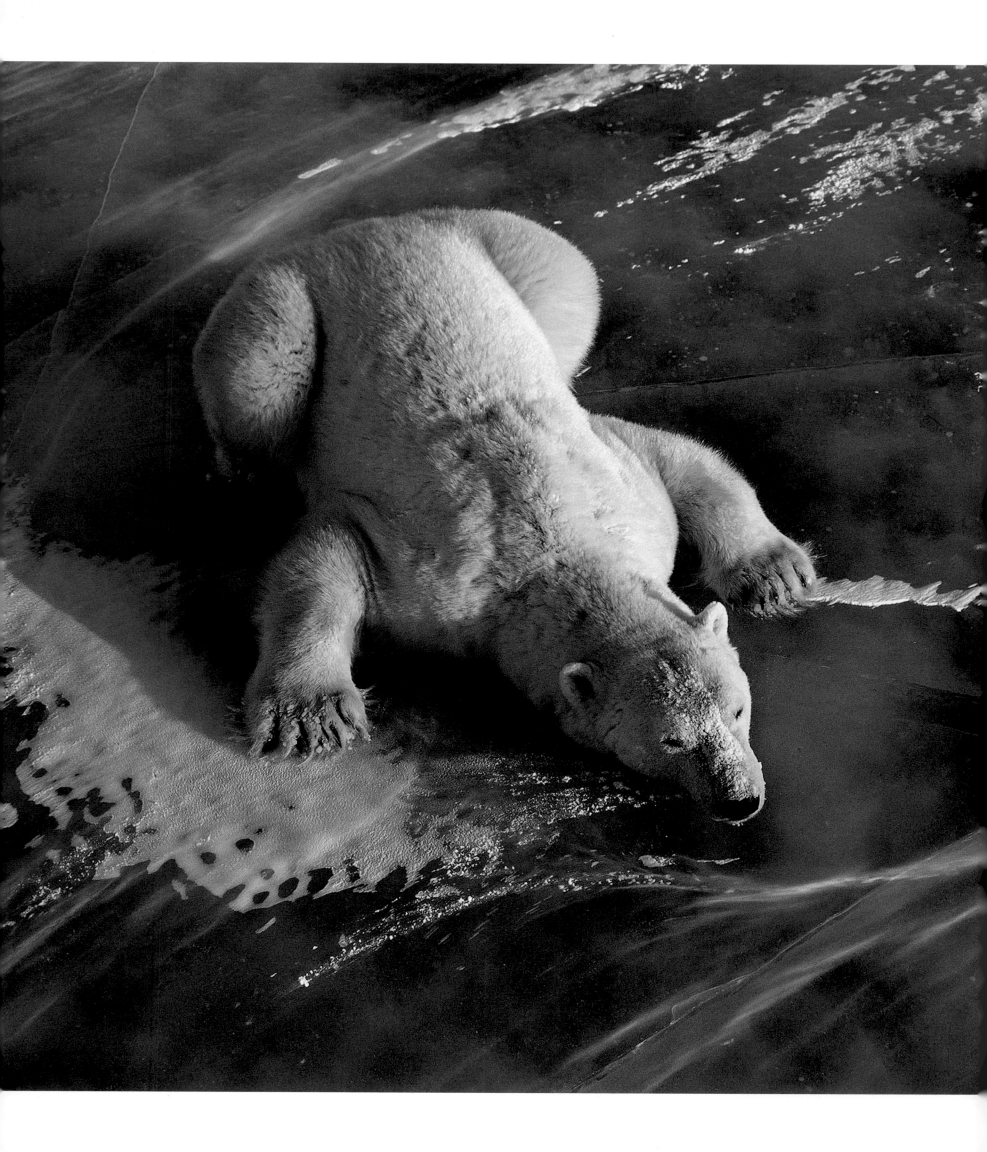

34-35 The polar bear may wait for hours, stretched out on its abdomen with its chin resting on the ground near a seal's breathing hole in the ice, waiting for the seal to pop up to get some fresh air.

35 From the tips of their noses to the ends of their tails, adult male polar bears are on average 7–8 ft (2–2.5 m) in length and weigh from 880 lb (400 kg) to about 1,320 lb (600 kg). In general, female polar bears are about half the size of the males.

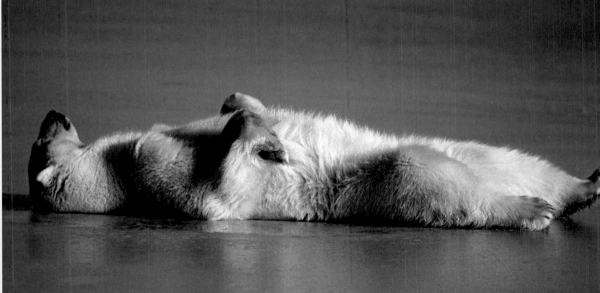

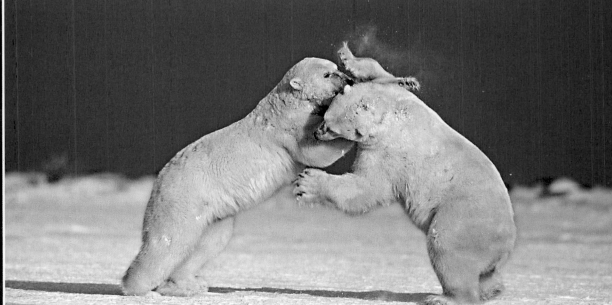

36 The pads of the polar bear's paws are covered with small soft growths called papillae that increase the friction between its paws and the ice, reducing the possibility of slipping.

36-37 Each female polar bear has two cubs, each one weighing only about 20 oz (570 g). They remain with the mother for about 2.5 years before making their own way in the world.

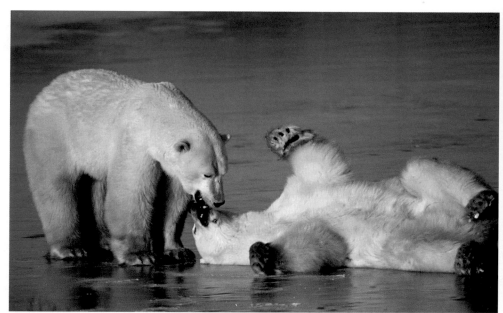

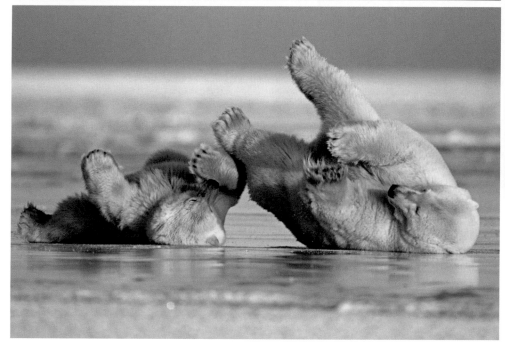

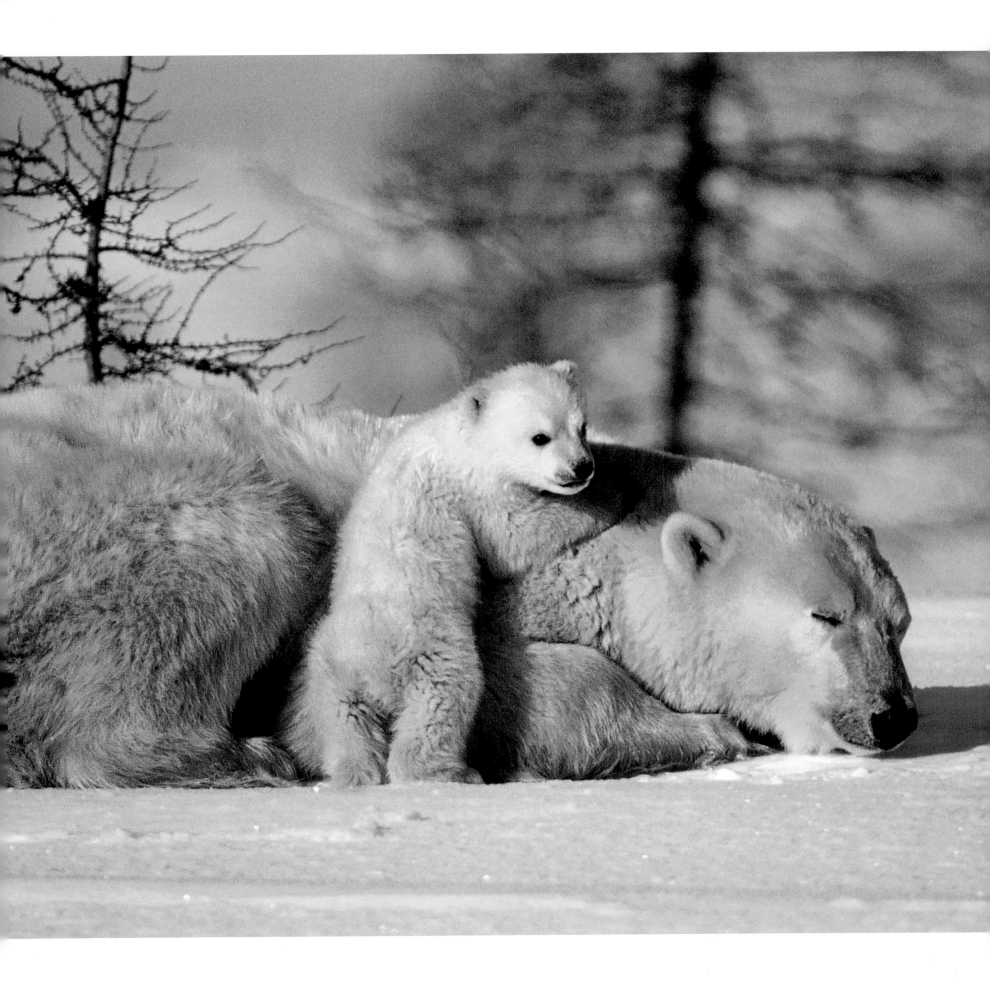

38 left and top right In order to survive, the polar bear needs pack ice where it has the best chance of finding food. The results of some climatic computer simulations indicate that by the end of this century the ice will completely disappear during the summer months.

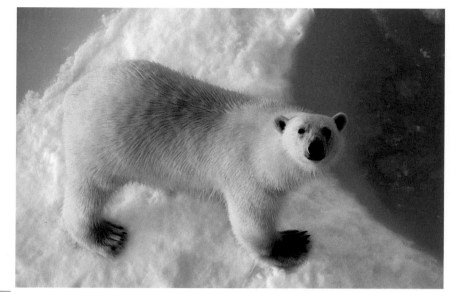

VANISHING ANIMALS

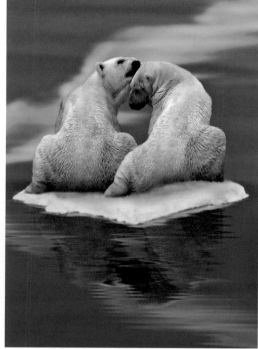

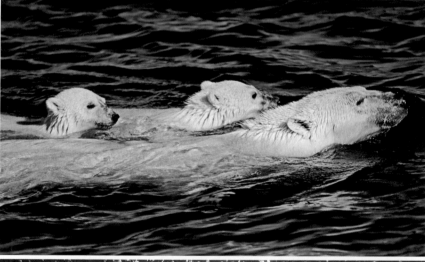

38 center right The polar bear has a layer of fat that can measure up to almost 4.5 inches (11 cm) thick in order to maintain its body temperature.

38 bottom right The polar bear is a skilled swimmer and can reach speeds of more than 6 mph (10 km/h), using its front legs as oars and the back ones as rudders.

39 Currently, there are 19 populations of polar bears around the Arctic: Canada, Alaska, Russia, Svalbard Islands (Norway), and Greenland (Denmark). However, five of these will go from having a high risk to a very high risk of decline within the next decade.

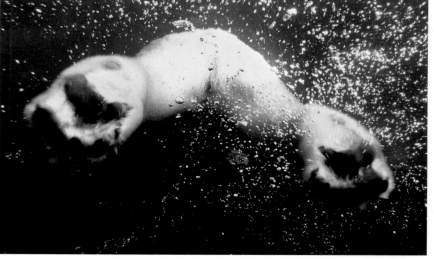

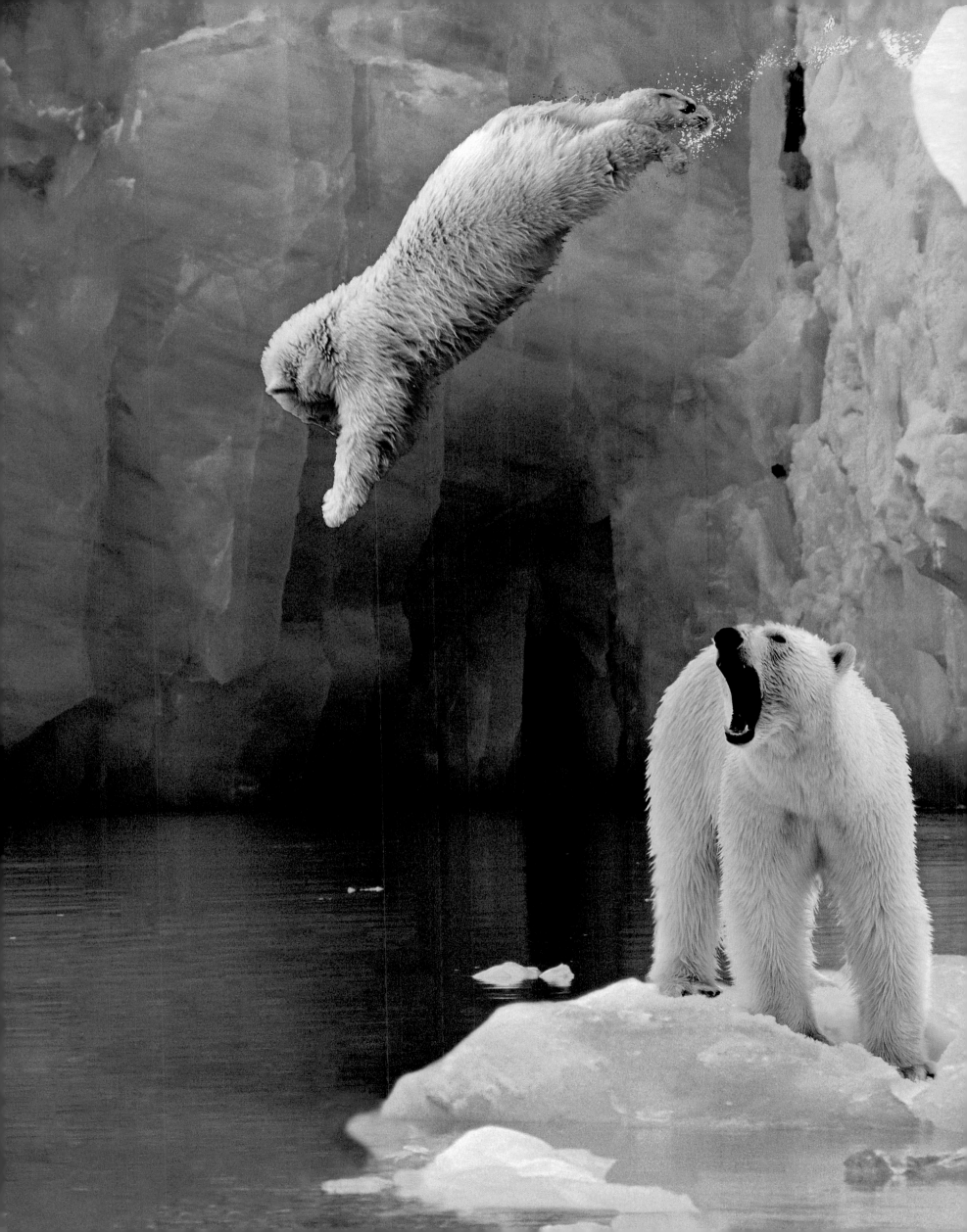

WOLF

Canis lupus

"The wolf is like the wind...just when you see it, it's already gone." These are the words of a shepherd, his skin bronzed by the sun, wrapped up in a heavy jacket, leaning against his staff. For the umpteenth time, he tells of a time when a wolf (*Canis lupus*) took a sheep or calf, leaving only a few remains behind. There are still many encounters like this throughout the mountains of southern Europe where the wolf, lacking wild prey, hunts livestock, playing out the ancient conflict between humans and animals. Sadly this means that every year dozens of wolves are victims of poaching, shot, caught in traps, or poisoned. In western Europe, the wolf has only survived in isolated populations in the Balkans, the Iberian Peninsula, and Italy. The latter two populations are considered vulnerable by the IUCN (World Conservation Union), including wolves that have recently colonized southern France. The difficult coexistence between humans and the wolf is particularly apparent with the fragmentation of the animal's habitat. The relentless pressure of human encroachment means that there are fewer and fewer peaceful areas where the wolf can raise its young. Road kills are a further significant human impact on the wolf population. In the last few years, legal protection of the species, abandonment of rural areas, expansion of woods, and reintroduction of wild ungulates (animals with hooves) on which the wolf preys have helped the recovery of its numbers in Europe. This is especially so in Italy where the wolf has repopulated the Apennine Ridge, from the Cadibona Pass to the Aspromonte. As part of the natural process of the young adults finding their own territories, some wolves have gone into countries where they have been absent for centuries, such as Germany and Switzerland, which has caused concern among the livestock breeders. The European Union considers the wolf a high-priority species for conservation. Important factors in this conservation effort are to provide for adequate damage prevention to and compensation programs for livestock, to re-create suitable natural habitat conditions for the wolf, to rebuild natural populations of its prey, and to inform public opinion. Additionally, it is necessary to control stray dogs that cause damage to livestock which is attributed mistakenly to the wolf. These stray dogs compete with wolves for food, are carriers of disease, and may also pollute the wolves' genes through hybridization.

LC

40-41 In the past, the wolf was widely distributed throughout most of the northern hemisphere. Today, it is extinct in Mexico and most of the United States.

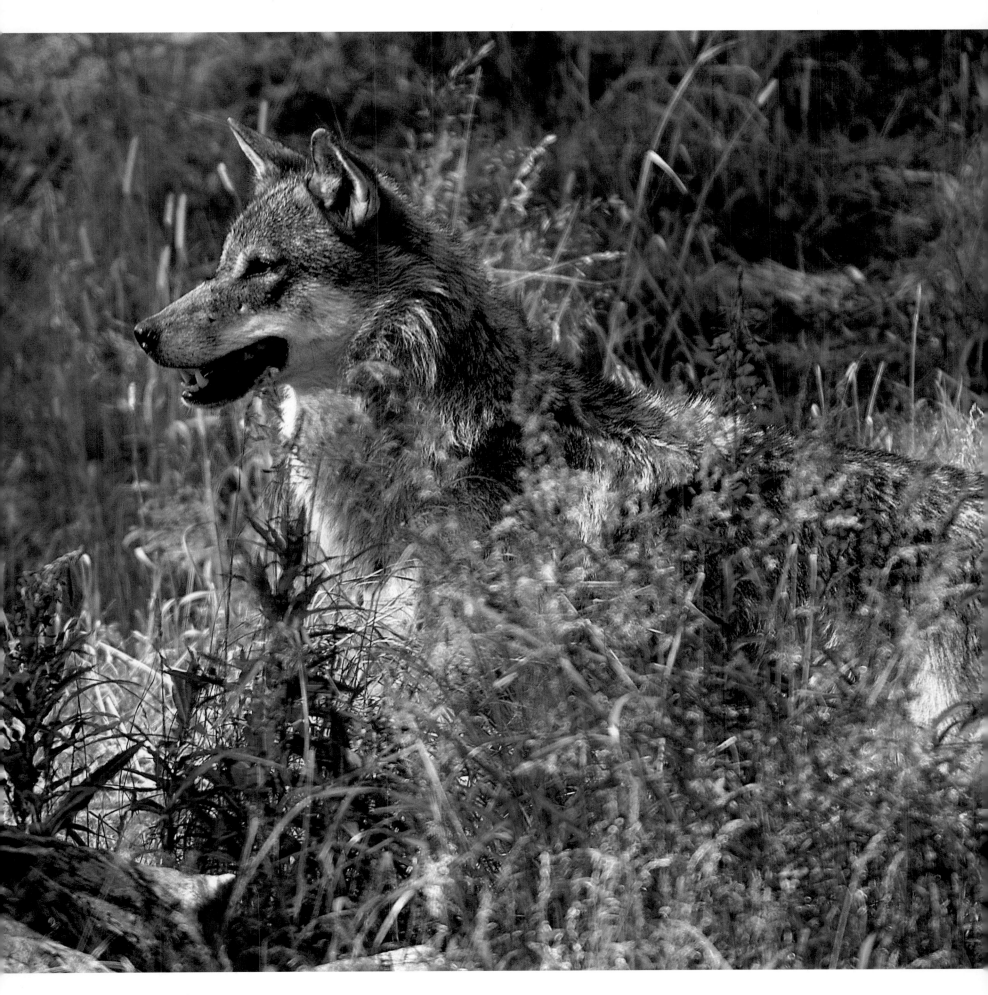

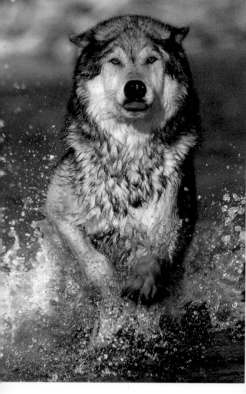

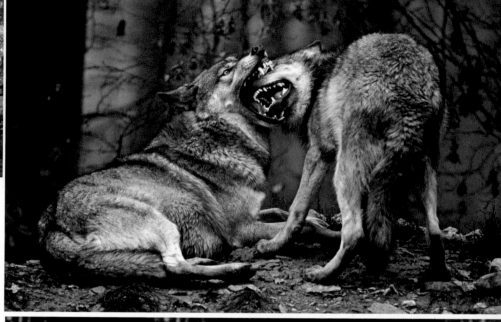

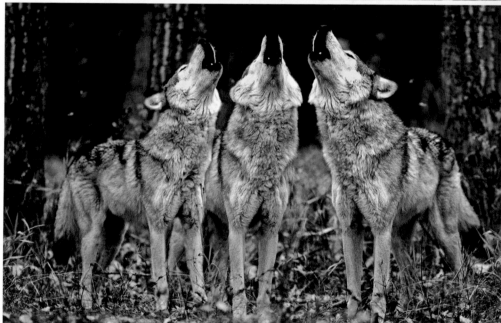

42 left In Italy an increase in the wild boar population, introduced for hunting, has resulted in a growth of wolf numbers in the last few decades. From an estimated 100 wolves in the early 1970s, the population has steadily risen to the current 400 to 500 specimens.

42 right Every wolf's role inside the pack is designated within a hierarchical structure. The size of a pack's territory can vary from 30 to almost 1,000 sq miles (75–2,500 sq km) and the wolves defend it with demarcation methods that include scent signals, scratch marks, and howling.

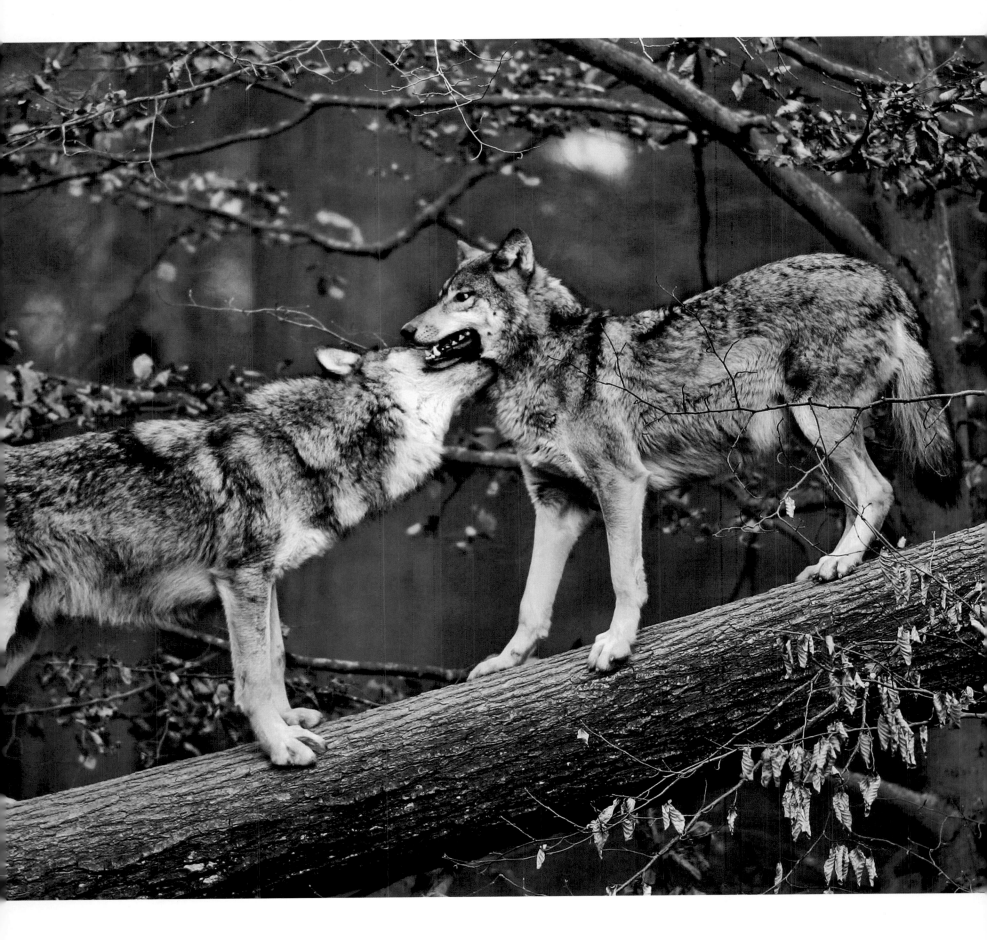

42-43 On average, a wolf is 2–3.25 ft (60–100cm) in height at the withers and can weigh between 65 and 132 lb (30–60 kg). Its limbs are long and its paws are broad.

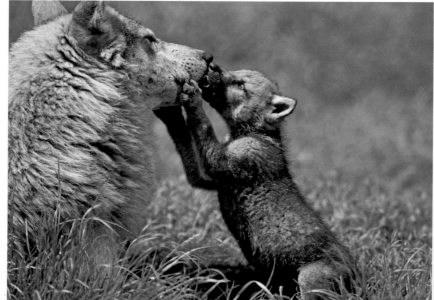

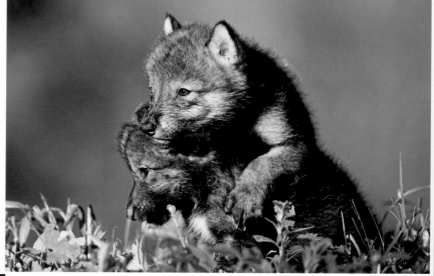

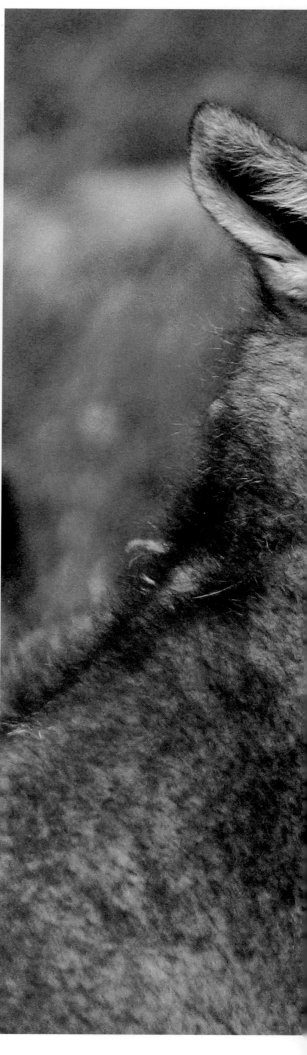

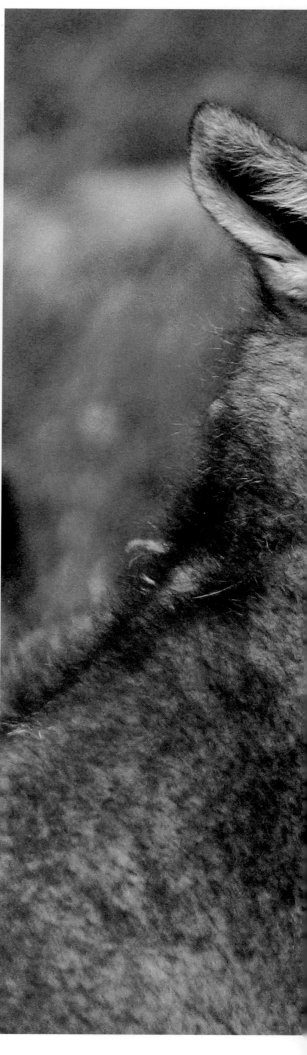

44 left The social unit of the wolf is the pack, comprising a breeding pair, the pups born in that year and in the years prior. Young wolves may leave when they one or two years old.

44 right Generally, all of the wolves in a pack take care of raising the pups. Once the young ones become adults, they may decide whether to

remain in the pack to help raise new pups or take their leave. For the most part, females get first choice, then males the second.

44-45 The dominant female gives birth to four to eight puppies (in Italy they would be born between April and June) which are completely dependent on the adults in the first phases of their lives.

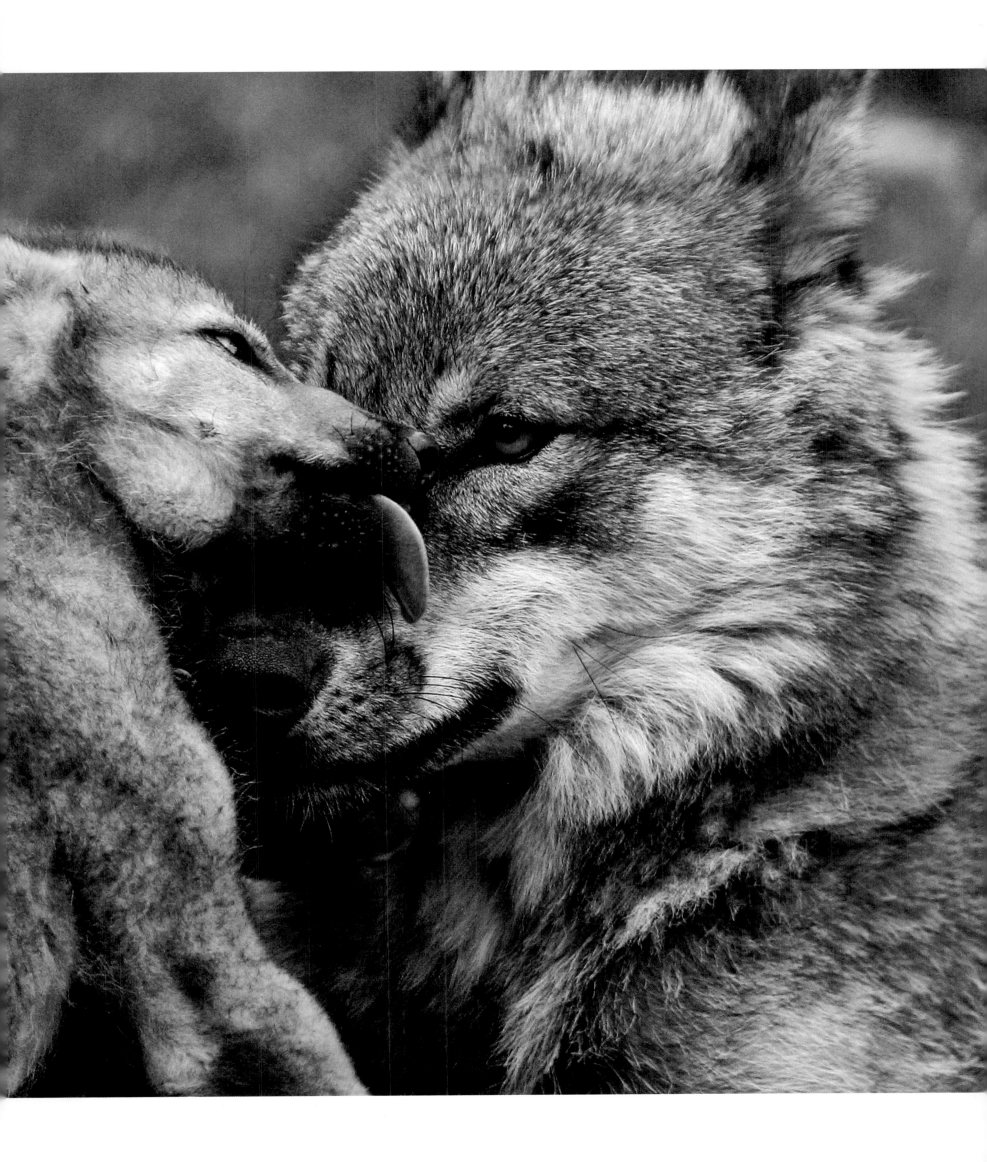

46 A wolf pack is led by two individual wolves situated at the top of the social hierarchy and this established order influences all the pack's activities. If the pack is made up of many wolves, it may also form other, separate internal hierarchies. Wolves travel up to 12 miles (20 km) per day when searching for their prey, and young wolves up to 25 miles (40 miles) in search of new territories and partners to create a new pack.

47 The wolf's natural prey are wild ungulates (hoofed animals), but it may also feed on domestic livestock, animal carcasses, and food remains found in trash dumps. It has various hunting techniques and it may use a surprise attack or scour areas for long periods of time before zeroing in on its prey.

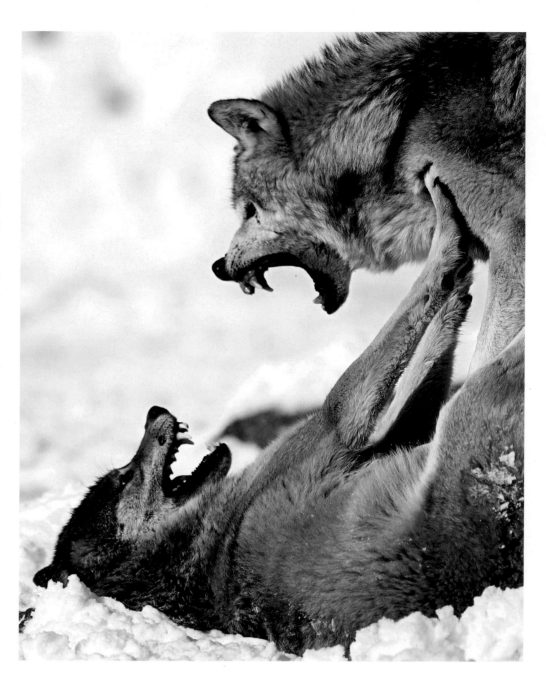

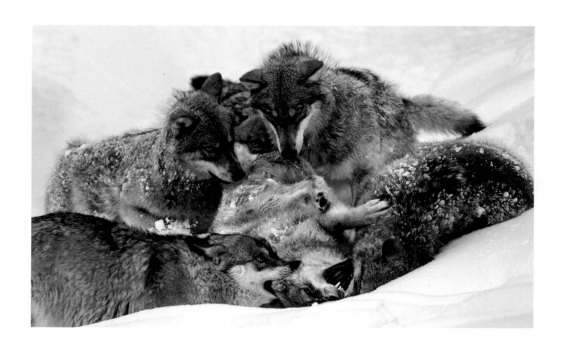

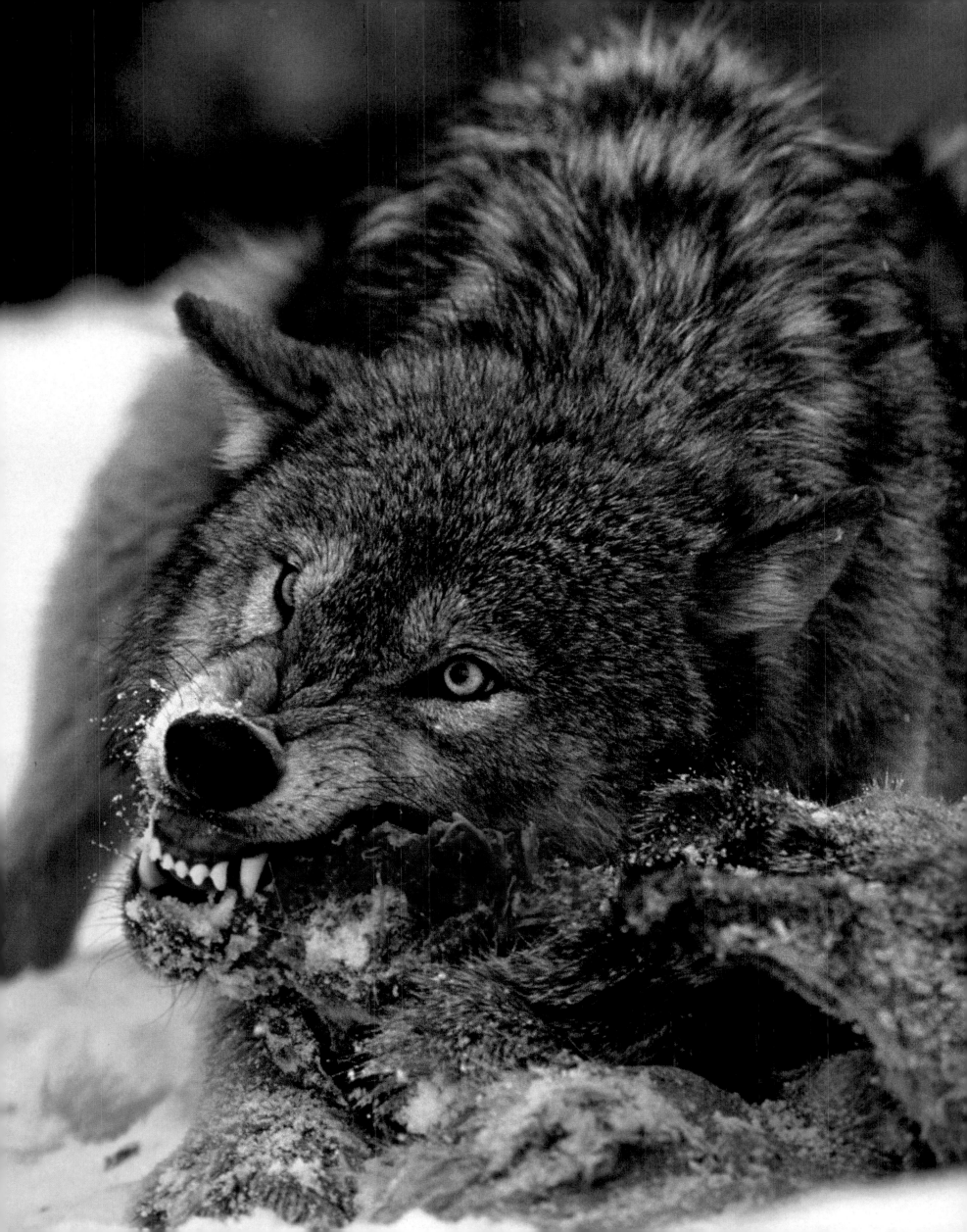

IBERIAN LYNX

Lynx pardinus

Of the 36 known feline species, one in particular is most at risk of extinction within just a few years, and surprisingly this sad prospect is not the fate of the tiger, the cheetah, or the jaguar, but a European feline – the Iberian lynx (*Lynx pardinus*). At the end of the 1980s, the Iberian lynx numbered about 1,100, distributed irregularly throughout Spain and Portugal. Since then, the situation has radically changed for the worse and with a population of less than 200 individuals today the species exists only in two regions of Spain: Doñana and Andújar-Cardeña. Groups of isolated individuals do survive in other areas of Spain and Portugal, but show no evidence of breeding and so can be considered in effect to be biologically extinct. Recently, a new and previously unknown population of Iberian lynx, comprising some 100 specimens, was discovered in the Castilla-La Mancha region. In light of this encouraging find, the WWF has requested the insertion of the Iberian lynx's habitat into the "Nature 2000" European Safeguarding Program, which provides a high level of protection. The decline of the lynx population began in the 1960s. During this period the rapid development of civil and industrial infrastructure and the intensification of agriculture caused the destruction and fragmentation of woods and Mediterranean scrub, the typical habitat for this species. Reductions in its principal prey, the wild rabbit, has been another crucial factor in the decline of the lynx. In the 1950s, myxomatosis, a disease originating in South America, arrived in Europe and exterminated huge numbers of rabbits in just a few years. When this epidemic was coming to an end and the situation was improving, rabbits were then hit by hemorrhagic fever in 1988. The tight bond between predator and prey, meant that the lynx population inevitably suffered, deprived as it was of its primary food source. Over the years the lynx became rarer and rarer, until it vanished from many areas of its range. Other threats to this predator's survival and conservation come from poaching, road kills, and accidental capture in wolf traps. Today's conservation interventions are concentrated mainly in the areas where the two remaining breeding populations live, and are directed towards conserving their original habitat and restoring wild rabbit populations. There is also great optimism over the success of captive breeding programs and the subsequent reintroduction of these captive-bred animals into the wild.

CR

49 The Iberian lynx is about twice the size of a domestic cat and can weigh 18–33 lb (8–15 kg). Its tail is bobbed with a black tip, its ears have characteristic tufts of fur on top, and a long beard surrounds its muzzle.

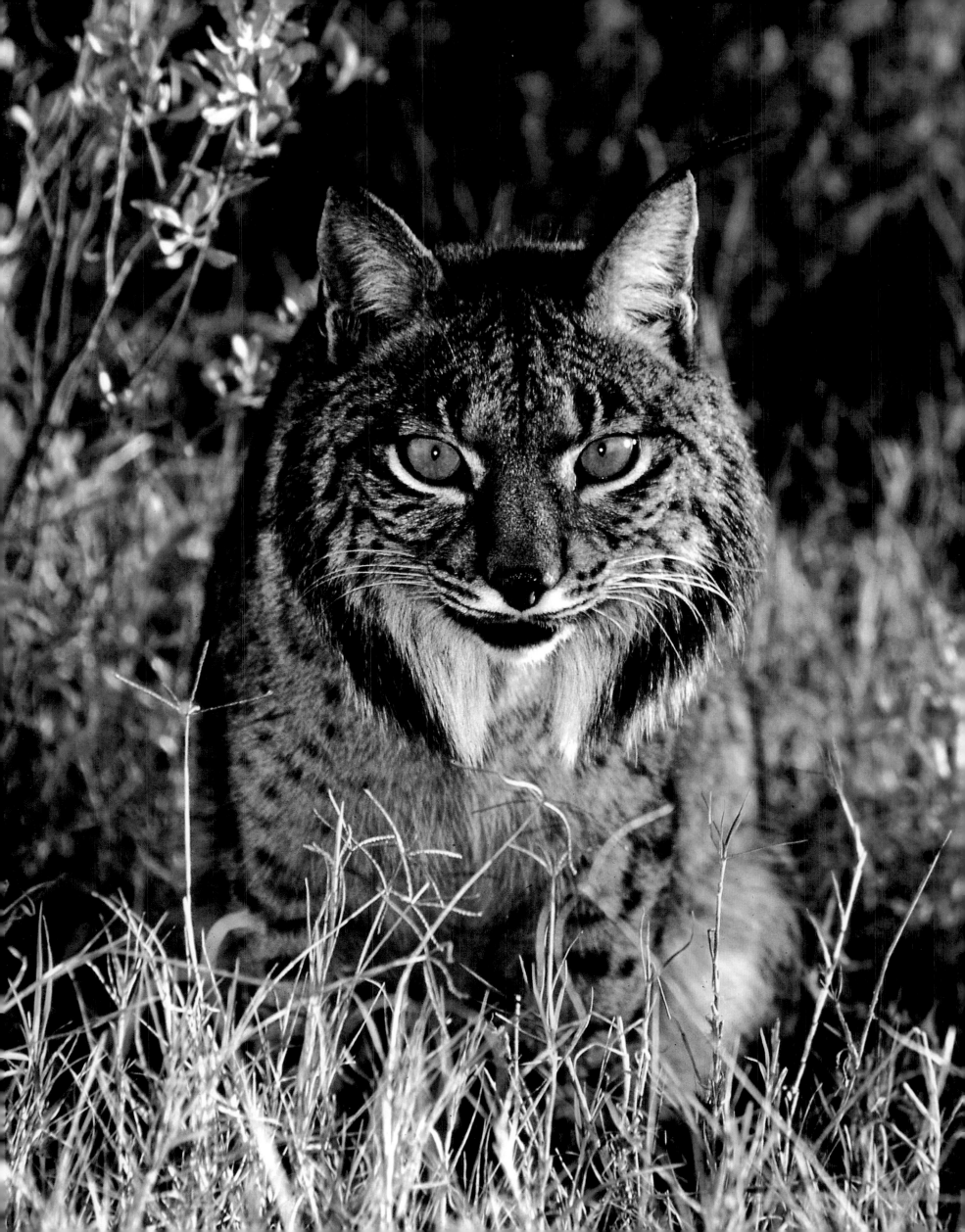

The consumption of cork
for the survival of the Iberian lynx

One of the major causes of the extinction of animal and plant species is the consumer choices made by people in the industrialized and developed countries. To maintain our lifestyles requires the unsustainable consumption of the planet's resources, which is also to the detriment of the poorer populations who live largely in the southern hemisphere as well as to wild fauna that depend entirely on the degraded and disappearing environments. However, although in general it is true to say that the consumption habits of humans are usually disastrous to many species and inevitably lead to extinction, or at least its threat, there is an exception to every rule and in this case it is the Iberian lynx. The future of one of the rarest felines in the world actually depends in large part on the continued consumption (and not just the conservation) of a natural product typical to the western Mediterranean – cork. The cork tree landscapes of Portugal and Spain are the preferred habitats of the Iberian lynx and owe their survival to the existence of the agro-forestry and livestock economies of the Mediterranean, which for many centuries have been based on the sustainable use of natural resources. The cork oak tree forests designated as *dehesas* and *montados* are the result of human intervention, which has shaped these landscapes over the generations. They can only survive, however, as long as the rural economies associated with cork production, sheep breeding, herb and mushroom harvesting, beekeeping, and small agricultural cultivation remain viable and their byproducts are purchased. The cork removal that produces and stably maintains these sparse woods does not damage the classic cork oak tree, which, if abandoned, would become hardwood holm oak tree forests over time. It is, indeed, these widespread, managed woods and fields that are the preferred hunting grounds of the Iberian lynx and birds of prey because they contain a rich supply of hare and wild rabbits. We are confronted here with a complex conservation issue. In order to ensure the future of the Iberian lynx, cork consumption must be promoted and crucial to this is to convince the wine industry not to use alternative plastic stoppers made from petrochemical byproducts, to encourage people to insulate their homes with cork panels instead of those made from polystyrene or other synthetic materials, and to purchase food products from the cork-producing regions. Additionally, the Habitat Directive recommends that these environments be protected for the high level of biodiversity they foster, which would then safeguard all the other species typical to these landscapes. Large territories of cork oak trees also exist in Italy (Sardinia) and North Africa (Tunisia, Algeria, Morocco) and will irrevocably disappear if the extraction of cork, and other agricultural and pastoral activities, are replaced by plantations and intensive agriculture. Consequently, we must encourage traditional agricultural production systems throughout the western Mediterranean basin, and promote the use of wine corks and other cork byproducts if we are to enjoy the Iberian lynx's return to these magnificent and ancient wooded areas.

51 The Iberian lynx has brown fur with noticeable black spots, in contrast to the European lynx whose spots are lighter in color. This gives it a similar appearance to that of the leopard.

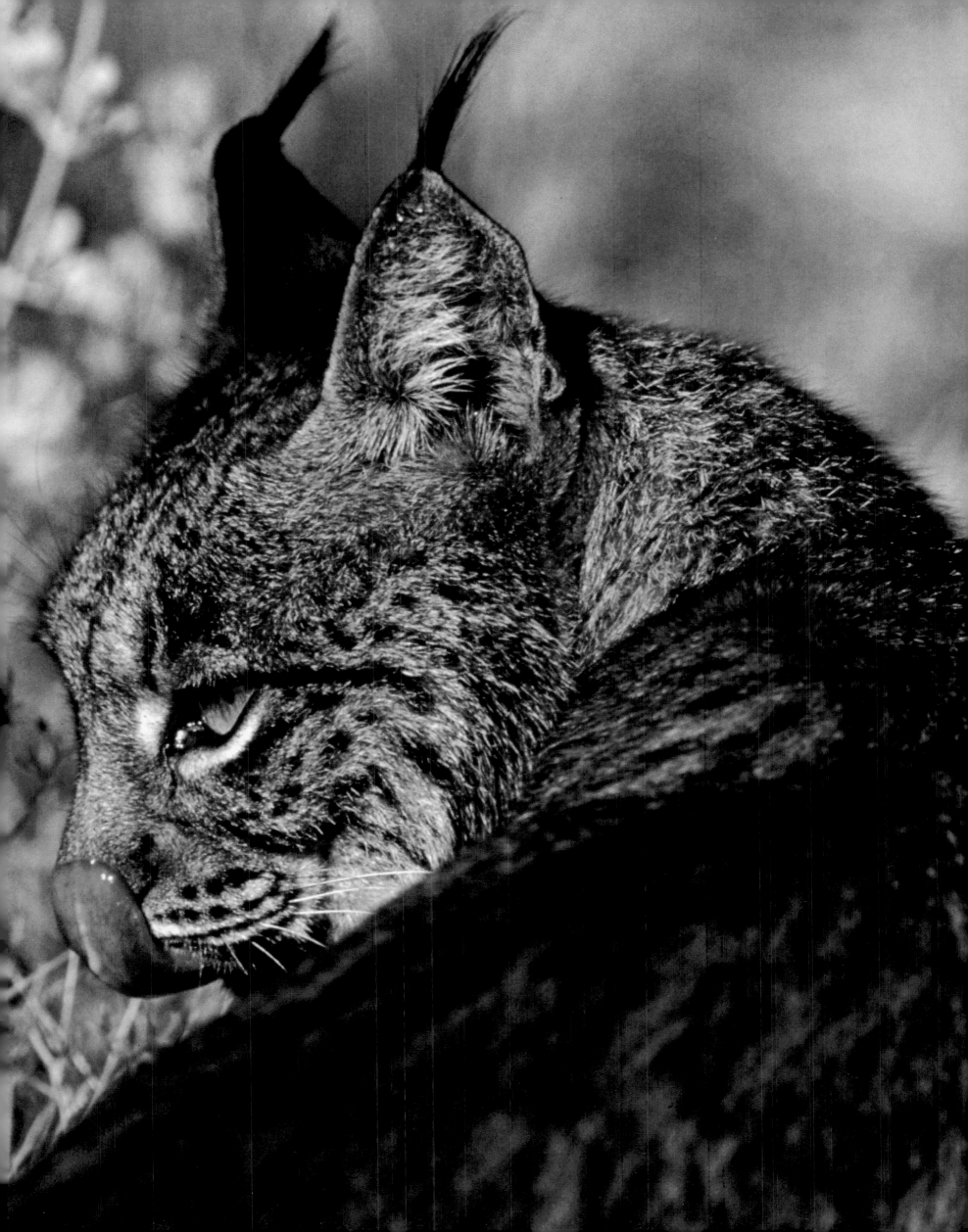

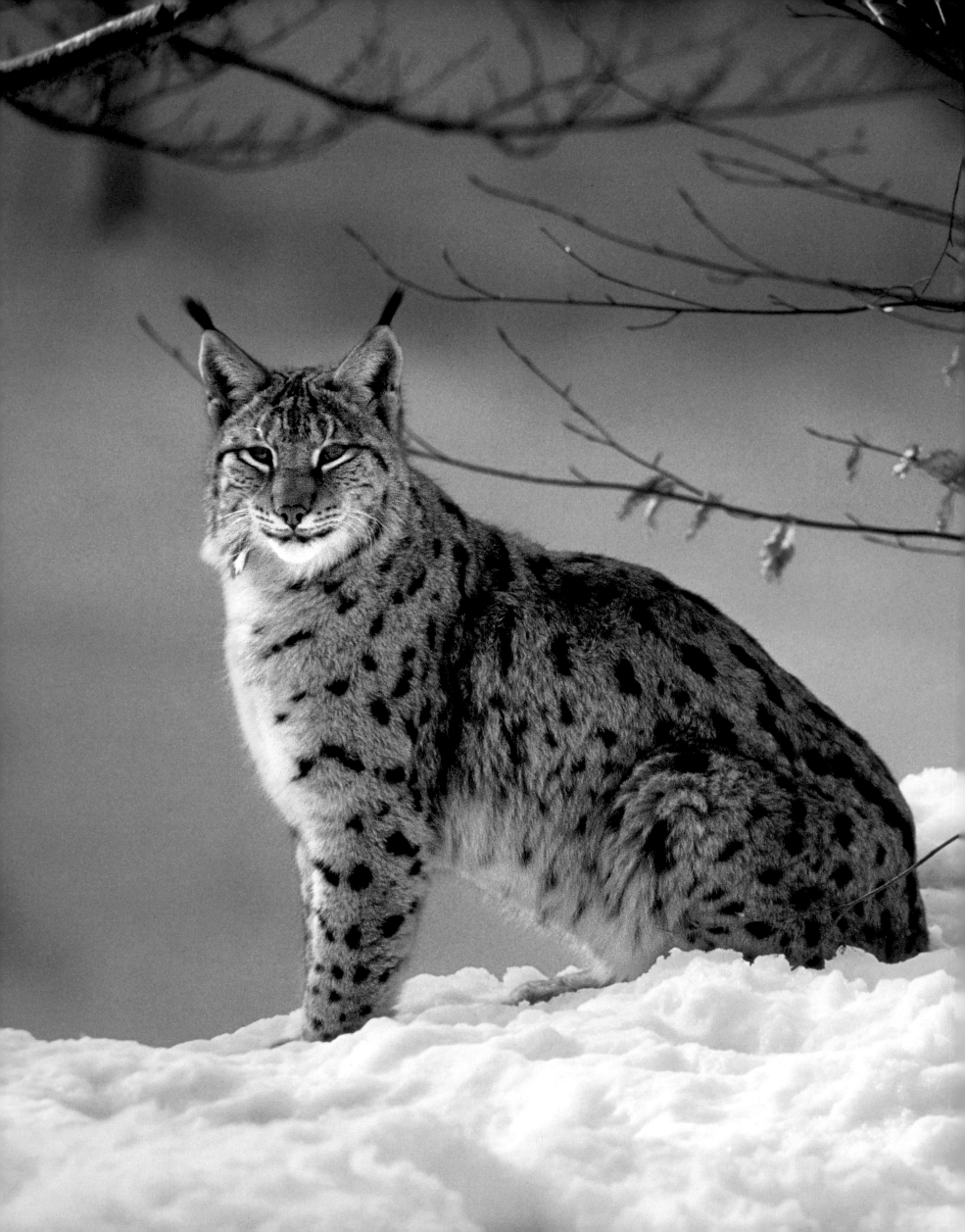

52-53 One of the rarest cats in the worlc it was once found throughout the Iberian Peninsula, but is now extinct on the plains and can only be glimpsed in remote, mountainous regions.

53

BEARDED VULTURE

Gypaetus barbatus

"*Gyps* and *aetos* (vulture and eagle) are the Greek words from which Gypaetus derives, the name of the family to which this great bird of prey belongs. In flight, its distinct narrow and pointed wings are more reminiscent of those of a large falcon than a vulture. Due to this particular wing shape, the bearded vulture (*Gypaetus barbatus*) is able to better exploit the air currents that rise up the sides of the mountainous valleys, maneuvering with incomparable agility, considering that its wingspan can reach up to 9.5 ft (2.9 m). Like all of its kind, the bearded vulture is a scavanger that feeds on the remains of dead animals, bones included. In Spanish it is known as the *quebrantahuesos* (bone breakers), because of its habit of breaking larger bones by dropping then from high altitudes onto rocky areas called "breakers."

The bearded vulture is present in southern Europe, southwestern Asia, as well as north-central, east-central, and southern Africa. Up to the beginning of the 1800s, it primarily inhabited the mountainous regions of central and southern Europe almost continuously from the Iberian Peninsula to the Balkans. In the last century, however, the bearded vulture suffered a rapid decline to such an extent that it became extinct throughout a large part of this range. Currently in Europe the bearded vulture is only present in the Pyrenees, where there are more than 90 pairs, in Corsica with ten pairs, mainland Greece has one or two pairs, while there are around ten pairs on Crete. Ruthless hunting is one of the main causes of the population decline because it is seen by many as a threat to sheep flocks. They are also killed both by poisoned bait intended for foxes and wolves and by eating the toxic carcasses of the foxes and wolves who have died after eating the poisoned bait. Thanks to current reintroduction programs, in which the WWF actively participates, today's number of nesting pairs is on the increase. In Europe, between 1986 and 2006 more than 130 young bearded vultures were released back into the wild.

LC

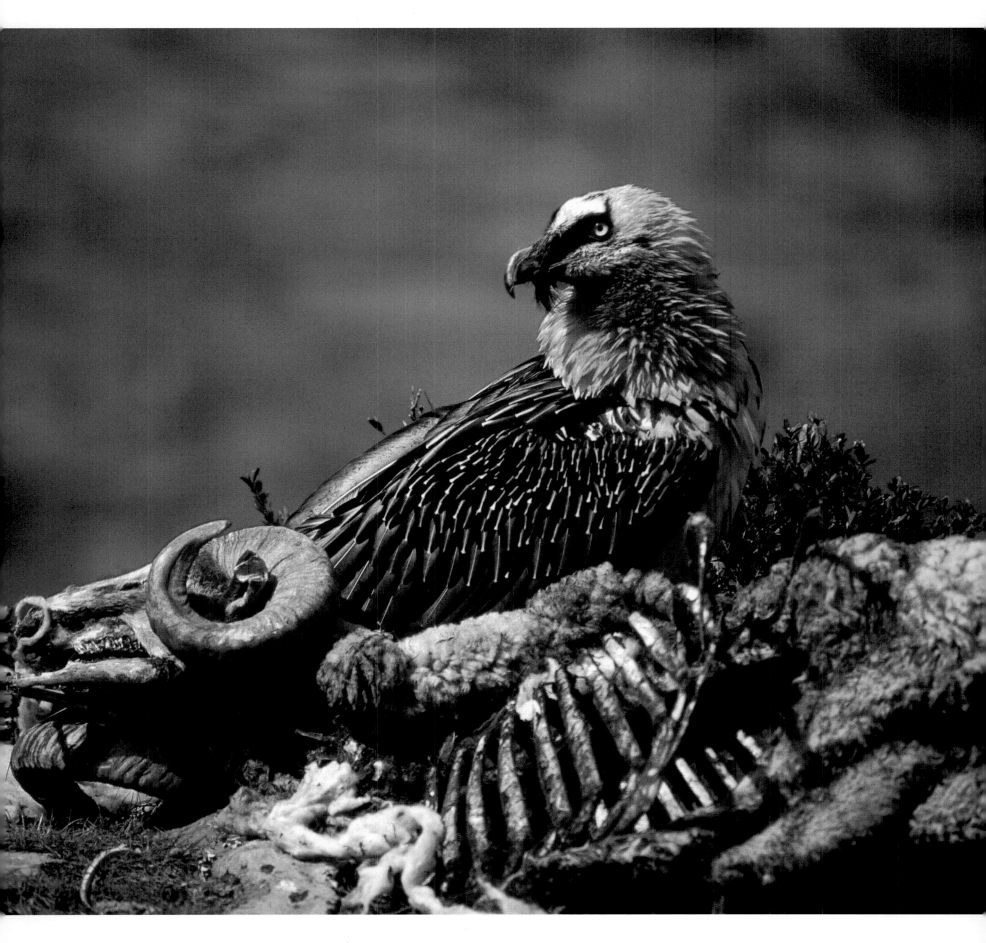

54-55 The bearded vulture lives in wild mountainous zones with plenty of rocky cliffs and steep valleys. It has black feathers on its head that look like a moustache on either side of its beak, and a red ring around its yellow eyes. This vulture almost exclusively feeds on dead animals, mainly preferring the bones of medium- to large-sized animals. Before eating the largest bones it breaks them apart, often dropping them from great heights onto sharp rocks.

The trans-border national park, beneficial to both animal species and human populations

The mountainous region to the north of Montenegro and Albania is one of the better conserved areas of continental Europe. Its quasi-inaccessibility has protected it from the most severe forms of human interference and exploitation, but at the same time this has limited its economic development, contributing to the creation of among the poorest societies in southeastern Europe. This situation has created a disharmony that now has a detrimental impact on both human life and the natural environment. In the last two years, the WWF has done an in-depth analysis of the region's ecology and socio-economic conditions, and has set up conservation and sustainable economic development programs and initiatives. Particular attention will be given to the Prokletije Massif which spans the border between Montenegro and Albania. This is an area of major ecological value, but it is also among the most conservative.

The main objective of the WWF is to support national and local administrations in both countries in the establishment of the Prokletije Trans-border National Park. The conservation objectives of the Park will involve the participation of the local communities through the development of economic activities linked to the protection and fostering of natural resources. The whole project will require the WWF to provide active support of the Montenegrin and Albanian governments in managing the Park and in organizing a conversation strategy that properly includes the full participation of the local population. Crucially, partnerships with corporate and private-sector organizations will be negotiated, which will help to create revenue-generating enterprises based on conservation, including research into innovative economic resource evaluation mechanisms. These are the first substantive steps to the institution of the Prokletije Trans-border National Park, which will not only protect the environment and many threatened species, notably the bearded vulture, but also improve the quality of life of the local people.

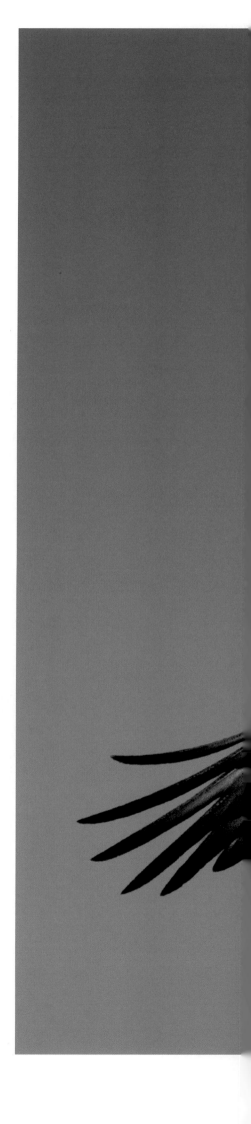

56-57 Thanks to a special reintroduction project established in 1986, there are now 60 bearded vultures in the Alps, with seven established pairs, three of which have already successfully reproduced.

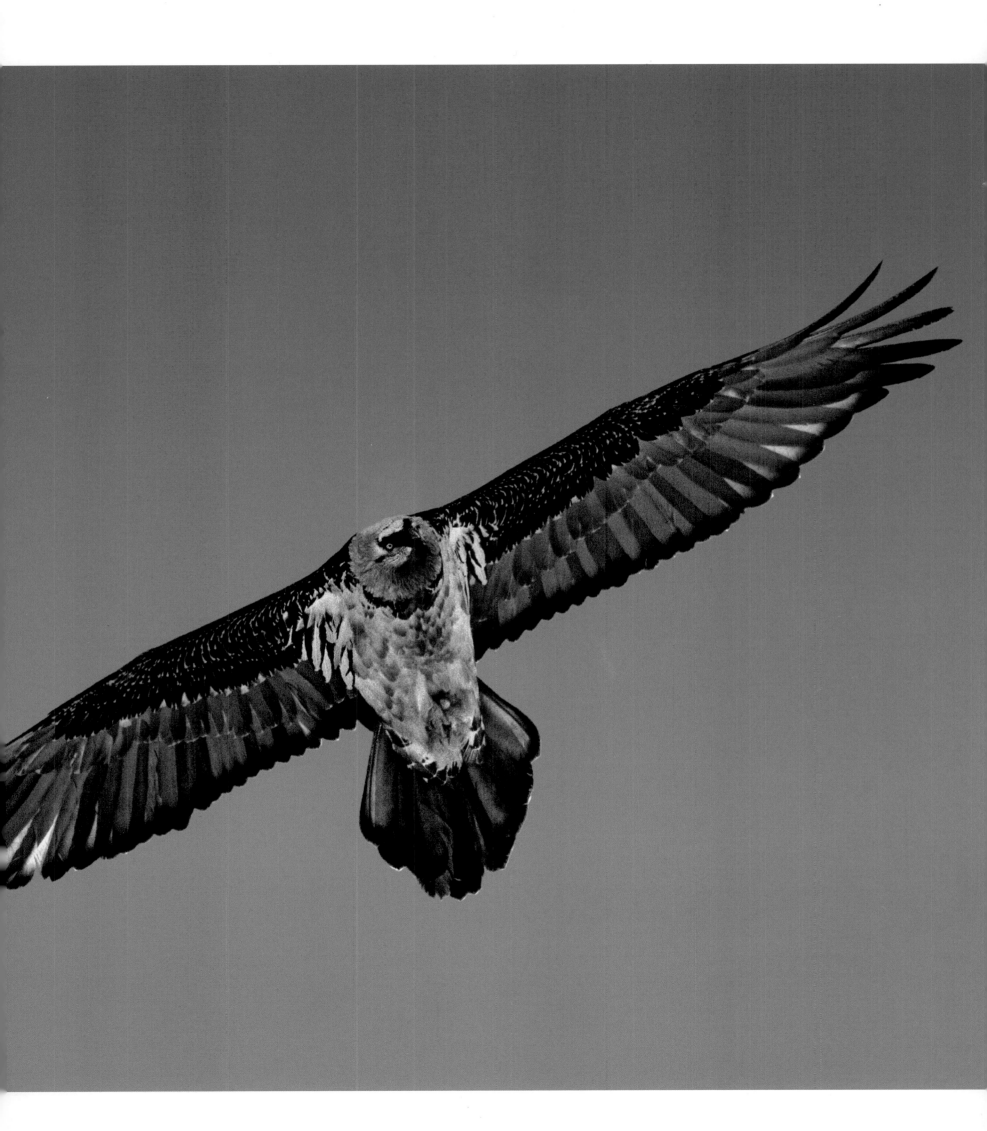

AFRICA

The boundless plains of Africa stretch as far as the eye can see beneath an immense sky. Africa is the second largest continent in the world in surface area and among the richest in mineral and natural resources. It is also a place where the population has long anticipated political, social, and economic control of its own continent. Divided into 53 independent countries, Africa embraces diverse habitats characterized by an array of unique and incredibly varied species. From the North African coasts to the gigantic Sahara desert which occupies the whole northern region of the continent, to the savannahs in the south, a sea of grass that during the rainy season is green and profuse, arching around the impenetrable tropical forests of the Congo River basin, a river that gives its name to entire region up to the Gulf of Guinea. Throughout the rest of the African continent, we find moorlands, mangroves, marshes, typical Mediterranean scrub vegetation, and a surprising variety of habitats with a great diversity of species. The island of Madagascar is also part of the continent and is a world unto itself with its distinctive wildlife and habitats. It is home to the majestic and ancient baobabs (monkey bread trees), with six species endemic to the island. Incredible scents and singular colors envelop the home of the "wood elves," the lemurs.

However, the whole continent and its rich biodiversity is gravely threatened by a growing population, which is increasing at a rate of 2.8 percent per year, the highest in the world. Communities in need of resources and land to cultivate inevitably expand towards untouched wilderness areas, rich in forests and water. They hunt and take living space from animals, forcing them into increasingly restrictive and inhospitable zones. This is a phenomenon that threatens the eventual extinction of more and more species. A policy of uncontrolled exploitation of environments and territory is inevitably leading to the loss of diverse types of habitat, converting them into agricultural fields and frequently aggravating the situation with cultivation and breeding of imported species. The introduction of foreign species is a threat to indigenous African flora and fauna. In Madagascar, for example, some plant types brought in from other places have led to the almost total extinction of endemic species. Some wild animal species, integral to the maintenance and success of an ecosystem, have quite often been replaced with domestic animals such as cows and

goats, which may cause radical changes to vegetation growth in the most arid regions.

In our journey through Africa, we must pause to reflect on the landscapes of the Rift Valley where the remains of our earliest direct ancestors have been discovered and enjoy some of the most incredible spectacles in nature. The millions of flamingoes at Lakes Natron, Nakuru, and Bogoria rise up in flight, temporarily changing the turquoise sky to pink in their corner of paradise. The African savannah, with its infinite green expanses teeming with acacias, spreads out across the Serengeti and the Masai Mara, home to impala, wildebeest, zebra, buffalo, giraffe, and other iconic species of this still undisturbed natural environment. Unfortunately, these animals are also at risk, bearing witness to an Africa that is changing because of human intrusion. Among these species is the African elephant, lord of the savannah, once distributed throughout the whole continent, but today a veritable symbol of a besieged, tortured, wounded, and ruthlessly exploited Africa. Some of the most atrocious wars in Africa were financed with sales of ivory. In almost all of Africa, heavy arms and machine guns now represent the greatest threat to wild fauna, once only hunted with traditional weapons.

Unlimited hunting and poaching has heavily reduced elephant and rhinoceros populations, once comprising hundreds of thousands specimens but today only a few tens of thousands survive. Today, many reintroduction and/or anti-poaching surveillance projects exist, but as yet have not conquered the threat of extinction of many of these animal populations. A symbol of strength and power, and the uncontested ruler of the African savannah, the lion was once distributed throughout the continent but today suffers from human interference. In central Africa in an area of great political instability, the volcanic chain of the Virunga Mountains rises toward the sky, providing a home to mountain gorillas that spend their time in these emerald green forests searching for those delicacies that constitute their vegetarian diet. The tranquil life of these animals has for decades been placed at serious risk by human activities, particularly the destruction of its habitat by clearing and burning the forests, which is unfortunately a common problem in many regions of Africa.

LEGEND

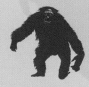
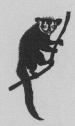

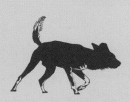

5

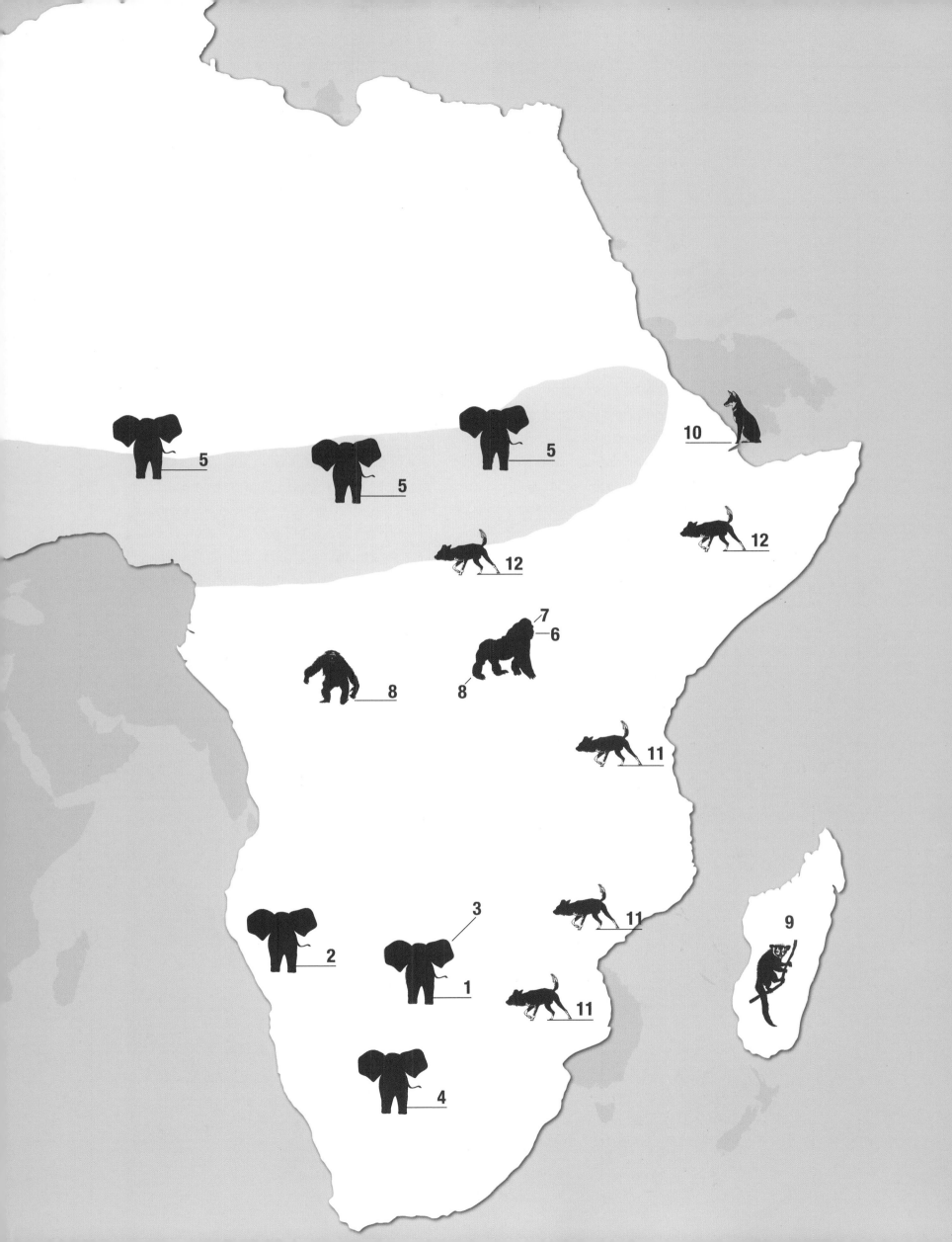

AFRICAN ELEPHANT

Loxodonta africana

The African elephant is present in 37 countries in sub-Saharan Africa, distributed over 1.25 million square miles (3.24 million sq km), a territory equal to 22 percent of the entire African continent. However, parks and preserves only protect one-third of this immense region. In the 1970s, the entire population was estimated at around 1,300,000. Currently, it is thought that there are not more than 473,000 African elephants, more than half of which are concentrated in southern Africa. In the 1970s and 1980s, the species fell prey to a buying frenzy for the ivory from the tusks of both sexes. In 1990, a prohibition on the sale of products manufactured with elephant parts, ivory included, was declared and the African elephant was included in Appendix I of the Convention on International Trade in Endangered Species of Wild Fauna and Flora (CITES). The debate over this prohibition is still intense and African countries are divided between opposing viewpoints. In 1997 in Botswana, Namibia, and Zimbabwe, then in 2000 in South Africa, elephants were again subject to controlled removal from their habitat, destined for international sales. Although culling, that is, selective slaughter aimed at containment of populations considered surplus, had already resumed in the 1980s. Today, another growing threat is where the elephant population comes into conflict with economic activities. As a result, numerous projects dealing with this problem have been established. Without a doubt the elephant is one of the most powerful symbols of African wildlife, to such an extent that the WWF is firmly committed to its conservation. Conserving the elephant means protecting the whole ecosystem to which it belongs and its conservation must be integrated into the cultures of local peoples. The Monitoring Illegal Killing of Elephants Program, MIKE, is supported by international bodies, including the WWF, and has a presence in all of the countries within the African elephant's range. In addition to collecting data on illegal killings, its mission is one of helping governments to resolve the conflicts between economic activities and the elephants, and to provide tools and technical capacity to establish better forms of control in order to decrease illegal killings. The Elephant Trade Information System, ETIS, is a database managed by Traffic, a program run jointly by the WWF and the IUCN (World Conservation Union), which monitors sales of wild fauna that are extinct. Between 2000 and 2006, WWF founded the first specific program dedicated to the African elephant, which includes the following projects: training of local workers; information acquisition; creation of a new protected area in Mozambique; and proposals for two others in collaboration with MIKE and ETIS. The second program, WWF Species Action Plan: African Elephant 2007–2011, provides for, among other things, a 40 percent reduction in the conflict between humans and elephants by 2011, and improvement in living conditions of populations present in at least 20 regions of the elephant's range by developing economic activities linked with the conservation of nature.

VU

63 The African elephant is the largest living land mammal in the world and is capable of uprooting a tree with its trunk. A male may weigh up to 6 tons (5.5 tonnes), be up to 22 ft (6.7 m) in length, and reach 10 ft (3 m) in height at the withers. The female is slightly smaller and may weigh up to 3 tons (2.7 tonnes). Recent genetic research indicates that the African elephant population should probably be divided into two species: the African bush elephant (*Loxodonta africana*) and the smaller African forest elephant (*Loxodonta cyclotis*).

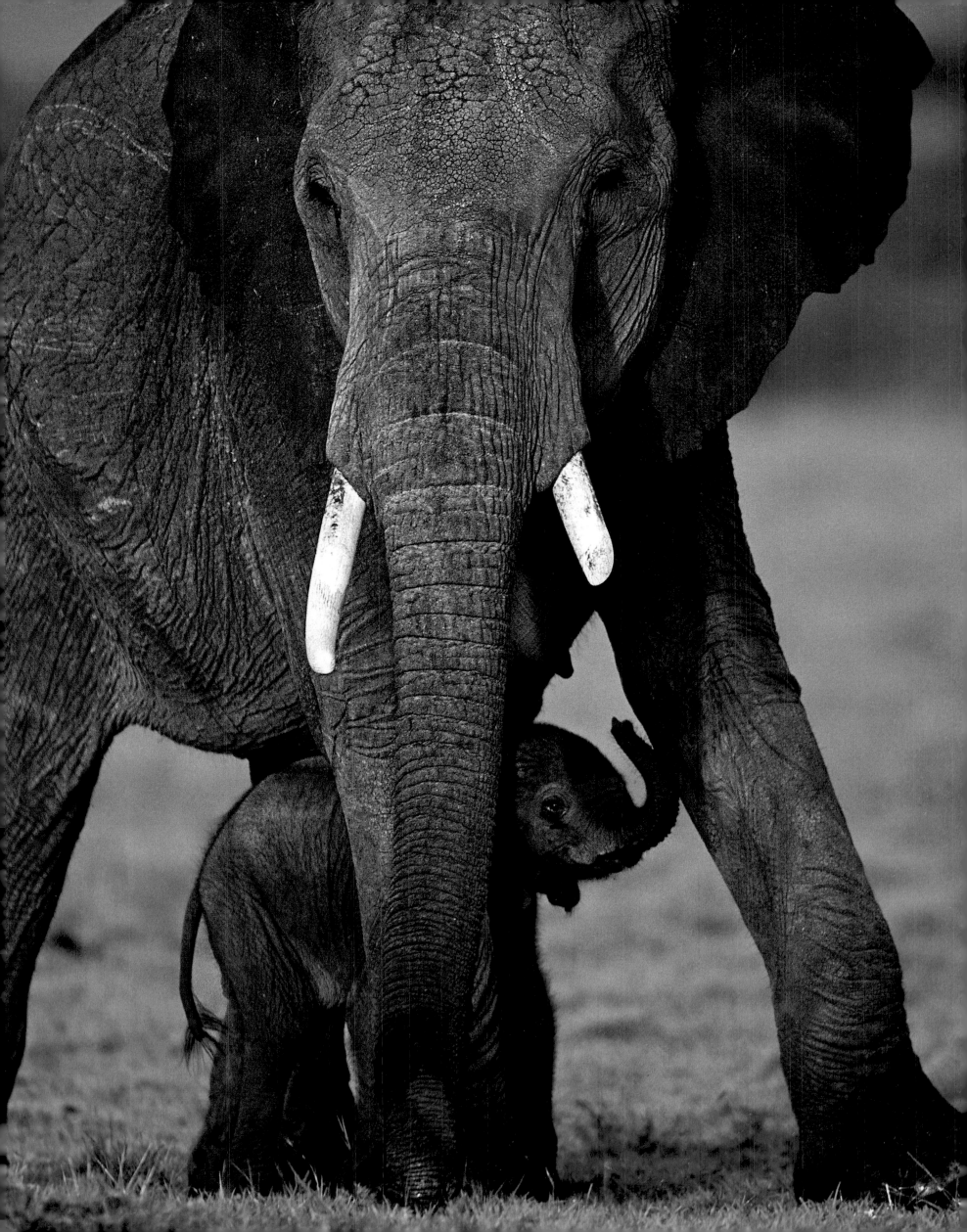

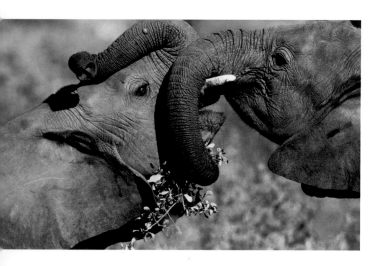

64 top A distinctive characteristic of
African elephants is their ivory tusks. Made
of dentine, a cartilaginous and calcified
sodium material, tusks are upper canine
teeth and in older males can be between
6.5 ft (2 m) and 10 ft (3 m) long. Elephants
use them for many tasks, to strip bark
from trees, dig up roots, display them as a
sign of strength in social encounters, and
as weapons.

A F R I C A N E L E P H A N T

VANISHING ANIMALS

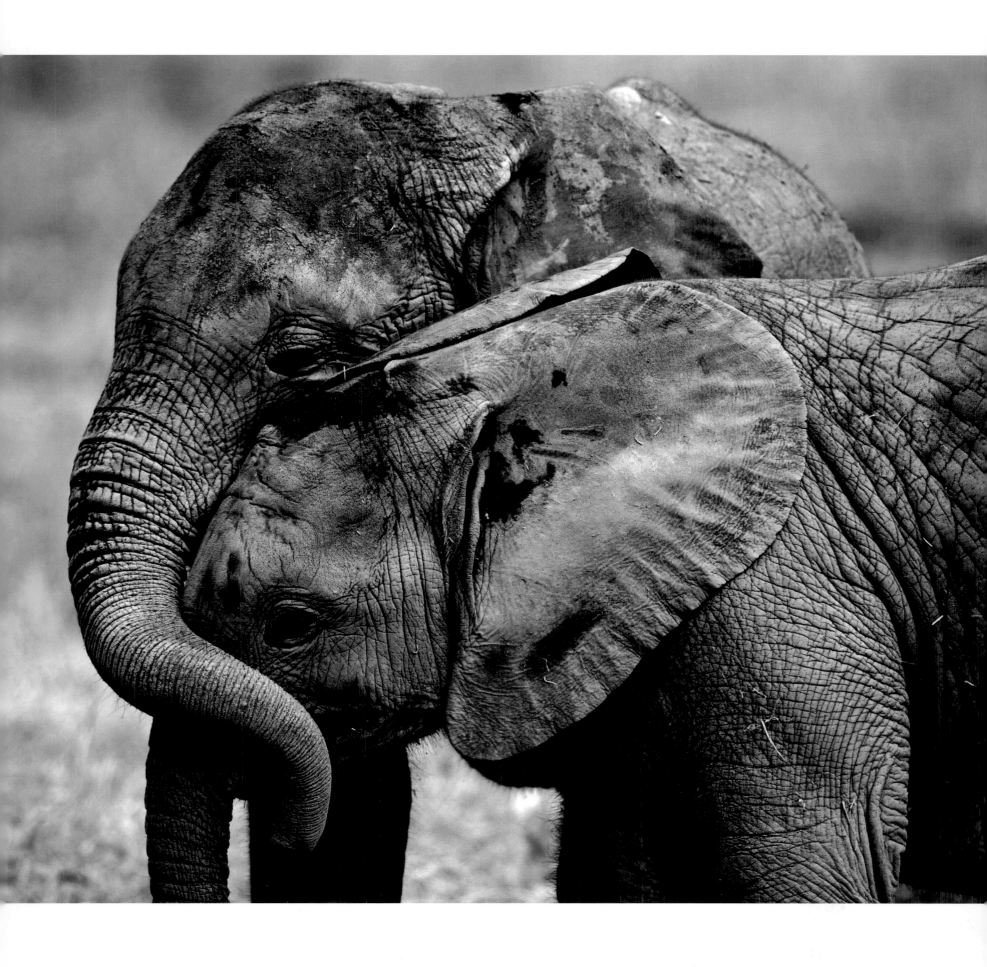

64 center and bottom Female African elephants live with their young in extended family groups led by an older female, the matriarch. Males are solitary or join together in small packs.

64-65 African elephants create deep bonds with the members of their family groups, are capable of defending wounded companions, and have a rich vocabulary of signals to communicate with their peers. Females produce infrasounds that can travel for miles to communicate their sexual availability to potential partners.

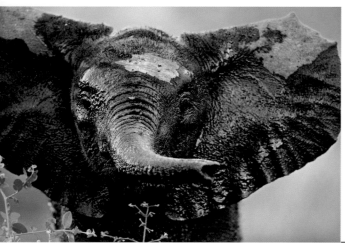

68-69 African elephants are capable of traveling great distances. They frequently trek for miles to reach saltwater pools. In order to satisfy their sodium requirements, elephants often search for natural salt deposits outside or inside caves, digging with their trunks to extract the soil rich in mineral salts.

66 left Enormous ears are typical of African elephants. Their ears may reach up to almost 22 sq ft (2 sq m) and are equipped with a dense network of veins where blood can be cooled to 41°F (5°C) when they are flapped.

66 right and 67 The African elephant's trunk is both a nose and upper lip, a single organ capable of touching, grasping, and smelling. Strong enough to uproot a tree, sensitive enough to pick a piece of fruit the size of a berry, long enough to reach the highest foliage in trees, the trunk is used to drink by vacuuming water and blowing it into the mouth as well as to wave, caress, threaten, and dust the elephant's own body to prevent sunburn and insect bites.

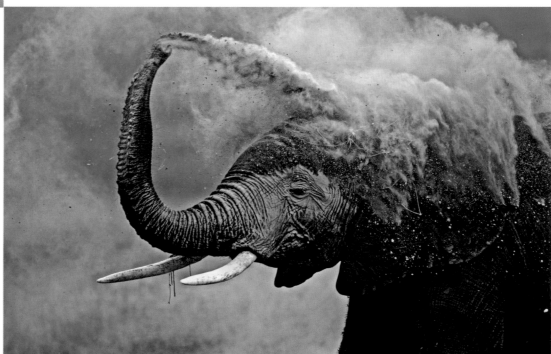

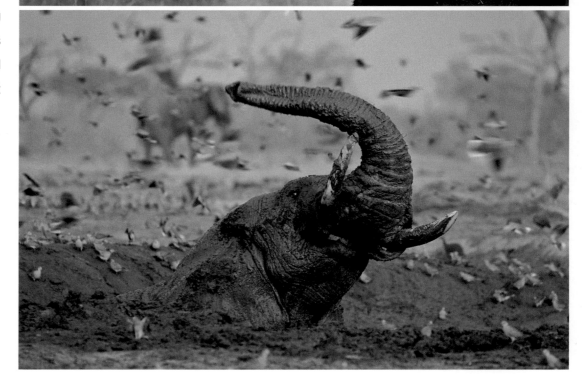

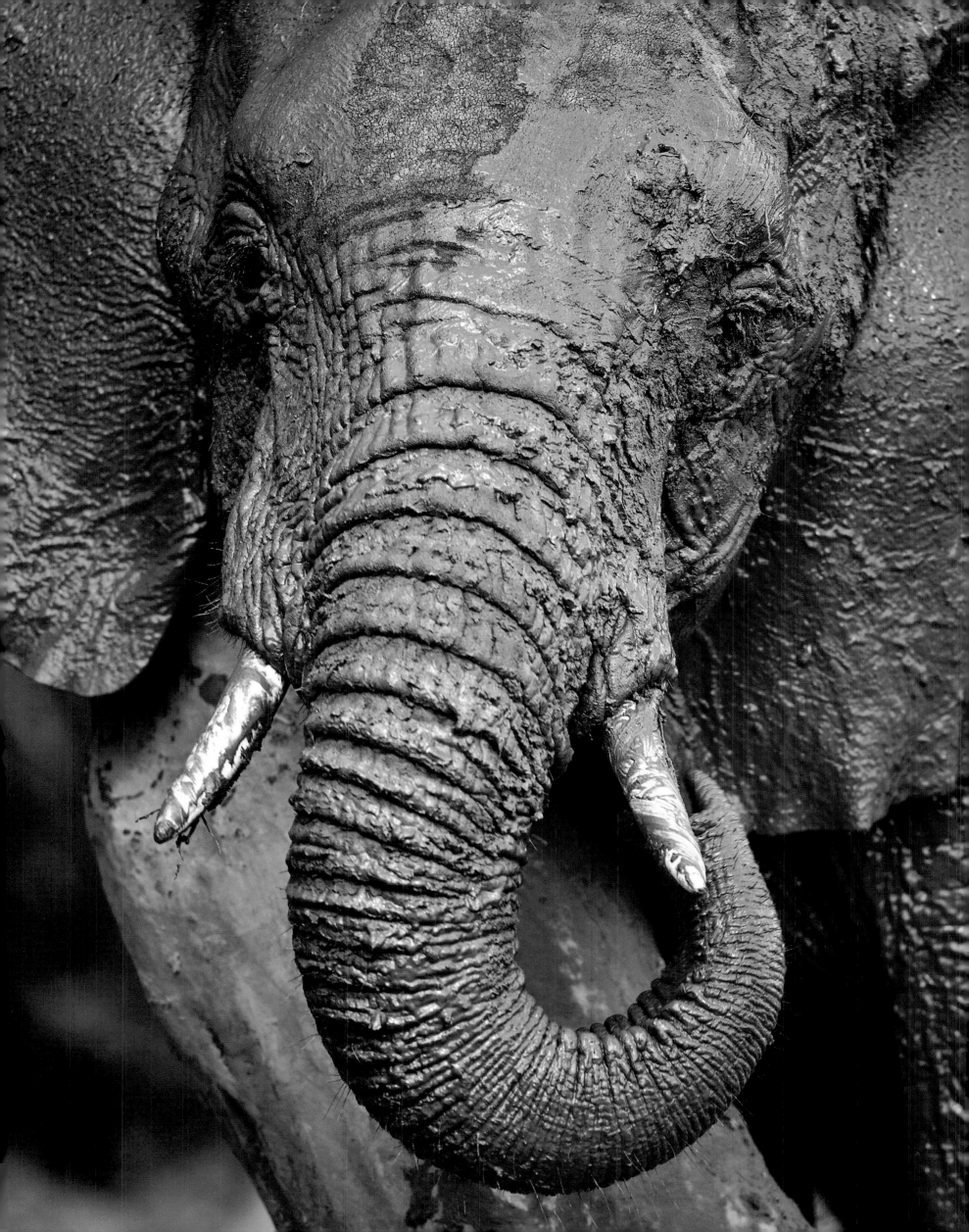

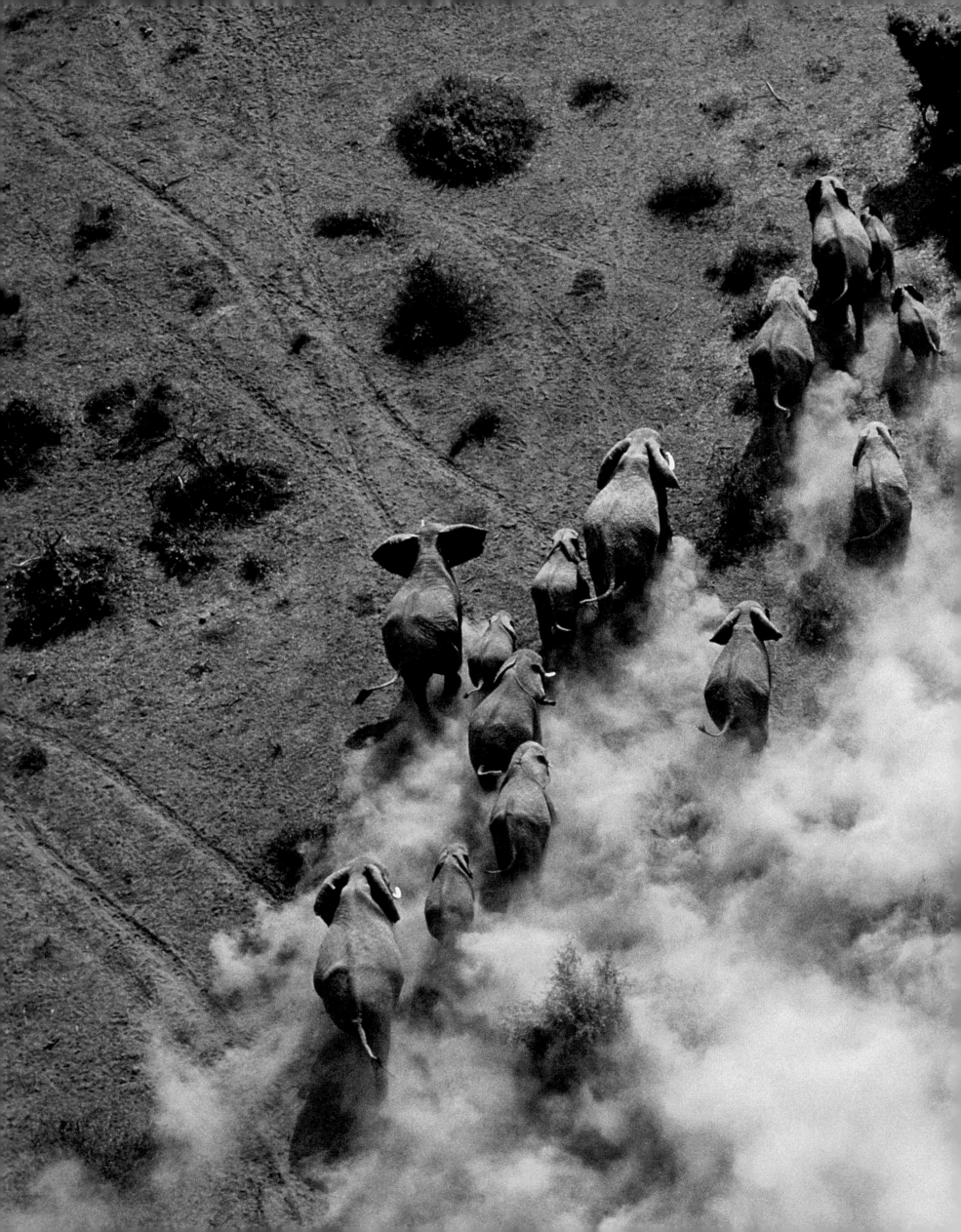

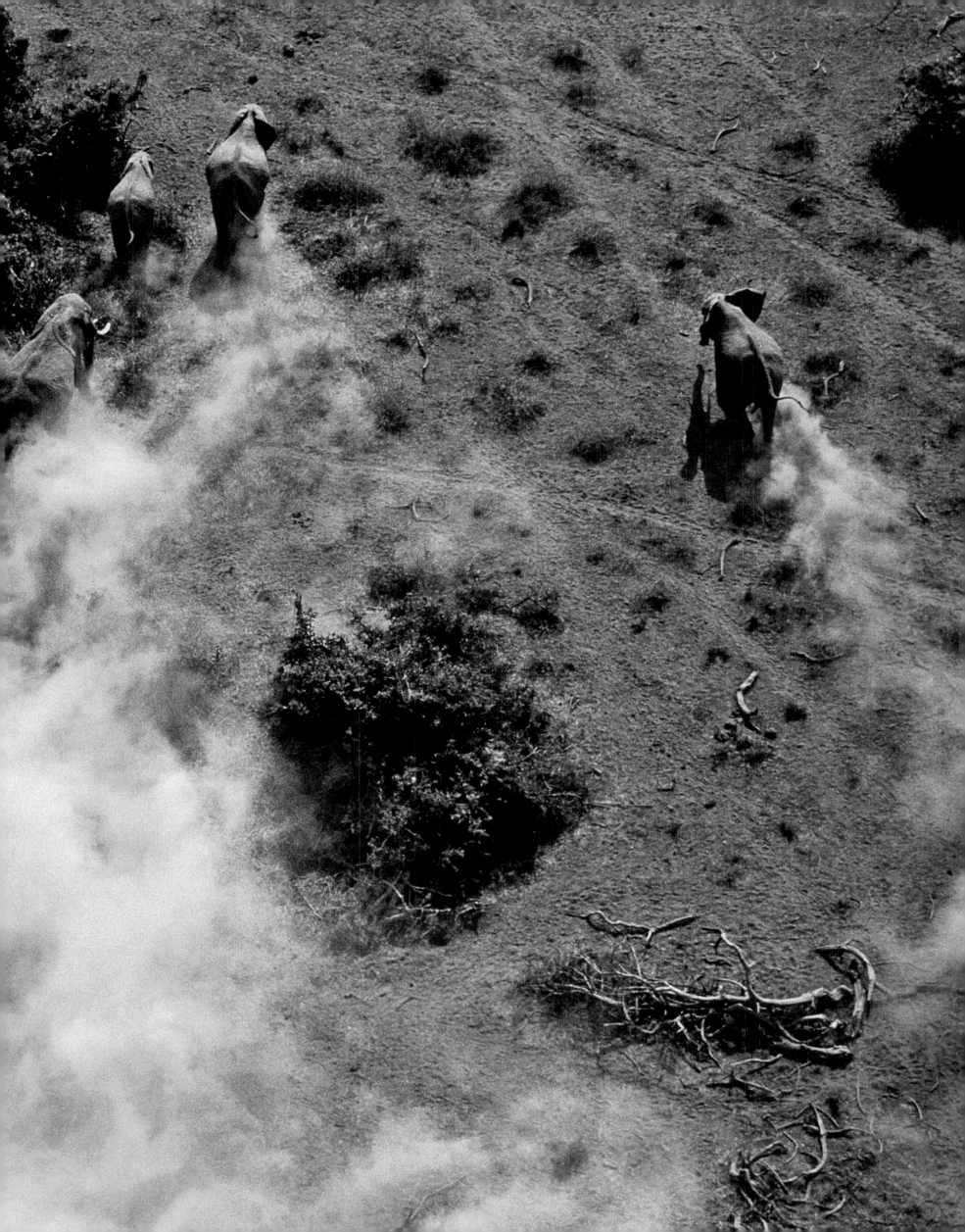

MOUNTAIN GORILLA

Gorilla beringei beringei

Today, only a few hundred individuals survive of our not-so-distant relative the mountain gorilla (*Gorilla beringei beringei*), of which there are two distinct populations. The first and perhaps most well-known population lives in the high altitude forests of the Virunga Mountains, while the second lives in the impenetrable Bwindi Forest, now among the most beautiful national parks in Uganda. The major conservation problems for this area and its magnificent inhabitants are political instability and extreme poverty. Today's gorillas are still prey to traps set in the forests, though not intended for them, by ruthless poachers who make circus attractions out of their offspring as well as selling their hands to a market that's quite surreal. However, the most urgent problem is the destructive development of their territory, the loss of space and food resources, and deforestation of those woods that for millennia have been their home, but which in the last few decades have been cut down to satisfy the demands of the local communities. This is the largest and most interesting challenge for the WWF who have taken the opportunity to promote and collaborate with local governments and other non-governmental organizations on the re-launch of efforts to conserve the gorillas, and other neighboring species, to make these animals the true wealth of the region. Thanks to the conservation of the gorillas it is hoped that this troubled society will have a brighter future. The struggle to protect and conserve the mountain gorilla unquestionably began with the heroic work of Dian Fossey. During the 1960s, because of her drive and passion, and under the direction of Louis Leakey, Fossey was able to move into the Virunga Mountains to carry out pioneering studies of this species. Although work had been initiated not too long before by another great zoologist, George Schaller. From 1967 until her tragic death in 1985 (killed with a machete in her sleep), Dian Fossey spent her whole life letting the world know of the precious beauty of the Virunga Mountains and their first citizen, the mountain gorilla. Until that time, this gorilla subspecies belonged to the eastern gorilla species (*Gorilla beringei*) and was only known about through explorers' sometimes fantastic tales. They told of a large monkey, with incredible strength, capable of overwhelming anything it encountered. The studies and documentation produced and collected by Fossey instead revealed the true, gentle strength of this giant good guy, its social behavior, attention to its peer and social group, and diligence to the care of its young. But even more incredible, was its ability to "hold out" its hand to another species, humans, who clearly represent the only threat against its survival. A famous example of this was included in a documentary by the National Geographic with the famous scene showing Dian Fossey's hands coming into contact with those of Digit, an alpha male mountain gorilla who was later killed by poachers.

CR

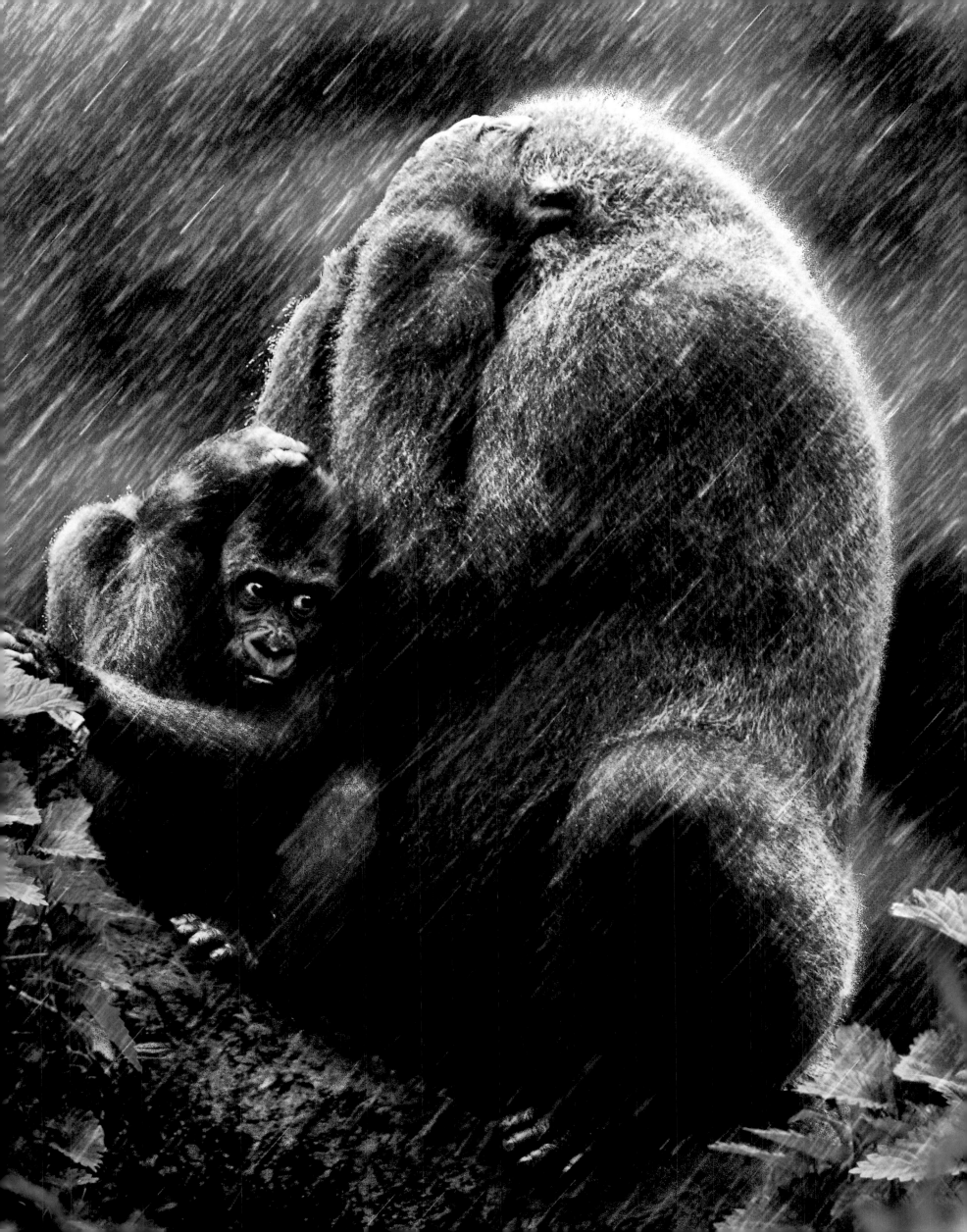

The WWF's activities
to protect mountain gorillas

Frequently enveloped in a dense fog and covered by a thick growth of hagenia trees, the volcanic Virunga Mountains follow the border between Rwanda, Uganda, and the Democratic Republic of Congo (DRC), with peaks reaching 14,764 ft (4,500 m). An exceptionally rich endemic fauna and flora thrives along the river branches, in the marshes, in the clearings, and tall forests, making this region one of the largest areas of biodiversity in Africa. The steep and impenetrable walls of the eight volcanoes, some of which are still active, accommodate more than half of the remaining 700 mountain gorillas. Part of the territory is protected by three national parks: the Virunga National Park in the DRC; the Park of Volcanoes in Rwanda; and the Mgahinga Park in Uganda. However, the gorillas' habitats are constantly under threat, particularly in the Congo where they have been reduced to small islands immersed in a sea of cultivated fields and pastures. Sadly, even the scientific discovery of this subspecies began with the killing of two specimens on the slopes of the Sabinyo Volcano in October 1902, by a German captain of German colonial troops, Robert von Beringe. Matschie, the zoologist from the Berlin Zoological Museum, described what was then considered a subspecies (today's science recognizes two species of gorilla: the plains gorilla or western gorilla and the eastern gorilla), and called it *Gorilla beringei beringei* for that reason. From 1990, the first year of the civil war and ethnic conflicts that have blighted the Great Lakes region, Virunga Park endured a large invasion of refugees from nearby Uganda fleeing the fighting, as well as rebel soldiers and poachers. This invasion persists even today, even though it is not as violent a disturbance. In 2004, farmers and shepherds penetrating the park territory transformed, in less than one month, almost 6 square miles (15 sq km) of forest into agricultural and pastoral areas. The war and continuous humanitarian emergencies have made the protection of gorillas extremely difficult and dangerous. But from 1987, the WWF has not abandoned their field work and in collaboration with the Congolese Institute for the Conservation of Nature (ICCN), they have supported direct and indirect conservation initiatives with environmental education programs, agro-forestry projects inside the park to convince the population to abandon use of the most fragile areas, and the creation of nurseries for the reforestation of areas destroyed by the removal of timber, with economic and technical support to park security rangers. In 2002, the WWF found further financial resources to increase the number of rangers per anti-poaching team, the duration of patrolling, and the size of the monitored area within the Virunga Mountains. By means of specific training, they now collaborate with the resident population on developing sustainable tourist programs based on gorilla safaris. The success of these initiatives is demonstrated by the result of the latest 2003 gorilla census in the Virungas that estimates their population at 380 specimens, a 17 percent increase from 1989. Even during this time of war, the WWF does not work alone but with many other smaller organizations in places where they develop projects and facilitate meetings for the local populations to participate in the sustainable management of natural resources.

Finally, all of the direct conservation and monitoring initiatives are coordinated within the International Gorilla Conservation Program (IGCP), which is also supported by other international organizations and, since 1991, they have agreed to direct all field activities and promote a transnational species management system that also takes care of other gorilla populations in the Bwindi National Park in Uganda. The threat of extinction has perhaps been avoided, even though there are still signs of killings this year due in part to the uncontrolled availability of arms to rebels who only bring death to a defenseless population, our most peaceful ancestors.

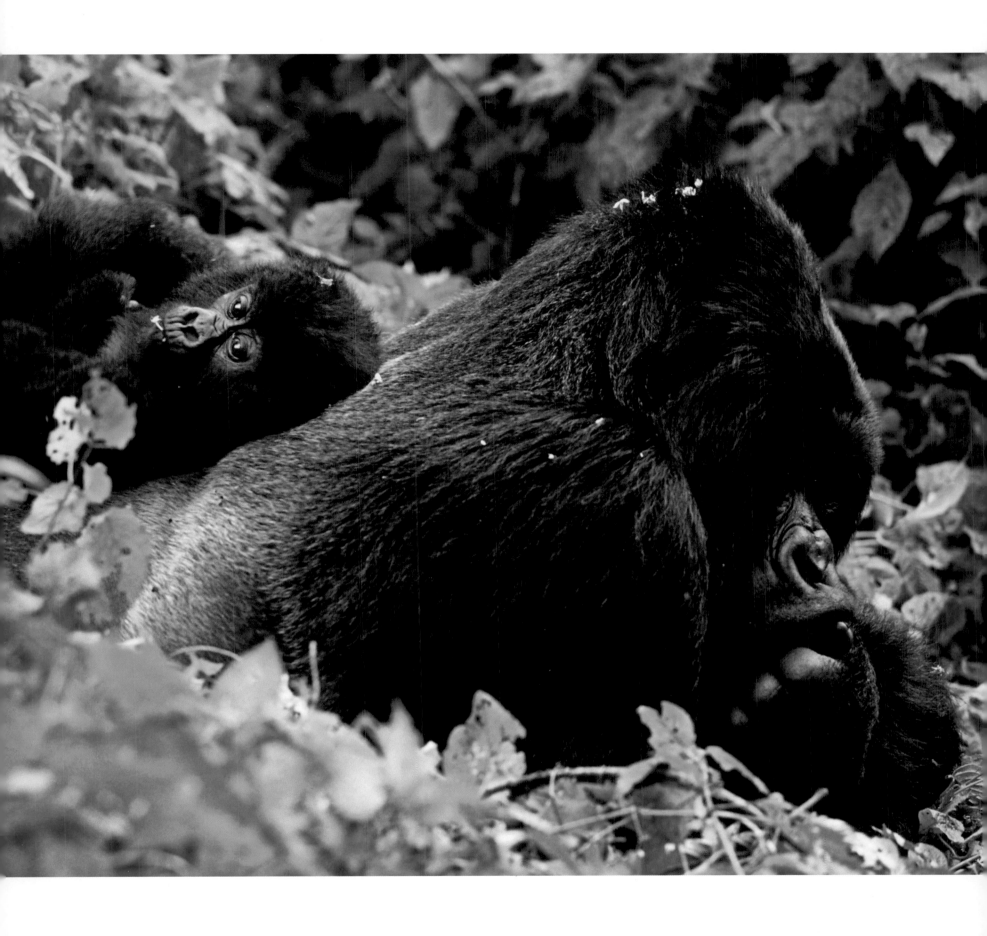

71 The high infant mortality rate, long gestation period, almost always single births, and the prolonged period of maternal care all mean that on average it takes six to eight years to raise a young mountain gorilla.

72-73 Occupying a territory 2–12 sq miles (5–30 sq km) in size, mountain gorillas are essentially herbivores and feed on stems, buds, shoots, fruit, and sometimes also bark and invertebrates.

74 and 74-75 Mountain gorillas have an advanced social structure, living and moving around in family groups of 2 to 35 individuals, but usually 5 to 10 is the normal number. In these groups, there is normally one dominant "silverback" male, three adult females with 4 to 5 offspring, and several young gorillas. These gorillas love to spend a large part of their time on the ground. However, in order to move from one place to another, they must use all four of their limbs, walking on the soles of their feet and supporting themselves with the knuckles of their fingers.

VANISHING ANIMALS

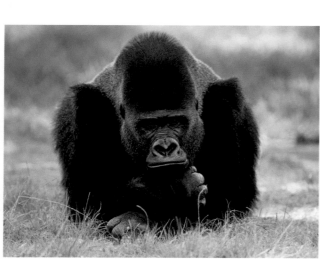

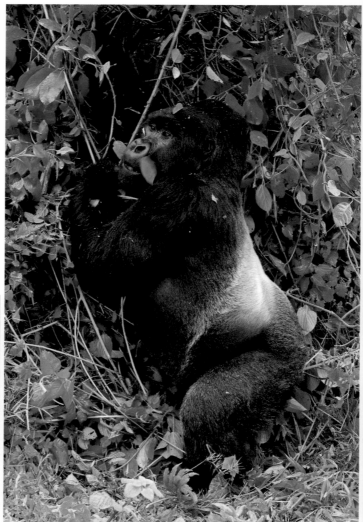

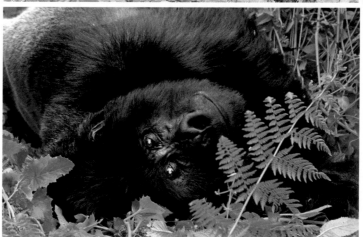

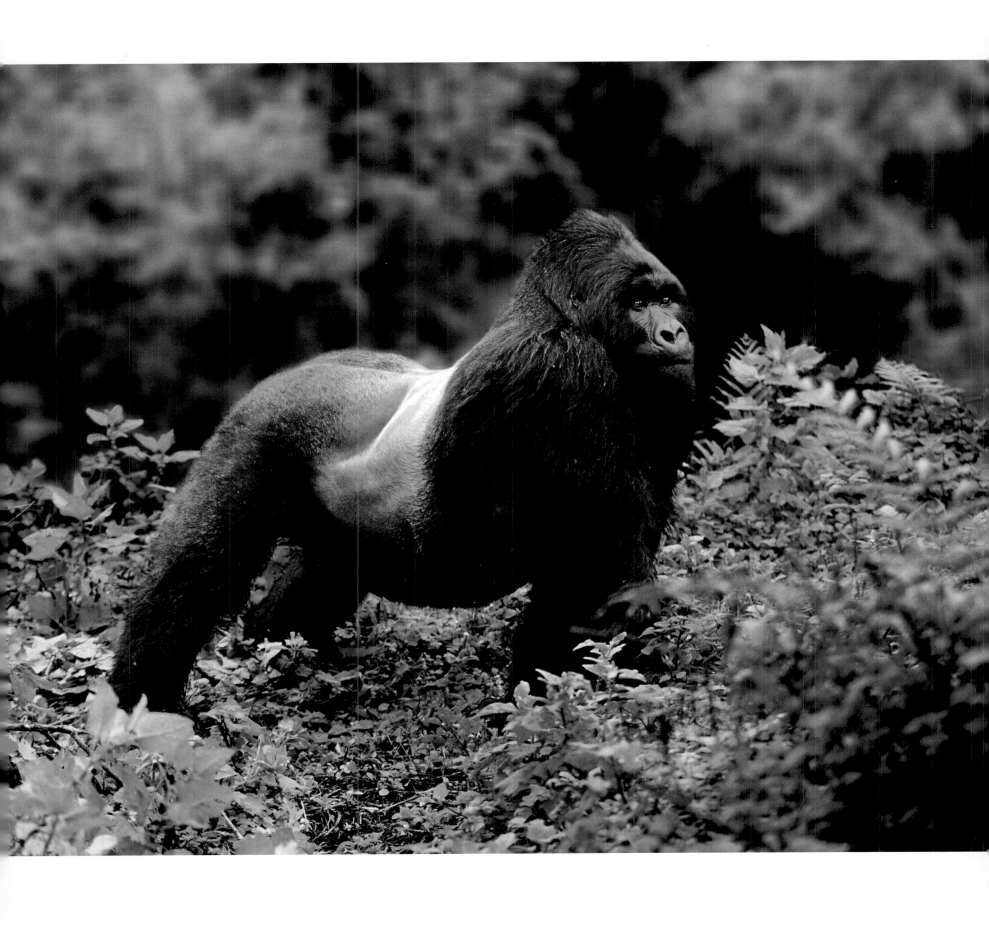

MOUNTAIN GORILLA

76 and 77 Male mountain gorillas are the largest of the primates. An adult male gorilla may measure up to 5 feet and nine inches tall (becoming more than 7.5 feet tall in the unnaturally erect position), and may weigh more than 400 pounds. The female is smaller and weighs about half that of the male.

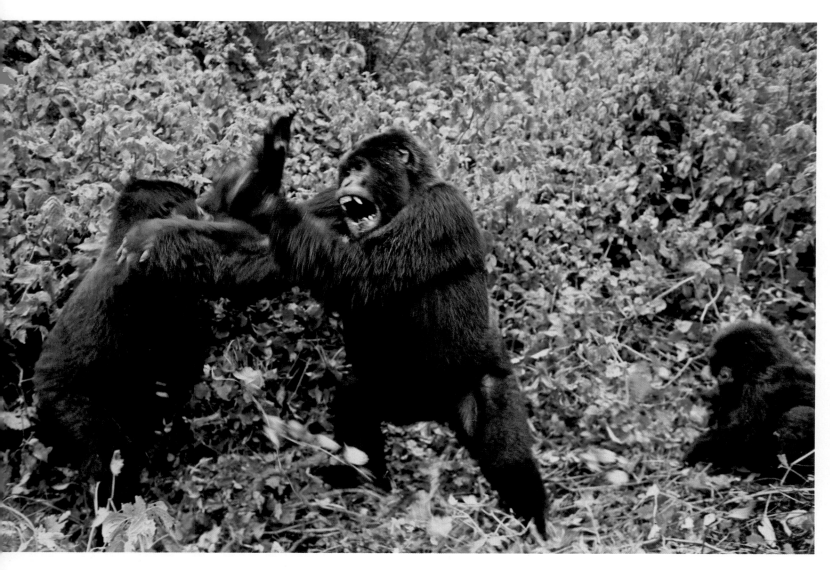

78-79 Mountain gorillas are predominantly threatened by the destruction of their habitat and by poaching for various reasons. The African forests, whether on the plains or in the mountains, are being destroyed and replaced by cultivated fields and pasture for livestock.

VANISHING ANIMALS

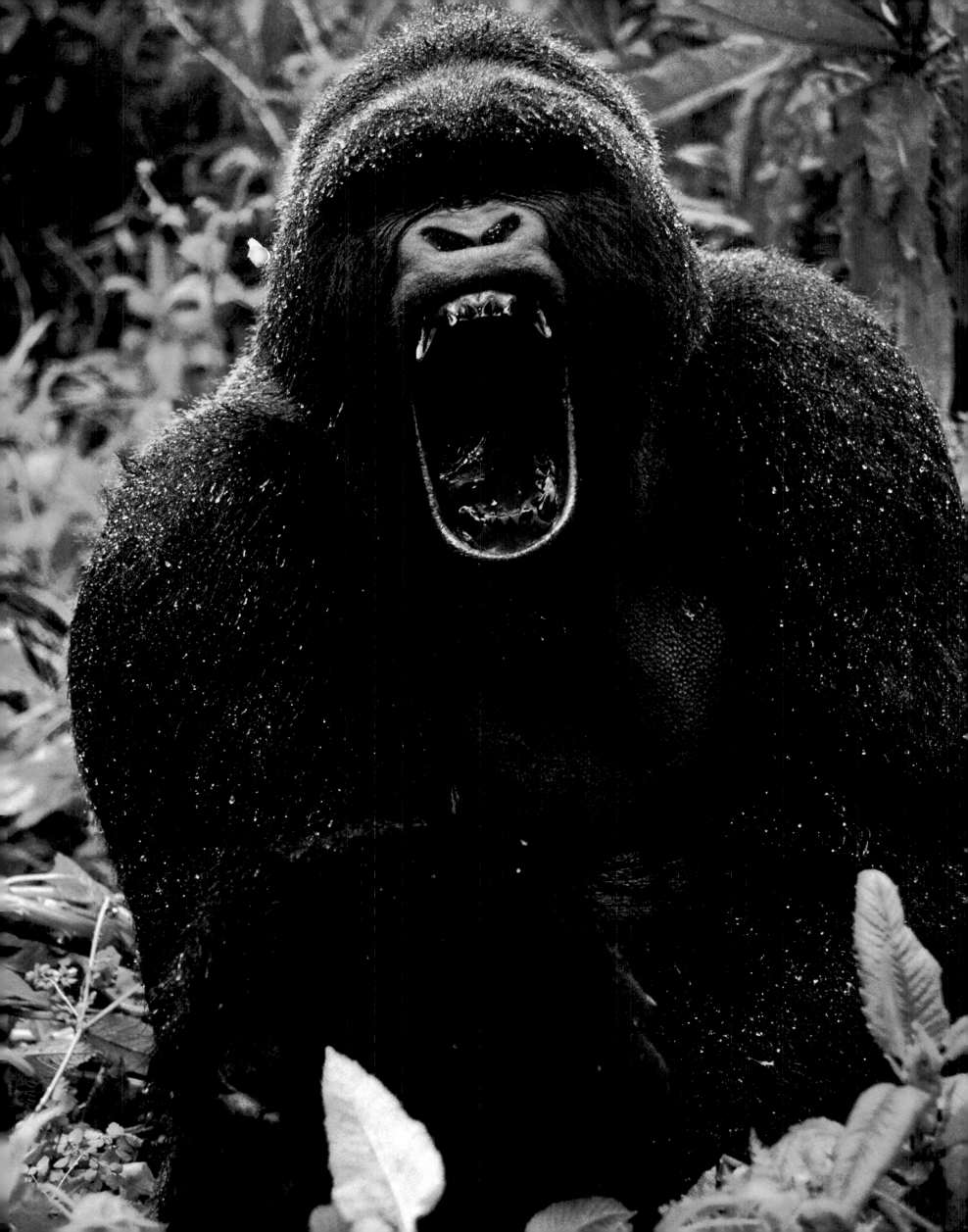

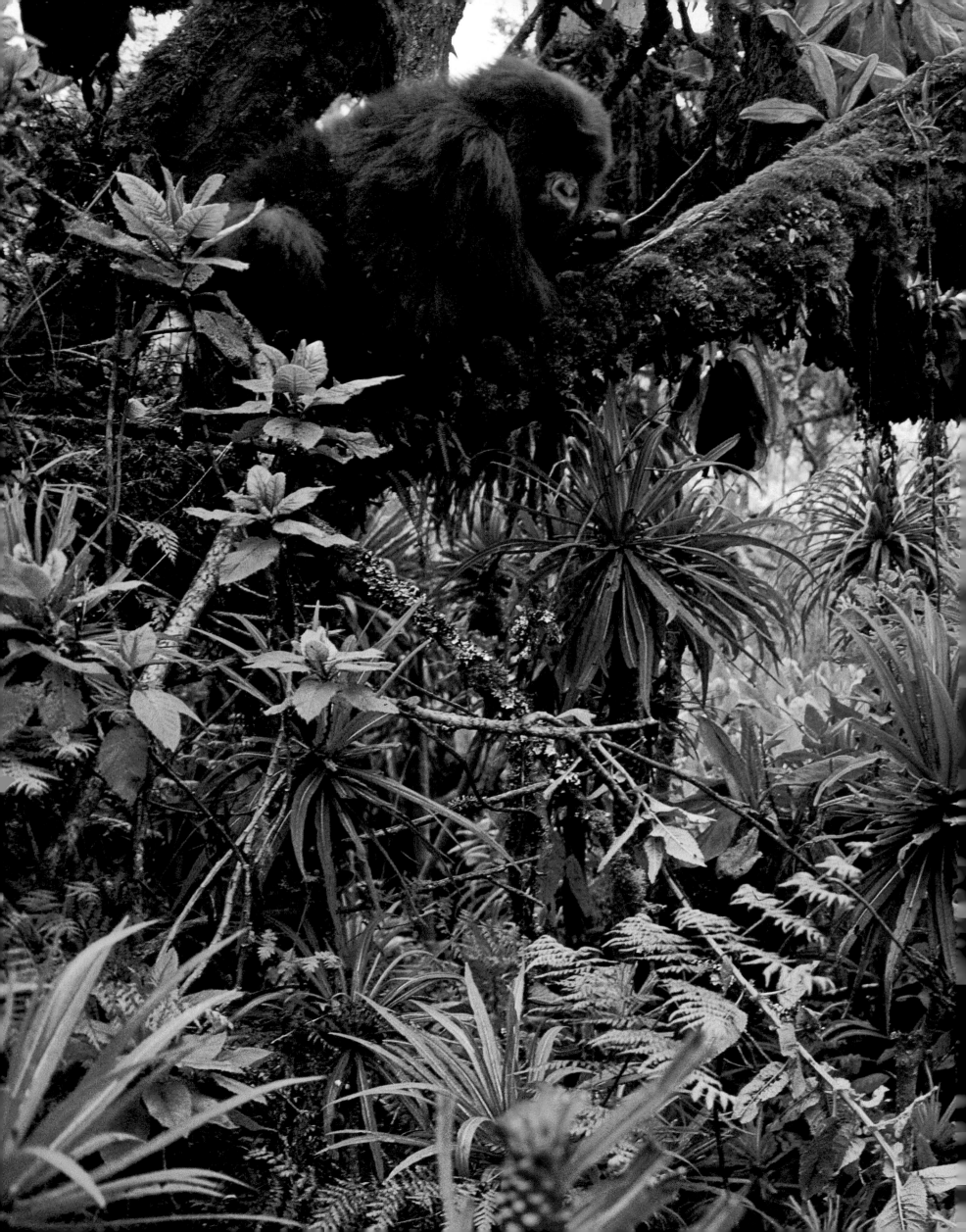

BONOBO or PYGMY CHIMPANZEE

Pan paniscus

When there is anxiety in the air or something that could lead to a dispute, the bonobo (*Pan paniscus*) have sex to lessen the tension. It is their strategy to mitigate conflict. The bonobo use sexuality to understand each other, console each other, make peace after a conflict, relax following a difficult task, as well as for encouragement, friendship, or play, independent from their reproductive instinct and the fertility of the female. They are peaceful animals par excellence. The term *bonobo* means ancestor in an ancient Bantu tongue. Indeed, when the pygmy chimpanzee wanders around, walking on two feet searching for food in the thickest parts of the equatorial forests of the Democratic Republic of Congo, it is like a scene from the distant past to the origin of the human species. Smaller and more delicate than the common chimpanzee, this relative of ours feeds on fruit, seeds, grass, and smaller animals. It spends a large part of its time in the trees where it sleeps by night on platforms of branches and leaves, built often at a height of almost 100 ft (30 m). The bonobo lives in a community of small groups where males and females share power. Relationships among them function on a level of equality. The social status of newborns depends on that of the mother to whom the youngsters remain connected for their whole lives. Because of the destruction of tropical forests, illegal hunting for their meat, and killing of mothers in order to sell off the young, the bonobo are in grave danger of extinction. Numbered among the 21 species of primates at critical risk of extinction on the IUCN's (World Conservation Union) Red List, the bonobo are among the most compromised anthropomorphic monkeys. In the past, many chimpanzees had been captured and exported for entertainment and research purposes. Increased legislative restrictions have reduced illegal trafficking of these animals, but they remain a hugely endangered species.

EN

Protection of the bonobo also occurs through sustainable tourism

The area encompassing Lake Tumba and Lake Tele, straddling the Congo River, represents the most expansive and uninterrupted forest system in Africa. The Congo River passes through this region, forming an insurmountable bio-geographical barrier that separates two species of African primates, many other endemic species, and a rich biodiversity of scarcely studied freshwater fish. The densest population of plains gorillas, the western species, is located in the Lake Tele area in the Republic of Congo (ROC), Conversely, the highest populations of bonobo have been recently discovered around Lake Tumba in the Democratic Republic of Congo (DRC), and it was the WWF team who found what could be the densest population of bonobo ever described in November 2005: 7 to 10 specimens per square mile. Over the eight-month course of a census performed south of Lake Tumba, the WWF researchers iden-

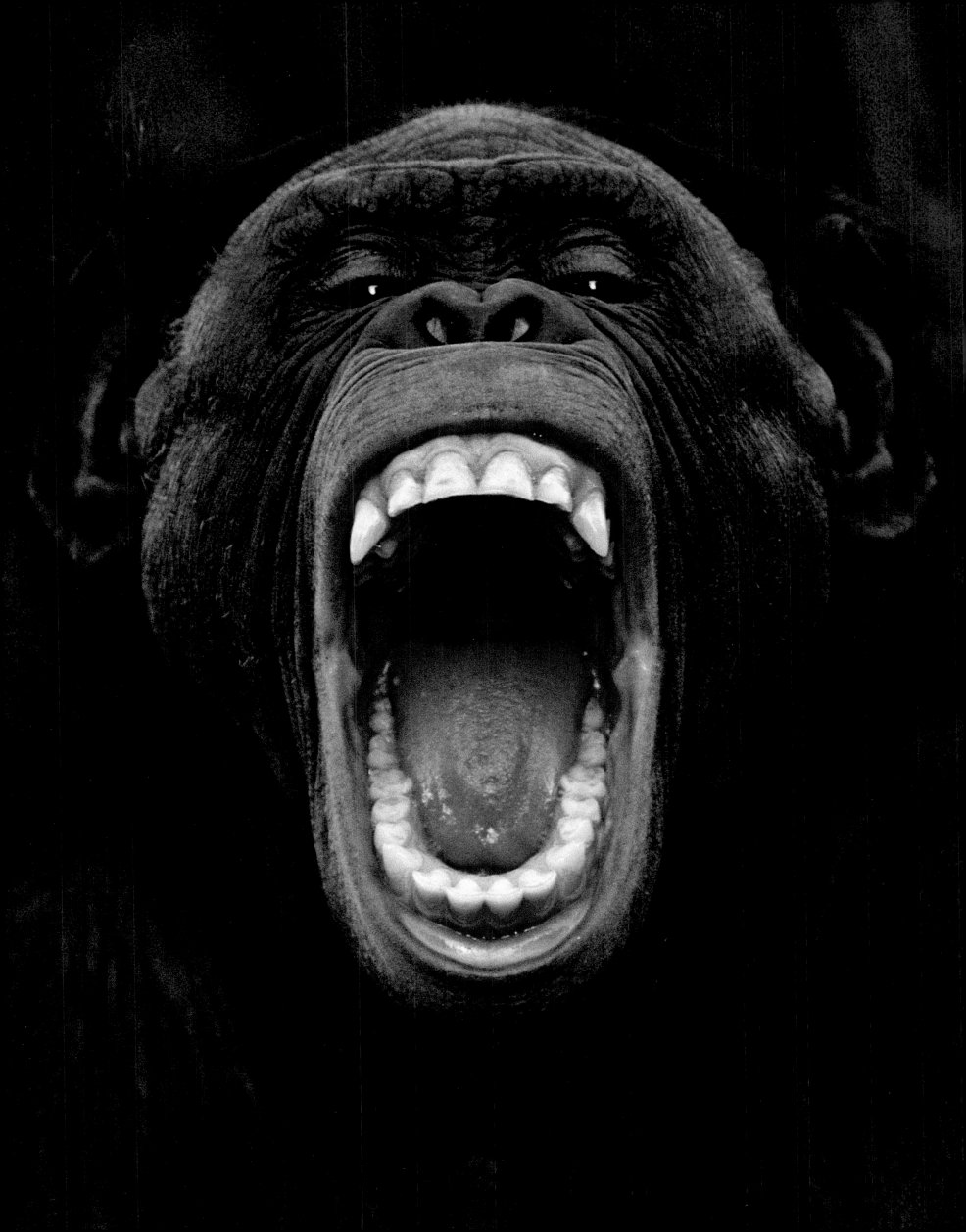

tified the bonobo population with the highest number of specimens ever observed and allocated throughout a habitat as yet considered unusual for the presence of these primates. Theses results would indicate that the bonobo prefer a mixed habitat of savannah and gallery forest to the thicker forests they have been identified with up to now. There are two reasons for this: a more differentiated habitat guarantees more availability of fruit over the whole year and greater ease of movement on two legs (a characteristic of this species which is genetically closer to humans) is possible in more open areas. Another reason that makes this discovery an important success is that the population was found on a huge cattle-breeding ranch, managed by a Belgian citizen at Malebo. The ranch is not inside a protected area, but its manager has signed an agreement with the WWF to start some sustainable tourism activities in collaboration with the local indigenous population. The WWF has committed to providing financial resources to develop conservation initiatives and the ranch owner has already created a visitors' center as well as the only airport in the area. Thanks to the WWF's commitment, about 20 traditional huts are currently under construction to accommodate visitors. It is important to note that these projects are occurring in an area where the power of traditional authority is strong, in this instance it is the people of the Teke tribe who have always protected the bonobo because they believe them to be their ancient ancestors. The Bolobo Teke tribe lives in the Bandundu area, one of the smallest areas in the DRC where power is still exercised by the traditional chief authority, a direct descendant of King Makoko who signed the historic peace agreement with Pietro Savorgnan di Brazzà, an Italian explorer in service to the French colonial authority in 1880. The situation in the DRC is quite a unique case, in which traditional authority and political-administrative power are in the hands of the same person, which constitutes in this case the only recognized authority in the area populated by the Teke. Following the discovery of established populations of forest elephants and buffalo, the WWF has even been able to start a clear and well-developed conservation program with the full involvement of the local community and tribal authority, rather than apply the more typical conservation scheme that would have involved external surveillance and armed patrol personnel. The traditional chiefs, who also represent local administrative authority, have publicly declared their desire to support sustainable management of natural resources in the area and to guarantee the protection of the most endangered species, such as the bonobo and the forest elephants. By signing the collaboration agreement with Chief Bateke, the WWF has invested in an historic goodwill accord with an indigenous population that wants to protect its own traditions and natural heritage from excessive exploitation. The WWF has also committed to demonstrating to them the benefits of improving living conditions and generating goodwill by utilizing sustainable practices in the management of agricultural, fishing, and tourism resources. In this area, as in other parts of the DRC, a series of direct threats requiring the immediate launch of habitat-protection programs for those environments that are extremely fragile is paramount. Research by the WWF has in fact highlighted the effects of impending deforestation that in the last few years has generated strong conflict among timber dealers who continue to operate despite the government moratorium and illegal operations managed by contractors commissioned by Asian businessmen, who encourage the removal of wenge wood (use frequently as a veneer) and bushmeat (meat derived from wild animals in forested areas). Additionally, there is unsustainable fishing of the lakes, clearly demonstrated by the increasingly smaller size of fish destined for markets in the nearby capital. All of these activities has created a conservation awareness in the local communities, who have expressed a desire to participate in the decision-making on the future use of natural resources, thus creating conditions for the success of conservation programs and their shared management and implementation along with the local stakeholders.

81 Male bonobo are slightly larger than the females and may reach a weight of about 100 lb (45 kg) while females reach about 66 lb (30 kg). They live in social groups and can live for 40 years. According to

Professor Frans de Waal, one of the most respected primatologists in the world, the bonobo is frequently capable of altruism, compassion, empathy, kindness, patience, and sensitivity.

83 The bonobo is more slender than the common chimpanzee. Its head is smaller but its forehead is higher. It has a black muzzle with pink lips, small ears, wide nostrils, and long hair on its head.

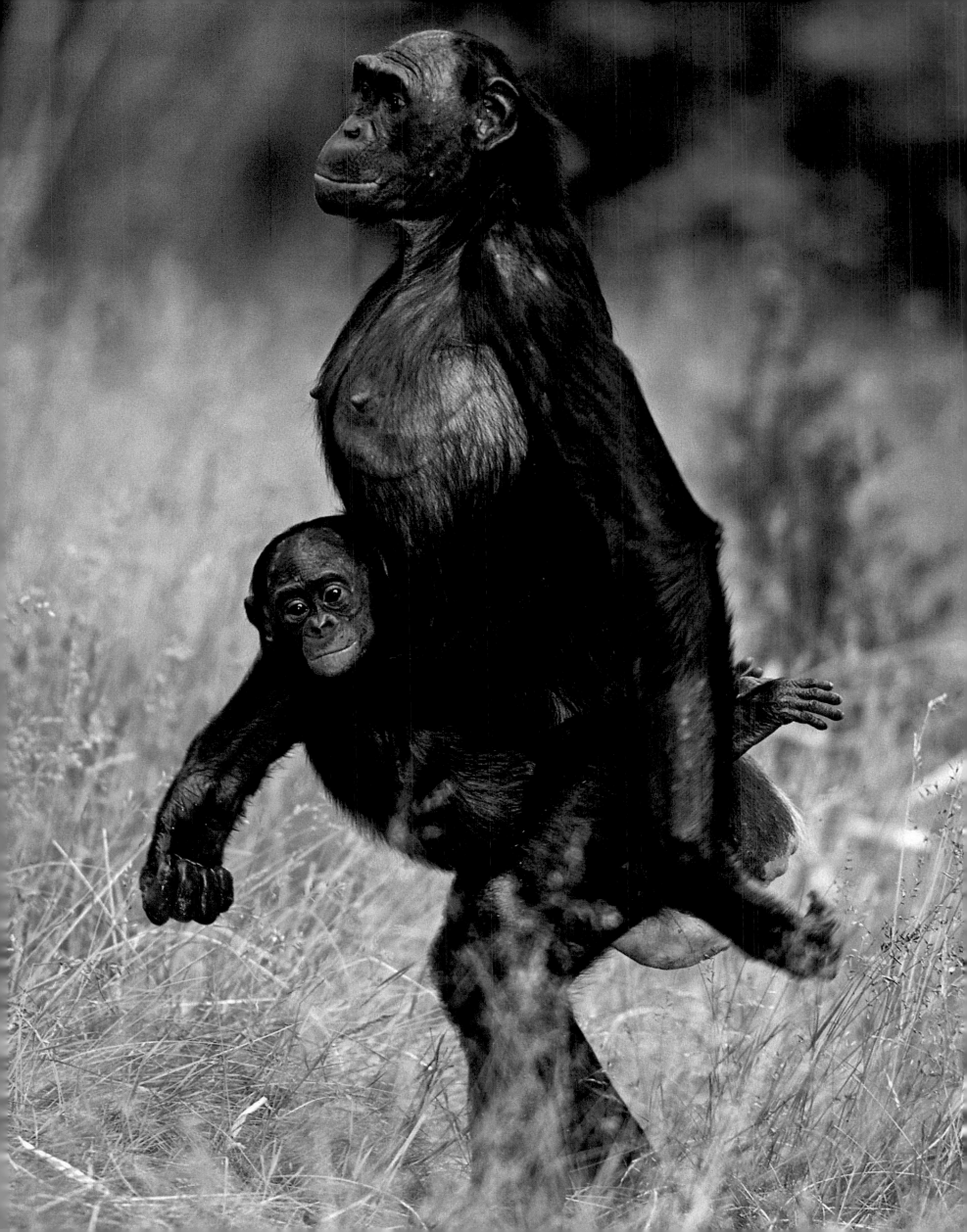

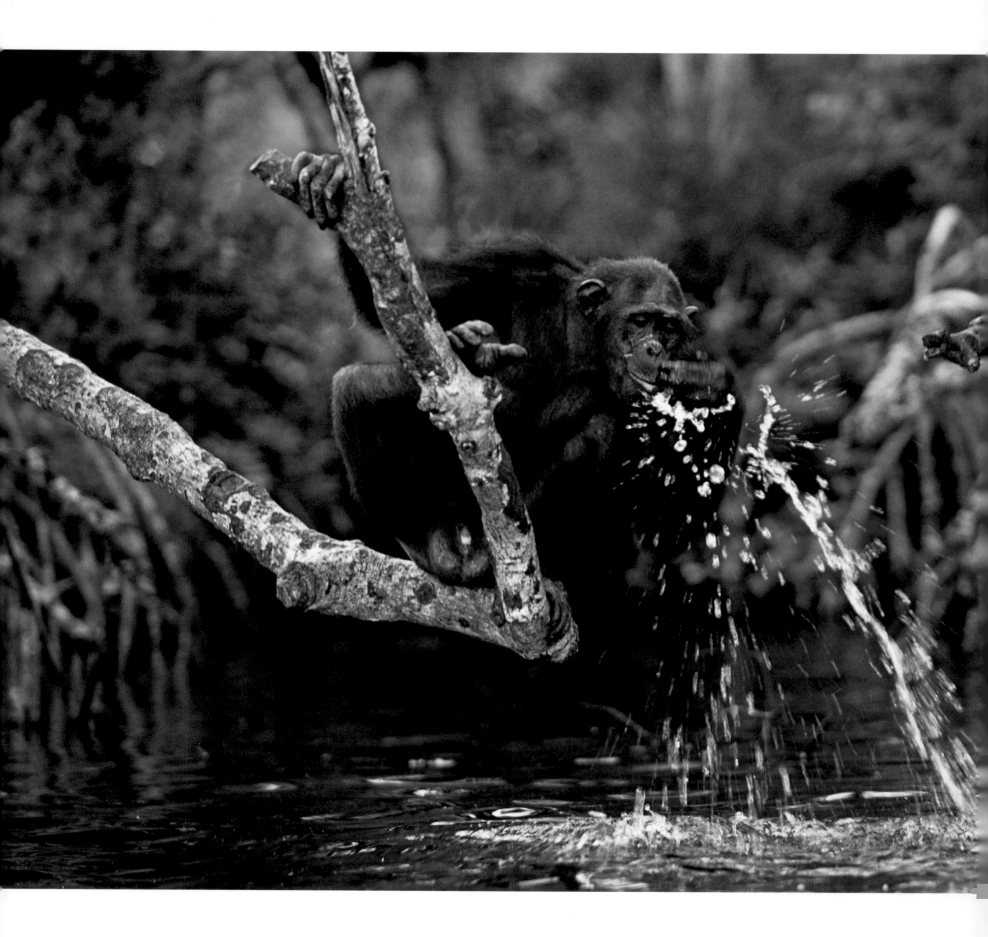

84-85, 85 top and center The bonobo live on the south side of the Congo River, while the more aggressive common chimpanzees are on the north side. Since neither of the two species is capable of swimming and thus of crossing the river, they naturally never come into contact with each other.

85 bottom About every five years, the female bonobo gives birth to one sole offspring after around an eight-month gestation period.

 VANISHING ANIMALS

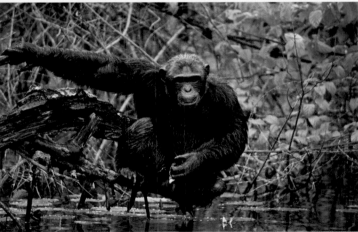

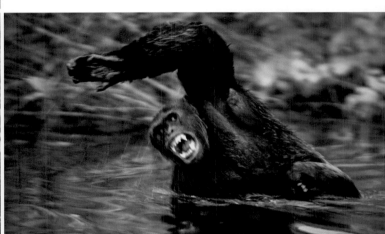

B O N O B O

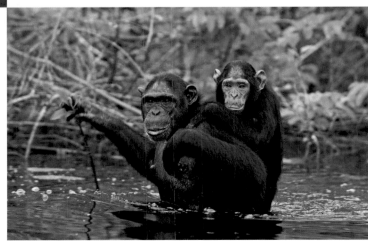

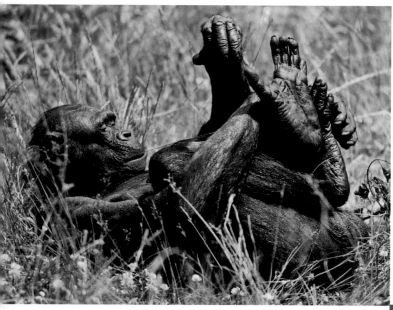

86 and 87 The bonobo was only recognized as a separate species in 1928. Recent genetic analyses have confirmed that it is a different species to the common chimpanzee. Given that about 98 percent of the bonobo's DNA sequence is identical to that of humans (*Homo sapiens*), some scientists conclude that the *Pan paniscus* species should be reclassified with the common chimpanzee as a member of the Homo genus: *Homo paniscus, Homo sylvestris,* or *Homo arboreus.*

VANISHING ANIMALS

BONOBO

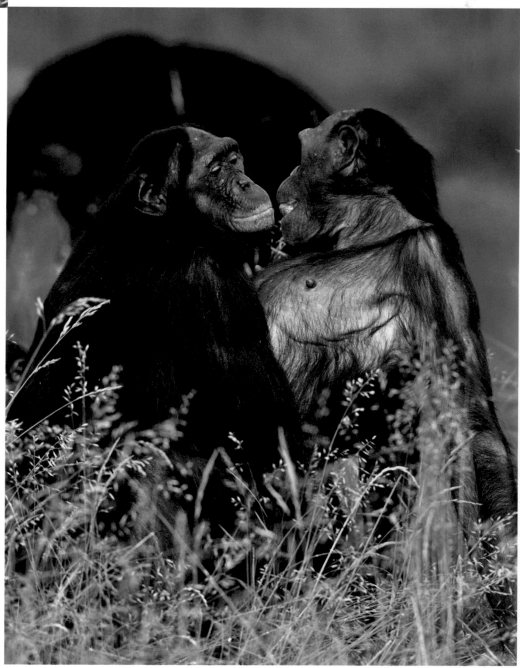

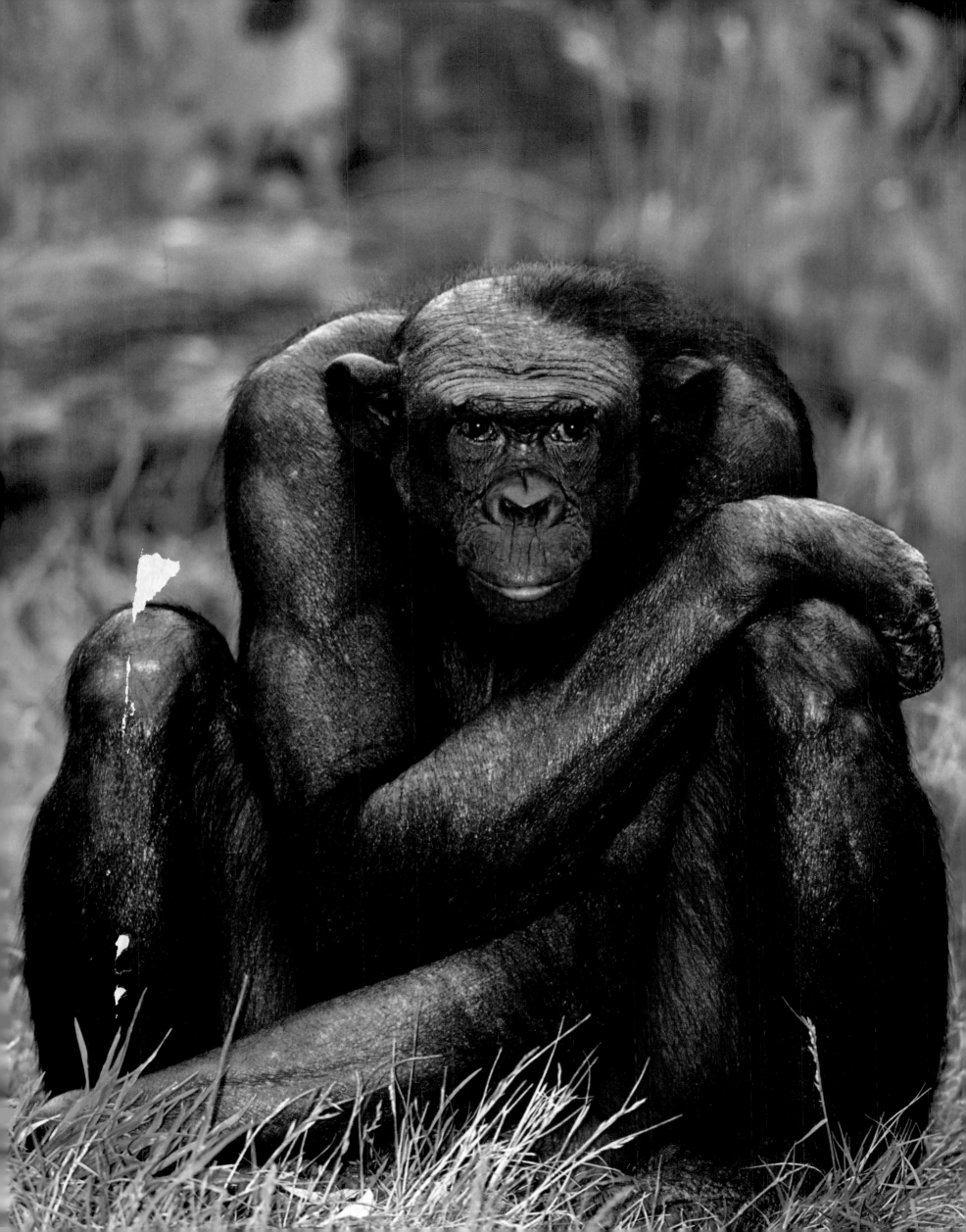

AYE-AYE

Daubentonia madagascariensis

It has teeth like a rabbit, ears like a bat, bristly skin like a wild boar, the hands of a monkey, and a tail like a wolf. This is one of the first descriptions of the aye-aye (*Daubentonia madagascariensis*), classified towards the end of the 18th century as a rodent because of its stereotypical set of teeth, and it was only later recognized as a lemur. The aye-aye is the ET of the animal world. Its slender and very long middle finger is reminiscent of the alien character from Steven Spielberg's film that uses it to "phone home" from a faraway place. The aye-aye utilizes its special finger as a tool to pull larvae and insects from small holes and cracks in trees. With its long incisor teeth, it greedily removes pieces of bark from trees to search for the tasty larvae. It particularly likes to feed on beetles, bamboo pith, and coconut pulp. In contrast to the indri, which has always been revered, the aye-aye is traditionally associated with disaster and bad omen, and is feared by the local population. For this reason, it has been the object of indiscriminate hunting that has brought the species to the threshold of extinction. In reality, the aye-aye is a timid and solitary animal with nocturnal habits, making it somewhat difficult to target. To observe it, just venture into the forests near the edges of Ranomafana National Park, Verezanantsoro National Park, or Nosy Mangabe Special Preserve. Some specimens have been reintroduced since 1966 on Nosy Mangabe Island in Antongil Bay in an attempt to ward off their extinction. The species is considered critically endangered by the IUCN (World Conservation Union) whether from hunting or the destruction of Madagascar's forests. Based on the criteria of evolutionary uniqueness and scarcity of the population, the London Zoological Society considers *Daubentonia madagascariensis* one of the 100 mammal species with the greatest risk of extinction.

EN

The WWF and Local Communities Protect the Lemurs in Madagascar

The protection of lemurs in Madagascar is at the heart of many projects that the WWF develops with the direct involvement of local communities. In these poor areas, the dependence on natural resources is growing and human populations have had a huge impact on the environment. The forests are in large part destroyed by illegal activities, fires, and management of territory for agricultural purposes. Rice growing is the most prevalent agricultural activity in addition to coffee cultivation, which is in overall decline because of aging plants and lower prices on world markets, and cattle breeding actually exceeds the territory's capacity. With the "Protection of Two Lemur Species in South Midongy project," work is under way to reduce pressure on these animals and increase the knowledge of local communities of their existence and necessity for protection. The objective of the "Build a home for the Maki and other lemur species" program is also to ensure their conservation and use the program as a red flag for the restoration of habitats at risk. The "Forestry management and restoration to save the lemurs and their habitat in the Marojey-Tsaratanana corridor in northern Madagascar" project focuses on the management of natural resources by the local communities, the reforestation of some areas, the creation of nurseries, poultry farming, beekeeping, and fish-breeding facilities.

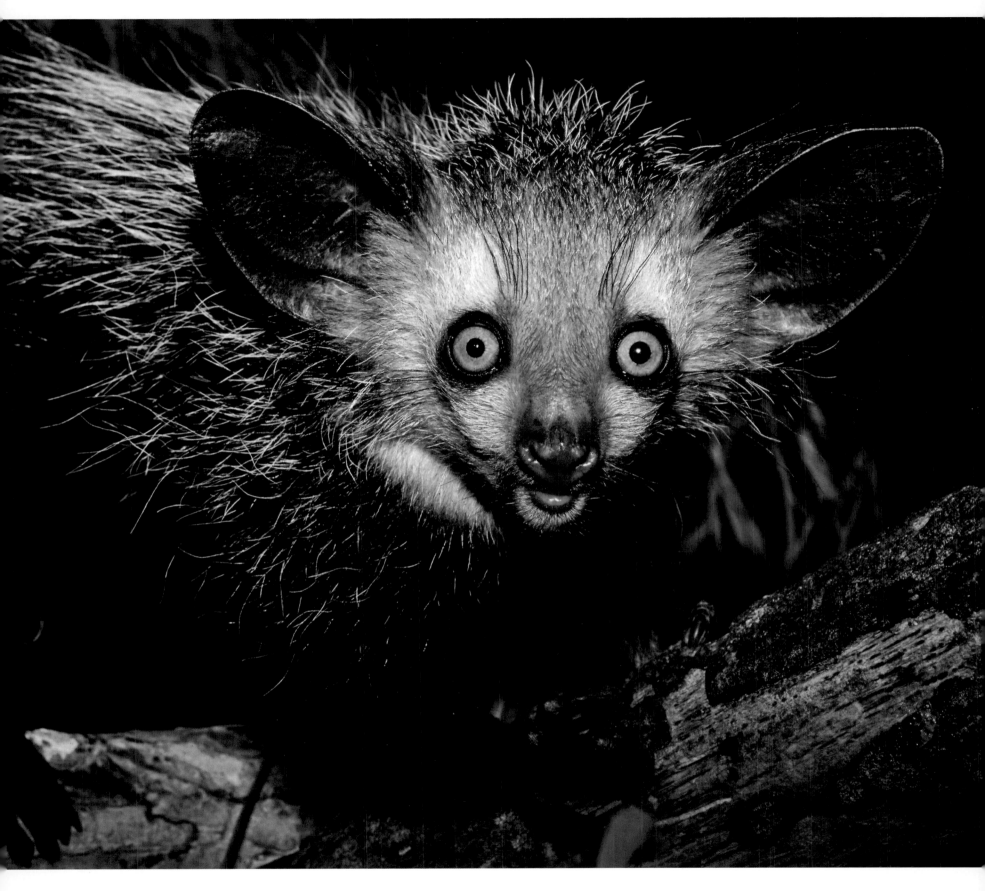

88-89 The aye-aye is about 32 inches (81 cm) long, 16 of which are the length of its tail, and it weighs 4–7 lb (1.8–3 kg). Its baby teeth are like the lemur's and its permanent teeth are similar to a rodent's, and because of this it was initially classified as a rodent and only later recognized as a lemur. The aye-aye has almost vanished from the face of the Earth thanks mainly to excessive deforestation as well as indiscriminate hunting.

ETHIOPIAN or SIMIAN WOLF

Canis simensis

Crouched on the ground, the Ethiopian wolf (*Canis simensis*) is on a solitary hunt in the high mountain prairies of Ethiopia. It is stalking a fat African mole rat that pops up out of its underground burrow from time to time. The wolf moves furtively to within several feet when the rodent disappears underground, safe after appearing temporarily on the surface. Then, with a final leap, the wolf grabs the rat before it again disappears into the depths of the earth. With an orange coat, white throat and abdomen, black-tipped tail, pointed ears, and narrowed muzzle, the Ethiopian wolf looks much like a jackal but in reality is genetically much closer to a coyote or a wolf in the strict sense of the word. The Ethiopian wolf is one of the rarest African carnivores and the canid most at risk of extinction in the world. Endemic to Ethiopia, there are actually about 500 counted specimens of this species, confined to seven mountainous areas, at altitudes between 9,840 and 14,760 ft (3000 and 4,500 m) above sea level. Half of the whole population is located in the Bale Mountains, where 96 percent of its diet is comprised of mole rats. In the past, Ethiopian wolves were blamed for doing enormous damage to domestic livestock, and therefore persecuted, especially during periods of political instability in the country when firearms were more prevalent among the population. Current threats to the survival of this species include domestic dogs that live in the same areas as the wolf and are carriers of zoonosis (disease) capable of extinguishing in a single epidemic one of the smallest existing populations. Also, the dogs are capable of mating with the wolves and thus introducing hybrids into their wild population. However, the largest threat is represented by the expansion of subsistence agriculture, which now occupies 60 percent of the territory above an altitude of 10,500 ft (3,200 m). The loss of ideal habitat for a species that is extremely adapted to the afro-alpine ecosystem, is increasingly exacerbated by intensive grazing of livestock, especially in the zones where commercial breeding enterprises have been established.

EN

90 The Ethiopian or Simian wolf's body reaches a length of just over 3.25 ft (1 m) and its tail may be up to 1 ft (30 cm) in length. A fully grown adult may weigh up to 42 lb (20 kg).

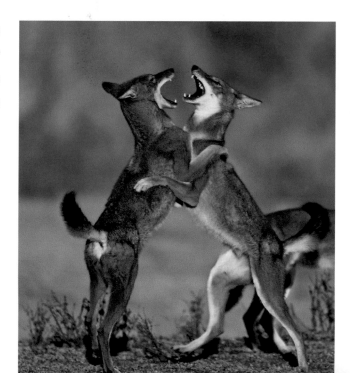

91 The Ethiopian or Simian is diurnal and hunts alone, probably because it is a specialized predator of small animals that would not satisfy the dietary requirements of a whole wolf pack. Thanks to its long and narrow muzzle, it is successful in catching its preferred prey of other small mammals.

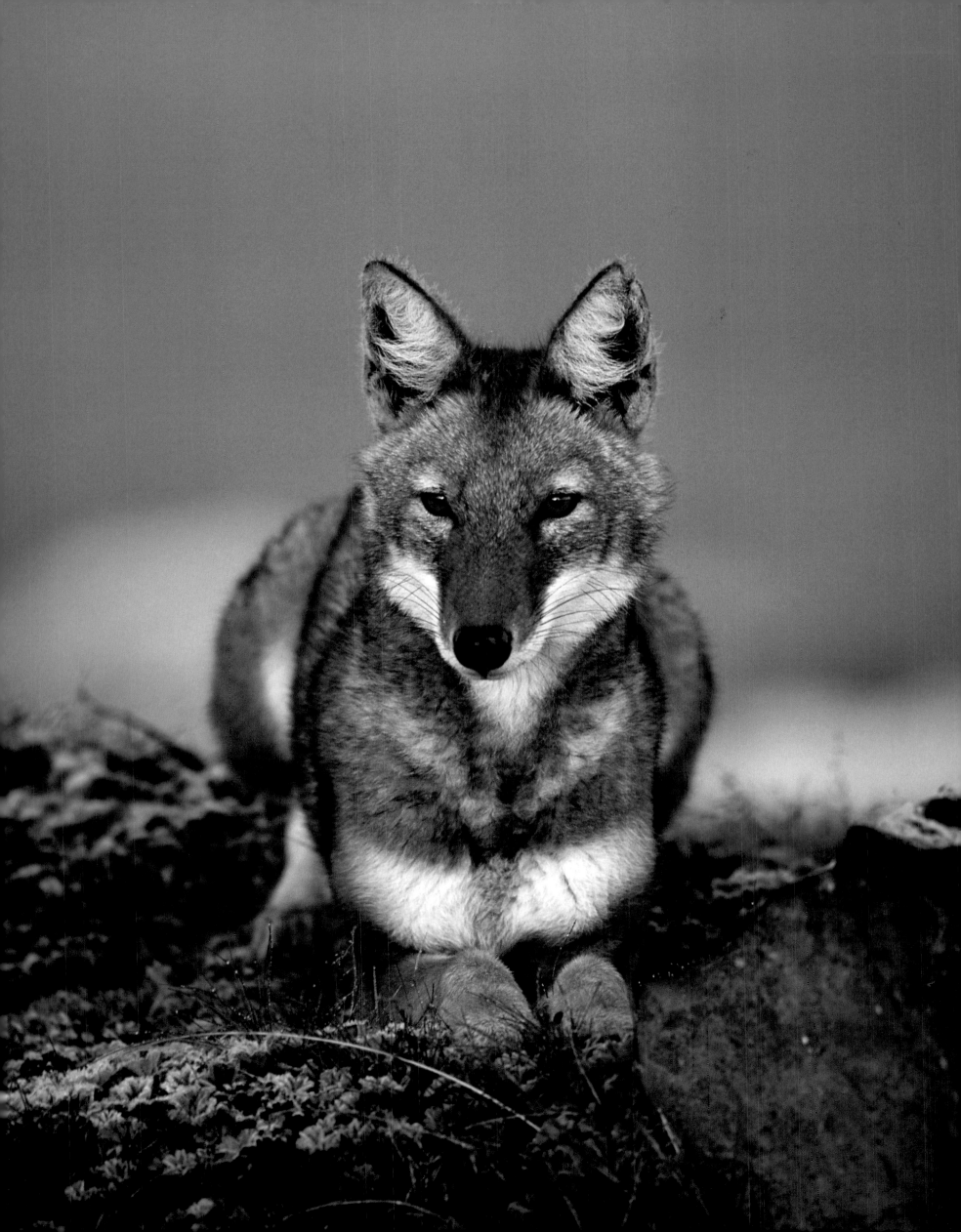

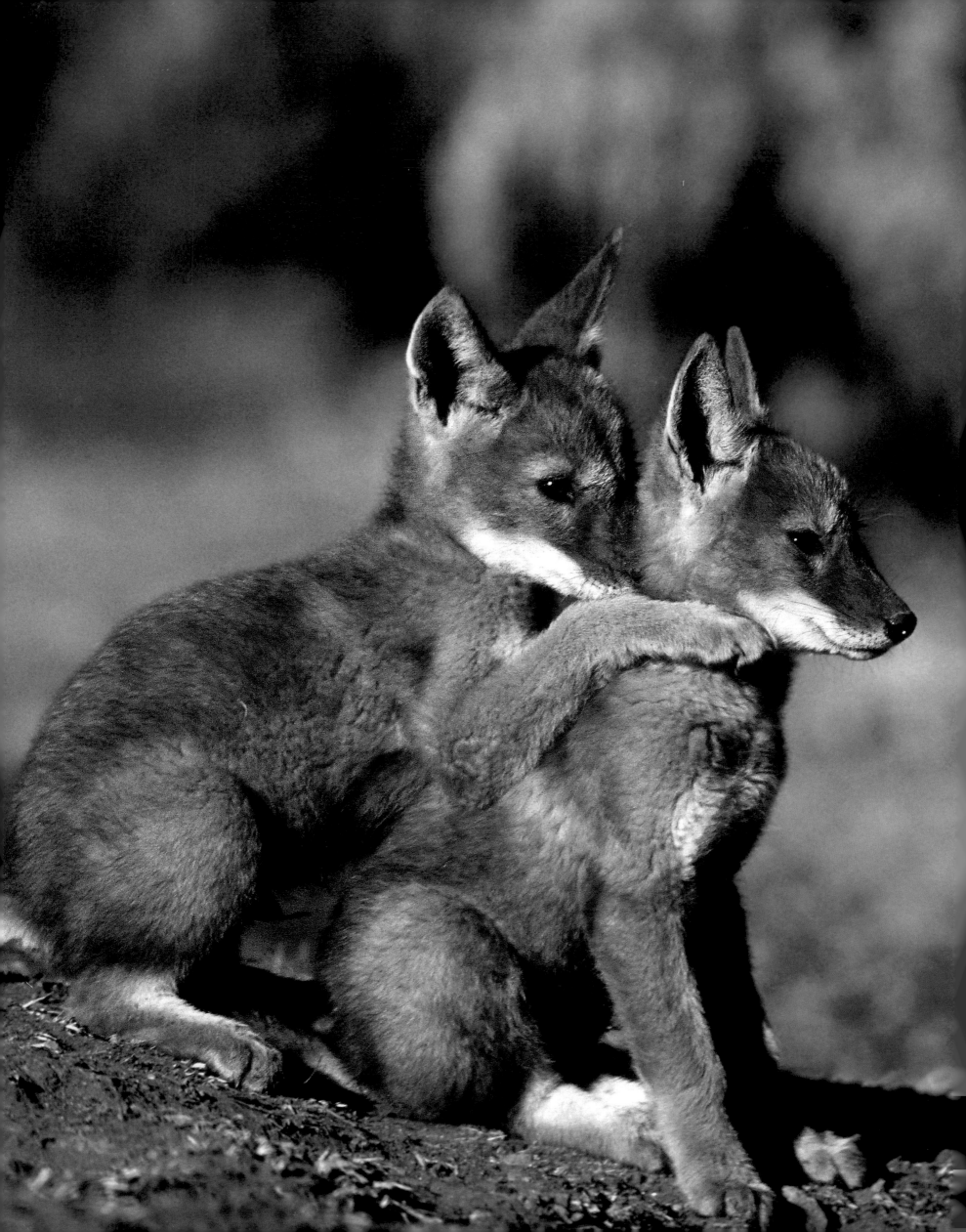

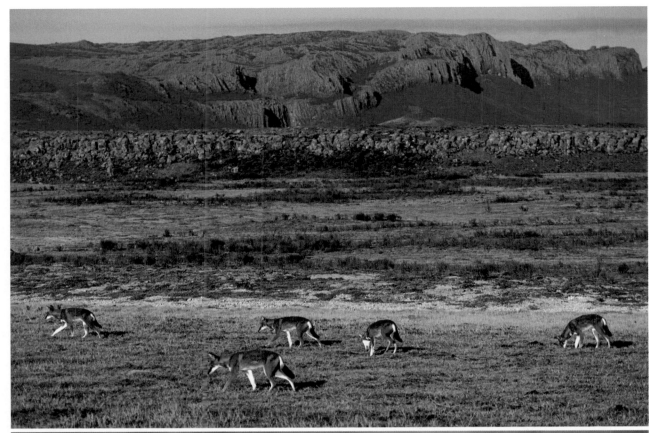

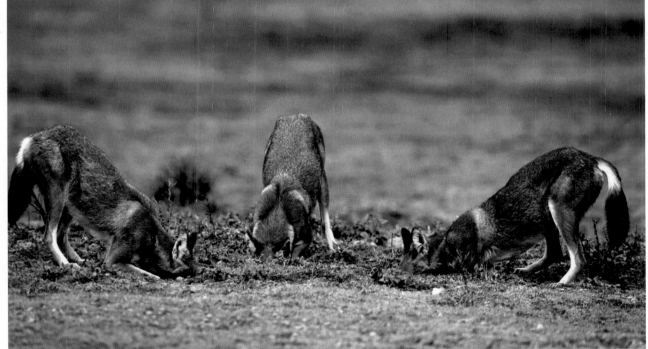

92 In their first four weeks of life, Ethiopian wolf cubs are suckled by their mothers and then fed by all members of their packs with regurgitated food. Young males reach sexual maturity and remain with their original packs while mature females move on, living in nearby territories occupied by other packs, replacing the fertile females that have left those packs.

93 Individual Ethiopian wolves reunite with their packs at sunset when all the members of the group patrol the boundaries of their territory and then spend the night together. They usually mark their territory with scent signals and vocalizations, both of which become more intense during the mating season.

94 The Ethiopian or Simian wolf lives in packs of between three and 13 adults that only occasionally hunt in groups, preying on young antelope, lambs, or hare.

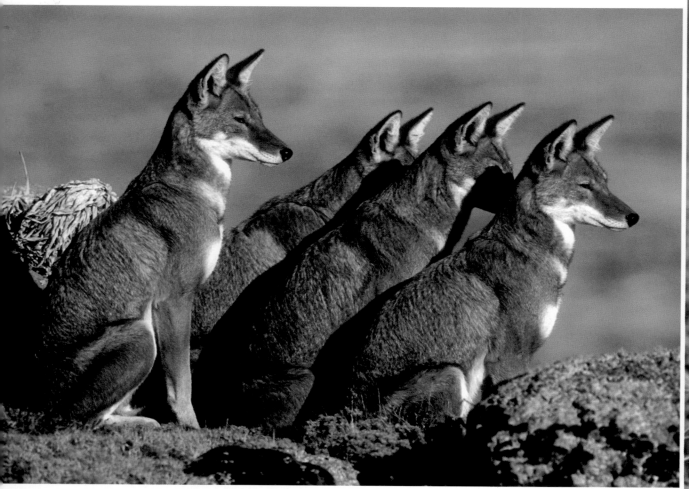

94-95 With pointed ears, fox-like head, and long legs, the Ethiopian or Simian wolf has reddish brown hair on its back, sides, and base of the tail, while its abdomen is white.

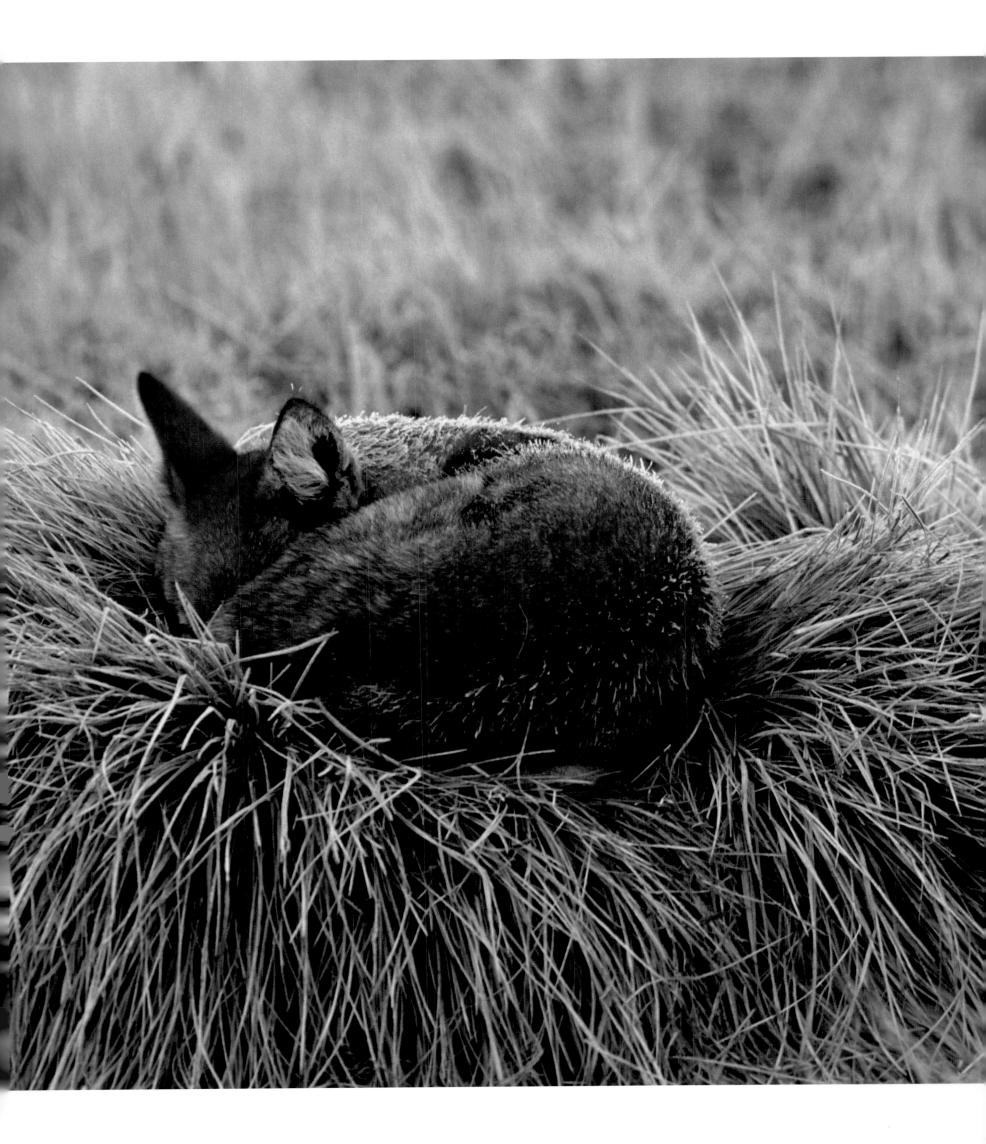

AFRICAN WILD DOG

Lycaon pictus

Received by raucous yelps of welcome, African wild dogs (*Lycaon pictus*) return from the hunt to lairs excavated from the sandy soil. The young surround the arriving adults, pleading for food and the adults feed them by regurgitating what they have killed. Even some of the larger dogs that remain with the litters take part in the meal. African wild dogs demonstrate a complex group life. The social unit of the species is the pack which may include more than 20 specimens. New packs form when the brothers from one litter move away from their original pack and unite with a group of female dogs. In this way, all males are allied by marriage, but not with the females, and all females are also bonded as in-laws, but not with the males. It is estimated that there currently remain not more than 5,000 of this exclusively carnivorous mammal, living in small populations in southern and eastern Africa. Although the species has never been naturally abundant, the range of the African wild dog once included the whole continent of Africa south of the Sahara, occupying the most diverse environments, from semi-arid deserts to forested plains. A pack of African wild dogs occupies a territory ranging from 200 to almost 2,000 square miles (500 to 5,100 sq km), depending on their breeding activity and the availability of prey. While the young are raised in the den for three months, the dogs have a restricted territory that increases when the entire pack is able to lead a nomadic life. Because of their great range, the dogs' territories often do not fall completely within a protected area. Further complicated by the fact that African wild dogs, like cheetahs, frequently occupy regions with a lower density of prey to avoid competing with hyenas and lions, and these areas generally coincide with the peripheral edges of preserves near human settlements. Imminent threats to the destiny of African wild dogs depend in large part on their direct persecution by humans who blame them for preying on domestic livestock. Other dangerous threats include the fragmentation of their habitat, accidental death in hunters' traps, vehicle accidents on roadways, and disease spread by domestic dogs.

EN

96-97 A canid with a similar physique to a hyena, the African wild dog has long legs, and large, wide and rounded ears. It is up to 35.5 inches (90 cm) in length and weighs around 80 lb (36 kg). The African wild dog produces a particularly pungent odor, which some scientists maintain serves as a means of communicating with other members of the pack.

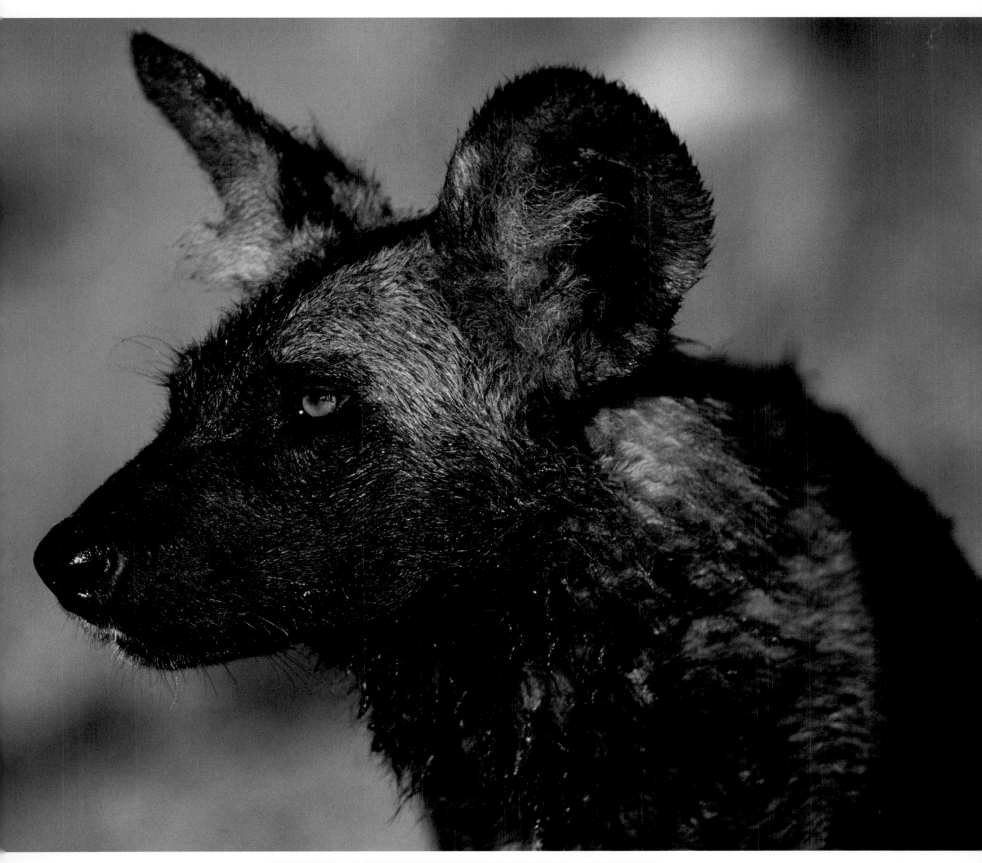

97 bottom African wild dogs are easily recognizable by their coats because the distribution of black, cream, and white spots typical of this species varies and is unique to each individual. Wild dogs in northeastern Africa typically demonstrate a predominance towards darker markings while those in southern Africa have lighter colored spots.

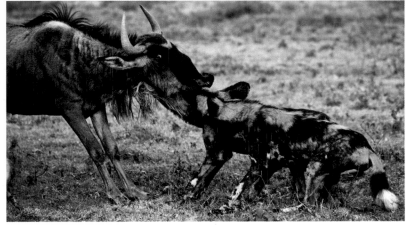

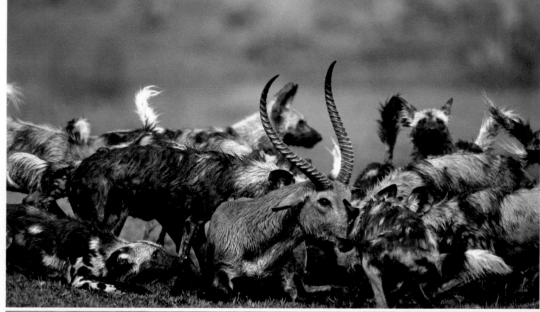

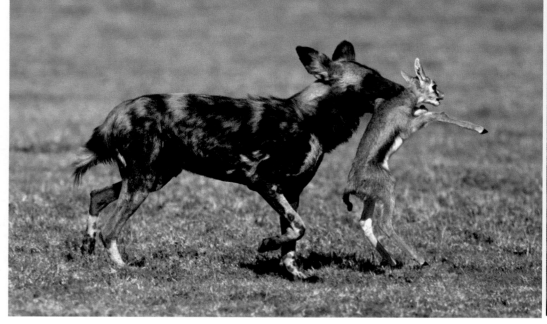

98

AFRICAN WILD DOG

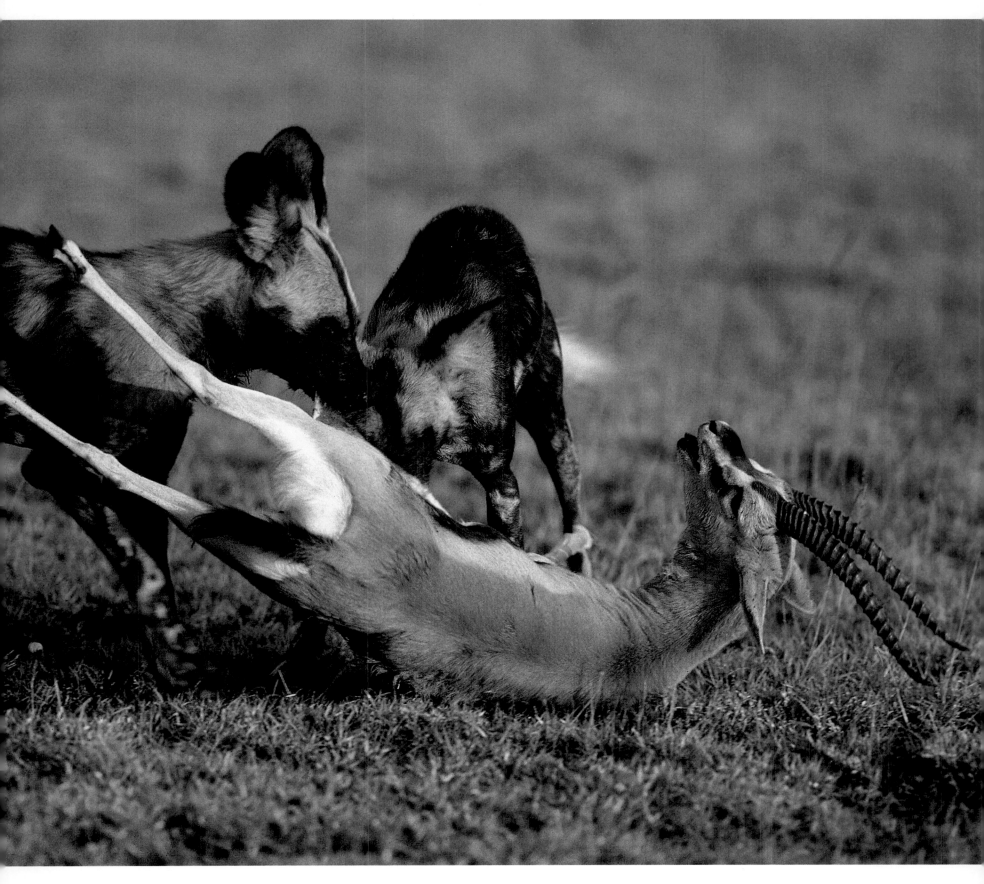

98 and 98-99 African wild dogs are the most efficient of all predators. More than 70 percent of their attacks result in a successful kill, and their prey ranges from a small gazelle to a buffalo. During the hunt, African wild dogs may run at speeds of up to almost 38 mph (60 km/h). In general, when the prey is located, the attack begins and only concludes when it has been cornered by one of the pack. At that point, all the pack members make every effort to knock the prey down and once it is on the ground it is killed.

AMERICA

The geographic region know as the Americas contains a great diversity of environments within which are a stunning variety of habitats supporting a wealth of flora and fauna, which face numerous threats to their existence. In a large part of Canada, some parts of the United States, and the desert areas of Mexico, the density of the human population is still quite low and one can enjoy unspoilt landscapes as far as the eye can see. In other areas, humans have had a greater impact, and small cities and metropolises have taken the place of forests and prairies, and industrial areas alternate with intensive farming. Development in the Americas has been rapid and largely uncontrolled, accompanied by a frenzied exploitation of natural resources resulting in deforestation, pollution, and desertification in many regions. Today, there is a greater sensitivity towards environmental issues and the havoc wreaked in the past occurs less and less frequently. However, there are still numerous problems throughout the continents. The need to conserve many of North America's ecosystems and species is increasingly urgent. For instance, the tundra that provides a home to grasses, peat, dwarfed woody plants, lichen, and habitats of caribou, white bears, wolves, and Arctic foxes is an especially fragile ecosystem that human activity can easily damage. Climatic change and mining activities are now the major threats to this tundra. This is particularly true for Alaska, where the implementation of a proposed oil exploitation plan would inevitably seriously endanger the preservation of one of the few areas in the world still spared the detrimental effects of human greed. Further south, the tundra's squat vegetation gives way to tall coniferous and deciduous forests. In the past, these forests have suffered a drastic decline due to logging for wood and paper products. Thanks to specific laws now protecting the forests, these disasters are no longer occurring today, but the occurrence of fire is increasingly troublesome, particularly along the western coasts of North America. Temperate prairies constitute the typical environment of one of the iconic animals of North American fauna – the American bison or buffalo. The bison and other endemic herbivores have been replaced by domestic livestock almost everywhere and areas not used as pasture have been converted into farmland. In Canada, it is estimated that just two percent of the original prairies are still intact. Human pressures have even affected the cold desert of Chihuahua along the border between the United States and Mexico. Major threats there include livestock breeding as well as excessive removal of water to support increased agriculture and urbanization. Additionally, the intense removal of cacti gravely endangers other species in that region. Problems that plague others parts of Latin America and the Caribbean are due to great poverty among at least one-third of the local populations and the huge imbalance between the immense wealth of natural resources there and the lack of a plan for sustainable management. The Amazon Rainforests are threatened by many factors such as deforestation that triggers a host

of major problems, such as a loss of biodiversity, habitat degradation and fragmentation, modifications in global climate, dysfunction in the hydrological cycle, and serious social impact. It is calculated that a large part of the wood exported from this Amazon region was illegally acquired. A tree with high commercial value, mahogany, was recently included in the CITES Appendices thanks to pressure from the WWF and TRAFFIC because it has been subject to such intense removal that in many countries it has almost disappeared and in some it is now commercially "extinct." Ninety percent of mahogany in today's market comes from Peruvian forests, exported illegally from that region. In general, it is estimated that for every plant removed for commercial purposes, 27 other trees with diameters less than 4 inches (10 cm) suffer damage, more than 131 ft (40 m) of road are created, and a good 6,500 sq ft (600 sq m) of forest are cleared. The construction of new roads and areas available for cultivation and livestock breeding bring new "colonists" into the forest. Soybeans are the most frequently cultivated crop species and their global demand continues to grow rapidly. On average, every European citizen consumes 192 lbs (87 kg) of meat and 250 eggs annually. In order to produce these quantities, 4,306 sq ft (400 sq m) of soybean cultivation are required for breeding the livestock that produce the meat and eggs, in addition to the processing of the soybean oil byproduct, which is also in great demand. Agriculture then requires more fertilizer and pesticides which pollute soil and water. Mining activities that extract ferrous, manganese, and gold materials from rich Amazon sources bring new threats to this ecosystem and conflict with local native communities. Among other things, gold mining requires the use of mercury, a poison that has now been found in fish, an integral link in the food chain that ends with humans. The extraction of gas and petroleum products leads to the construction of large processing plants and pipelines. One of the most dramatic examples of their impact on biodiversity and indigenous populations is the gigantic oil pipeline installed by Texaco in the Ecuadorian region of El Oriente. The "Camisea Natural Gas Project" in Peru is another example of ecological and cultural disaster. This pipeline was built in a fragile ecosystem, which has led to deforestation, decreased quantities of available fish, pollution, and finally to the illness and death of indigenous people coming into contact with gas pipeline workers. Dam construction also alters the forest environment. The Tucuruì Dam in northwestern Brazil has created a lake of about 30,946 sq ft (2,875 sq m), submerging thousands of acres of forest and forcing the relocation of 40,000 people. Threats to the fauna are not solely from the loss of habitat, but also due to the international trade in exotic animals involving intense trafficking of many species, such as the magnificently colored macaws, iguanas as well as the skin of reptiles used to manufacture luxury items. Frequently, sea turtles, sharks, swordfish, and dolphins also accidentally fall victim to or are the intended prey of the fishing industry.

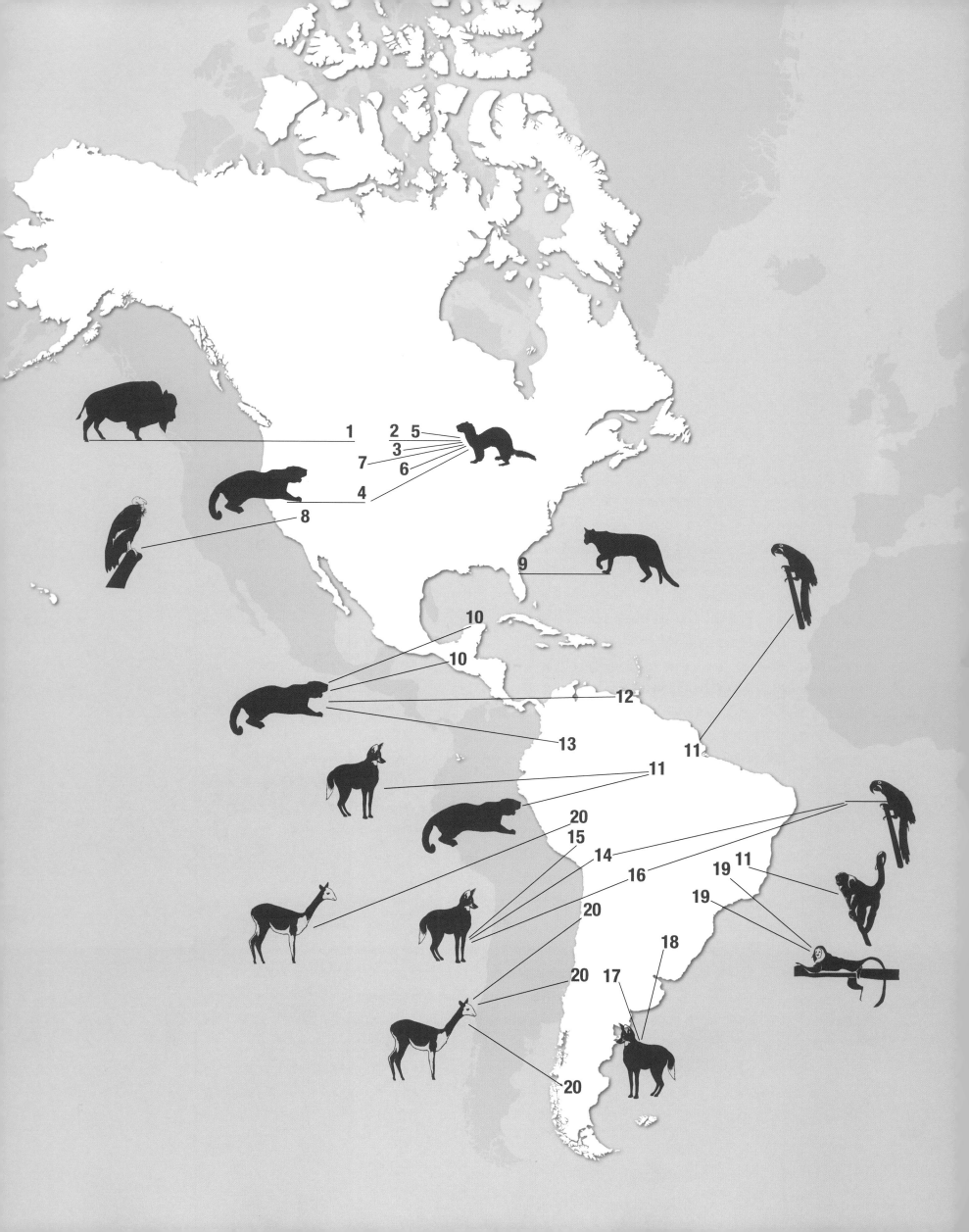

LEGEND

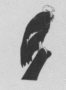

AMERICAN BISON or BUFFALO

Bison bison

The history of the American bison (*Bison bison*) involves its tragic and brutal near extermination and the happier story of its conservation and recovery. In fact, it is estimated that at the beginning of the 19th century some 65 million bison lived on the plains of North America, constituting the cultural foundation of many of the Native American nations, such as the Comanche and the Sioux, who obtained food sources and material for creating shelter, garments, and other everyday objects from these animals. The expansion of European colonies and then the railroad construction resulted in the inhuman strategy of annihilating the indigenous populations in order to obtain their territory so that ranches, farms, towns and so forth could be developed. The bison were exterminated either to force the Native Americans to abandon their lands or because the large herds were blamed for hindering railroad construction work and/or the actual passage of the trains. Uncontrolled hunting also contributed to the declilne, as bison hides were in high demand by the tanneries and were even exported to Europe. In 1890, less than 1,000 bison remained. In 1902, the last wild herd was located in Yellowstone National Park, which included 23 specimens. From this small nucleus and also some semi-domestic bison belonging to private and public organizations, the herds of bison were built up again.

Currently, the entire population of bison is estimated at 500,000, the largest part of which is managed on breeding facilities. It is thought that Yellowstone now has around 3,000 wild bison. Although the species is no longer at risk of extinction and their existence is supported by the Native Americans and by organizations charged with nature conservation, the management of these large animals is complex. Specimens that stray from protected areas are blamed for causing damage to agriculture and for transmitting brucellosis and other diseases to domestic cattle (ironically imported to America by European cattle brought by the colonists). The herds are subjected to selective slaughter for economic reasons and to manage their numbers, which is necessary in part because the ecosystems lack the natural predators of the buffalo. These magnificent animals will probably always require direct and constant supervision by humans in order to survive.

CD

105 The American bison or buffalo is the largest indigenous North American animal species. Males can reach up to 2,000 lb (900 kg) and females about 1,100 lb (500 kg). Its head is large, heavy, and round in shape, enveloped with a very thick dark and downy ruff.

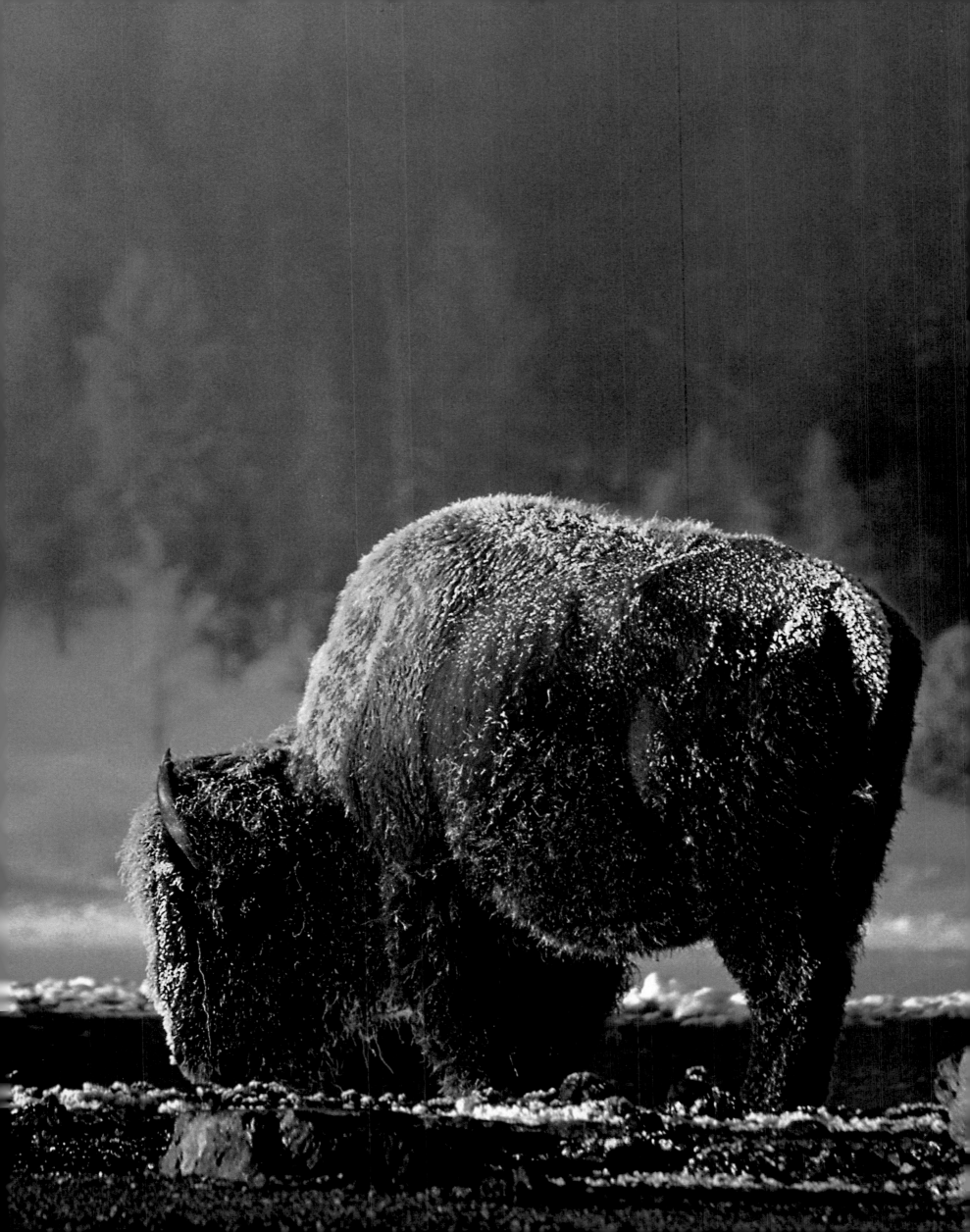

AMERICAN BISON

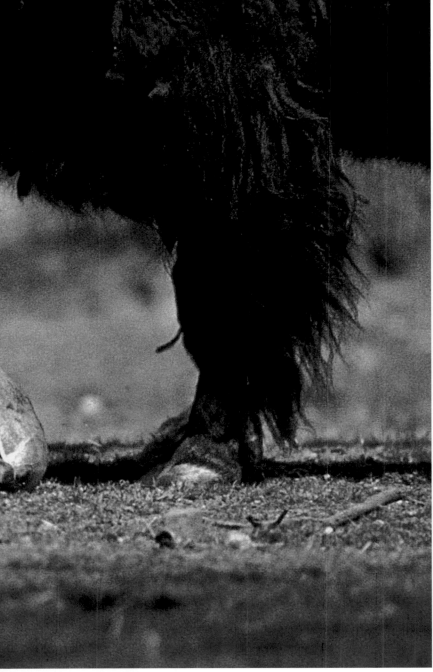

106-107 and 107 top Female American bison live in herds with their calves who are already able to run just a few hours after birth. The males are solitary animals and only join the females during the mating season, forming harems that they defend from other males.

107 bottom The American bison successfully resists the cold of winter thanks to its coat, and must dig through the snow to find food for sustenance. The bison is the natural prey of wolves that occasionally hunt the oldest, youngest, or least healthy specimens.

BLACK-FOOTED FERRET

Mustela nigripes

The survival of the black-footed ferret (*Mustela nigripes*) is at the center of a dispute between conservationists and ranch owners over the usage and management of the North American prairies. In the delicate ecosystem of the prairie, the harmonious relationship between predators and prey is fragile and their populations fluctuate in relation to climatic and environmental conditions, as well as in response to the fateful intervention of humans. The black-footed ferret has been on the verge of extinction several times. It relies on the abundance of prairie dogs which constitute 90 percent of its diet. A decrease in the prairie dog population is due to its indiscriminate persecution by cattle breeders who have long considered it a harmful species, causing damage to the pastureland of domestic livestock. The countless extermination campaigns against the prairie dog have inevitable repercussions on the fortunes of the ferrets who can find no other alternative food sources in cultivated fields. The ferret originally ranged from Canada to Texas and into Arizona, but today only two percent of its habitat remains, fragmented into small pieces, separated by great expanses of cultivated fields and urbanized environments, too disturbing and risky for the ferret's trek for food. It has also been subjected to extensive poisoning and hunting. Considered almost extinct in the 1960s, different ferret specimens were captured for breeding in captivity with the aim of reintroducing them into nature. An initial group of captured specimens died because some were affected by distemper, an illness typically transmitted by domestic animals. Further captures followed and up to 50 ferrets have been captive-bred and returned to the wild population, which still remains protected in seven different conservation sites.

EW

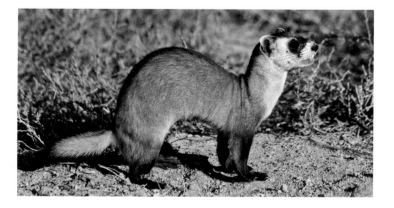

108 and 109 The black-footed ferret is a nocturnal and solitary animal. This species is sexually dimorphic in that the males are larger than the females. A standard adult may reach a length of 24–25 inches (60–63 cm), tail included.

CALIFORNIA CONDOR

Gymnogyps californianus

Fossil remains dating back to the Pleistocene epoch testify to the presence of vultures in all of the continents, except for Australia and Antarctica. However, the first recent description of the California condor (*Gymnogyps californianus*) dates to 1792 when the species was discovered in many parts of North America and Mexico, but since the 1930s it now only nests in California. This drastic decline would be puzzling without an understanding of the vulture's reproductive cycle. It only reaches sexual maturity at six years and lays just one egg every two years, which are characteristics that make it extremely vulnerable. The small number of specimens documented in south-central California were successfully reintroduced through captive breeding programs (the last wild capture for these programs took place in 1987). In fact, at the end of the 1970s, the population was less than 25 individuals. This was too small a number to guarantee the survival of the species in its natural habitat, where the search for food and nesting sites became increasingly difficult due to human encroachment. The extent of the detrimental impact of human activity on the population of California condors was clearly demonstrated by the discovery of a high concentration of DDT and lead in their eggshells, which resulted in smaller eggs that were extreme fragile. Hunting, looting of nests, and poisoning are just some of the factors that, once eliminated, may lower the California condor's mortality rate, assuring that reintroduced specimens will have the opportunity to produce a genetically and demographically vital population.

CR

110 The California condor has black plumage with blue metallic reflections. Its head and neck do not have feathers and are bright orange to reddish in color.

111 The condor has always aroused fascination and curiosity. With a wingspan of almost 10 ft (3 m), it circles in the sky, patrolling large areas for potential sources of food.

VANISHING ANIMALS

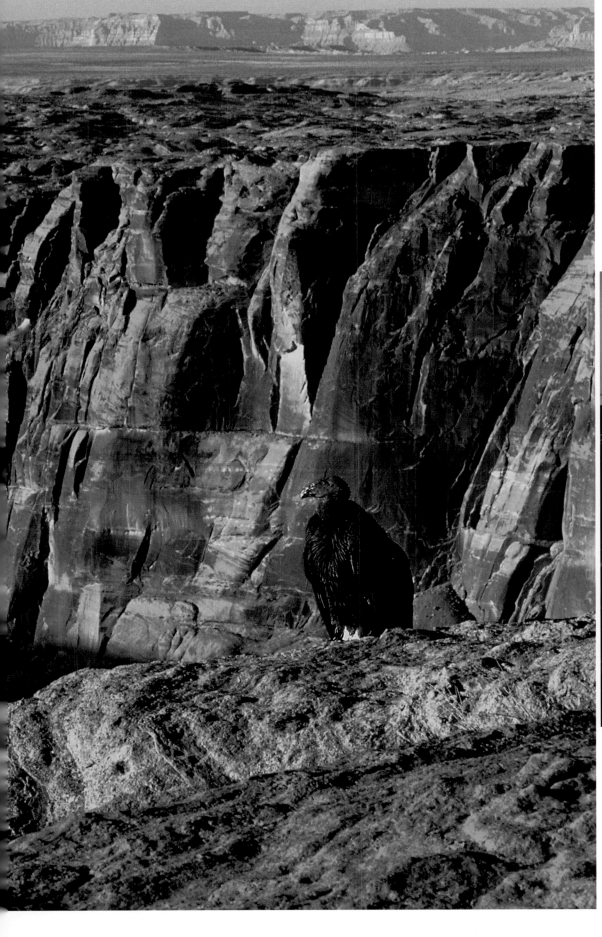

112-113 and 113 The California condor is necrophagous, a carrion eater, searching for and clearing away any animal remains in its territory, which provides a useful service to humans. Unfortunately, humans transformed the condor's food specialty into an extermination tool: in order to eradicate predators (such as coyotes) farmers poison carcasses with strychnine, which inadvertently kills the condors as well.

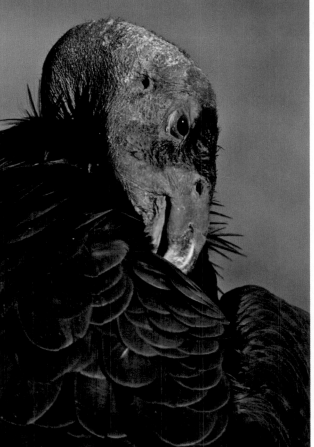

FLORIDA PANTHER

Puma concolor coryi

The Florida panther (*Puma concolor coryi*) or panther, as it is called locally, once occupied a range that extended across the whole of the southeastern region of the United States. By the early decades of the last century it had already disappeared from most of this area. Local livestock breeders hunted the panther as they blamed it for preying on their cattle and posing a danger to people, especially children. In 1950, there only remained a small population in Florida where the species was legally protected and it was then thought to have become extinct until 1973 when one specimen was sighted. Currently, it is estimated that there are only 30 to 40 existing adults, confined within suitable strips of territory, mainly in Everglades National Park and on the Big Cypress National Preserve.

Threats to the survival of this panther subspecies, considered in critical danger of extinction by the IUCN (World Conservation Union), are so many and are not limited to the antipathy felt by the livestock breeders towards the species, but also include the destruction and fragmentation of their original habitat, comprising tropical and arid subtropical forest. The isolation of individuals, interrupting the genetic flow and promoting mating between blood relatives, weakens the capacity of the population to respond to sudden environmental changes and diseases such as rabies, feline HIV, and parasites, especially when carried by domestic cats and dogs that may dangerously intrude into their environments. The lack of prey in the wild, particularly white-tailed deer, and highway accidents constitute further threats to the future of the panther, along with mercury poisoning. The latter is probably caused by the feline's habit of feeding on raccoons and alligators that feed on fish living in mercury-polluted water. Currently, many private associations and governmental bodies do all they can to ensure the survival of the Florida panther through the creation of ecological corridors that favor the relocation of panthers over diverse areas. The monitoring of deer populations, construction of special crossings for fauna under highways, organizing captive breeding programs and reintroductions into the wild all serve to protect this valuable species.

CR

115 The Florida panther is the smallest of western pumas, having legs that are longer than its body, smaller paws, and a shorter coat. Males weigh almost 155 lb (70 kg) and are almost 7 ft (2 m) long. Females weigh 50–110 lb (22–50 kg) and are about 6 ft (1.8 m) long.

114

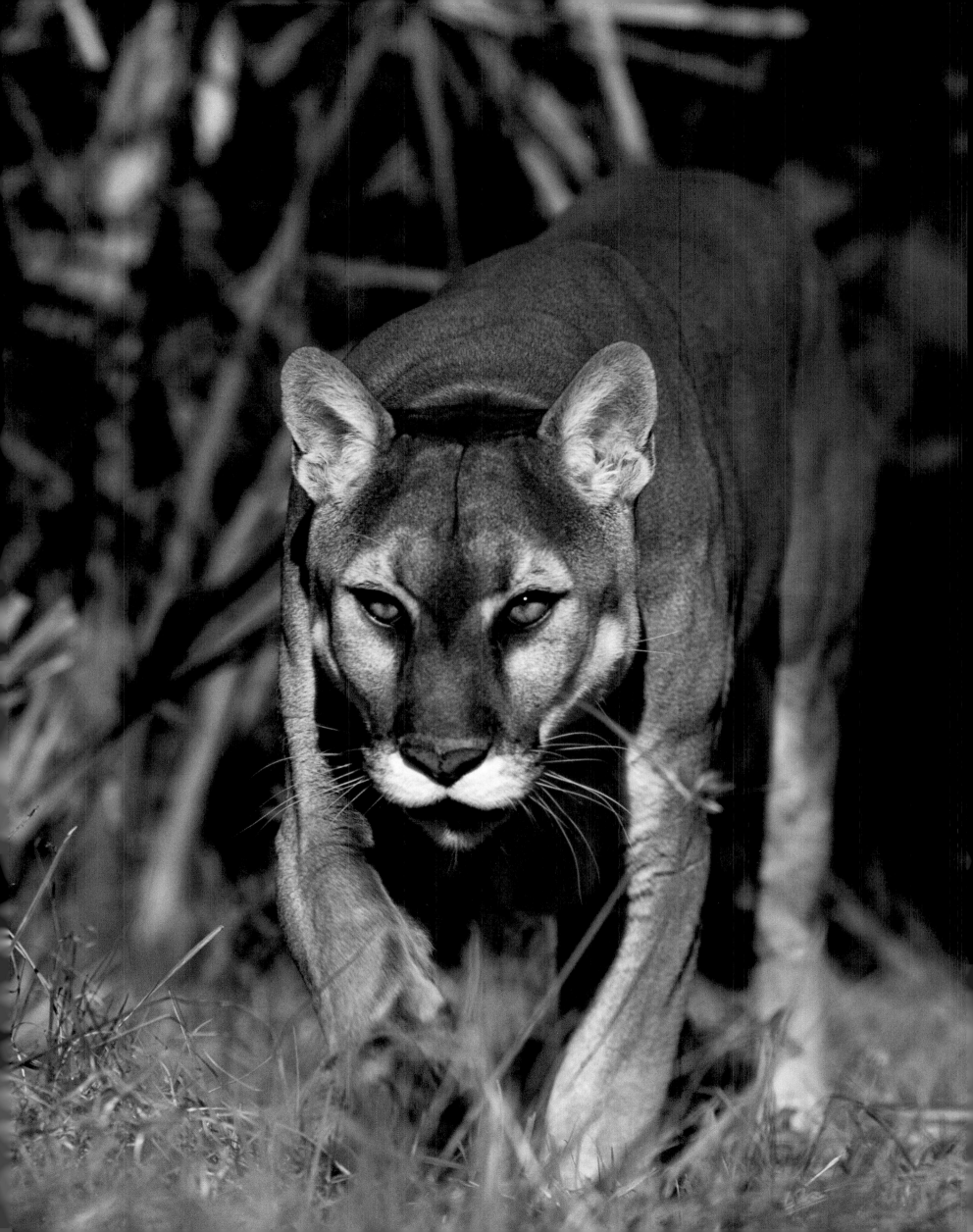

116 The Florida panther prefers to travel and hunt during the cooler times of day. White-tailed deer, wild boar, raccoons, armadillos, small alligators, rodents, and aquatic birds are some of its favorite prey. Its hunting technique is simple but efficient, killing its prey with a quick bite to the throat or base of the neck.

117 A breeding pair of Florida panthers requires an ideal territory of almost 200 sq miles (518 sq km). It is estimated that a stable population of 250 specimens would require an area of almost 12,000 sq miles (31,000 sq km), which is a great challenge for those trying to conserve this species.

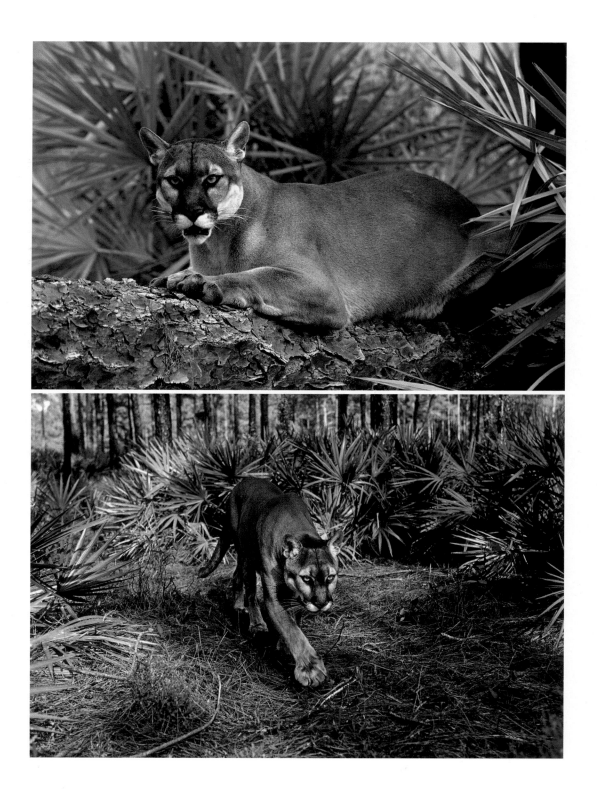

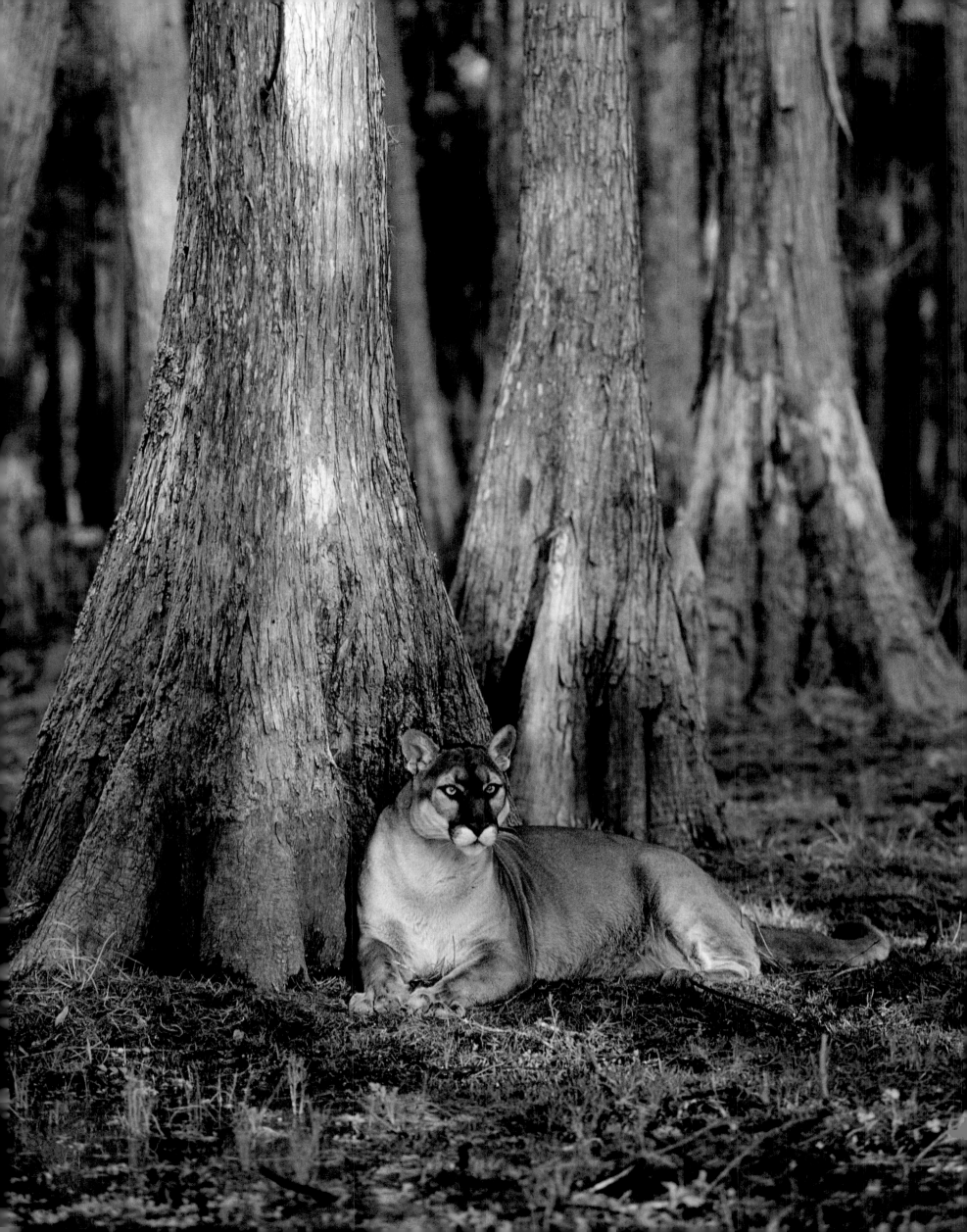

JAGUAR

Panthera onca

From the second half of the last century, the demand for jaguar (*Panthera onca*) pelts used in luxury clothing resulted in the death of about 18,000 specimens each year. In 1975, the jaguar was added to Appendix I of the Convention on International Trade in Endangered Species of Wild Fauna and Flora (CITES). Since then, the largest American feline is no longer subject to hunting for commercial purposes and is protected in most of the countries within its range of distribution. Currently, the jaguar population is estimated at around 50,000 specimens. It is present in South and Central America with only fragmented and reduced populations, and completely extinct in the United States in Arizona, New Mexico, and California. In Mexico, the species lives in mountainous regions, on the Yucatan peninsula, and in Chiapas where one of the last jaguar refuges is located and where the last descendants of the Maya live in the Lacandon Forest, on the border with Belize, who consider the jaguar a symbol of strength and power. Recently, some reports indicated the sporadic presence of jaguars in Arizona where environmental projects are being planned for the reformation of natural corridors that would allow the species to resettle in the region. The jaguar can subsist in a great variety of environments, such as rainforests and the flooded marshes of the Pantanal, pampas prairies, arid deciduous woodlands, and forests with easily accessible sources of water.

Unfortunately, though hunting for commercial purposes has been banned, new threats cloud the future of this species. Areas occupied by jaguars are often surrounded by human settlements and lands converted to pasture for cattle, so the loss and fragmentation of their habitat forces them onto pieces of land that are too small to maintain a viable population. The lack of natural prey, such as deer or tapirs, compels jaguars to attack domestic livestock, mainly cattle, provoking conflict with humans who often kill them. Hunting, absence of controls, and persecution by ranchers all threaten the survival of this species. A symbol of the South American continent and revered by ancient local civilizations, the great challenge in saving this species is to succeed in mitigating existing conflict between the jaguar and cattle owners and to promote coexistence between humans and this magnificent wild cat.

NT

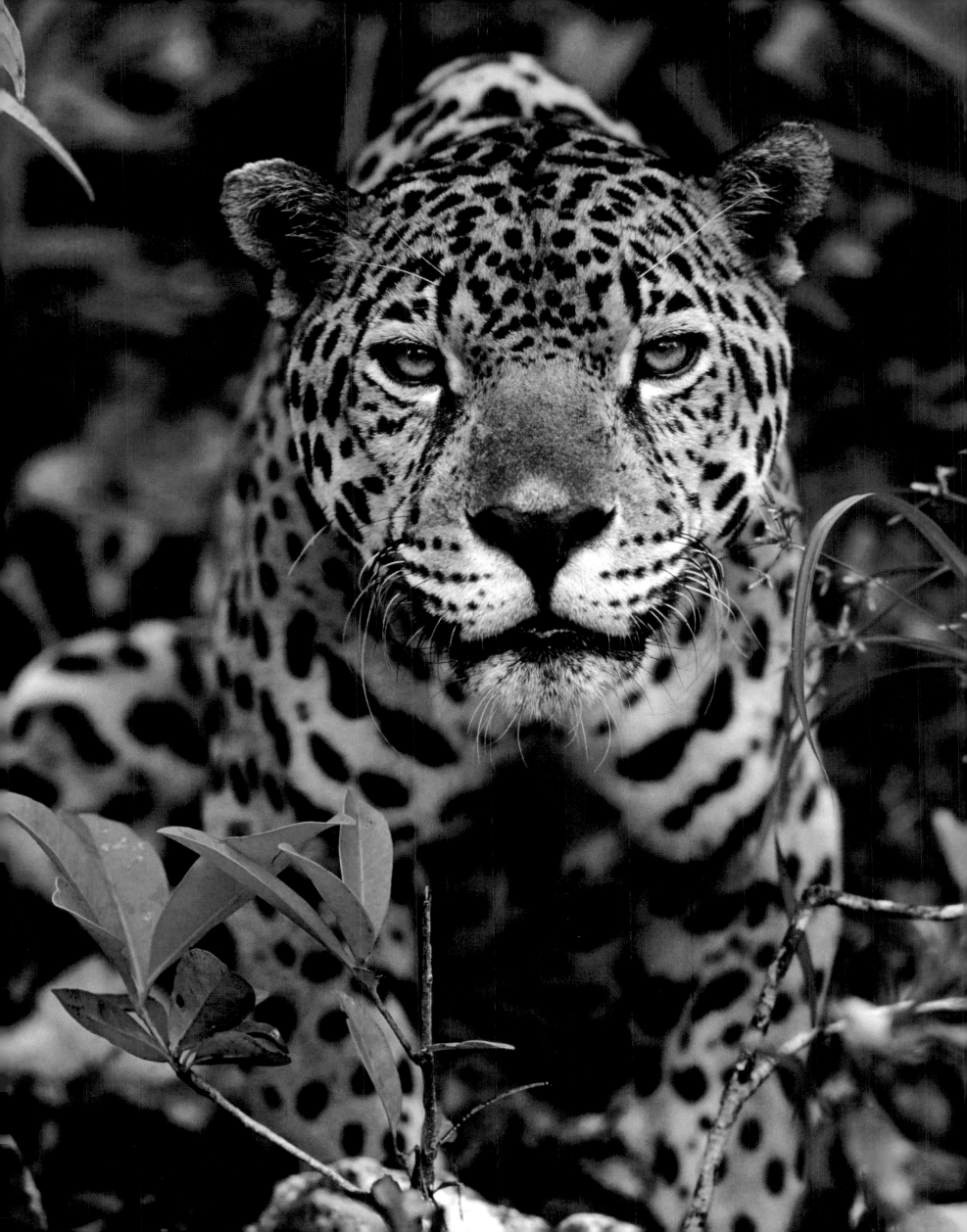

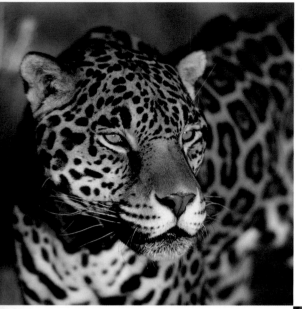

120-121 The jaguar is an opportunistic predator, so much so that up to 85 animal species make up its diet, from the peccary (javelina) to the tapir as well as deer.

122-123 A study based on jaguars in the Pantanal area estimates that at least 1,236 sq miles (3,200 sq km) of consistent space will be necessary to effectively protect a viable population.

118 The jaguar leads a solitary life and finds a mate only during the mating season. The female produces one to four cubs per pregnancy and they remain with their mother until two years of age.

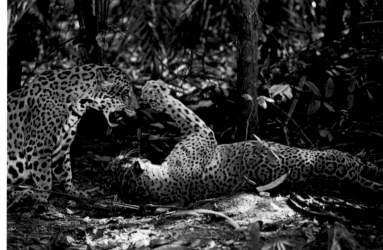

119 The jaguar is the largest American cat, weighing up to 200 lb (90 kg) and reaching almost 7 ft (2 m) in length.

120 top The jaguar's head is quite large and its coat is made up of variously sized washer-shaped spots. At the center of these spots are small black dots, differentiating it from the leopard, which does not have these extra markings.

120 center and bottom Jaguars that live in open environments are larger than those in the forests, probably because of the larger quantities of prey found there.

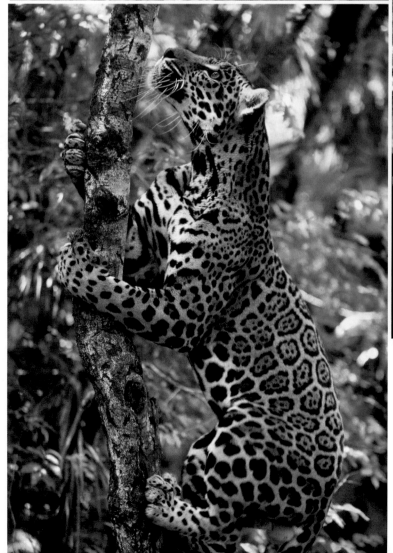

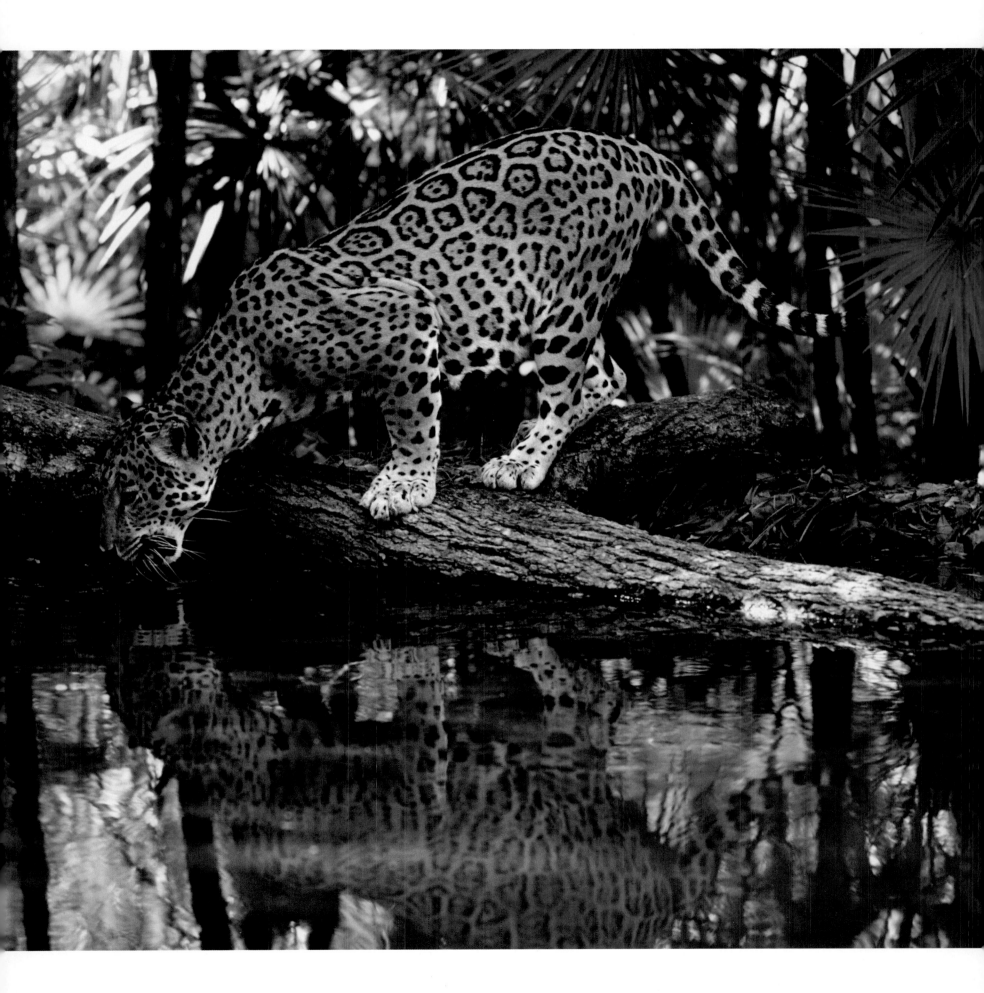

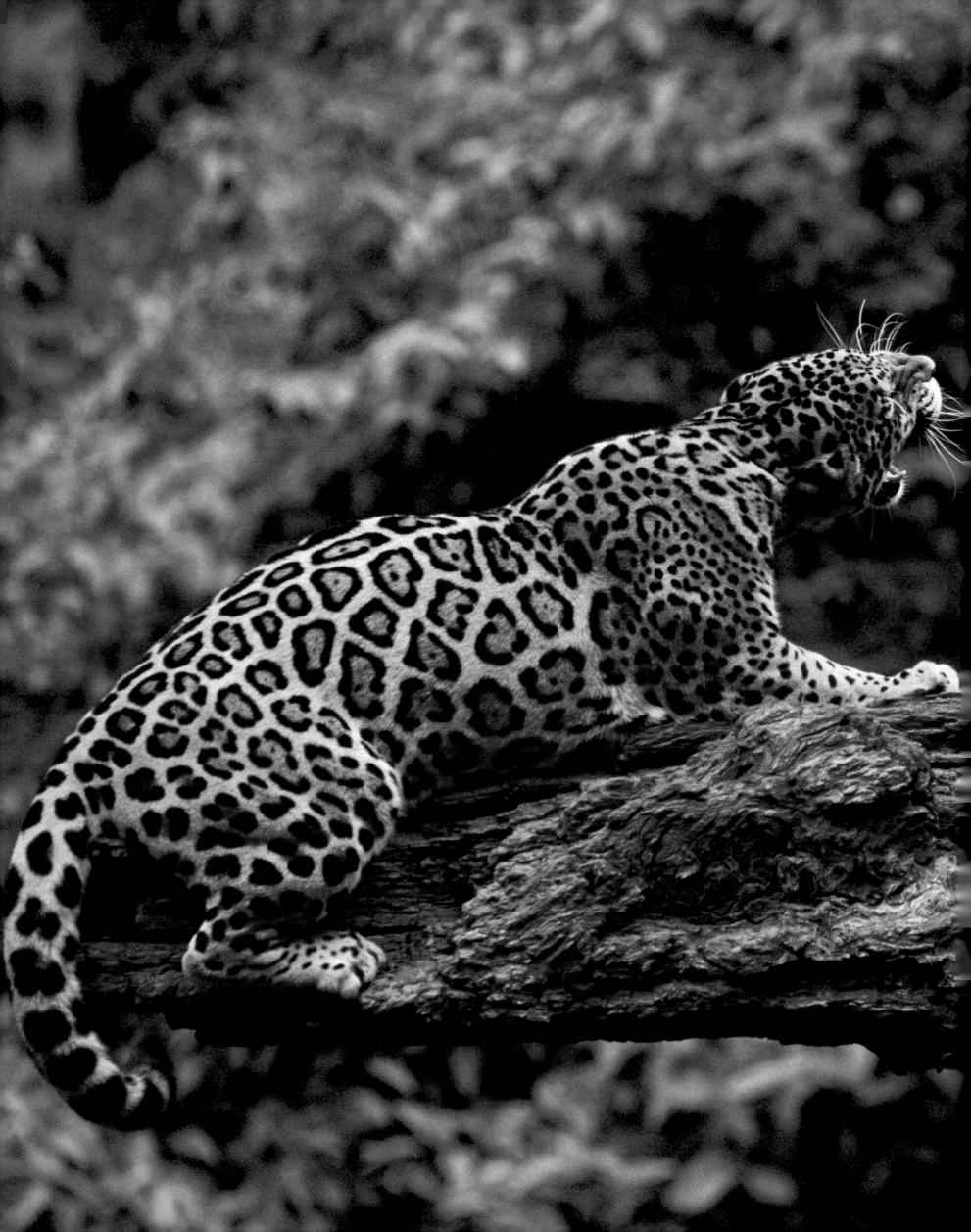

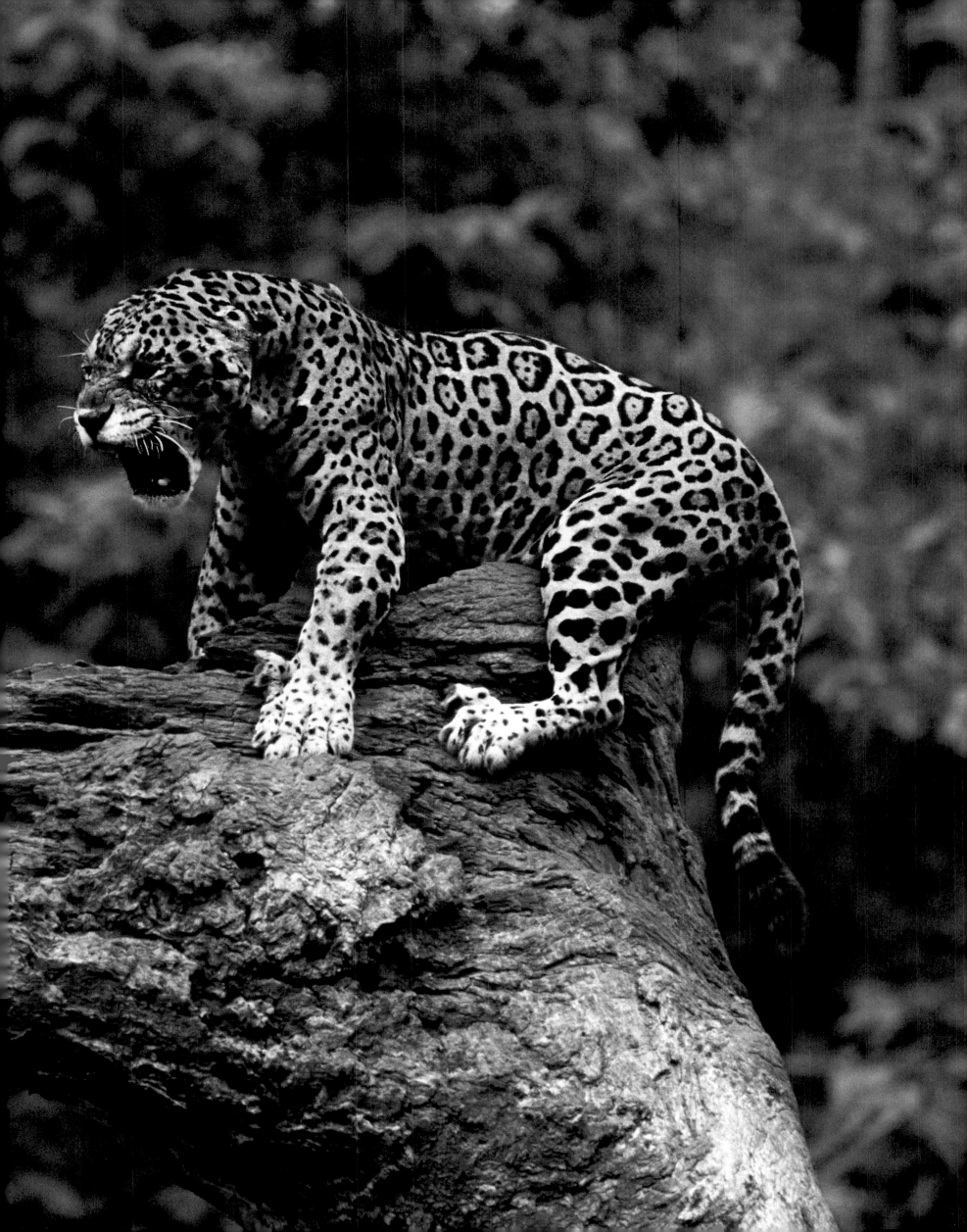

MANED WOLF

Chrysocyon brachyurus

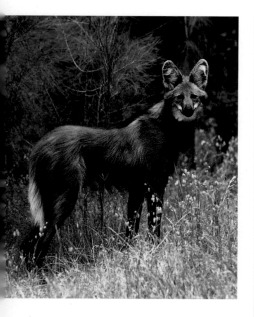

A pair of large pointed ears and two curious dark eyes rise above the high grass, it is the maned wolf (*Chrysocyon brachyurus*) with its long legs and slender physique, advancing into the thick grassy vegetation of the South American prairies hunting for small prey, such as rodents, other mammals, and birds. The maned wolf is a member of the Canidae family but a large part of its diet comprises "wolf fruit" from a solanaceous plant of the nightshade family, which is consumed in great quantities perhaps for its therapeutic effects against a liver parasite that infects them and is considered one of the most serious diseases affecting this species. Maned wolves naturally occur in low densities – where density means the relationship between the number of animals and the surface area they occupy. Despite their ability to occupy a vast array of environments considered common in some areas of central Brazil, the increasing fragmentation and loss of their ideal habitat constitutes a growing threat to the future of this species. It is estimated that 20 percent of the territory once occupied by the *cerrado* (protected) savannah, one of the maned wolf's preferred habitats, was converted into farmland and only I to 1.5% of it falls into the protected category. This habitat fragmentation forces maned wolves into smaller populations where the high rate of close blood relationships leads to genetic impoverishment and increases the risk of extinction. The reduction of its range also pushes maned wolves into contact with human settlements, where they are persecuted because they are blamed for killing domestic poultry. Another major cause of mortality is road kills which cause the loss of about half of their pups in some preserves every year. Additionally, the proximity of maned wolf populations to humans means that the transmission of contagious diseases from domestic dogs is far more likely. And while in most local cultures the maned wolf does not play a particularly important role, some ethnic groups consider that certain body parts are good luck charms or powerful remedies against disease.

NT

124 and 125 The maned wolf is the largest member of the Canidae family in South America and has very long legs that allow it to move with its head above the tall pampas grasses of Argentina, Bolivia, Brazil, Paraguay, and Peru.

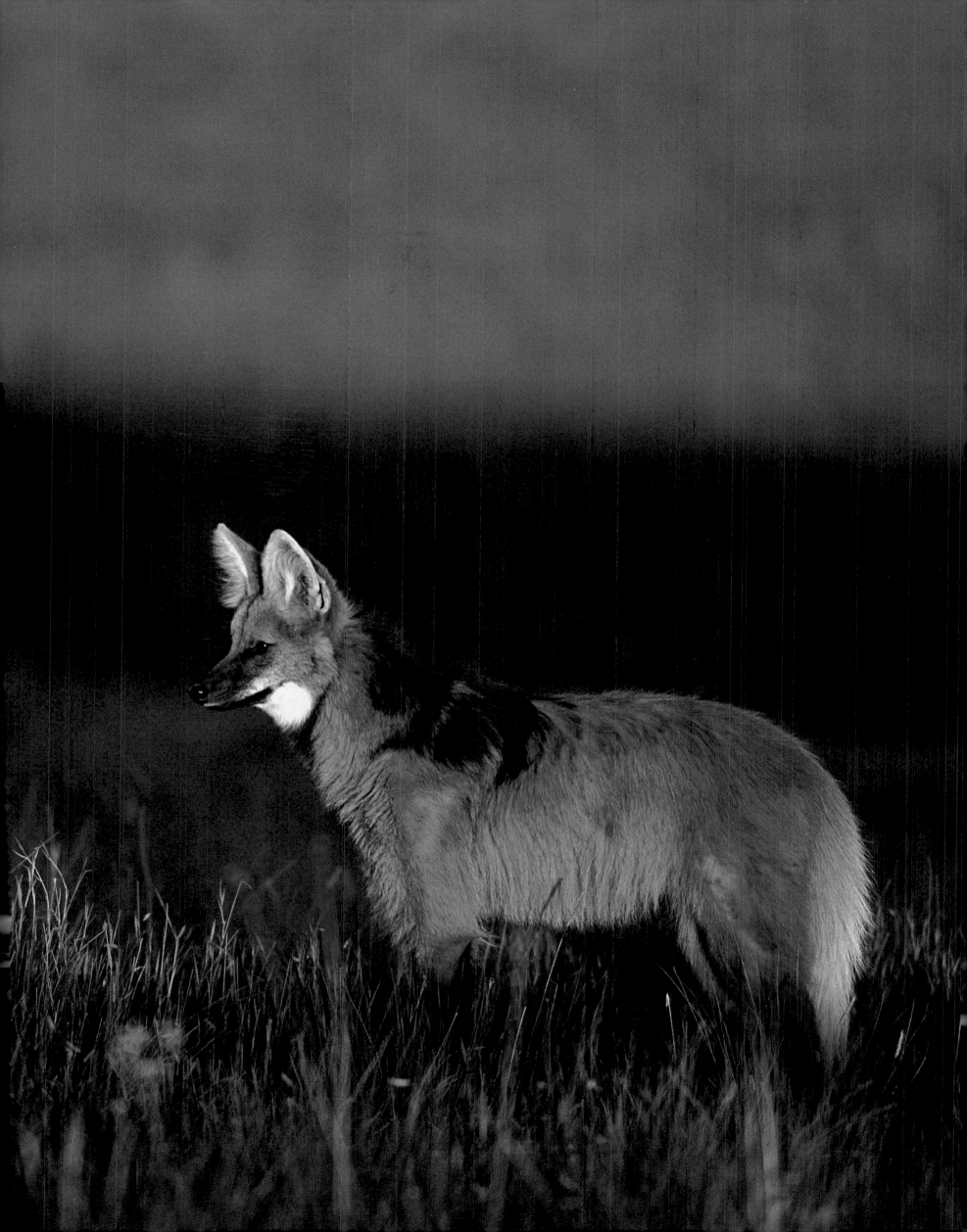

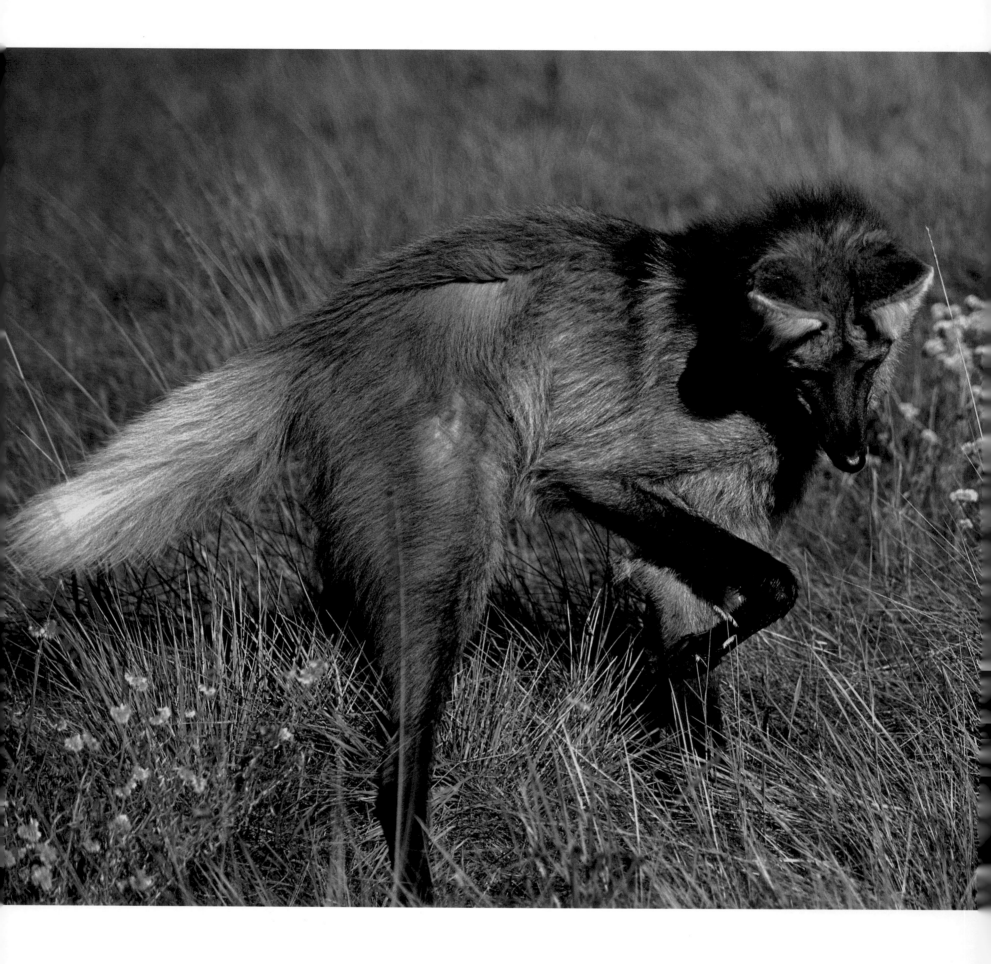

126-127 and 127 Because of its black mane, large eyes, white tail, and rust-colored fur, the maned wolf is not likely to be confused with any other member of the *Canidae* family. The maned wolf is generally a lone hunter and its usual prey are hare, birds, and rodents, but fruit also represents an important component of its diet. It normally spends the day in thick gallery forests and riverbank vegetation, while passing the night moving through open areas.

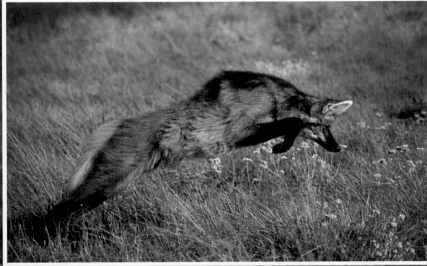

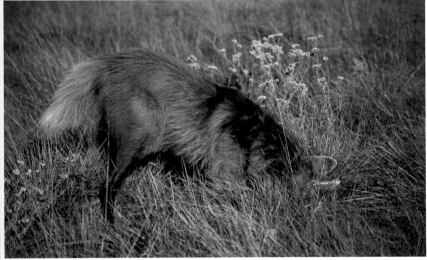

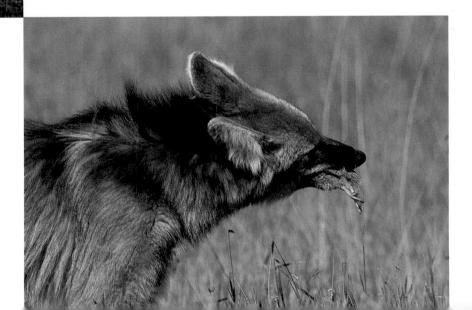

GOLDEN LION TAMARIN

Leontopithecus rosalia

The golden lion tamarin (*Leontopithecus rosalia*) is a small primate with a thick golden red mane around a black face, which is how it got its name. Barely 1 ft (30 cm) tall, this monkey is not the king of the forest where it lives (like its namesake), but is perhaps the symbol of something much more important. It is an example of how a species that seemed destined to disappear off the face of the Earth can make a remarkable recovery and continue to survive. It reached the edge of extinction at the beginning of the 1970s when the population in the wild fell to less than 200, but it is now on the road to recovery thanks to an internationally supported conservation program. Following the extinction alert, a breeding program was immediately set up for the 71 specimens living in zoos throughout the world. In the space of 15 years the population expanded to over 500 monkeys. Together with various partners, the WWF started a reintroduction program that has increased the number of specimens in the wild by 40 percent. In 2001, the birthday of the 1000th female monkey reintroduced into nature was celebrated.

The habitat of the golden lion tamarin is Brazil's Atlantic Forest, one of the most threatened ecosystems on the planet. Once extending over more than 24 million acres (9,700,000 hectares: the size of Egypt), this coastal forest is now only 7% of its original dimension. Because of the destruction of its natural environment, the golden lion tamarin has been inserted onto the IUCN's (World Conservation Union) Red List of endangered species. The fate of the forest is unavoidably connected to the future of this monkey and that of hundreds of other animals that feed on the flowers, berries, and leaves in these rich woods, or that are the prey and food sources of predators such as the puma or jaguar.

EN

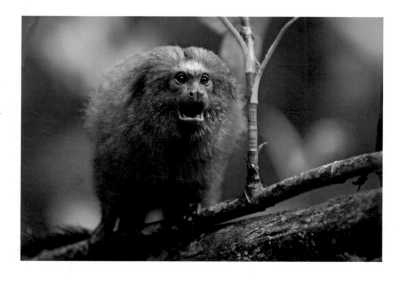

128

128 and 129 The golden lion tamarin may reach a length of 15 inches (38 cm) and a weight of 2.25 lb (1 kg). It is a diurnal animal, lives in trees and feeds on fruit, tree rubber, flowers, insects, and sap. As a rule, it hides in dense forests. The males are among the best fathers in the animal world as they aid females during the birthing process by cutting the umbilical cord with one bite, disposing of the placenta, and seeing to every need of newborn monkeys.

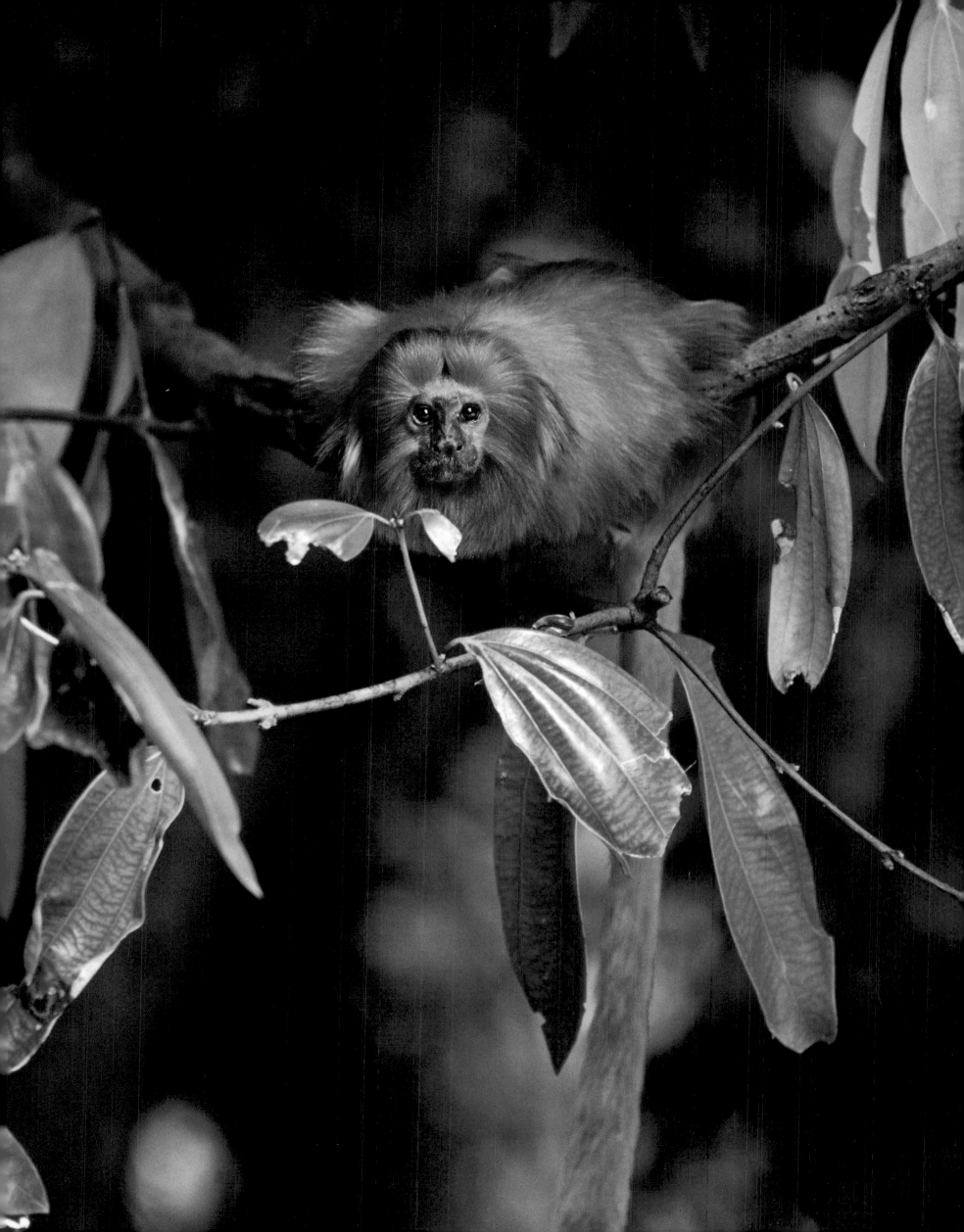

MURIQUI or WOOLLY SPIDER MONKEY

Brachyteles arachnoides

The muriqui (*Brachyteles arachnoides*), also called the woolly spider monkey for its extraordinary agility, is capable of climbing with great skill thanks to its slender body, long limbs, thumbless hands, and prehensile tail. It lives in the Brazilian coastal jungle of Minas Gerais, northwest of Rio de Janeiro. Woolly spider monkeys are among the most agile primates on the planet, using their tails as a true fifth limb and are able to reach almost 200 different types of fruit wherever they grow, even at the tops of the most lofty and delicate branches. Running along branches on four legs, they swing between trees hanging by their hands or tail and can cross gaps over 30 ft (9 m) wide. They generally move in single file in groups of up to 20 individuals. The group leader acts as the trailmaker, going ahead of the others to verify the strength of branches. The woolly spider monkey is the largest monkey in the Americas. It can grow up to 5 ft (1.5 m) tall and weigh 25 lbs (11 kg), its coat is thick and a light tawny color while its face is black.

A team of Brazilian scientists have studied one group of them in depth and have discovered that they are remarkably loquacious, capable of producing 534 phonic sequences. Another idiosyncrasy of these animals is that they do not ever fight, instead they pass their time hugging and cuddling, and the strongest never prevails in a group, rather the most loved does or the one that receives the most hugs from all the others. For this reason, the woolly spider monkey has been called the "monkey of peace." Inextricably linked to the fate of the tropical forest, this species has now been reduced to only about 500 individuals in the wild and is included on the IUCN's (World Conservation Union) Red List of endangered species. The greatest threat to the survival of this species is the destruction of its natural environment – the Brazilian Atlantic Forest.

EN

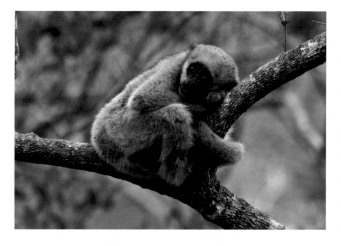

130 and 131 The muriqui, also called the woolly spider monkey for its thick, light tawny-colored coat, lives in the western Amazon rainforest, leads its life mainly in the trees, eating plants, fruit, nuts, seeds, leaves, spiders, and bird eggs. Able to climb with great agility, the muriqui lives hidden within the dense foliage of the rainforests on mountainous plains reaching almost 9,800 ft (3,000 m) in altitude.

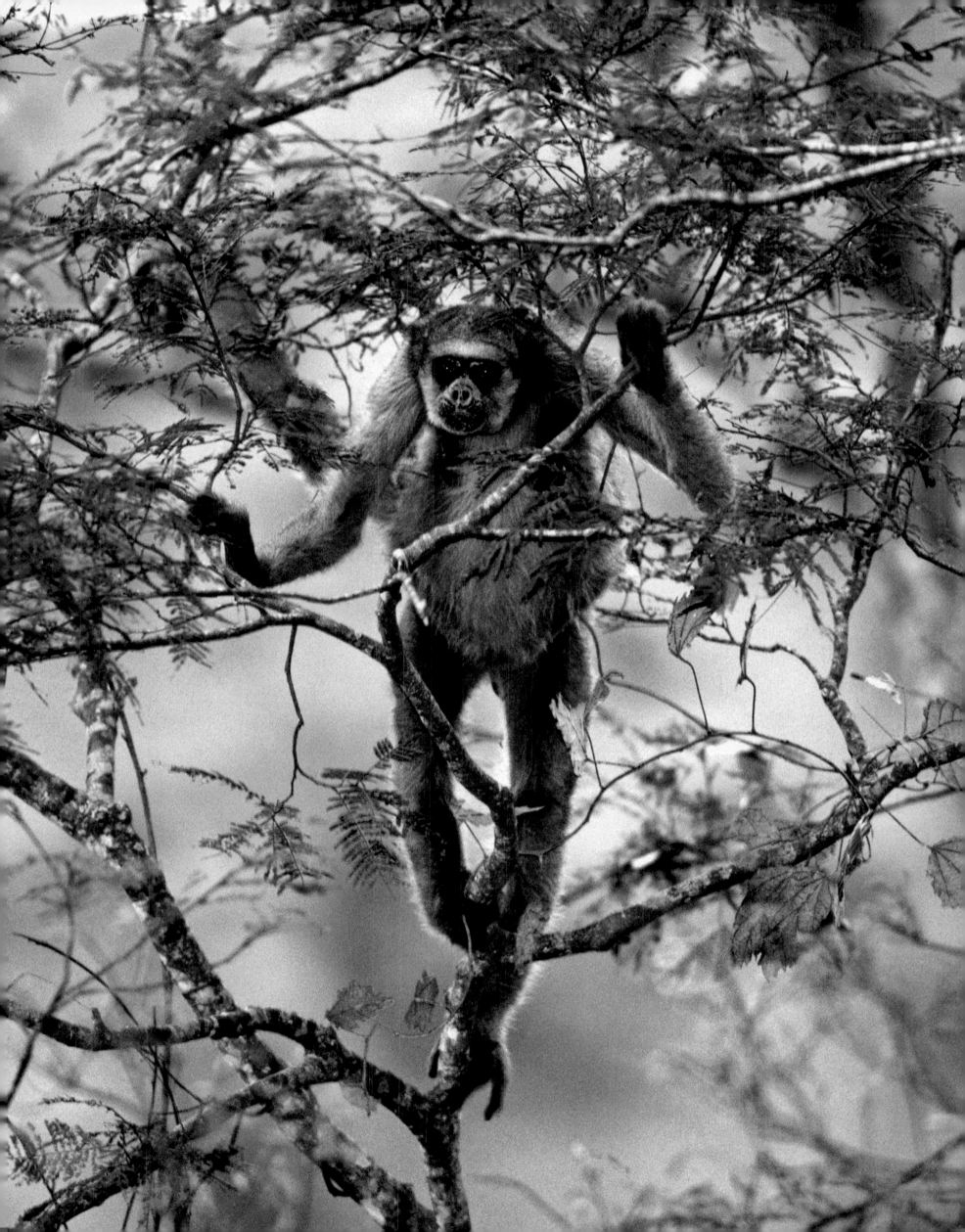

Ecotourism to preserve the rich biodiversity of the Brazilian Atlantic Forest

The Atlantic Forest extends along the southern coast of Brazil and is home to 14 species of primates, almost 25 percent of all primate species on the planet. This eco-region makes Brazil the richest country in the world in terms of primate diversity. Among the species that find their home here, ten are endemic to Brazil and several are on the official list of endangered species. As well as primates, more than 52 percent of existing tree species and 92 percent of amphibians in this region are not found anywhere else in the world. Over time, the Atlantic Forest has become the country's center of agricultural and industrial development, and it contains two-thirds of Brazil's population, for instance, the cities of São Paolo and Rio de Janeiro are in close proximity. Significant development of the region began in the early 20th century and today only seven percent of this coastal forest remains. For decades, the area has been the victim of unsustainable exploitation and its fragmentation, considering the wealth of biodiversity present here, makes it one of the most endangered tropical forests in the world.

The WWF launched huge conservation efforts in 1998 and their anticipated fruition is in 2010. An integrated plan is being implemented that brings many projects together, from pure conservation to the development of economically beneficial activities for the local communities. The aim is to offer an alternative to the short-term exploitation of natural resources and enable, through the conservation of the environment, new positive expectations for sustainable long-term development. Given the country's history and the fascination it holds worldwide, an obvious idea is the development of eco-tourism. In fact, one of the projects provides for the encouragement of eco-tourism in the region of Serra de Paranapiacaba, situated south of São Paolo. An important network of protected areas is located there, comprising three regional parks: the Upper Ribeira State and Tourist Park, the Carlos Botelho State Park, and the Intervales State Park. The project's general objective is to contribute to the conservation of the Atlantic Forest and develop economic alternatives for people living there. It is hoped that this will be achieved thanks to a regional eco-tourism strategy of consolidating protected areas and supporting increased legal protection of the forests, with the involvement of landowners around the protected zones by incentivizing the creation of private protected areas.

THE RESULTS MAY BE SUMMARIZED AS FOLLOWS:

- protection of almost 25 acres (10 hectares) through the establishment of 30 private reserves
- appropriate management of about 1,680 acres (680 hectares) of protected areas
- establishment and protection of 14 forested corridors
- guaranteed protection of primates
- training of 130 instructors in four different sites for the development of educational activities
- organization of commerce and export of organic cocoa to Switzerland
- consolidation of eco-tourism activities in the region

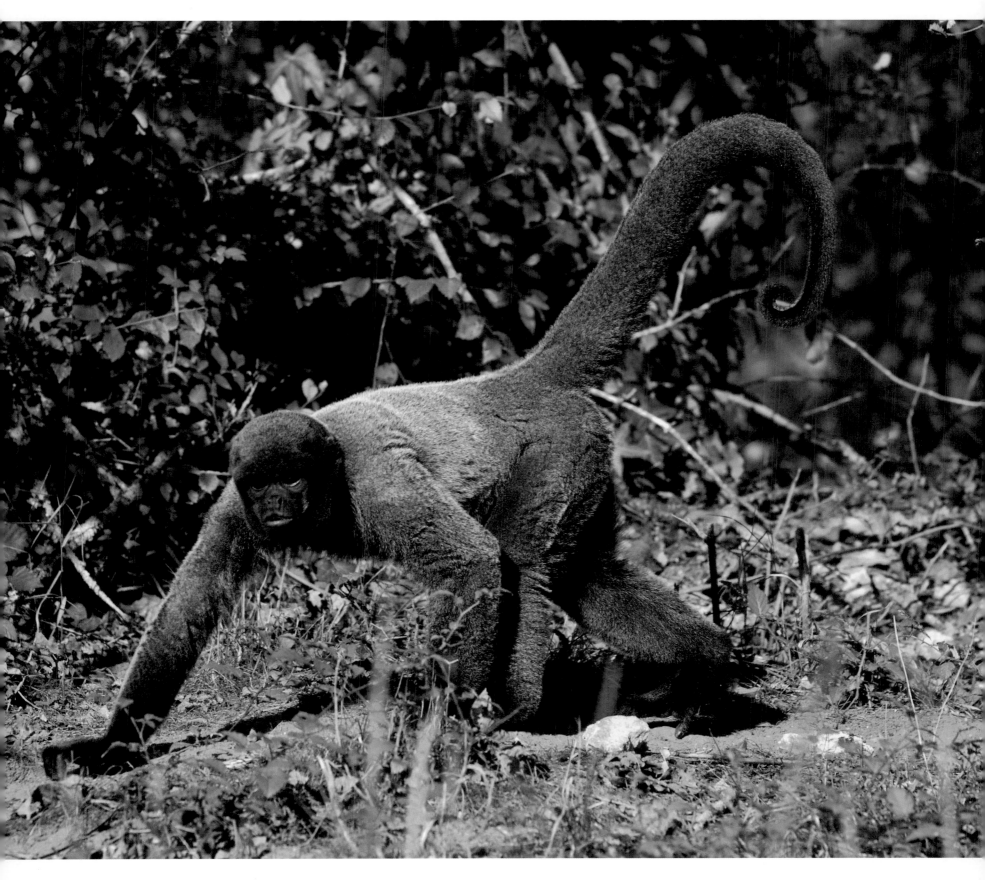

132-133 The muriqui is the largest monkey in the Americas. It is nearly 24 inches (60 cm) long and has a tail that can be up to 33 inches (84 cm) long. The males spend their whole lives in their "families of origin," while the females leave to join a new group when they reach sexual maturity.

VICUÑA

Vicugna vicugna

Spanish and Portuguese conquistadors explored throughout South America in search of gold, silver, and gems, and for any other goods that had value on the European markets. In their pursuit of treasure of any type, they encountered along the way the vicuña (*Vicugna vicugna*) on the high plains of the Andes, which were considered a valuable treasure by the Inca. The vicuña is one of two South American wild Camelidae. The other species is the guanaco (*Lama guanicoe*), an animal used to the harsh climates of the mountainous regions of the Andes from Peru to the southernmost point of Chile. For millennia the guanaco was the real wealth of the many different peoples who lived in those regions. Different from its cousin that ventures south to Navarino Island in the southern extremes of Tierra del Fuego and colonizing territories between sea level and pastures at almost 15,000 ft (4,600 m) altitude, the vicuña inhabits the coldest areas of this world suspended among the clouds, from about 11,800 ft (3,600 m) to more than 16,000 ft (4,880 m) altitude. It has an incredible constitution but a delicate appearance. The Inca always fiercely protected the vicuña from the 10th century to the arrival of the greedy Spanish conquistadors. For millennia before them, all the other peoples that inhabited the rugged Andes Mountains also defended and safeguarded this treasure, shepherding and managing their numbers with great skill and care, only taking slight advantage of the precious gifts the vicuña could provide to help sustain human life at such altitudes. During the so-called *chacos*, ritual hunts in which entire communities participated, at times led by their own emperors, the Inca captured thousands of vicuña, shearing their precious wool and spinning it in a special way, which was perhaps the only fabric emperors would use for clothing at that time. Valuable artistic relics show the capture of animals that were first put into special pens, then sheared, and finally set free. This respectful relationship was broken with the arrival of the Europeans who, hungry for this valuable wool, began to hunt the vicuña relentlessly. By 1553, just a few decades after the arrival of the conquistadors in South America, Pedro Ceza de Leòn, a Spanish historian of that time, wrote "in times past, before the Spanish conquered this kingdom, there was a great quantity of native sheep throughout the mountains and countryside, and a large number of guanaco and vicuña as well, but with their rapid killing by the Spanish, there remain so few that it seems they exist no longer." From then on, the persecution of these animals was continued for centuries and the government officials of countries in the Andes tried to put a stop to their slaughter. The Real Cedula prohibited the killing of vicuña during hunts in 1777 and even General Simon Bolivar, governor of Peru, published two decrees prohibiting vicuña hunting at the beginning of the 1800s. Severe punishment awaited those who violated these laws. However, illegal hunting continued for centuries, substantially changing the vicuña's range of distribution. Because of this, the vicuña lived in incrreasingly isolated populations and the total number of vicuña packs was greatly reduced. From the millions that the Spanish encountered during their conquest, today's vicuña population is estimated at little more than 130,000. A relatively small number when compared to the vast herds of the past, but this is more than double the number of animals which inhabited Peru and neighboring areas in the second half of the 20th century, after centuries of illegal and indiscriminate hunting.

CD

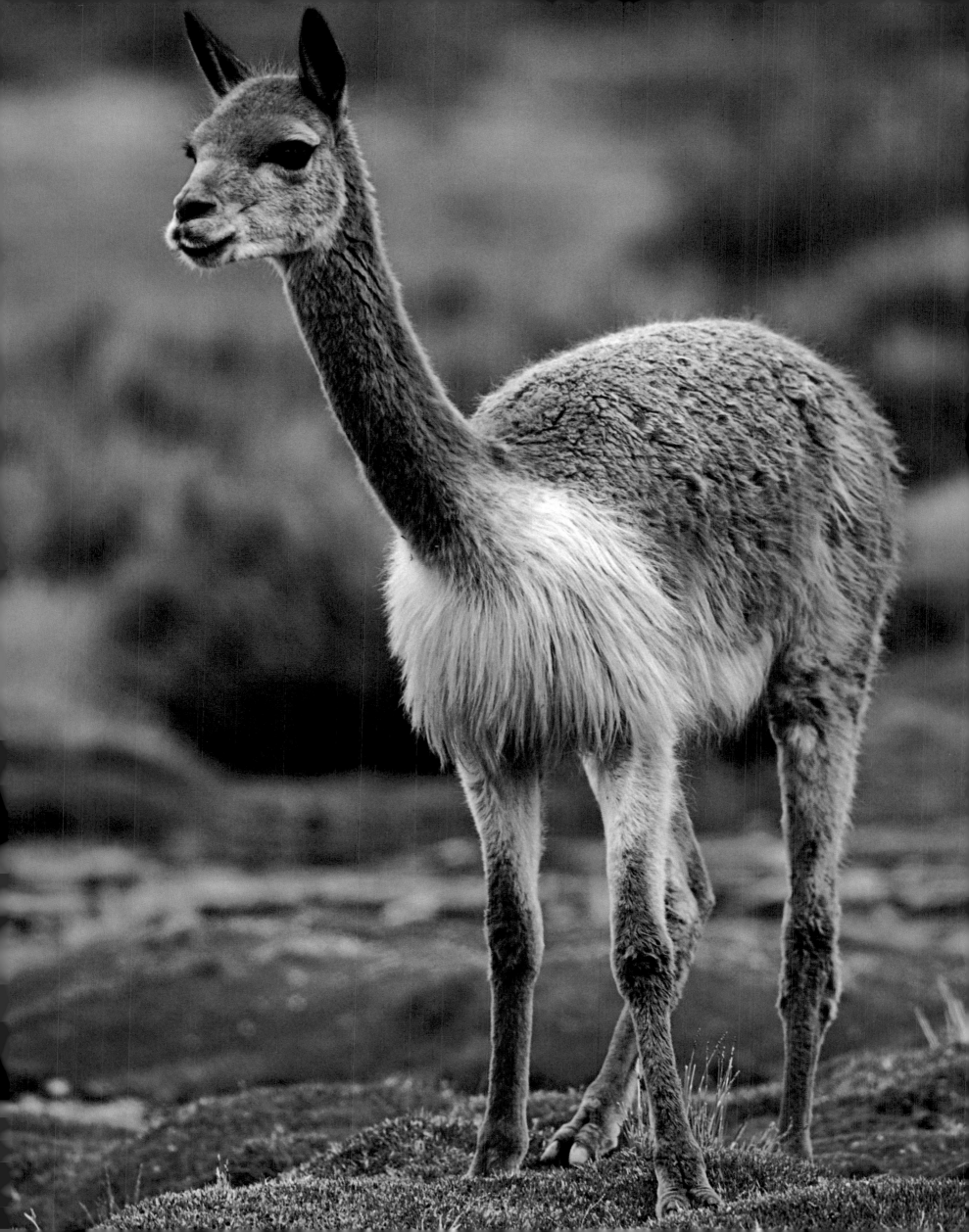

134 and 135 The vicuña is the smallest known member of the Camelidae family. On average it is 5 ft (1.5 m) long, reaches a height of just over 3.25 ft (1 m) at the withers and its weight rarely exceeds 120–133 lb (54–60 kg). Its head, upper part of its neck, back, and thighs are a reddish yellow color, while the lower part of its neck and inside of its legs are ocher-yellow. Its abdomen and chest hair is white and measures just over 5 inches (12 cm) long.

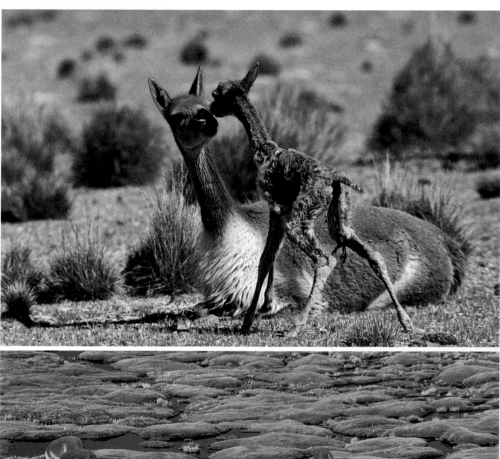

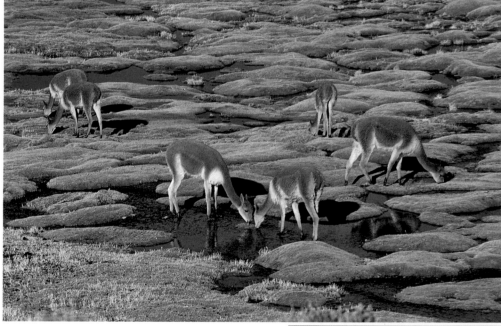

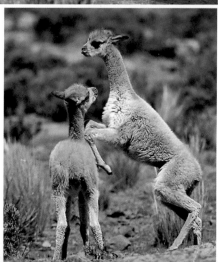

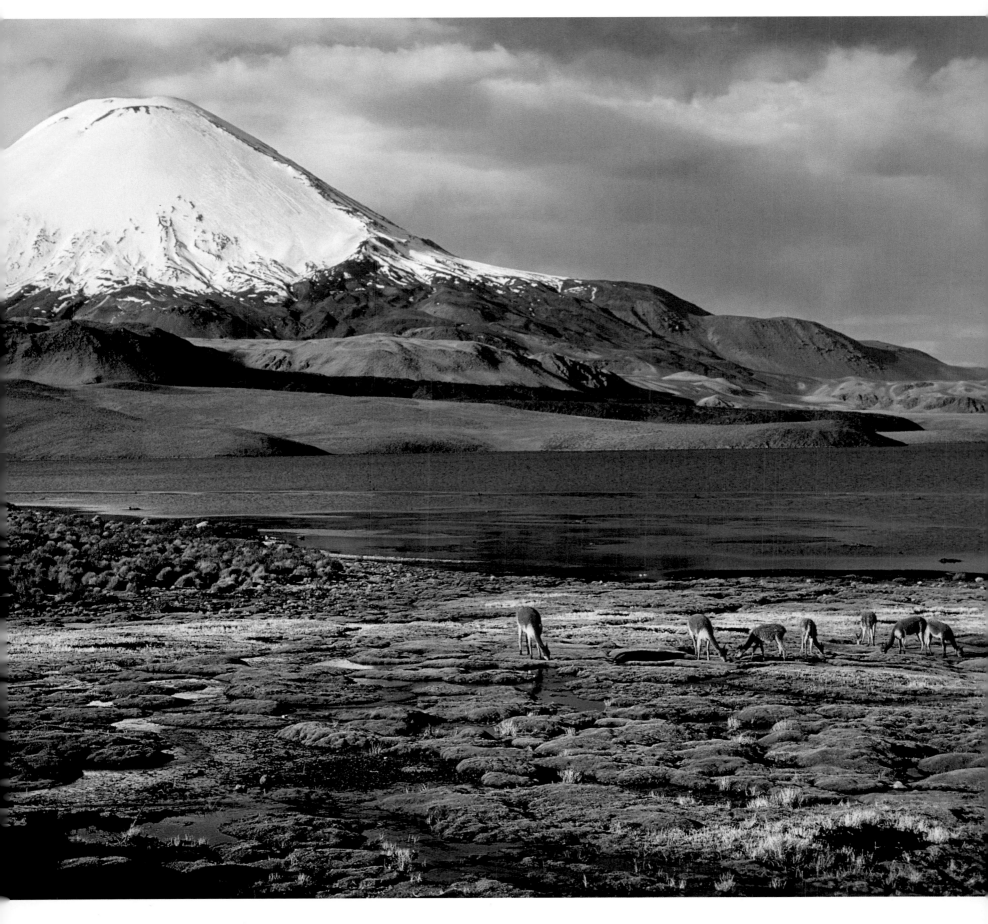

136 The vicuña lives in family groups made up of many individuals. It only descends to the valleys during the hottest seasons, spending the rest of its time on the parallel ridges of the cordillera (mountain ranges).

136-137 A grazing animal, the vicuña is equipped with sharp incisors that grow constantly. Thanks to this special set of teeth, it is able to skillfully bite off the grass on which it feeds.

HYACINTH MACAW

Anodorhynchus hyacinthinus

Cobalt blue is the color of the hyacinth macaw (*Anodorhynchus hyacinthinus*), one of the largest and rarest parrots in the world. The stunning bright blue plumage contrasts with the yellow ring around its eye and spot near its beak. The blue feathers have always been used by indigenous peoples as traditional decorations, but their desirable vibrant blue appeals to many people and led to the capture of 10,000 birds from the wild in the 1980s for sale as pets. Currently, three populations exist, all located in Brazil. One is found in the northeastern bushy savannahs and rocky gorges of the Amazon Rainforest, the second in the southeastern wooded savannahs called *caatinga* and *campo cerrado*, and the third population is in the south-central Brazilian savannahs, which are subject to seasonal flooding from the Pantanal wetlands. This last population also marginally occupies parts of Bolivia and Paraguay. Depending on its environment, the hyacinth macaw nests in natural hollows in the trunks of the largest trees or in clefts of rocky cliff walls. It lays two eggs, but generally only one youngster reaches maturity. Macaws are active in the morning, late afternoon as well as at night, illuminated by the moon. Their preferred food source is coconuts from palm trees such as the *acuri* or the *bocaiuva*. *Acuri* coconuts are so hard that the macaws are unable to feed on them until after they have been digested and excreted by herbivorous mammals. In the areas of their highest concentration, macaws move around in groups of 12 to 20 individuals, among which couples, lone macaws, or those accompanied by the current year's offspring are easily recognized, even in flight. The wild population of hyacinth macaws has endured a drastic decline in the last 30 years, though they have been protected since 1987 by a prohibition of the international trade of this species, sanctioned by CITES. Currently, their total population is estimated at between 2,500 and 10,000. Following a conservation program, the population in the Pantanal region has increased, but throughout their remaining range illegal removal of young from their nests continues to threaten its survival, along with degradation and loss of their ideal habitats caused by the construction of powerful hydroelectricity generating stations in the forest, intensive livestock breeding, and widespread commercial plantations growing exotic plant species.

EN

139 The hyacinth macaw is one of the largest parrots and very long-lived, with some individuals living up to 80 years.

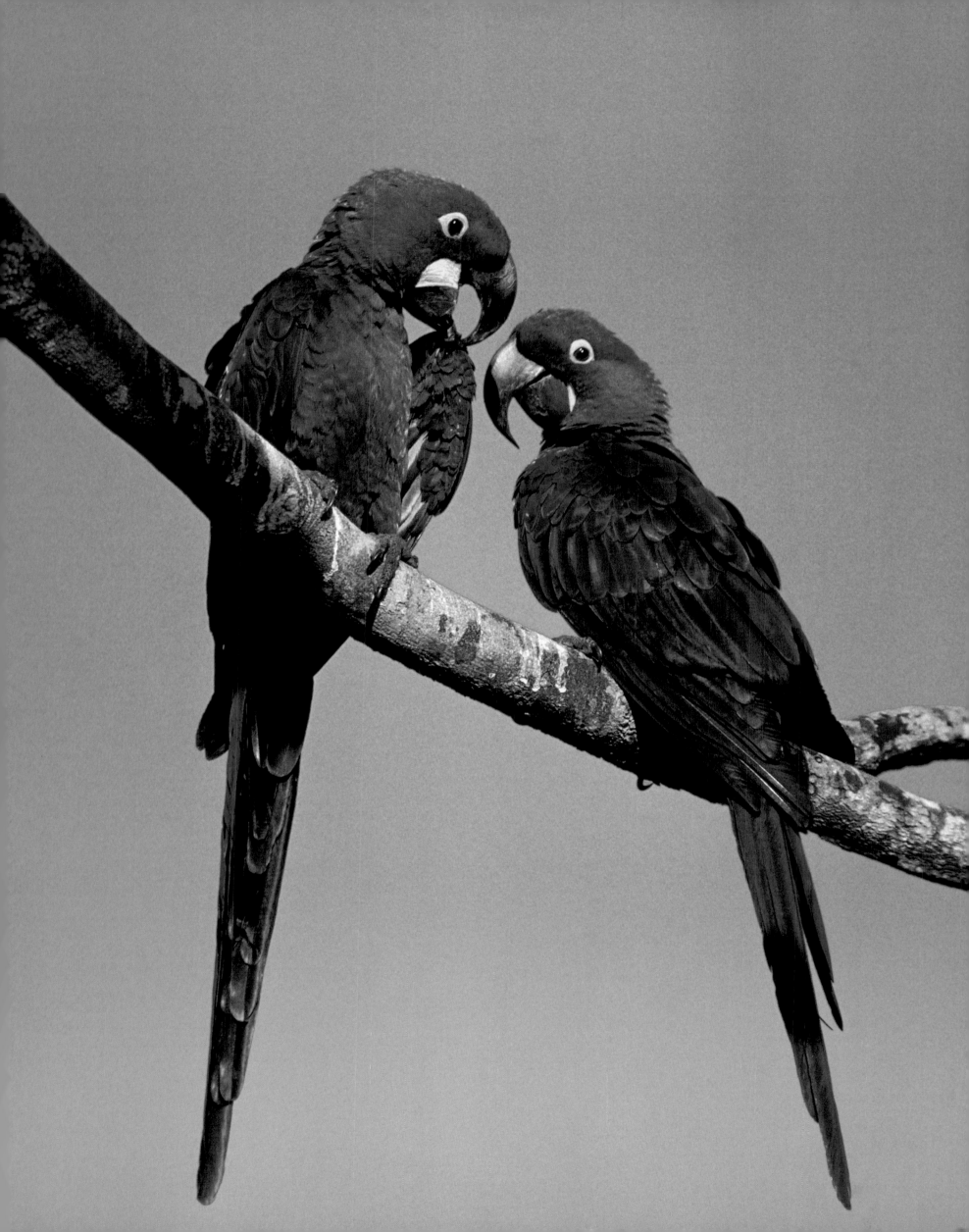

140 The hyacinth macaw can reach up to 3.5 ft (1 m) in length with a wingspan of almost 50 inches (1.3 m) and a weight of almost 3.5 lb (1.6 kg). Its tail is very long, its sturdy beak is dark gray in color. Its plumage is cobalt blue in color, and only the area surrounding its eyes and the base of its mandible (jaw) are colored with bright yellow feathers.

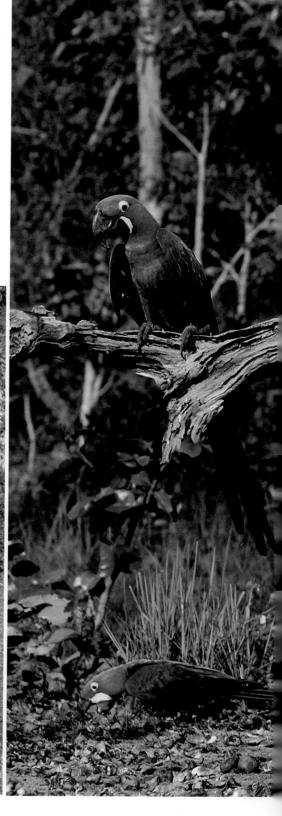

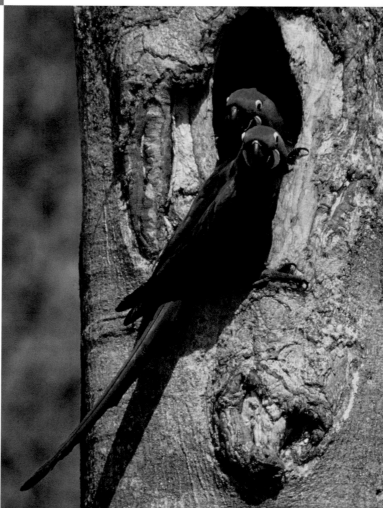

140-141 and 141 bottom The hyacinth macaw is a very social bird. It is generally found in groups of 12 or so. It is one of 23 species of macaw in the world, including the Spix's macaw (*Cyanopsitta spixii*), which is currently extinct in nature. The last three specimens of this species were captured for commercial reasons in 1987 and 1988 and the last male, discovered in the wild in 1990, died in 2000. In captivity, only about 70 specimens still survive.

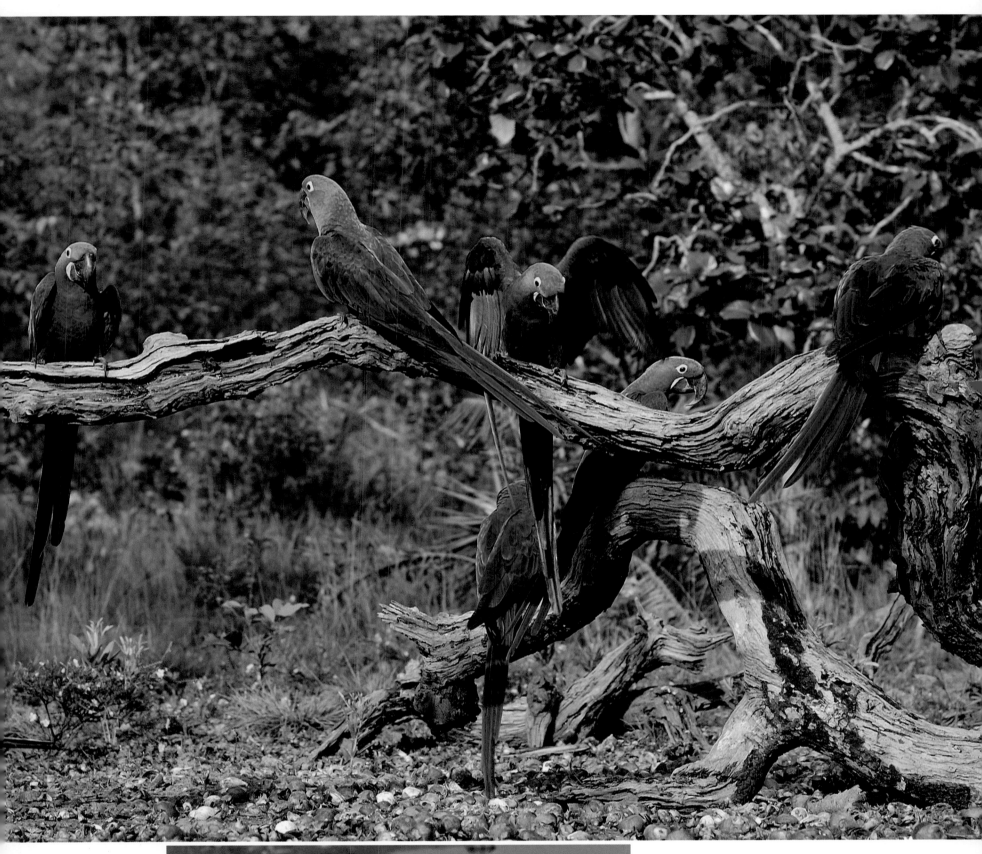

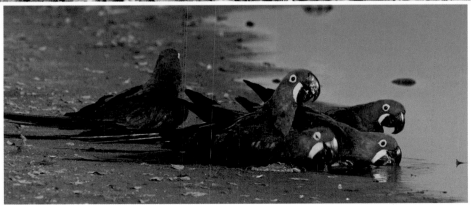

RED-FRONTED MACAW

Ara rubrogenys

The red-fronted macaw (*Ara rubrogenys*) lives in a difficult and hostile environment that has few sources of food. It is an environment that is quite different from the lush jungle habitat commonly associated with colorful and noisy parrots. Endemic to south-central Bolivia, its habitat is dry and arid, punctuated by entire forests of tall saguaro cacti. The red-fronted macaw is found in an area along the Rio Mizque, Rio Grande, and Rio Pilcomayo rivers, with its rocky cliff walls and narrow, often impenetrable valleys. This area is divided between the provinces of Santa Cruz, Cochabamba, and Chuquisaca. A challenging land where resources are so scarce that this species is constantly clashing with humans, for instance, it often feeds on the maize (corn) in the sparsely cultivated fields. Generally, macaws live in natural hollows in the rock, adapted for nesting, from which they make daily long journeys over dozens of miles in search of food. Food, however, that is increasingly in short supply because of the destruction of galleried forest sites along the riverbanks, which are replaced by settlements of people in search of fertile ground and new spaces to cultivate and so drastically altering these already fragile ecosystems. This subsistence agriculture, promoted by local farmers, is robbing the macaw of its few remaining habitats among the sparse forests beside the rivers. These threatened areas are vital to the survival of the red-fronted macaw.

However, even when protected by national or international laws, the red-fronted macaw is still in demand by collectors worldwide, who are ready to pay remarkable sums for a young bird captured illegally in the heart of Bolivia. The poverty of local populations, and scarcity of resources and opportunities, motivates country folk to capture these animals by attracting them to their land with maize cultivation and to then sell them in local markets or to merchants from other countries. Capturing young from their nests was quite a common practice until just a few years ago due to easy access to the rocky cliff walls where red-fronted macaws nest. All of the birds that are found in collections throughout the world share a common, tragic story that begins with capture, followed by a nightmarish journey in restrictive cages on a truck for hundreds of miles to the Sucre or Santa Cruz markets, from there they are dispatched to their final destinations around the world. The battle that the Bolivian environmental organizations face today in order to protect the red-fronted macaw can be won if they and ornithologists, who want to observe it in its own environment, succeed in finding a new source of income for the local populations, and then this beautiful bird will survive for future generations to enjoy.

EN

142 and 143 The red-fronted macaw reaches almost 2 ft (60 cm) in height and is another long-lived parrot, often living for up to 50 years.

ASIA

Asia encompasses a fantastic multiplicity of languages, cultures, customs, and peoples. It is a vast continent with countless facets of diversity, containing both some of the poorest economies and also some of the most rapidly developing ones that are perhaps the true inheritors of the 21st century. Asia is the largest continent in the world and has the highest mountains, the Himalayas, where humans can try to touch the sky, and some of the largest expanses of grasslands and deserts, such as the evocative Gobi desert. It also contains many tropical islands, full of life and color and home to an invaluable wealth of biodiversity, representing a great treasure to be protected. The tiger once roamed across vast areas of this continent, from the shores of the Caspian Sea to the small island of Bali, linking many diverse cultures and communities. The enormous mountain systems of Asia are home to the snow leopard, the big cat that moves stealthily over steep slopes hunting goral, tahr, markhor, and yaks in a land of eternal snow. In the heart of southwestern China's bamboo forests, the giant panda steps forward as a the worldwide symbol of conservation. Indeed, China itself exemplifies the struggle between balancing the demands of progress with the needs of conservation.

The exceptional number of plant and animal species found in Asia make it one of the great repositories of biodiversity for the entire planet. A biodiversity, however, that is seriously threatened by the systematic destruction of the habitats, by the uncontrolled economic growth of various countries, and by the consequent increase in consumption of natural resources and increased levels of pollution. From the tropical forests of Malaysia and Indonesia to the icy cold forests of Siberia, deforestation represents a particularly serious problem for the whole continent. If the situation does not change, in a just a few years

Sumatra, Thailand, and Laos are endanger of losing over three-quarters of their original forests. This is a crisis that could lead to a catastrophic ecological disaster, as this region is home to one of the highest concentrations of endemic species on the planet. Deforestation also affects other types of habitat, such as flooded forests, mangrove, and arid forests. All of which are facing similar problems of clearance and destruction. Forest loss threatens not just species biodiversity, but it also puts humans at serious risk as we lose the natural resoucres that are necessary for a healthy planet. Also, many local populations still rely on the forests for all of their basic needs, such as food, materials for everyday objects and for construction, and fuel for cooking and heating their homes.

Unfortunately, there is only a limited network of protected areas which cover just a small part of Asia's natural wealth. Often the protection is only in writing because governments and local authorities do not have the means to manage properly the officially designated conservation areas. The small territories that are managed effectively may not guarantee the survival of many endangered species, such as the tiger, elephant, snow leopard, Indian rhinoceros, Sumatran rhinoceros, and Javan rhinoceros, because they require large, undisturbed areas. While various species of gibbons, douc langur, Bornean and Sumatran orangutans, and many other animals are defenseless against the attacks of poachers, animal brokers, or Asian alchemists who carelessly decimate populations in the pursuit of profit. In general, illegal removal of timber, conversion to cultivated fields and plantations, mining activities, and bad management of natural resources are compromising and jeopardizing the existence of these supposedly protected areas, the loss of which which would compromise and jeopardize our own existence.

145

5
12 6
11
1
9

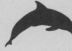

4

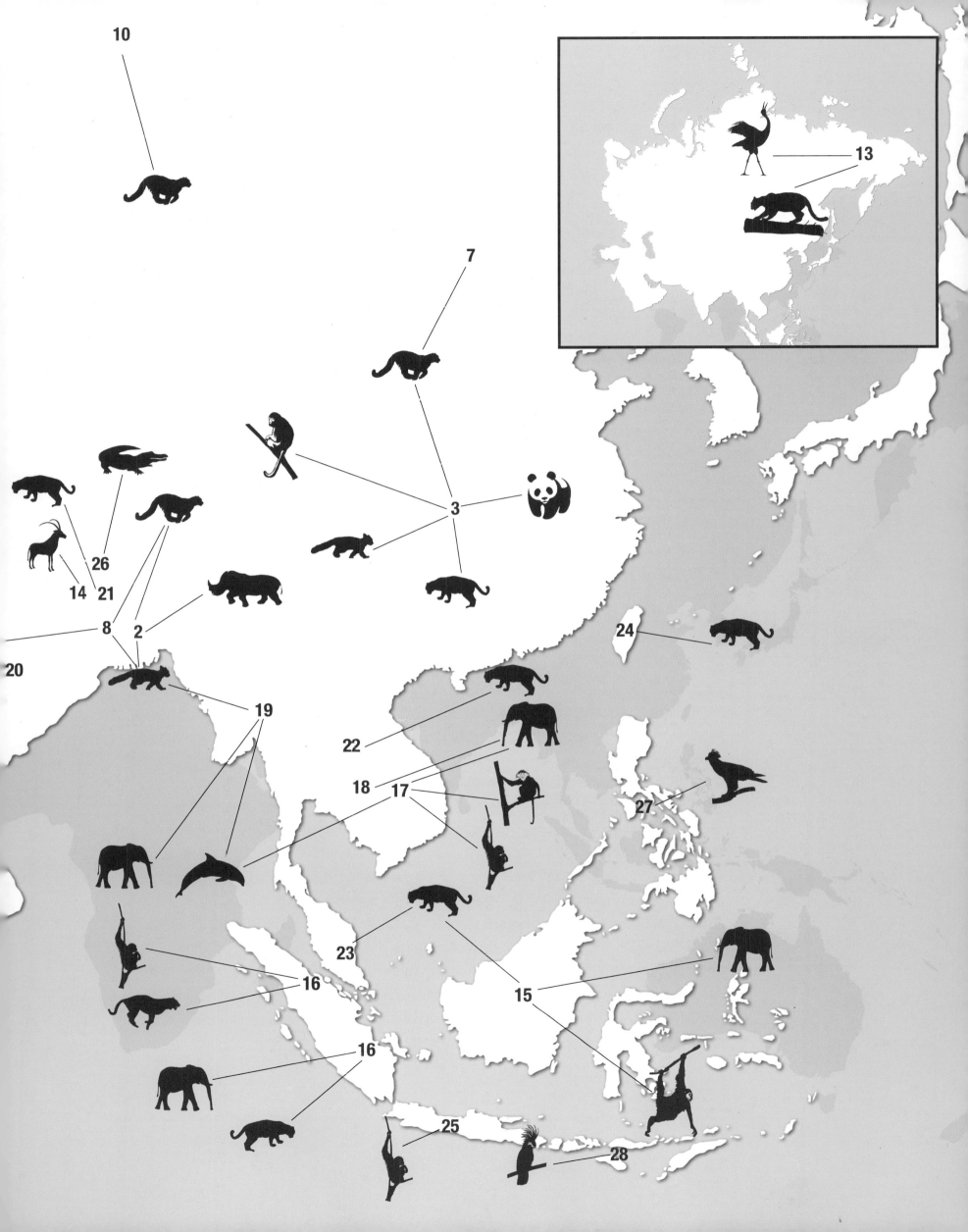

SNOW LEOPARD

Uncia uncia

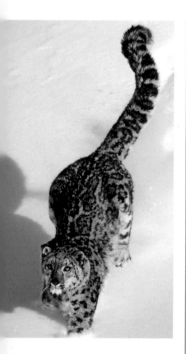

Shy and reserved like few others of its kind, the continued existence of the snow leopard (*Uncia uncia*) is at risk due to general indifference as a result of a lack of familiarity or recognition by the general public. It is less popular than other large and more charismatic cats and lives in one of the least hospitable regions of the world, a bleak land of eternal ice and snow. The snow leopard was discovered at the beginning of the last century when explorers began to catch glimpses of its coat, then its paw prints, and finally the snow leopard itself in all its beauty, with its regal air and graceful feline movement. As elusive then as it still is today its appearances were enveloped with an aura of mystery which continues to surround what we know about this species. The snow leopard lives, though perhaps in many cases it is more accurate to say lived, in a vast area of central Asia (Afghanistan, Bhutan, China, India, Kazakhstan, Kirghizistan, Mongolia, Nepal, Pakistan, the Russia, Tajikistan, Uzbekistan) at the edges of the perennial snowline between about 4,900 ft (1,500 m) and 19,600 ft (5,900 m), in some of the most hostile regions on the planet where survival is a question of strength and tenacity. Its total population has been reduced to between 4,300 and 7,200 specimens, which are few considering the territory it inhabits and could still potentially inhabit today if humans were not steadily reducing its habitat day after day, forcing it into increasingly marginal areas.

This great predator has few natural enemies but humans pose an ever-increasing threat to its survival. Although the snow leopard is protected in almost all of the countries throughout its range, and the sale of its pelt or other body parts is prohibited by international law, it still suffers persecution and indiscriminate hunting in those countries where poverty and political instability foster corruption and illegal activity. In fact, as often happens, the demand for the hunting of protected animals comes from far away, usually Europe and the Middle East, where hunting trophies or marketable pelts are in great demand, or where there are circuses and antiquated zoos who profit from exhibiting rare species. In some areas, local populations track the snow leopard because it raids their flocks in that age-old battle fought between the predators and those who make a living from livestock. There is also a great demand for the snow leopard's bones, teeth, and internal organs from practitioners of traditional Asian medicine. These dubious alchemistic processes intended to transfer the strength, pride, and nobilty of predators to humans have also brought other species, such as the tiger, to the edge of extinction. Traffic (an international network that monitors flora and fauna in the wild), the WWF, and the International Snow Leopard Trust have recently launched an urgent appeal to all countries within in the snow leopard's range to enact and enforce better management controls and action plans aimed at mitigating the principal threats to this magnificent animal.

EN

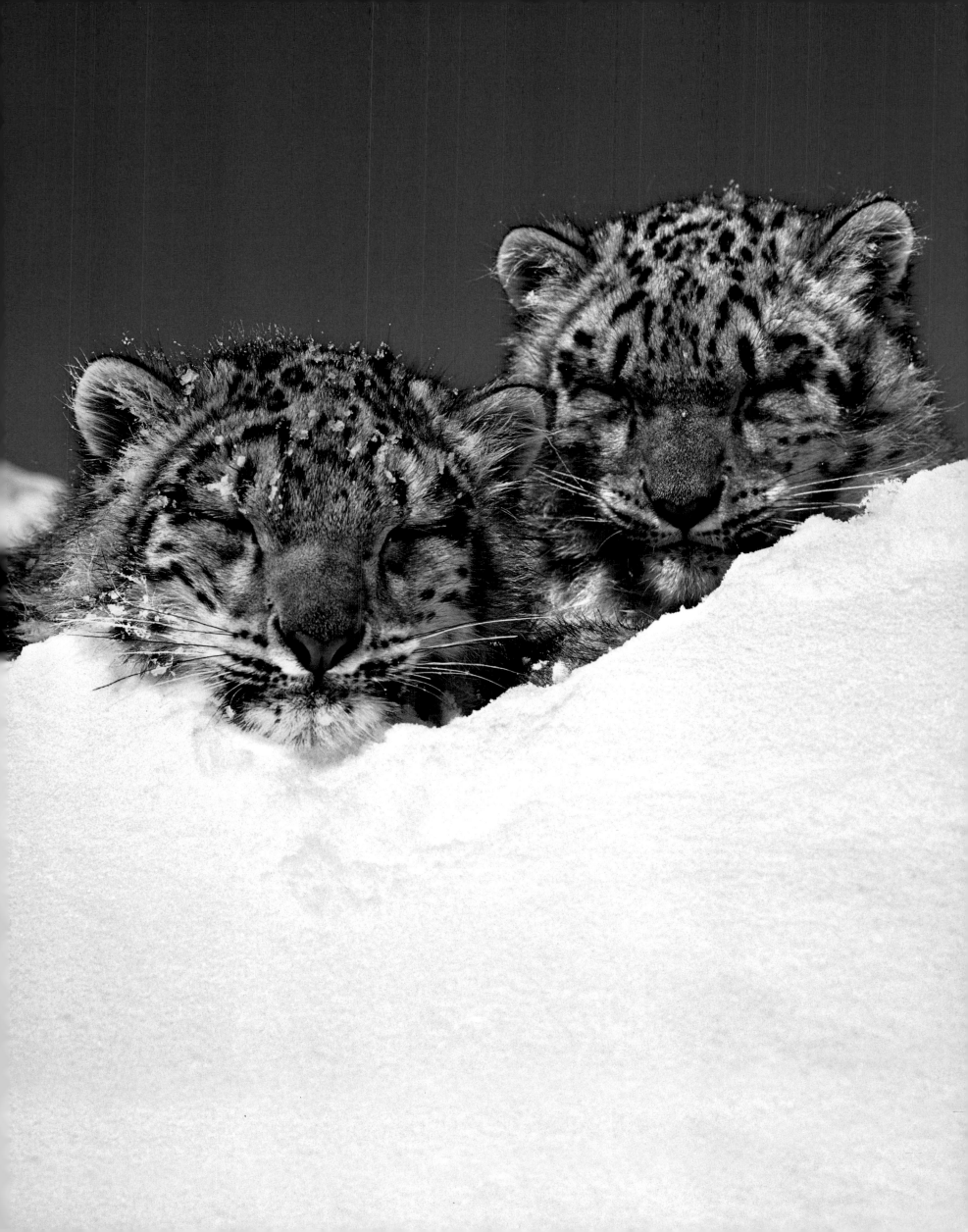

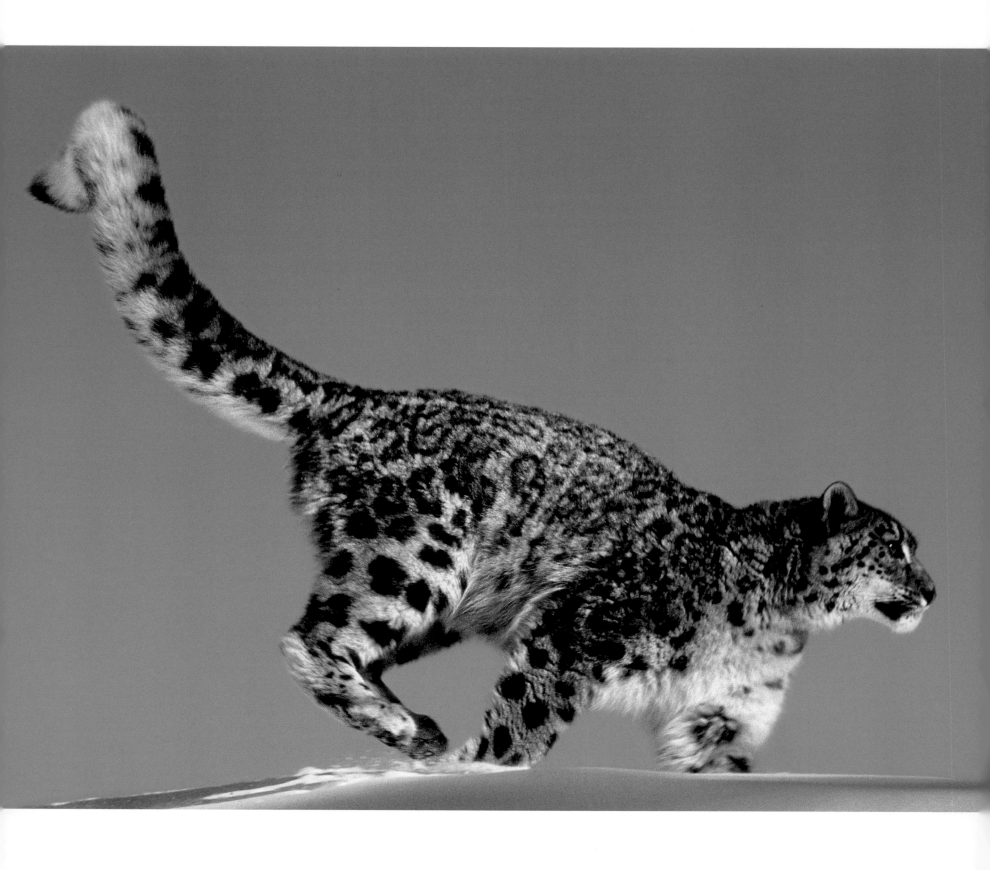

148 and 149 The snow leopard possesses a very thick gray-colored coat, covered with small dark spots. Its long and heavy tail has two functions, serving as a tool for maintaining balance and as a warm "scarf" during the coldest nights. Even its dense and downy undercoat allows the snow leopard to cope with the long cold seasons typical of the mountainous climate in which it lives.

150-151 It can measure more than 6 ft (1.8 m) in length, of which about 35 inches (88 cm) are its tail. In winter, its coat grows thicker, and the differing lengths of its front and back limbs give it an incredible leaping ability.

151 top left The mating season among snow leopards begins at the end of winter and lasts until the start of spring. Two to four cubs are born following a gestation period of around 90–100 days.

151 center left The snow leopard's hair is generally about 0-8 inch (2 cm) long over its whole body, but about 2 inches (5 cm) long on its tail and a good 2,8 inches (7 cm) long on its chest and abdomen. This very long hair gives it the appearance of being heavier than it actually is.

151 bottom left and right The snow leopard is predominantly a nocturnal hunter, but it will sometimes move around during the day in search of food. Birds, squirrels, but also deer and ibex are its prey, and it requires the larger prey every 10 to 15 days to maintain a proper diet and full health.

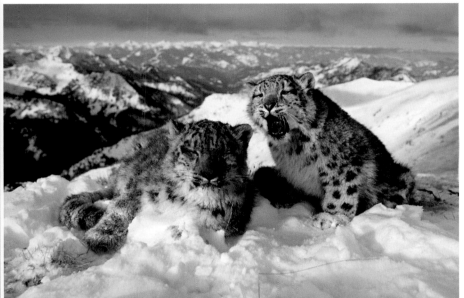

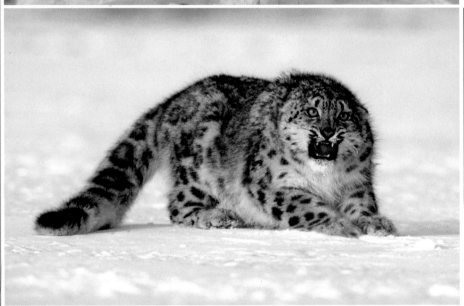

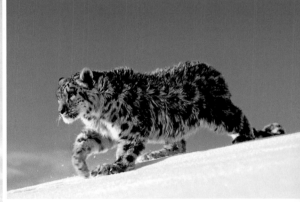

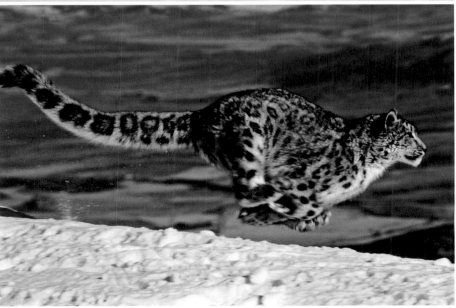

AMUR LEOPARD

Panthera pardus orientalis

The Amur leopard (*Panthera pardus orientalis*) is considered to be the big cat most at risk of extinction. It can still be found in the Ussuri River region of southeastern Siberia, but is thought to be practically extinct in the mountains of northeastern China, and the last sighting of it on the Korean peninsula was in 1969. Although its range coincides with that of the Amur tiger, they do not compete for food. On the contrary, the Amur leopard tends not to impinge on the tiger's territory, thus avoiding any competition over prey. Currently, there are around 200 Amur leopards in captivity and recent studies have estimated less than 40 specimens survive in the wild. This dangerously low number is mainly due to the destruction of its habitat and poaching. The Amur leopard prefers to live in forests but these have suffered a massive decline in the last few decades. This has drastically reduced and fragmented suitable habitats, and not just for the leopard but also for its prey: roe deer, Sika deer, hare, and badgers. It is also killed by poachers for its valuable coat and for its bones for use in traditional Asian medicine, and poachers also hunt the same prey as the snow leopard. As a result the Amur leopard has been increasingly relegated to marginal, isolated areas where conditions make its survival difficult.

Today, the aim of some conservation projects is to protect and support an already existing park, the Kedrovaya Pad Nature Preserve. Situated south of the city of Vladivostok, Russia, the preserve provides large protected areas, re-creating an ideal habitat for the leopard, and they are guarded by anti-poaching teams. Conservationists are pursuing research by marking these elusive animals and using radio-collars to study their behavior, habits, and needs. Because there are so few left in the wild, captive breeding programs will be essential if the Amur leopard is to be saved from extinction.

CR

153 The Amur leopard is the leopard subspecies found the farthest north. A male may reach a top weight of just over 132 lb (60 kg), measuring about 50 inches (1.27 m) from its head to the base of its tail, and with on average a tail 35 inches (90 cm) long. The females are slightly smaller.

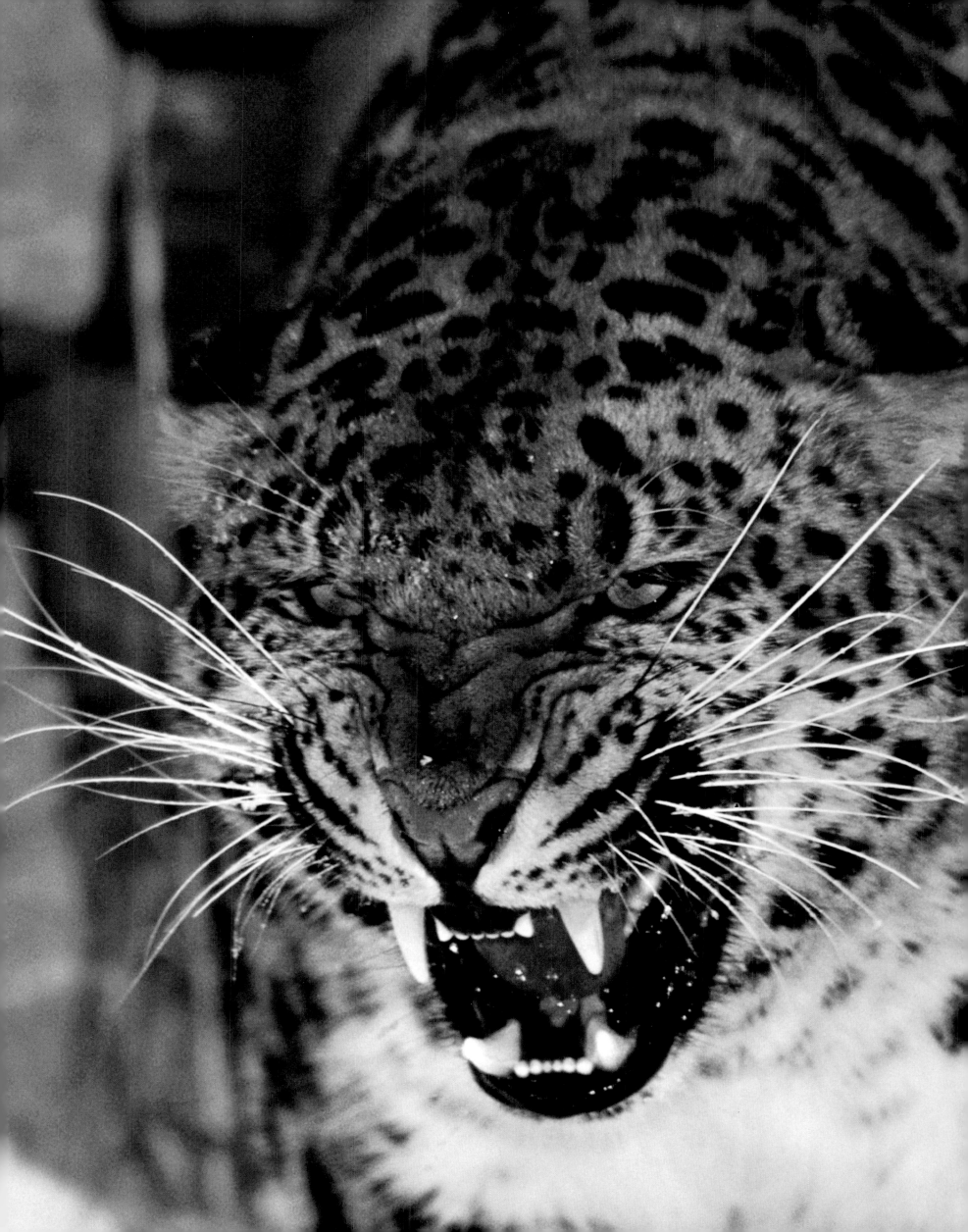

154 The main differences between the Amur leopard and other leopards are its longer coat, which reaches 2,8 inches (7 cm) in length during the coldest months, and large ring-shaped spots along its middle.

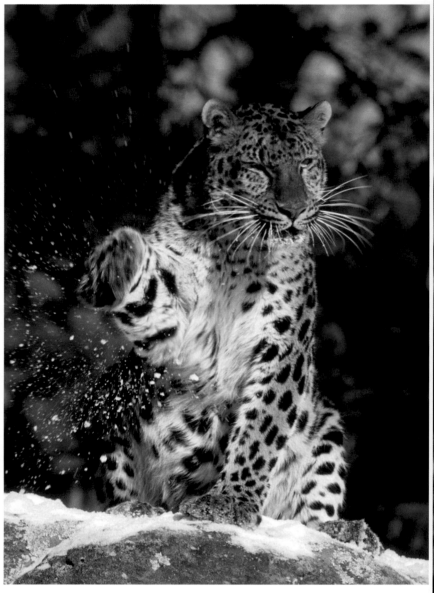

154-155 A solitary, nocturnal inhabitant of forests, the Amur leopard is a skilled and opportunistic hunter. Its diet can include a great variety of prey, such as deer, hare, badgers, and small rodents.

AMUR LEOPARD

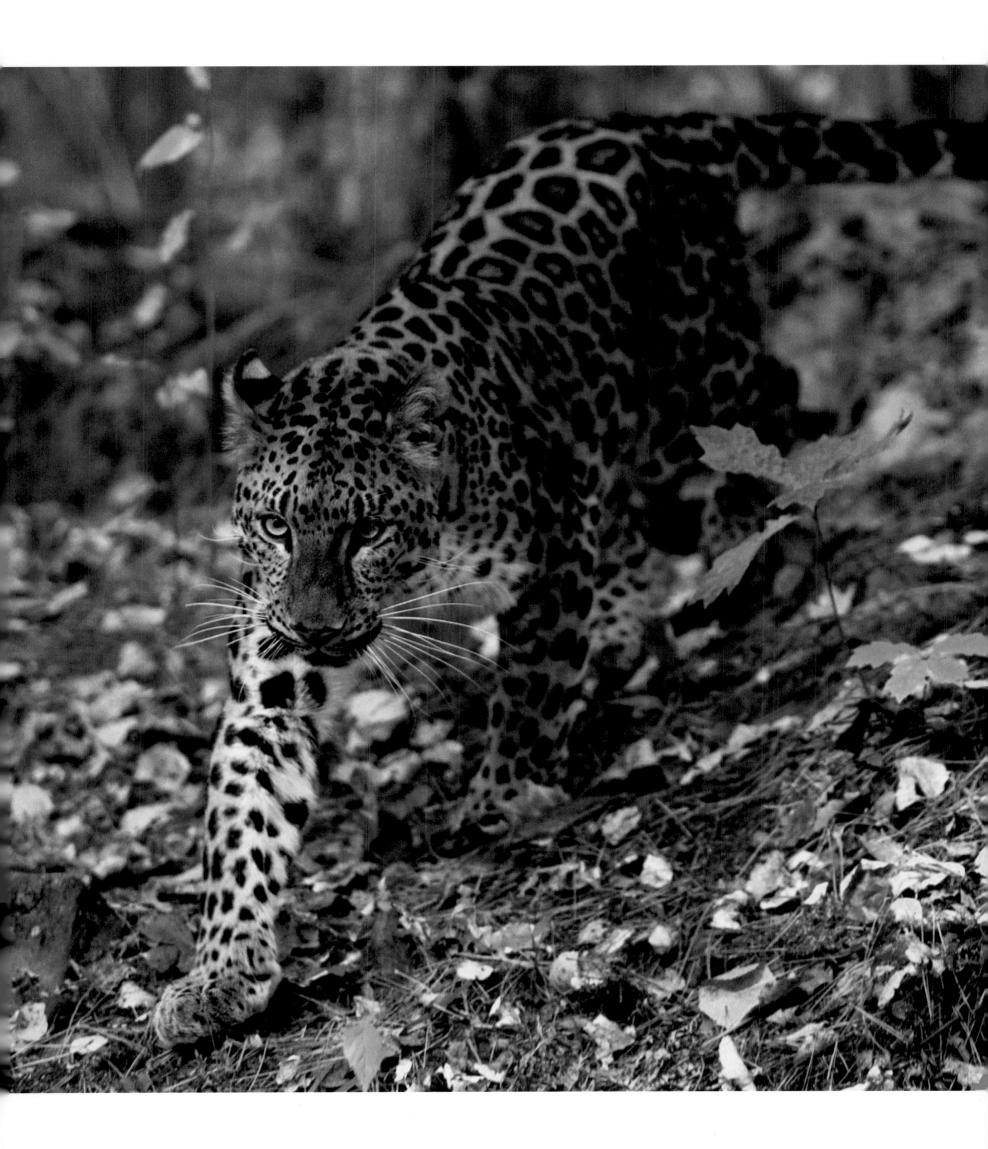

TIBETAN ANTELOPE

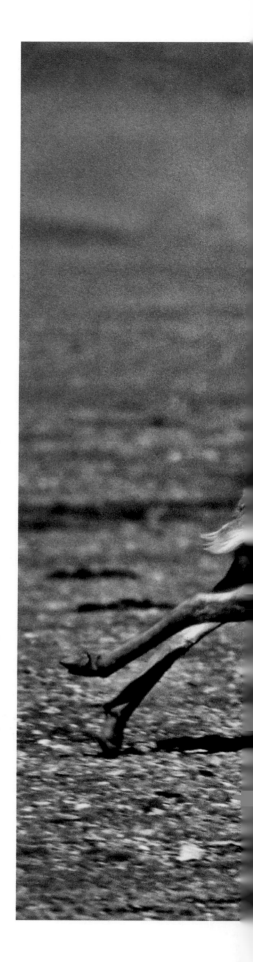

Pantholops hodgsonii

Hundreds of skinned carcases lie abandoned on the steppe of the Tibetan plateau. Among the remains are pregnant females and complete skulls with long, curved horns. Even in 1999, the extermination of Tibetan antelopes (*Pantholops hodgsonii*) or "orong" still took place in this way. The Tibetan antelope is a species primarily distributed over the Chinese high plains, while only a small part of its population migrates towards the region of Ladakh, India. It lives at altitudes between 12,100 ft (3,700 m) and almost 18,000 ft (5,500 m). Timid and reserved, it takes shelter from the mountain winds during the day and from predators by hiding in the rolling terrain, keeping to the pastures during the daylight hours. The orong's wool, called "shahtoosh," is light and soft, yet keeps it very warm. A shahtoosh pelt has a pile equal to three-quarters that of a cashmere wool pelt and a fifth of the thickness of human skin. For hundreds of years in Kashmir, shawls made with orong wool were part of the dowry that each girl brought with her into marriage. This tradition did not endanger the population of orong until these magnificent shawls were discovered by the Western world in the 1980s and became a luxury item to collect and give as gifts. To manufacture one shawl it takes the wool from four to five antelopes. The orong were completely protected in China until 1979 and shawl manufacturing was permitted only in the Jammu and Kashmir regions of India and sales were absolutely prohibited. In 1998 the biologist, George Schaller, recorded that out of an estimated one million antelopes in 1900, only 75,000 remained. It is calculated that each year 20,000 antelopes have been illegally massacred in the name of fashion. These shawls go to France, Italy, and Hong Kong at a cost of $3,000 to $15,000 USD each.

In 2002, thanks to Traffic's international activisim and lobbying, India prohibited even the spinning of wool for shawls and China's efforts in combatting poaching have resulted in arrests and confiscation. Thanks to extensive and hard-hitting awareness campaigns about the slaughter that is involved in the production of these luxury shawls that are as soft as a baby's skin, Western public opinion has now changed. However, the enormity of the Tibetan plateau, the lack of availability and scarcity of guards, and the perseverance of poachers mean that the future of the Tibetan antelope is still bleak.

EN

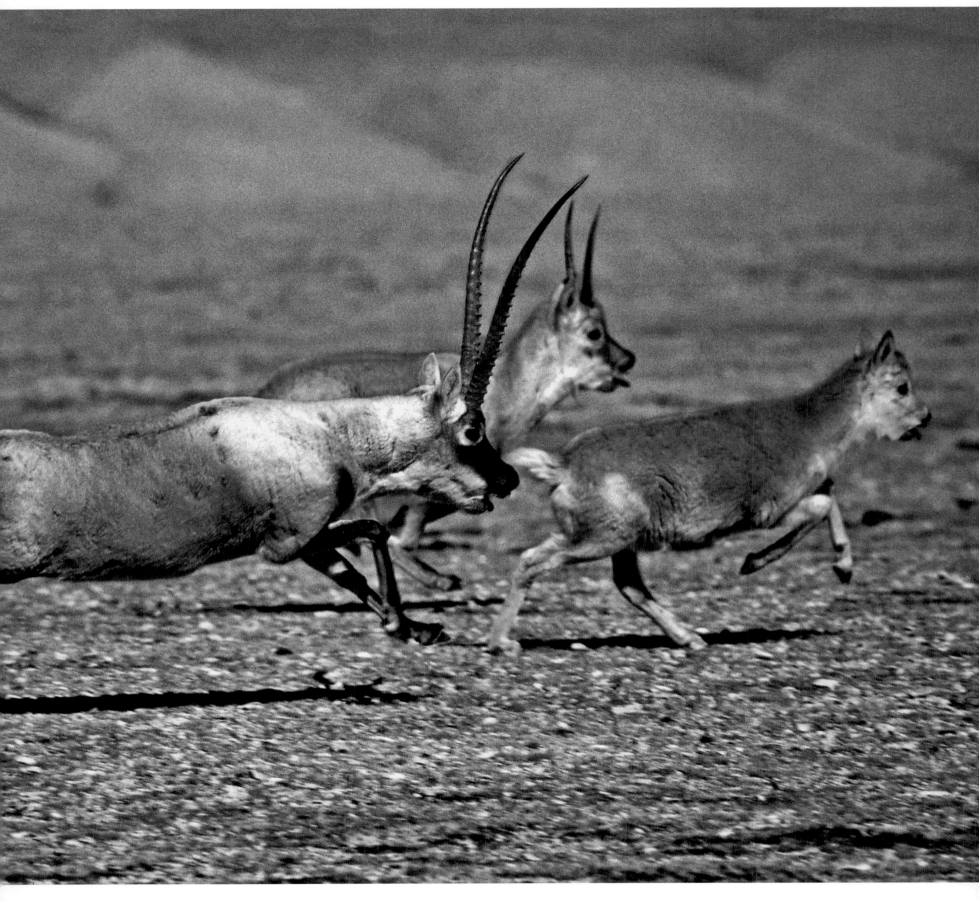

156-157 Genetic analysis indicates that the Tibetan antelope shares close ancestors with the wild goat and sheep. The males weigh 75–90 lb (34–40 kg), are 31–34 inches (78–86 cm) tall at the withers, and have long slender black horns, while the females are smaller and do not have horns. The only way to obtain the wool of the Tibetan antelope is to kill it, and the only way to stop this slaughter is to inform public opinion and so decrease the demand for shawls manufactured with its wool. Indian authorities confiscated 290 shatoosh wool shawls in the first three months of 1999. To produce these shawls, around 1,200 to 1,400 Tibetan antelopes were killed, and confiscations did not even equal the tip of the iceberg of the shameful amount of trafficking of this precious animal's wool.

GOLDEN SNUB-NOSED MONKEY

Rhinopithecus roxellana

The oldest forest of azalea trees in the world stands on Mount Laojun, which is considered to be the "ancestor of the mountains in Yunnan," in the southwesternmost province of China. Golden shapes less than 3.5 ft (1 m) tall wander among the vivid pink-colored flowers. They are golden snub-nosed monkeys (*Rhynophithecus roxellana*), moving through their natural environment. This monkey with the turned-up nose is one of four Asiatic mountain monkey species (three of which are found in China and the other in Vietnam) and it lives in the forests of the mountains of western China. It predominantly feeds on leaves and has a stomach that has made its entire family of Old World monkeys the most efficient herbivores among the primates. Since leaves have little nutritional value, these monkeys must eat a lot and their stomachs can represent up to a quarter of their entire body weight. During the freezing winter months, the golden snub-nosed monkey grows a long-haired coat, which provides superb insulation and enables them to endure temperatures as low as 23° F (-5° C) and they can continue to move agilely on the ground or through the trees. These monkeys live in large groups comprising hundreds of individuals, who then subdivide into smaller groups of one male and several different females. The males are generallly larger, about twice the size of females, and have black hair on their backs that makes them immediately identifiable. However, the beautiful color of the golden snub-nosed monkey's coat has meant that they have been ruthlessly hunted. The hunting for their pelts and deforestation causing the destruction of their mountainous habitats threaten the continued existence of these animals. Because of the degradation of their natural envirnoment, the golden snub-nosed monkey was placed onto the IUCN's (World Conservation Union) Red List of endangered species and their status is considered to be vulnerable.

VU

158 The golden snub-nosed monkey lives in the mountainous forests of western China. Almost 80 percent of its diet is made up of leaves, 15 percent fruit, and the rest flowers or small insects.

159 An adult golden snub-nosed monkey can measure, dependin3g on its gender, 21–28 inches (53–70 cm) long – males are about twice the length of females.

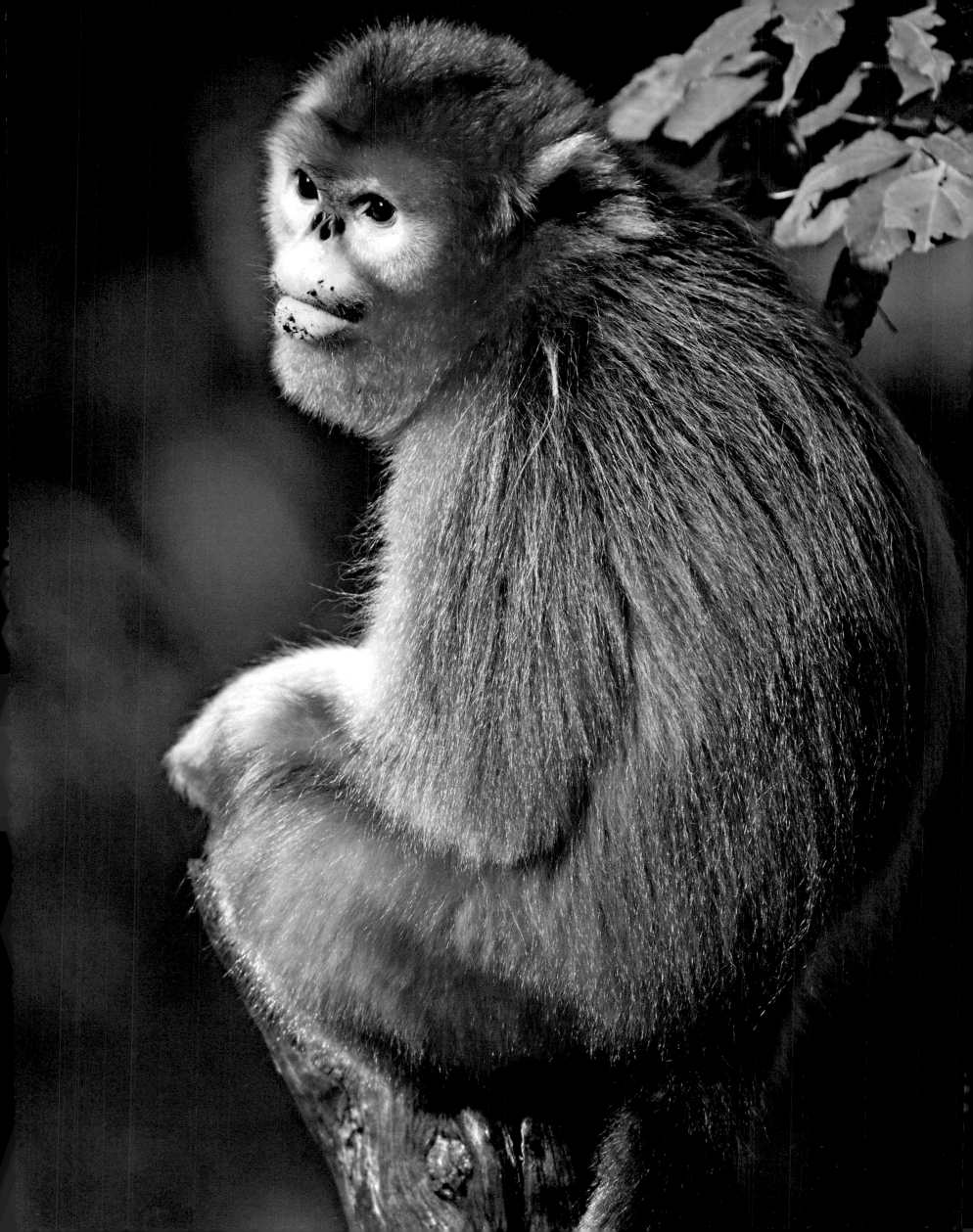

160 Special bacteria living in the golden snub-nosed monkey's stomach allow it to break down the cellulose and most of the toxins produced by certain plants that would otherwise prove fatal.

160-161 A female golden snub-nosed monkey sometimes cares for two or three other young monkeys besides her own newborn, doing a little "babysitting on the side." The females reach sexual maturity at about four years of age and the males a little later at around five. The lifespan of these monkeys is about 18 years.

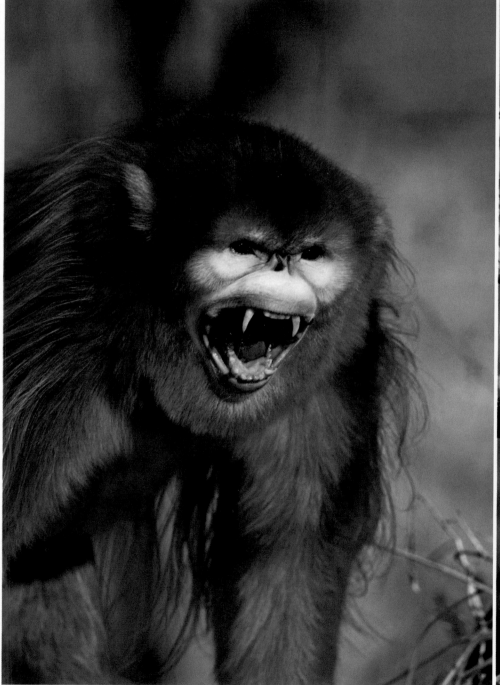

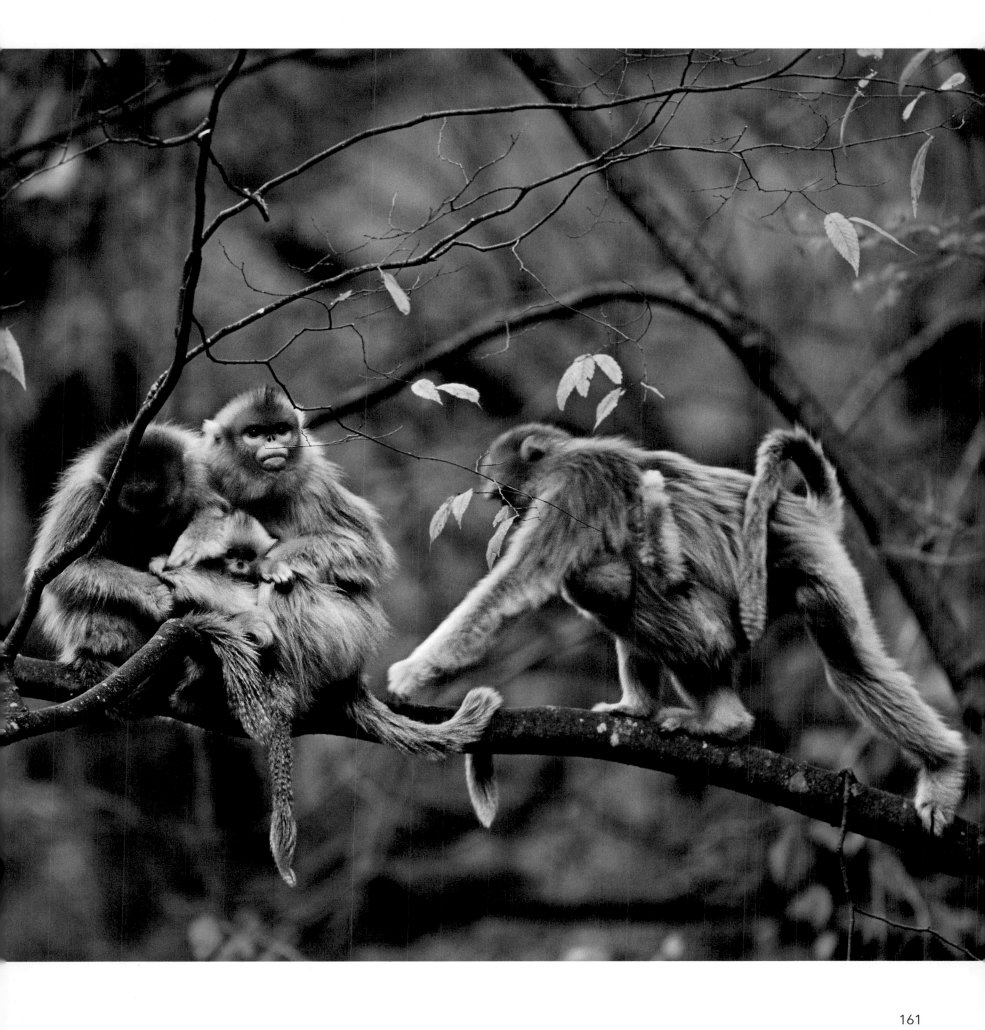

SIBERIAN WHITE CRANE

Grus leucogeranus

It is anticipated that the Siberian white crane (*Grus leucogeranus*) population will suffer a sudden irreversible decline in the next three generations as a result of the construction of the Three Gorges Dam on the Yangtze River in China, where the cranes winter. This enormous hydroelectric project constitutes only the latest threat to the survival of this magnificent bird. The long migrations the cranes undertake mean that they are exposed to the environmental degradation occurring in the regions they cross, if not the complete destruction of their ideal habitats for reproduction. The same risks threaten the survival of the Manchurian crane (*Grus japonensis*) who, like the Siberian white crane, needs deep marshy waters to feed and nest. Modification of these nesting or migratory stopover sites has resulted in a dramatic decline in the numbers of both species.

Following the eradication of the western and central populations from the only two sites in Iran and India where they spent the winter, the Siberian white cranes found in Asia became the only stable population. The major conservation efforts to protect these remaining birds are being focused on the identification of all the potential migratory routes and the stopover points during these migrations. The use of satellite transmitters has been crucially important in the successful mapping of migration routes, and the discovery of new routes and rest areas is largely due to the monitoring of one crane during its migration in the spring of 1996. Leaving the Caspian Sea on March 6th, the crane arrived in Russia on May 1st at a previously unknown area that the species had adopted as a reproduction site. During migration, the crane stopped to rest mainly on the eastern side of the Volga River delta, which is obviously an important region for the species. This data was vital in designing the conservation projects for protecting the newly identified areas which could replace the other sites now irreversibly damaged by human activity.

CR

162

163 Adult Siberian white cranes are almost completely white and only the feathers from the beak to the eyes have a dark red coloration. The males are almost 5 ft (1.5 m) tall and weigh about 22 lb (10 kg), while the females are generally somewhat smaller. These birds nest and winter in aquatic areas.

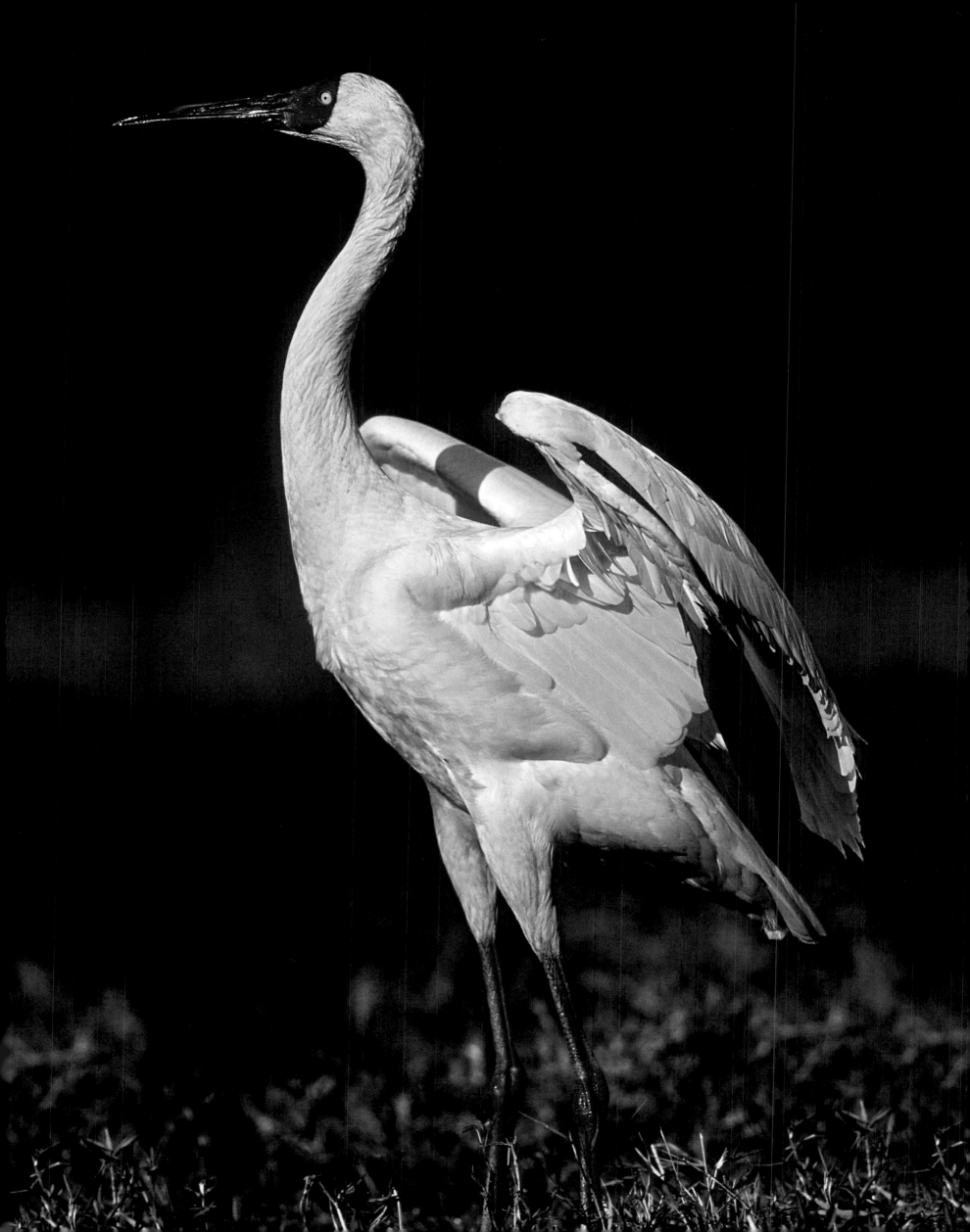

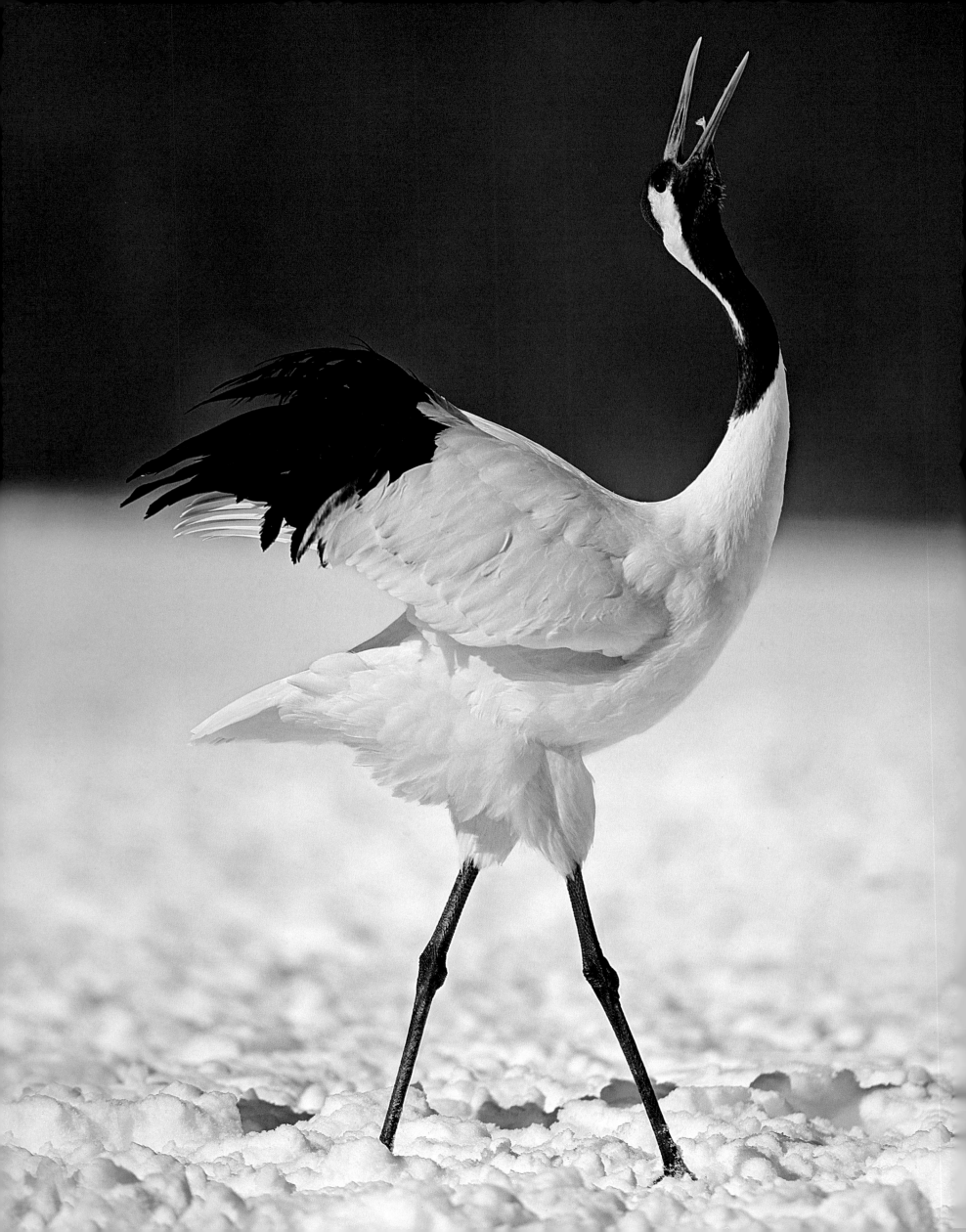

164 An adult Manchurian crane has white coloration and a splash of red skin on the head, which becomes brighter if the animal is irritated or excited.

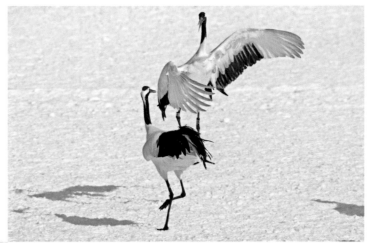

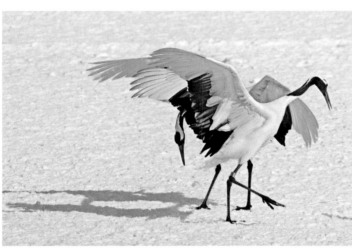

165 Manchurian cranes are famous for their delightful dance on the snow. A few cranes join together in groups and begin to move their necks, bending forward, flapping their wings, taking small steps forward, and jumping up. The dance is executed with elegant poses and is one of the most enchanting spectacles of nature, which is observed each year by many scientists and tourists.

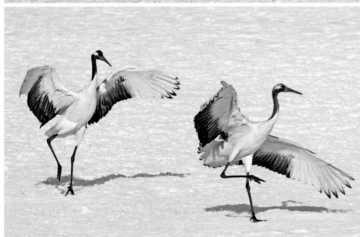

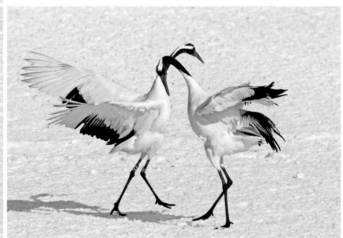

S I B E R I A N W H I T E C R A N E

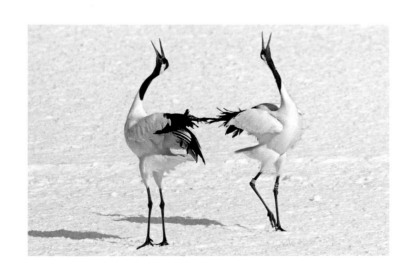

166-167 The Manchurian crane normally lives in places such as marshes, swamps, riverbanks, or rice paddies where there is water, perennial vegetation, and consistent food sources. Its diet is comprised of invertebrates, insects, and plants.

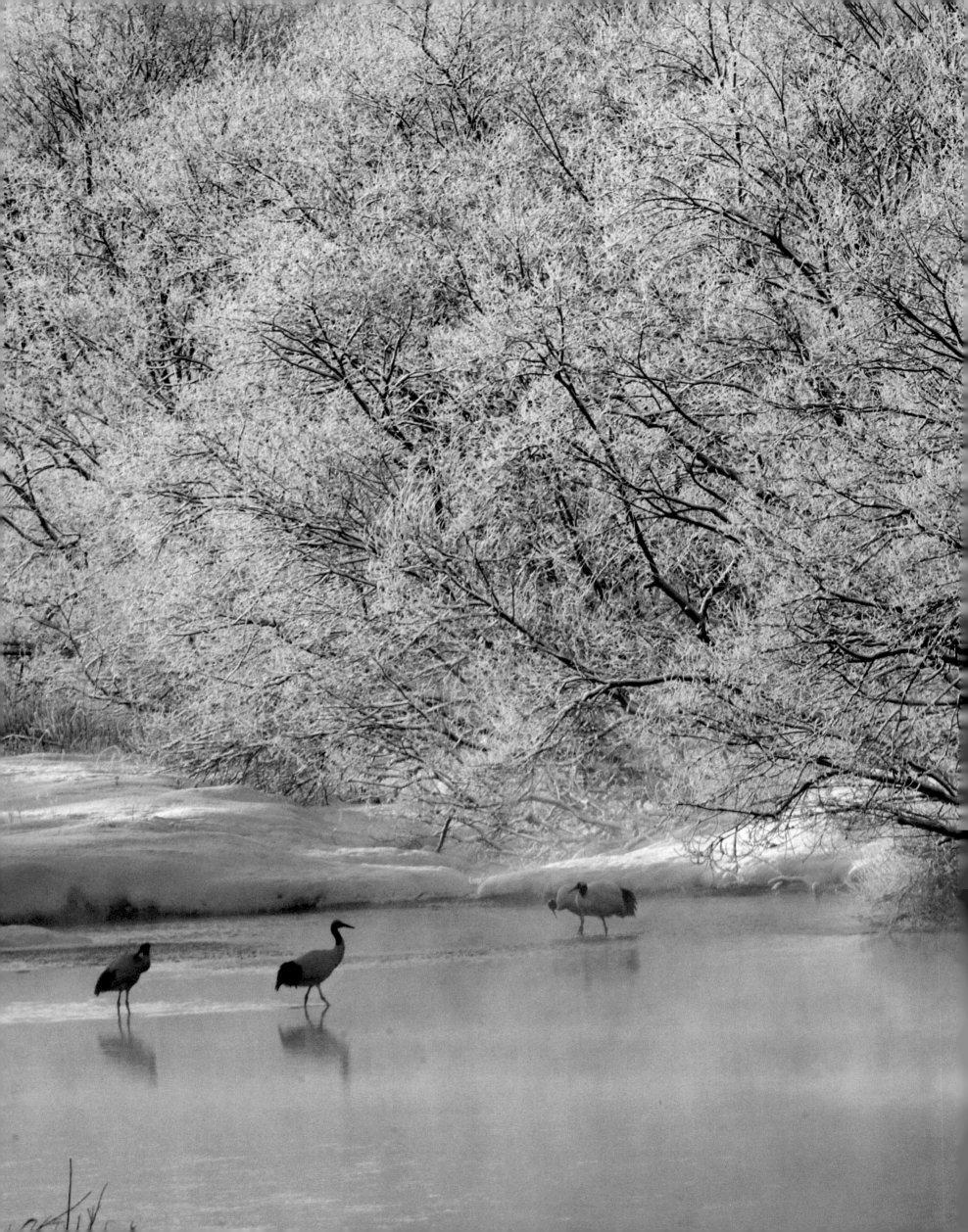

ASIAN or INDIAN ELEPHANT

Elephas maximus

One of the largest mammals in the world, sacred to and respected by many cultures, the survival of the Asian or Indian elephant (*Elephas maximus*) is at great risk. In fact, there remain probably little more than 30,000 of this social and long-living species, concentrated for the most part in India and neighboring countries. A few thousand others survive in the remaining strips of forest in southeastern Asia (Borneo and Sumatra) and a population of less then 100 lives in an area straddling the borders of Vietnam, Laos, and Cambodia. It is estimated that there are at least 15,000 specimens in captivity, stars of circuses and zoos, or trained specially by man to aid in commercial deforestation operations. Those wild elephants that are free to wander through the forests are divided into very small, isolated, and fragmented populations, and forced into increasingly smaller areas because roads and human settlements crisscross their natural wooded corridors, making their movement difficult. Since only the males in this species have tusks, illegal slaughter for the acquisition of ivory causes drastic demographic alterations. In some preserves, only one adult male for every 100 females remains, consequently less than one-third of adult females are accompanied by offspring. The loss of so many breeding specimens and the fragmentation of their habitat inhibits the intermingling of populations and so results in the impoverishment of the gene pool, making them more receptive to disease and changes in the environment, as well as marking them for early extinction.

The primary threat to this species is undoubtedly the loss of suitable habitat. Although hunting for commercial purposes, the ivory trade, or traditional medicines prepared with animal parts and byproducts are additional threats. Rapid and extensive deforestation and the conflict between the presence of elephants and local communities have put the future of these animals in grave danger. Groups of elephants remaining in isolated portions of the forest insufficient to support them often raid neighboring plantations, or are compelled by necessity to cross them to reach another portion of the forest, causing enormous damage to cultivated fields during their passage. Firearms, traps, as well as poisons are employed to slaughter them. The only hope for the Asian or Indian elephant is the resolution of this conflict.

EN

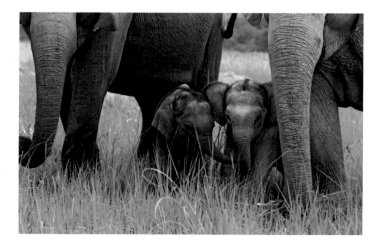

168 and 169 Female Asian or Indian elephants give birth to one offspring on average about every four years, because of the long gestation period and the prolonged parental care given to their young. Elephants have populated the earth for five million years and are the only remaining members of the Proboscidea order. Their surviving representatives are the Asian, or Indian, and African elephants.

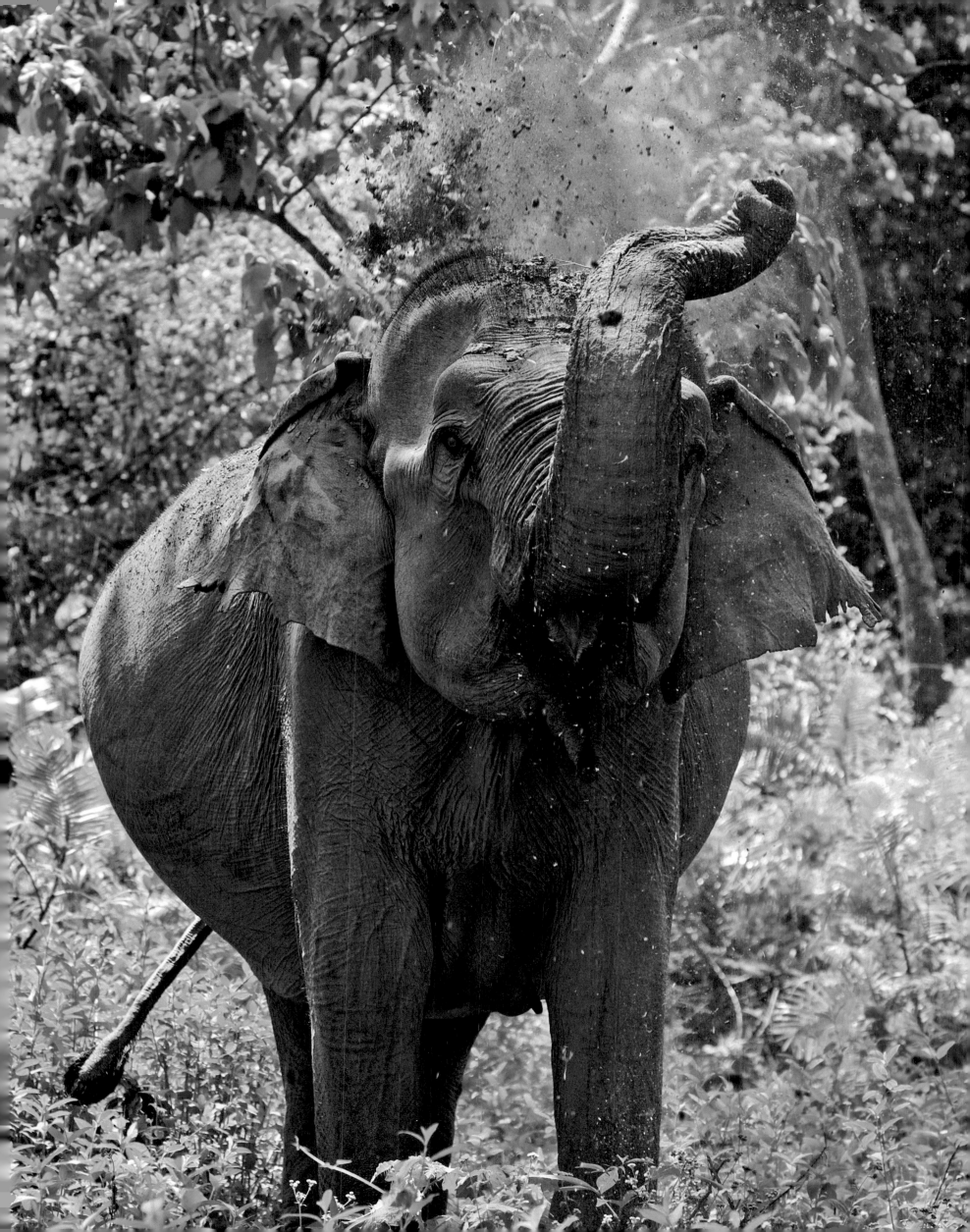

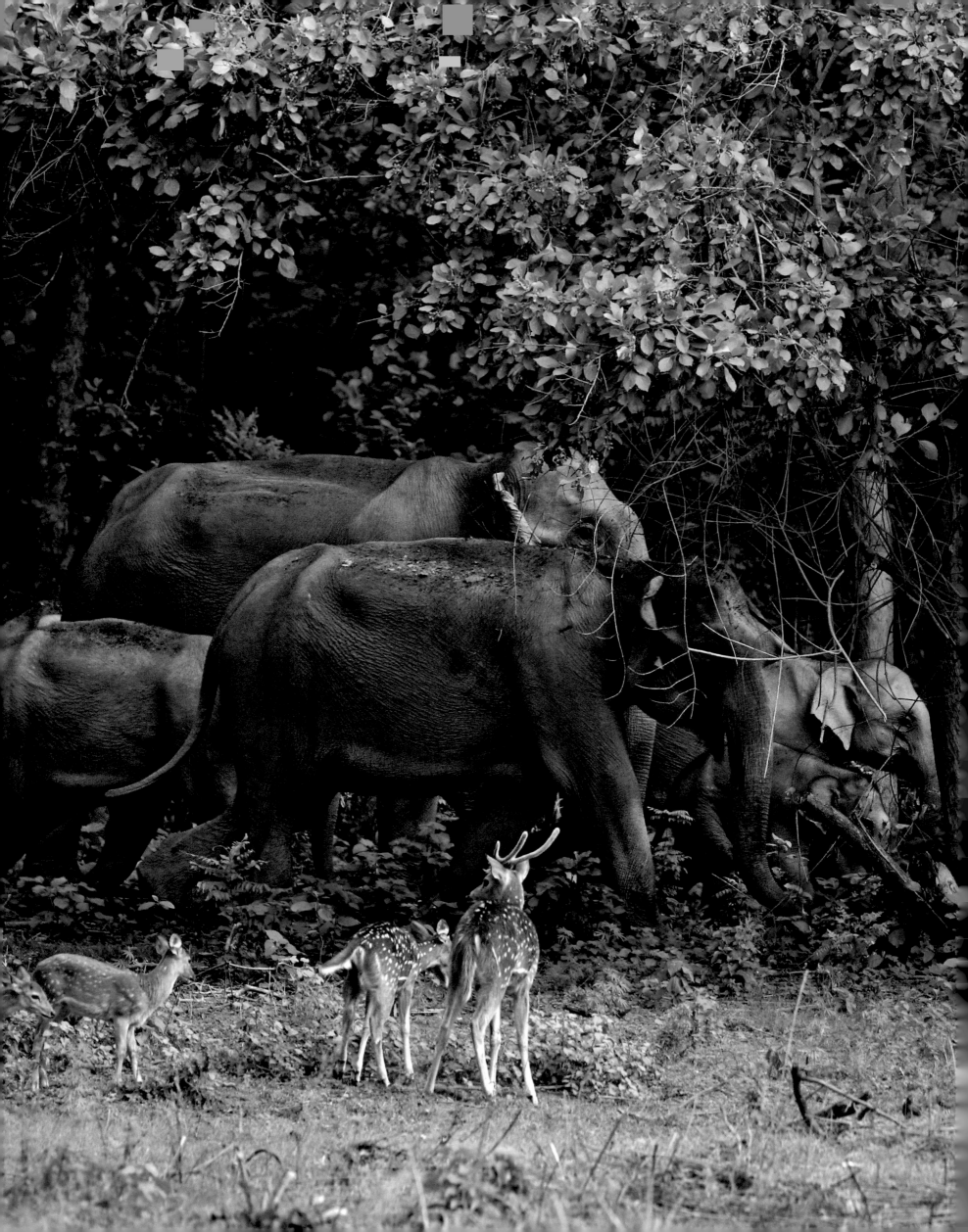

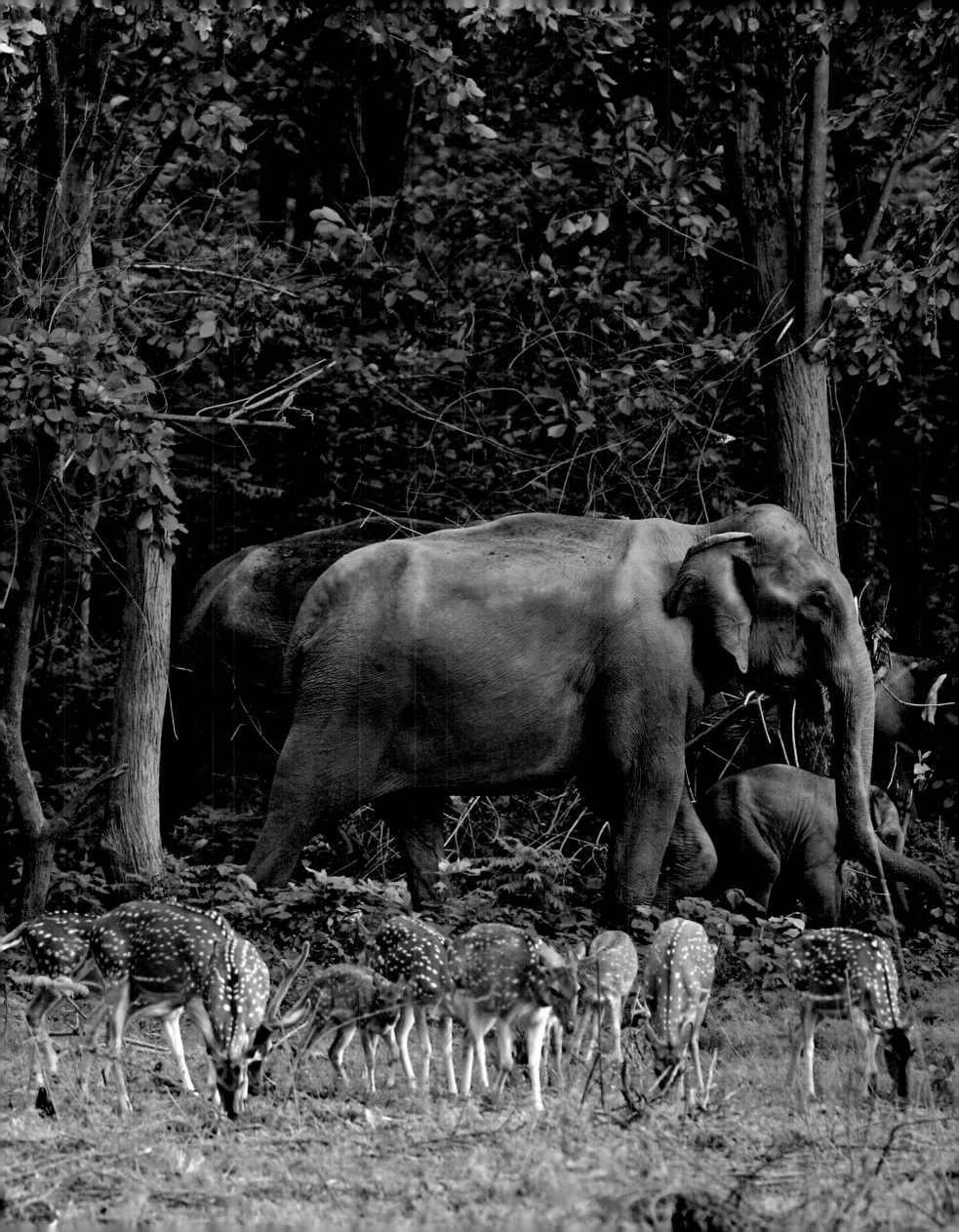

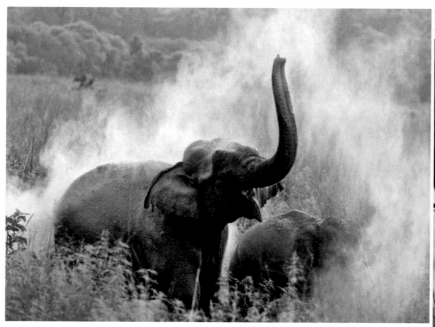

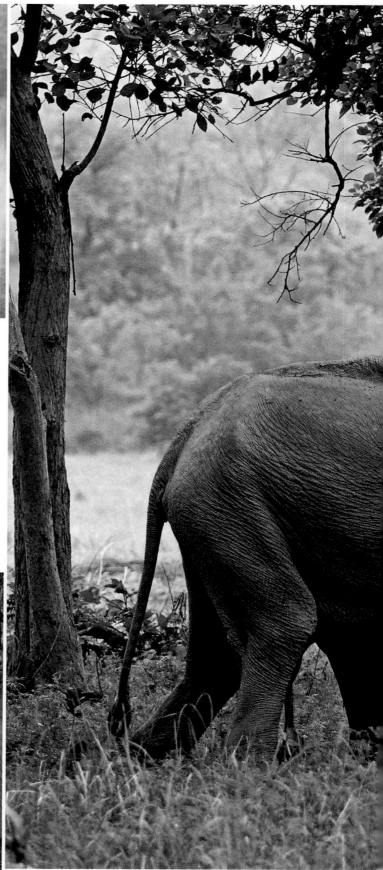

170-171 Even though smaller than its African "cousin," the Asian or Indian elephant can exceed 10 ft (3 m) in height and weigh more than 5 tons (4.5 tonnes). It needs about 330 lb (150 kg) of food per day. A male can weigh up to 5.4 tons (5 tonnes) and a female 2.7 tons (2.5 tonnes). Their length varies from between 18 and 22 ft (5.5–6.7 m). Their height at the withers may reach almost 10 ft (3 m).

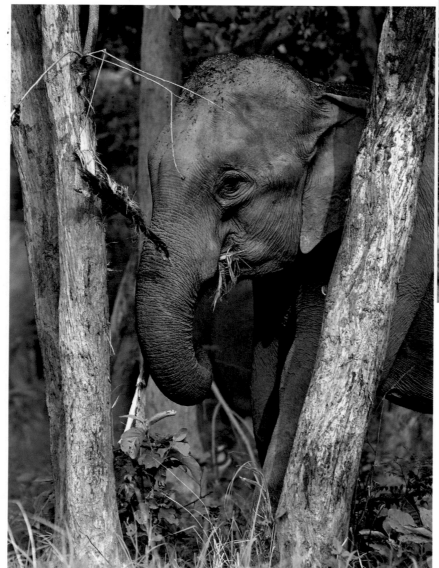

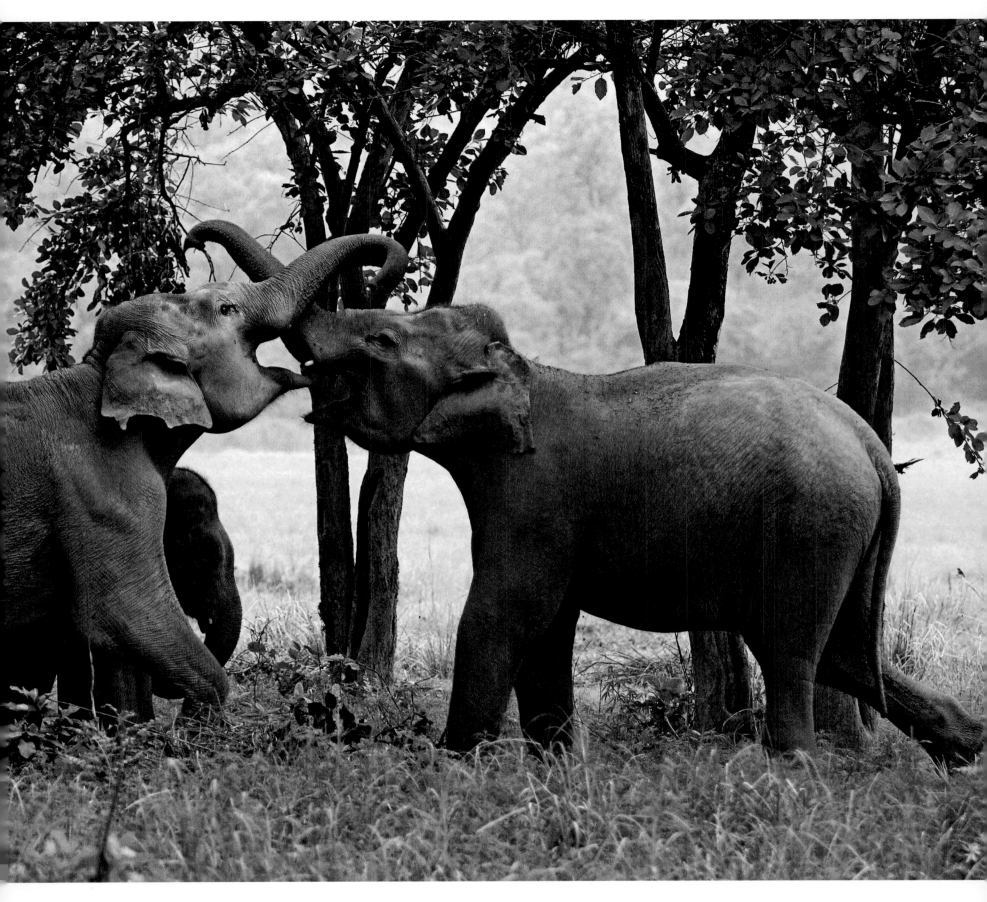

172 There are small, fragmented populations of Asian or Indian elephants in Southeast Asia: 2,000–2,500 in Sumatra; 500–1,000 in the Malaysian region of Sabah, which includes 90 percent of the whole population of Borneo; 3,000 in Thailand; 80–90 in Vietnam; and 2,000 in Burma. Accurate estimates do not exist for Asian or Indian elephants in Cambodia and Laos, but there are probably only a few hundred.

172-173 The Asian elephant has smaller ears compared to the African elephant and very few males have tusks while females do not have them. It is the second largest land animal in the world, and can be domesticated.

173

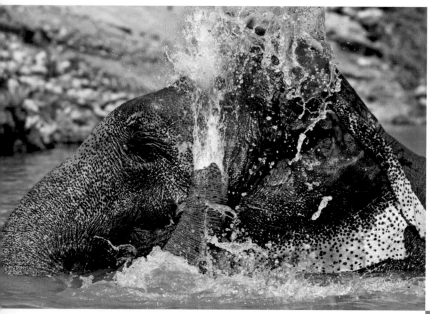

174 The Asian or Indian elephant loves to spend a lot of its daytime hours in or near water, and enjoys "showering" by using its long trunk. Its natural environments are the jungle and grasslands, but it also ventures into mountainous regions.

175 Asian or Indian elephants live in matriarchal family groups. The males live on their own after the age of seven and females remain with their mothers. They can live for up to 70 years.

ASIAN or INDIAN ELEPHANT

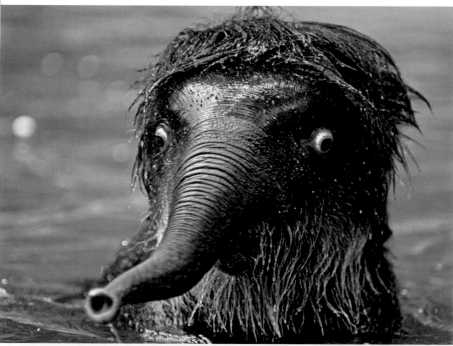

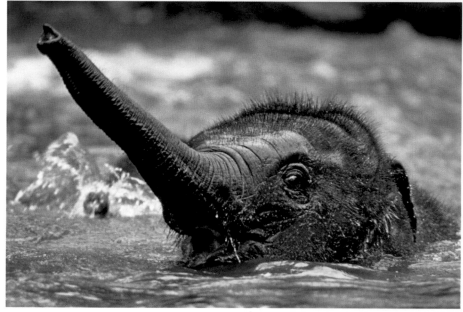

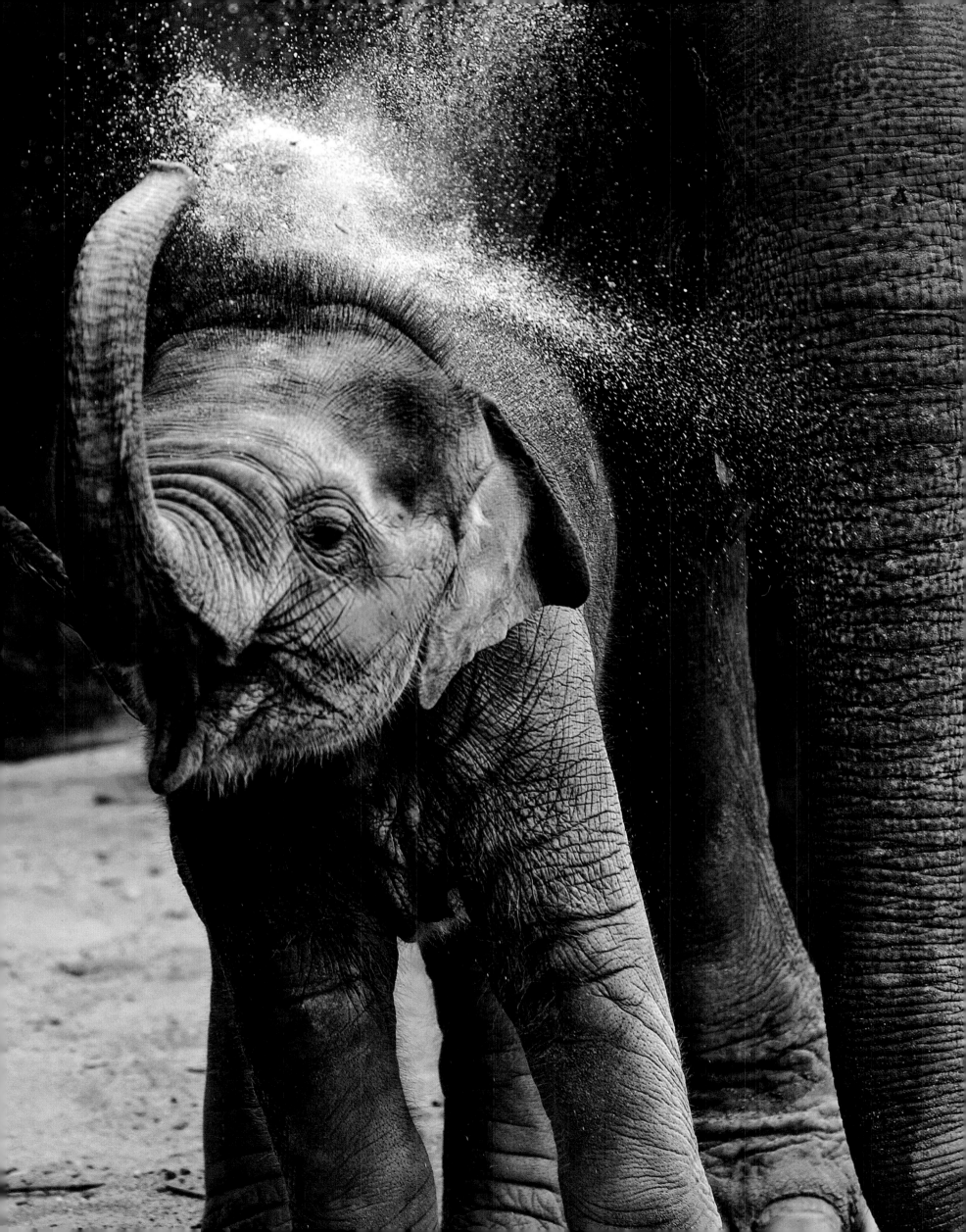

INDIAN RHINOCEROS

Rhinoceros unicornis

In the past, the Indian rhinoceros (*Rhinoceros unicornis*) was distributed throughout an extensive area, extending from Pakistan to the border of Burma. Over the years, the species has undergone a dramatic decline in numbers and there are now only a few small population groups, which are increasingly more and more isolated from each other, located in northeastern India, Nepal, and Bhutan. The Indian rhinoceros lives typically in grasslands and throughout the fluvial forests, but the increasing scarcity of these habitats has pushed it towards cultivated fields. It is generally a solitary animal, except for during the mating season and while raising offspring. Otherwise individuals usually encounter each other at pools, where they often submerge to regulate their body temperature and remove external parasites. This giant of the Indian forests has no real natural predators, except for the tiger which can pose a threat to a young rhinoceroses. Inevitably, the greatest danger to this species is human activity. The Indian rhinoceros is a herbivore and its diet includes grass, leaves, acquatic plants, and fruit that it picks by using its prehensile mouth. During the mating season, males fight amongst themselves and use their sharp lower tusks to strike other rivals. After a gestation period of about 16 months, the female gives birth to one offspring that remains at her side until her next pregnancy.

Of all the Asiatic rhinoceroses, the Indian rhinoceros is the least threatened. In the last few years, its numbers have progressively increased and it is estimated that there are now 2,000 in the wild. Thanks to various relocation projects, it can once more be found in areas from which it had previously disappeared. The principal cause of its decline, however, was indiscriminate hunting due to the high commercial value placed on its tusks, which have been used for millennia in traditional medicine for questionable curative properties. Despite being protected by national and international laws, the species is still threatened by poaching as well as destruction of its habitat.

EN

177 The Indian rhinoceros can reach up to 13 ft (4 m) in length, up to 6.5 ft (2 m) in height, and can weigh up to 2.6 tons (2.3 tonnes). It has just one horn on its head and is closely related to the Javan rhinoceros (*Rhinoceros sondaicus*).

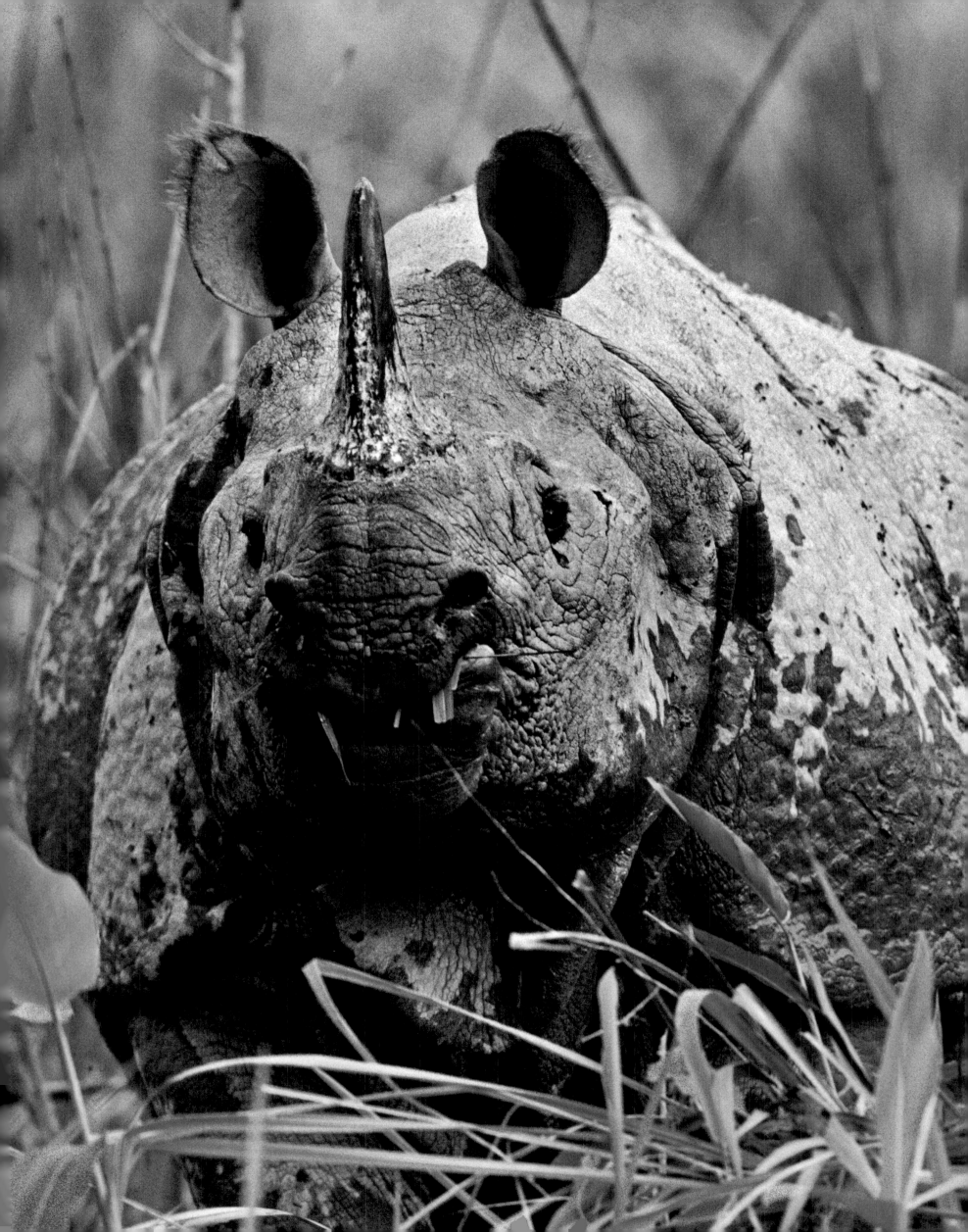

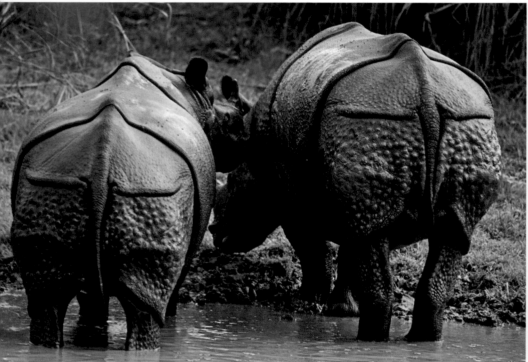

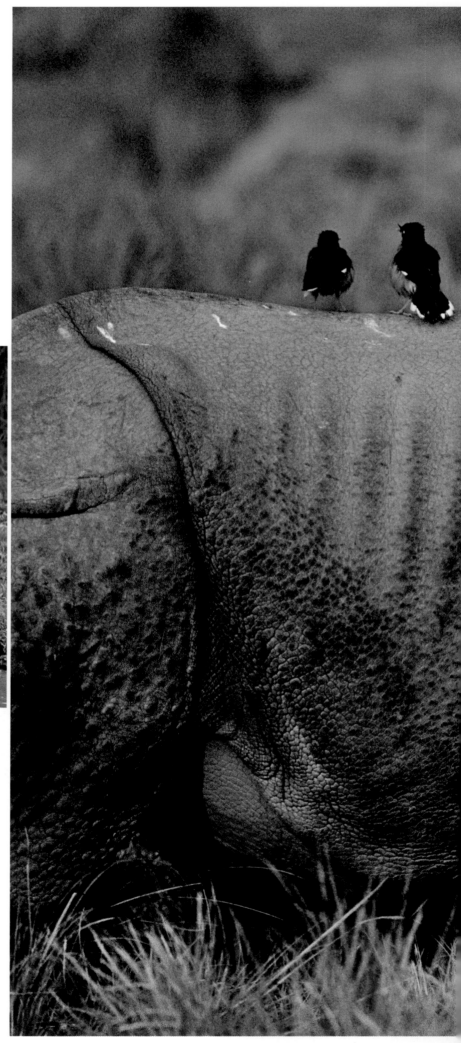

178 and 178-179 The Indian rhinoceros' hide is hard like armor and divided into large pleats. Quite a peaceful animal despite its size, it will become aggressive only if attacked or during the mating season when it must compete for females.

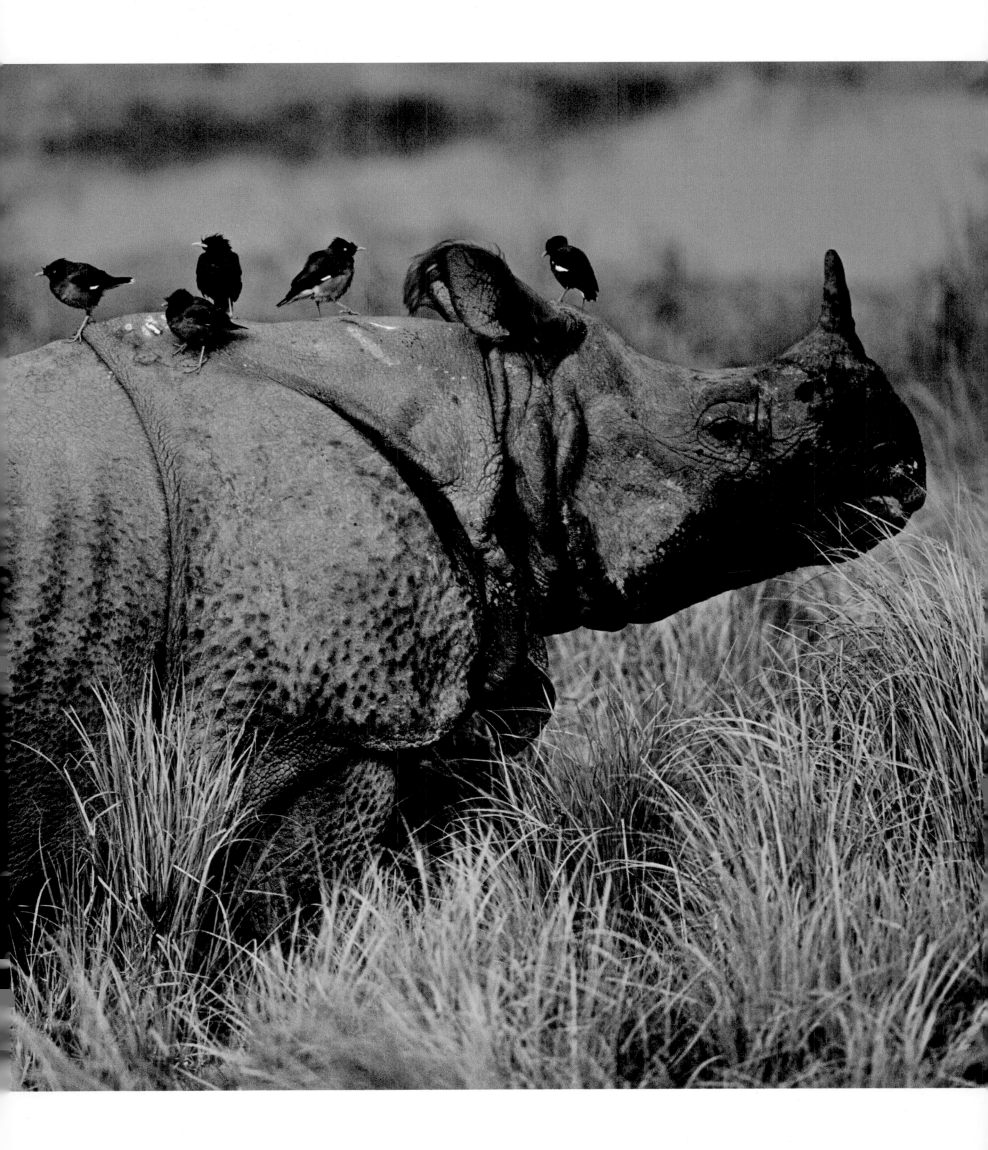

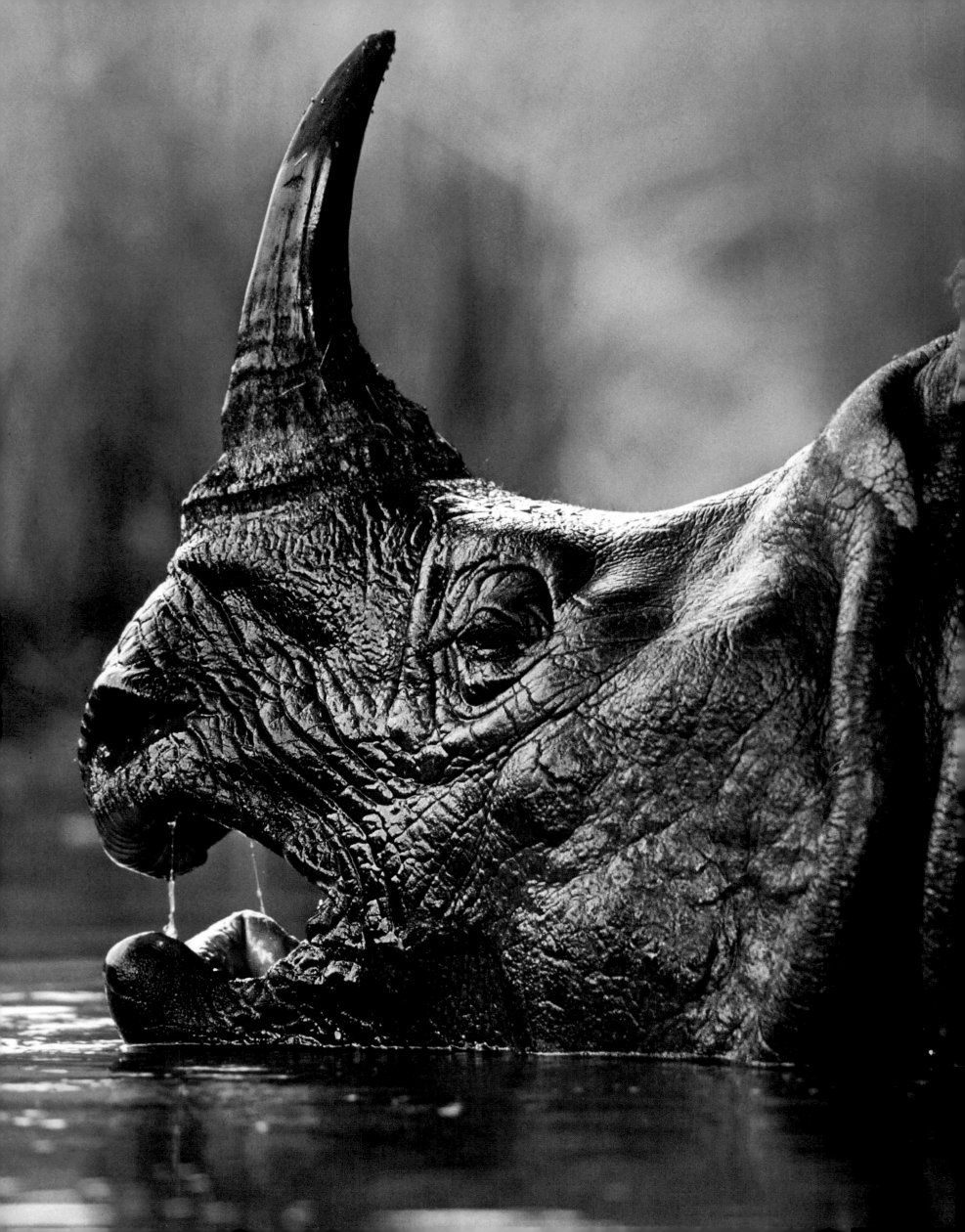

180-181 and 181 Morning and evening are the preferred times of day for the Indian rhinoceros to eat. Its diet contains meat, shoots and buds, grass, foliage, and various types of swamp plants. The rest of its time is spent sleeping or bathing in muddy pools.

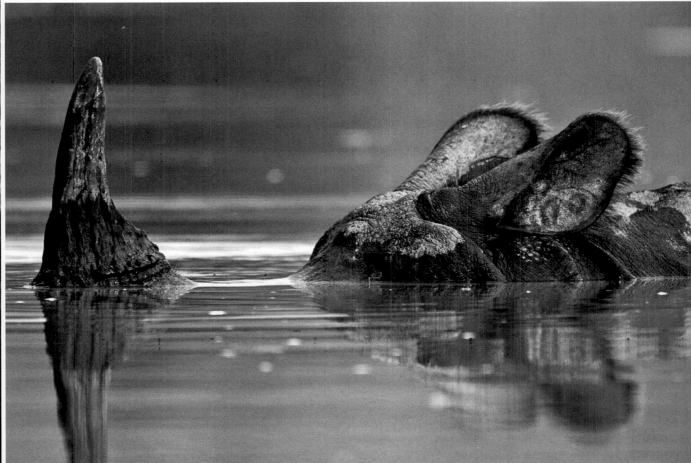

SUMATRAN TIGER

Panthera tigris sumatrae

A beautiful and elusive hunter, the *Panthera tigris* was once distributed throughout an area stretching from the shores of the Caspian Sea to the small Indonesian island of Bali, but today only a few thousand specimens remain. The largest of the big cats and perhaps the most charismatic, the Sumatran tiger is currently found in increasingly smaller, more subdivided, and isolated populations within pockets of forest habitat that humans, as yet, have not exploited for timber or agriculture. Because of its beauty and size it has long been a prized trophy species, especially in the past by British nobility and officers and Indian maharajahs, and is also a popular target for unscrupulous poachers who slaughter it for its pelt and bones. In the last 20 years, the Sumatran tiger has also been the victim of the development that has occurred in Southeast Asia, which was once an area in which local societies lived for centuries closely and sustainably with the environment, but now the rapidly growing economies are overwhelming these environments by consuming natural resources at an impressive rate.

At the beginning of the 20th century, the tiger was still present throughout its range. However, in the following decades the Bali tiger (*Panthera tigris balica*) subspecies became extinct, followed by the Javan tiger (*Panthera tigris sondaica*), and then the Caspian tiger (*Panthera tigris virgata*). The last two were similar in size and coloring to the tiger subspecies that can still be found in the region of Siberia overlooking the Sea of Japan, the Siberian tiger (*Panthera tigris altaica*). Today, of the eight known subspecies of tigers, only five still exist. The scientific and conservationist community have not positively observed the South China tiger (*Panthera tigris amoyensis*) in the wild for several years and so it must also be considered extinct in nature, though there are several dozen specimens surviving in captivity. China, however, has not accepted that the tiger has become extinct, although their conservationists have not yet developed a strategy to resurrect its population. Among the different subspecies still existing today, the Sumatran tiger (*Panthera tigris sumatrae*) is perhaps the one most at risk of extinction as there are little more than 400 left in the forests of Sumatra and their future does not look bright.

The island of Sumatra, Indonesia, is the sixth largest island in the world and is home to some of the richest most biodiverse forests on the planet.

183 Male Sumatran tigers measure on average just over 8 ft (2.5 m) in length and can weigh up to 265 lb (120 kg). The females are slightly smaller.

These forests once completely covered the island but they have suffered a rapid and dramatic decline during the last few decades. Economic development, the demands of the international markets, and political leaders who give little attention to the environment have all put this unique ecosystem in serious danger. A large part of the original forests have now been destroyed and so the incredible variety of species living in them are condemned to survive in ever smaller and limited habitats. As with the forests on the nearby island of Borneo, the Sumatran forests are the object of a continuous deforestation process which has reduced their extent by more than 50 percent in the last 30 years, threatening the existence of a still not yet fully explored wealth of biodiversity. Timber sales, agriculture, the practice of cutting and burning back forests have all meant that a variety of rare species, such as tigers, elephants, rhinoceroses, and orangutans, have been driven into increasingly smaller oases of forest, which are unlikely to be large enough to guarantee them a sustainable, long-term future.

If we want to save the tiger, we must urgently address the relentless exploitation of the forests and recover sufficient space and territory to allow these animals enough room to live. In the 1960s, the Sumatran tiger still numbered about 1,000 specimens, but it has been intensely persecuted in the last decades, right into the heart of the protected areas that were created especially to safeguard them, along with the other jewels of biodiversity still inhabiting this island. This splendid big cat is still illegally hunted for its pelt, bones, and other organs used in the traditional medicines of China and Korea, or it is simply killed as it comes into conflict with the increasing numbers of people and their domestic animals.

EN

S U M A T R A N T I G E R

184 and 184-185 The classic black stripes along the length of the Sumatran tiger's body are more subtle compared to those of other tiger subspecies. A skilled swimmer, this animal usually kills its prey in water. Large prey animals are a mainstay of its diet.

186-187 The mating season for Sumatran tigers occurs between October and February, which is the only time that males encounter females.

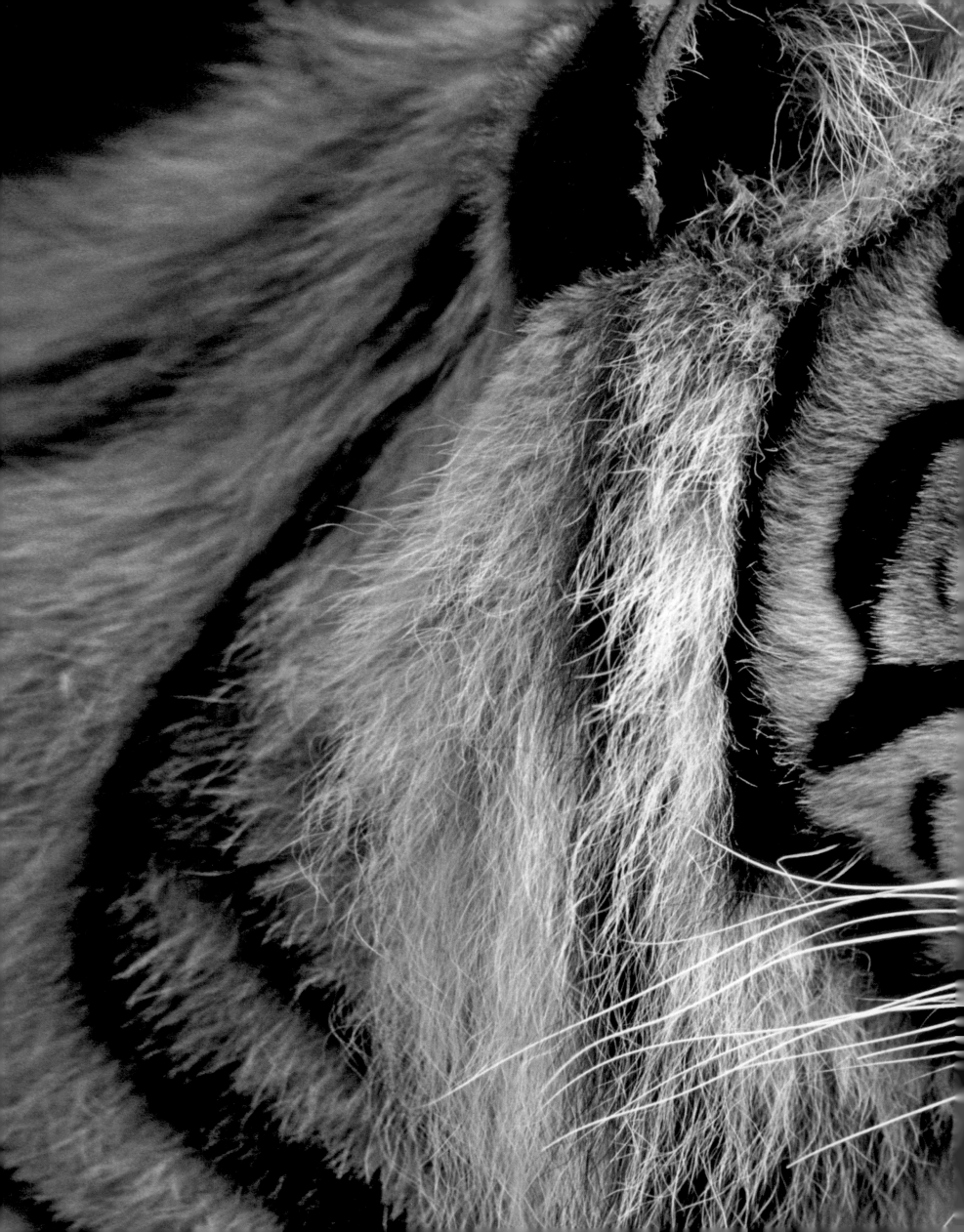

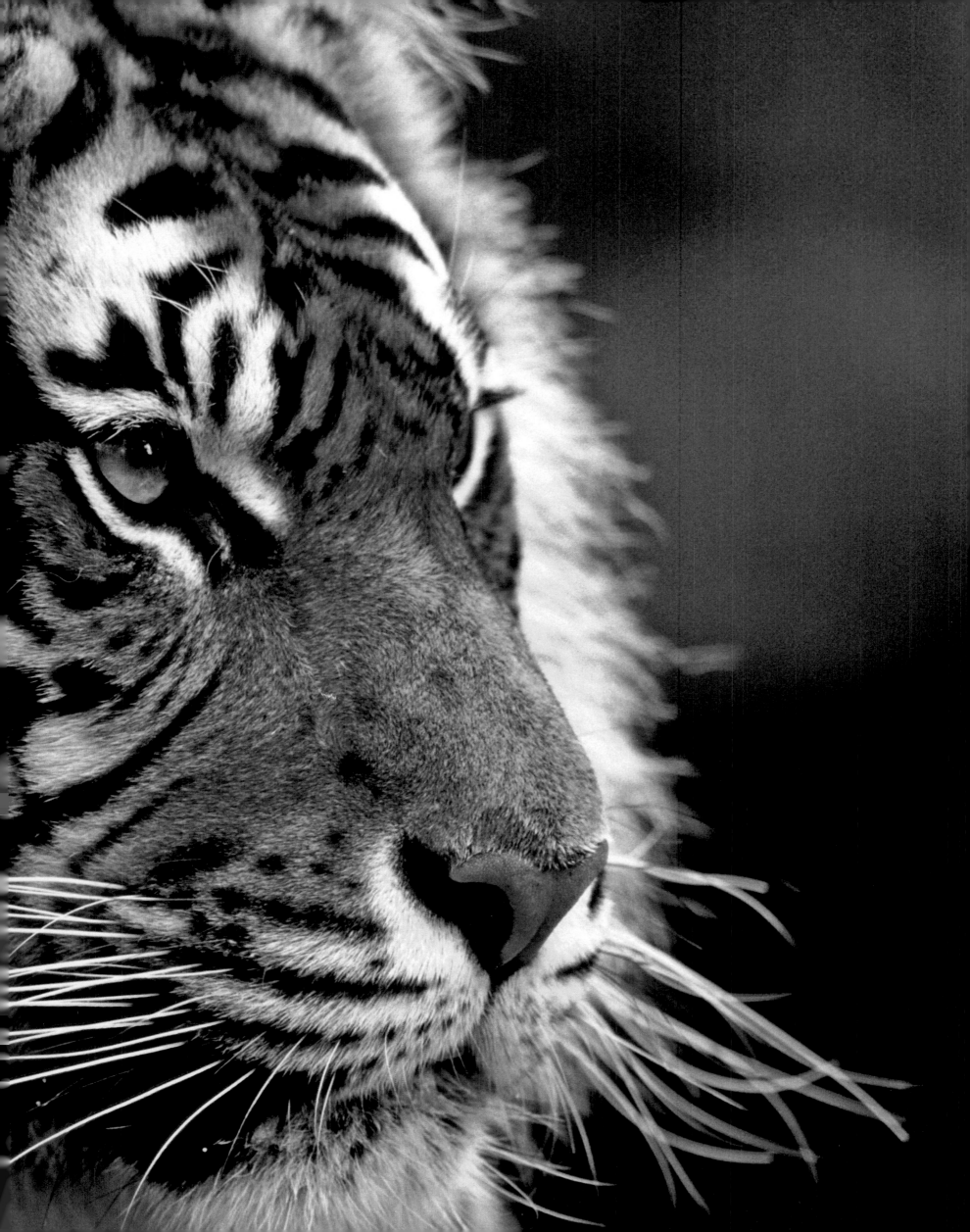

CLOUDED LEOPARD

Neofelis nebulosa

The clouded leopard (*Neofelis nebulosa*) lives on the slopes of the Himalayas in southern China, in the Malaysian peninsula, and on the islands of Taiwan, Sumatra, and Borneo. Definite information concerning the population of clouded leopards living in the wild does not exist, but this cat is certainly endangered throughout its range. There are a variety of threats to the survival of the clouded leopard, including the destruction of its habitat, human encroachment, uncontrolled hunting, and the reduction of its natural prey. In Taiwan, the population has been catastrophically reduced because they are the victims of uncontrolled hunting and could even be already extinct. In the last ten years, not even one clouded leopard has been documented, but it is thought that the leopard's habitat might extend from Chatien Mountain in the north to Tawu Mountain in the south, and confirmed information about it is still scarce. For some Asiatic tribes, the leopard is considered a sacred animal or it is at least greatly respected. The different attitudes of various societies towards the animal make it difficult to establish a coordinated conservation project that would be adopted by all the relevant governments. Whatever the political and social problems, the leopard's salvation requires some essential information. Its biology needs to be studied, its current distribution in nature must be mapped, and its needs in captivity must be fully understood so that captive breeding and reintroduction programs can be properly and effectively managed. Environmental education that could facilitate the safeguarding of the leopard in the wild, the creation of local action groups responsible for promoting public awareness of environmental issues, and the coordination of regional species management and reintroduction projects are also necessary. The monitoring of the clouded leopard by radio-tracking allows the verification of whether the protected territory satisfies the requirements of this species, for example, the dimensions of its range, presence of prey, and sources of available shelter. Only after all these assessments and initiatives are completed will it be possible to decide on the feasibility of reintroduction projects. Following molecular analyses of DNA and on the shape of the markings on their coats, recent research has confirmed that the Bornean populations are a different species to the mainland leopard. The island population that belongs to the new *Neofelis diardi* species is considered in good health, which is most likely due to the absence of other great predators such as the tiger and the leopard.

VU

188-189 The clouded leopard owes its name to its irregular, dark, cloud-shaped spots, which have darker ocher-colored centers on its head in contrast to those on the rest of its coat. The special structure of its skull means that it is distinct from other leopards, so much so that zoologists classify it as a separate subspecies of this cat family.

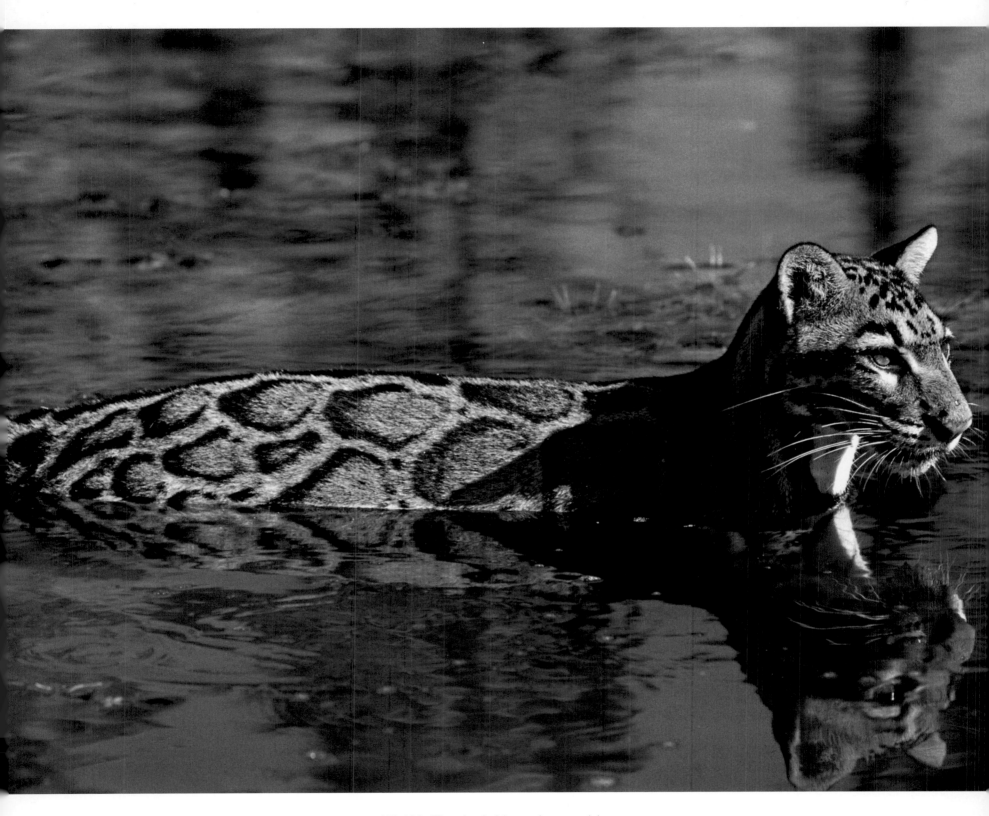

190-191 The clouded leopard may weigh 35–50 lb (16–22 kg), measure 2–3.5 ft (60–105 cm) from its head to the base of its tail, and has a tail up to 3 ft (90 cm) long. Its legs are short and strong, and proportionally it has the longest canine teeth of all the cats.

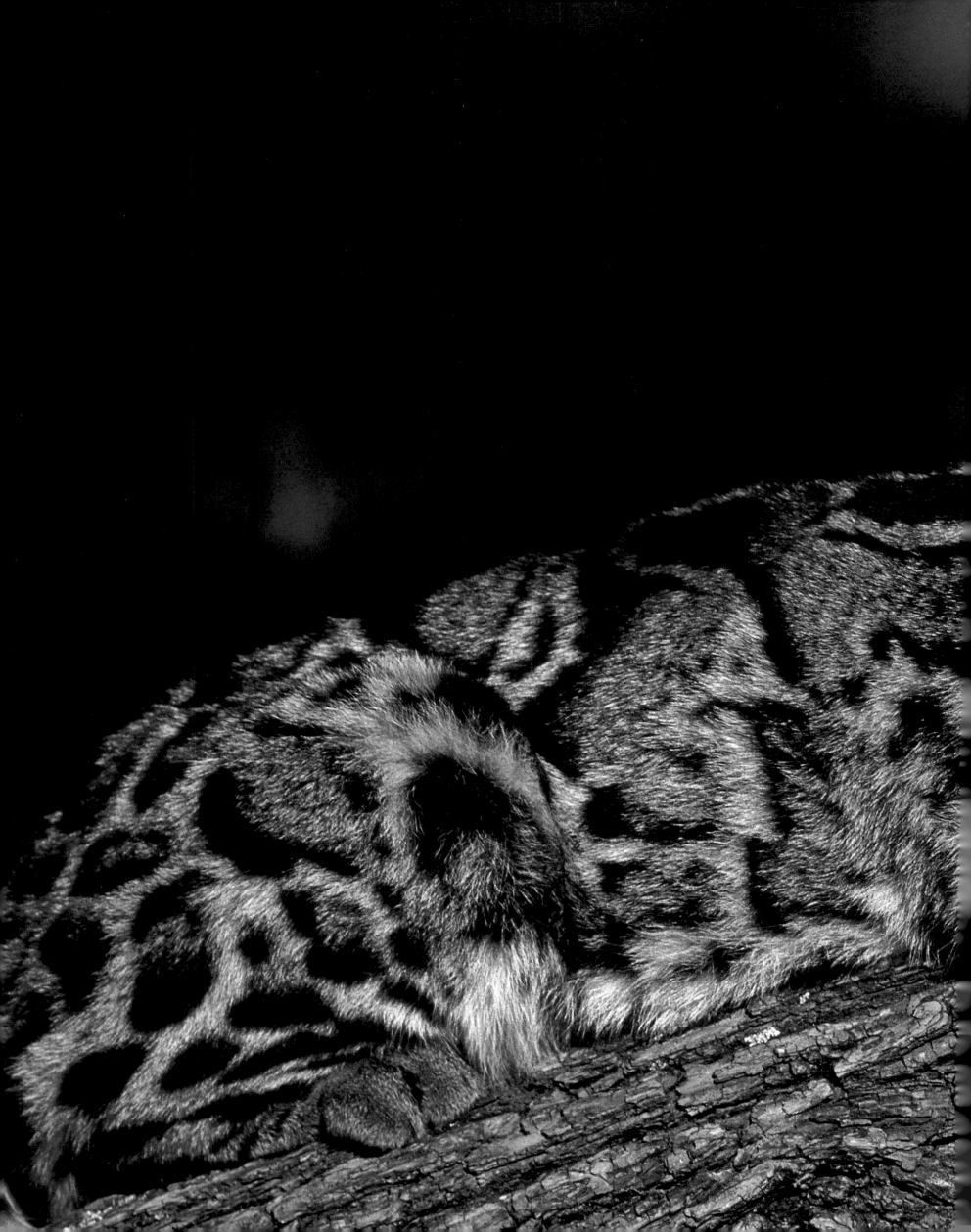

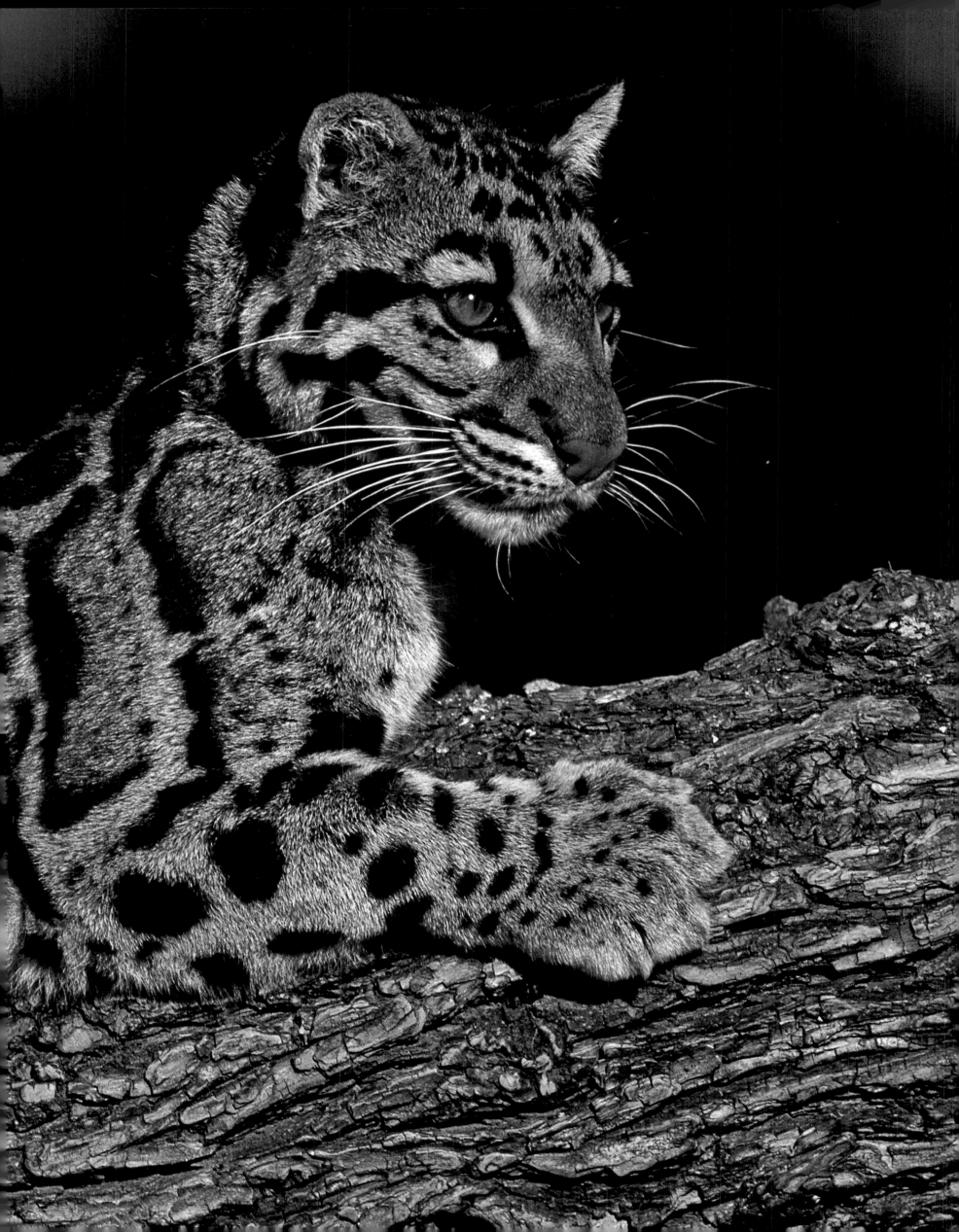

BORNEAN ORANGUTAN

Pongo pygmaeus

Only a century ago the population of orangutans (*Pongo pygmaeus*) on the Indonesian island of Borneo was estimated at about 230,000. After extensive research that number has now been reduced to just 45,000 to 65,000 individuals, testifying to the sadly steady decline of the species. Despite always having been hunted by the local people, the orangutan has succeeded in coexisting with humans for more than 40,000 years. They have shared the wealth of the tropical forests that once covered Borneo from coast to coast, as well as providing the occasional supplement to human diets. However, at no point were they ever threatened with extinction in any part of the island. Even the arrival of the renowned Dayak people, known to Westerners for their combat skills, who colonized Borneo some 4,000 years ago from the Malaysian peninsula and Sumatra, did not present any serious threat to the orangutan. Although orangutan hunting probably did increase because the Dayak considered the animal a delicacy and an important source of products for tribal medicine, but it was still not a level to pose a threat to their population.

The crisis in the orangutan population and decline towards extinction has only really come about in the last few decades, caused mainly by ruthless hunting using modern means, sport hunting, and collecting by Europeans for museum collections. Additionally, the market for household pets has become a growing concern in the last few years, with the export of thousands of young orangutans to the Chinese, Cambodian, Thai, and Malaysian markets, and subsequently to zoos and private collections throughout the world. An equally grave threat has been the destruction of the forests over the last 40 years, cleared at an alarming rate in order to satisfy the growing demand for exotic wood products, such as ramin. These unique forests, so full of life, have been replaced by oil palm tree plantations now extending as far as the eye can see or acacia nurseries. Millions of acres of trees have been burned, leaving only degraded fragments of the original forests. Inevitably, this has meant the loss of the ideal habitat for the orangutan, forcing them into increasingly restricted areas so poor in resources that they are unable to sustain a viable population for very long. Recent research has shown that there are more than 300 orangutan populations increasingly fragmented and isolated from each other, concentrated mainly in the Indonesian area of Kalimantan and the region of Sabah, where there are two different subspecies. The *P. p. wurmbii* subspecies is present in the southern part of Borneo, in central Kalimantan, and is the largest of the three recognized subspecies; Sabah and eastern Kalimantan is where the *P. p. morio* subspecies lives, which is the smallest; while in western Kalimantan and in the region of Sarawak there survive a few of the *P. p. pygmaeus* subspecies. Today, efforts to save the orangutan and its unique habitats with their incredible biodiversity are concentrated on the protection and conservation of the forests on Borneo. With the careful and responsibe management of these forests, there is a possiblity that this extraordinary and peaceful animal will be saved.

EN

193 The Bornean orangutan is a hominid monkey with full cheeks. A male can weigh up to 200 lb (90 kg), a female up to about 110 lb (50 kg).

195 The Bornean orangutan is covered with reddish, long hair, which acts like a type of "raincoat."

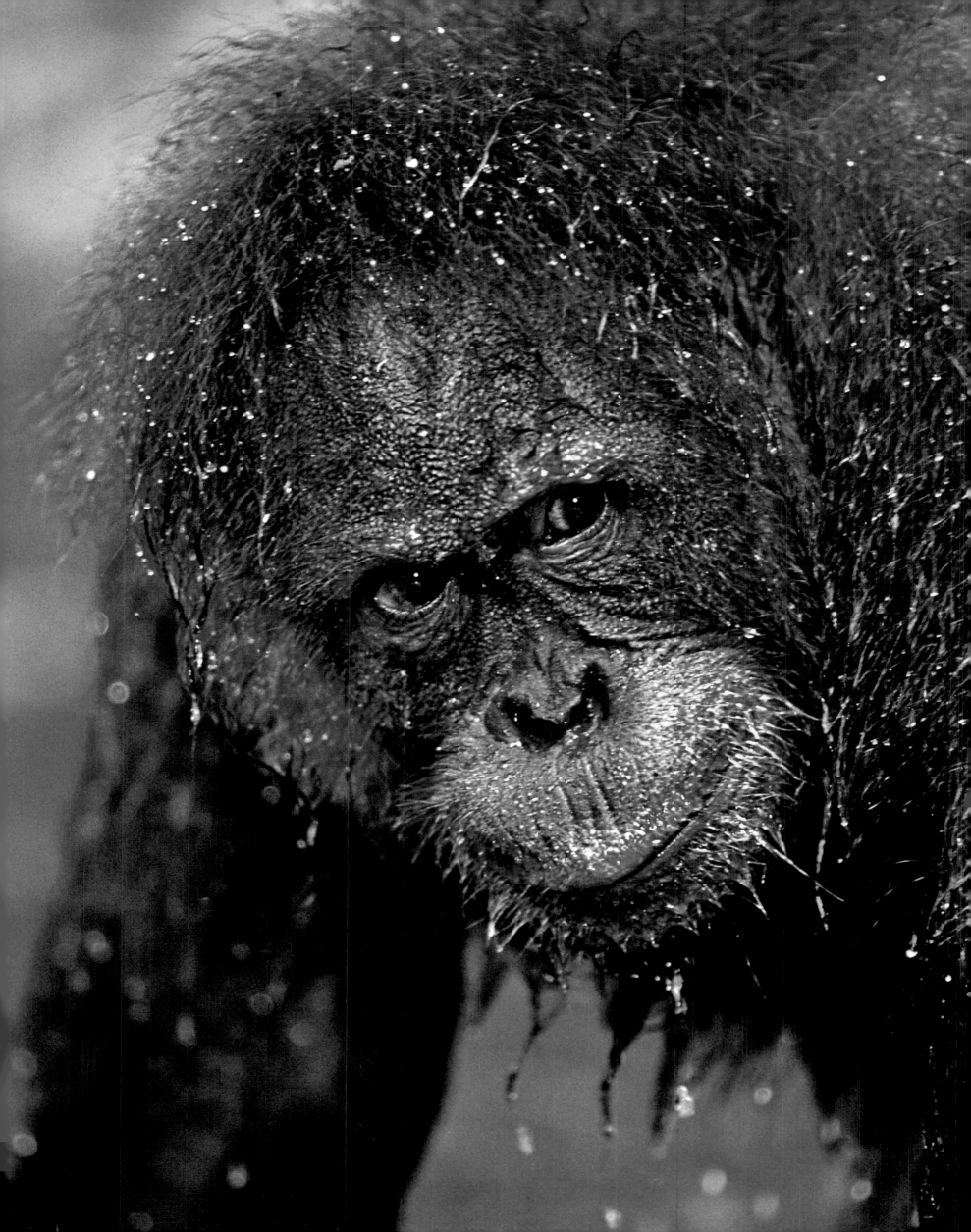

Sustainable management of the territory is essential for the conservation of the Bornean orangutan

The island of Borneo has a large forested area rich in biodiversity. In the last few years, however, it has been subject to severe deforestation that has steadily reduced this forested area. As in other tropical areas of the world, natural environments have been destroyed to make way for monoculture to satisfy the demand for raw materials and energy sources in the interests of economic growth, such as oil palm tree plantations for the production of fats and vegetable oil intended for the manufacture of biodiesel fuel. However, this does not improve the living conditions of the resident populations. For centuries, the indigenous Dayak people of Borneo have been the guardians of the forests that are home to the last specimens of orangutan, Javan rhinoceros, and pygmy elephant. Given their dependence on the resources offered by the forest, the Dayak have developed a proprietary territory management system that promotes the maintenance of a natural balance.

Currently, the survival of animal populations living inside the Kayan Mentarang and Betung Kerihun National Parks is threatened by illegal timber cutting, mining activity, and the trapping of species for sale on the international market. The destruction of these areas condemns the human and animal populations to the same destiny. Orangutan and gibbon habitats are being destroyed by industrial exploitation of the forest resources and fires, and so these areas become unable to support both humans and animals who are thus compelled to move away. In this case, what is advocated instead is shared territory management with the local communities in order to halt environmental decline caused by deforestation. The WWF coordinates an ambitious program that aids in reviving the traditional practices of agriculture, hunting, fishing, and use of forest byproducts, which would then make the inhabitants responsible for a beneficially sustainable management of the environment, and so the species most at risk would be conserved. In practice, the WWF facilitates the subdivision of territory into small manageable units that are established with the consensus of all concerned for the goals of:

- defining interactions between activities carried out by human communities and the protection of natural heritage
- documenting and recognizing usage rights regarding natural resources
- i• dentifying and resolving conflicts on access to resources for all those concerned
- promoting the participation of indigenous communities in the management of protected areas and conservation activities
- developing a local skill set and evaluating traditional knowledge
- facilitating territorial planning inside and around the protected areas by respecting the natural heritage of plant and animal species.

For the populations living in "protected" forests, this often means the opposite of what they think. Within protected areas, Indonesian law prohibits hunting, fishing, plant removal, and creation of smaller cultivated fields, activities that actually constitute the traditional way of life to the Dayak. Confronting such a threat to their survival, these communities are compelled to migrate to the cities, involving the inevitable loss of their cultural identity and traditional teachings, or otherwise turn to illegal activity to support their families. The new development is to include Dayak representatives on park management committees and to involve more than 50 villages in the shared control of natural resources. Eco-tourism and the sale of artisan products make up an important part of local revenues. But the most important aspect of this management system consists in the fact that the Indonesian government has recognized the Dayak's right to use their own land and be represented in the parks' decision-making bodies.

Social justice and respect for indigenous populations are essential elements in any program designed to conserve nature or combat poverty, whether in Borneo, the Amazon Rainforest, or the Bay of Congo.

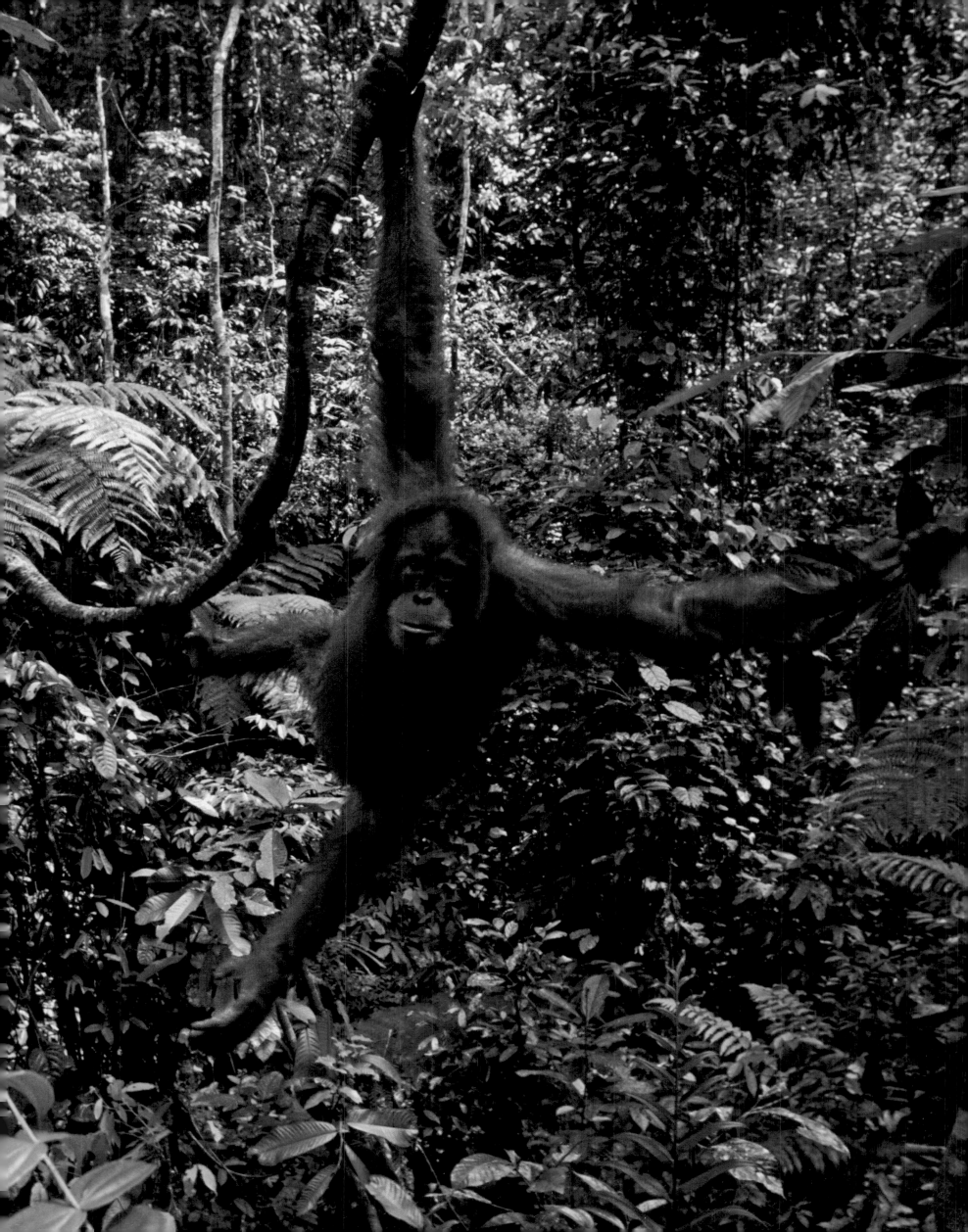

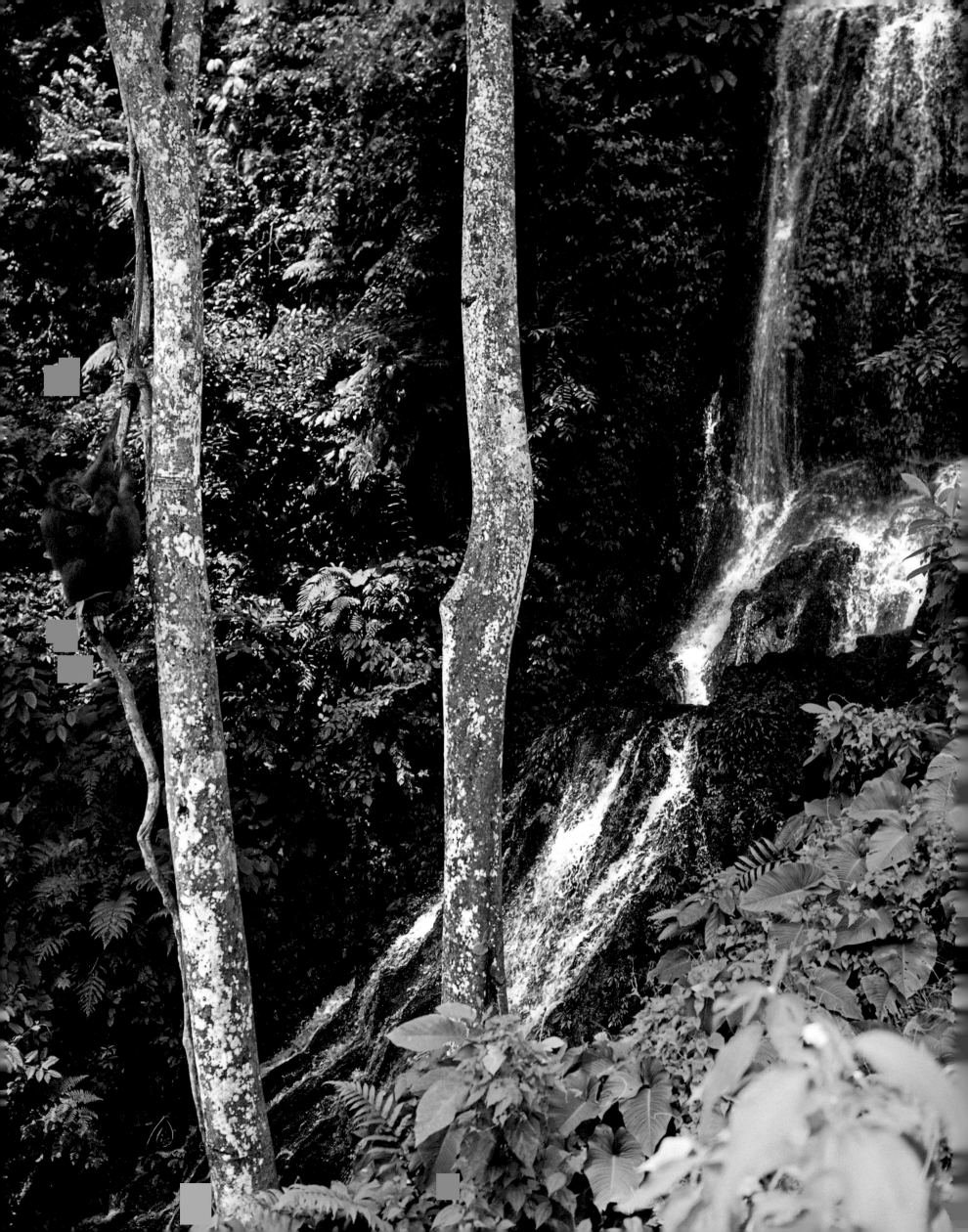

196 and 197 The Bornean orangutan's legs are short and weak and are unable to support its weight in an upright posture for long. On the other hand, its feet are wide and fat, with powerful big toes that allow it to grasp branches firmly.

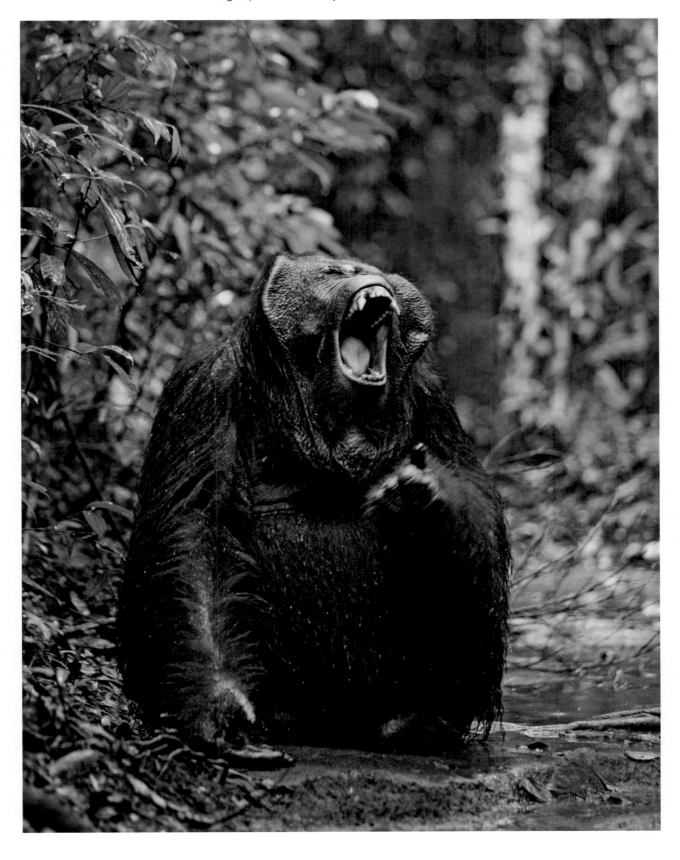

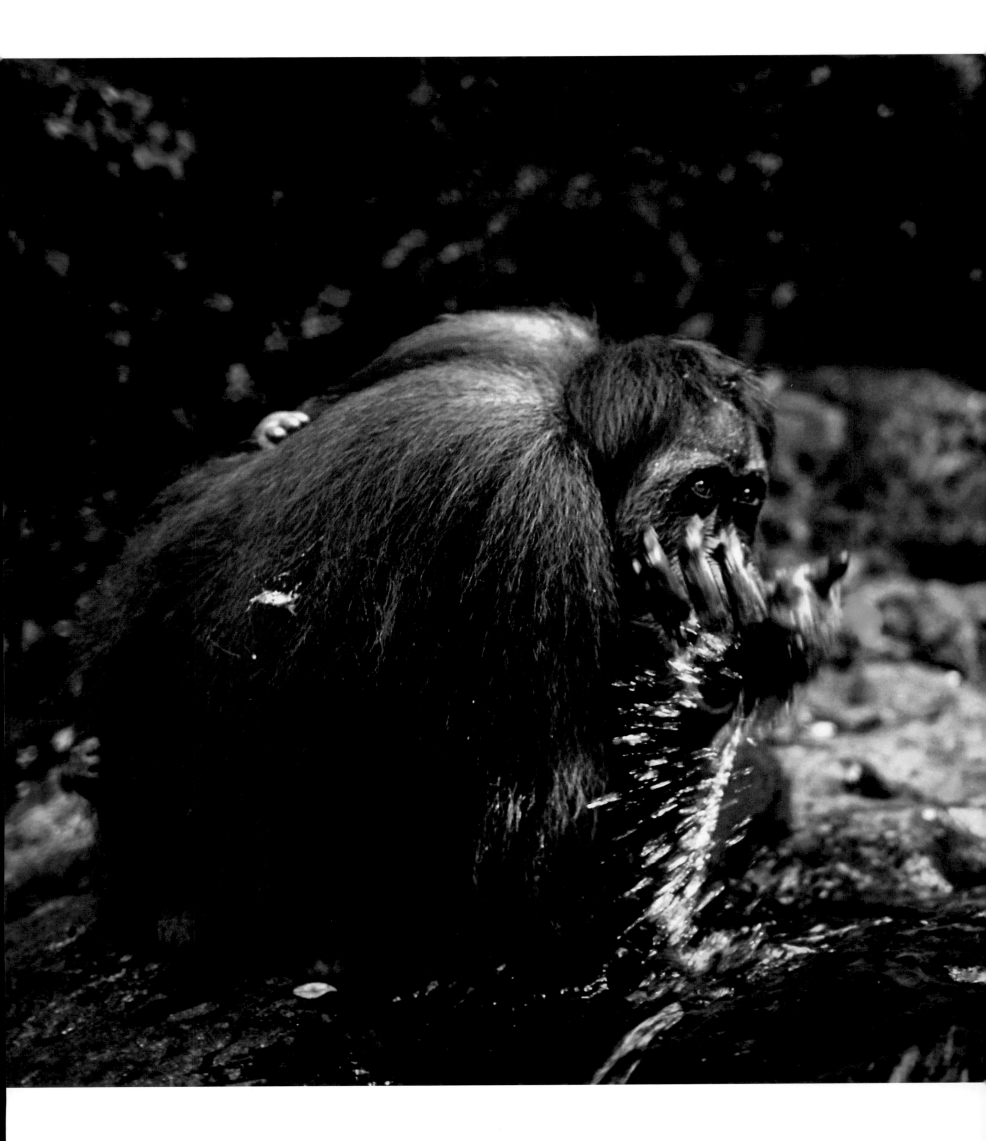

198-199 *and* 199 The Bornean orang-utan's hands are equipped with four very long fingers and a thumb that enables it to climb trees to get food. Even its arms are long and strong, allowing it to swing from one tree to another or for supporting it when searching for food or water.

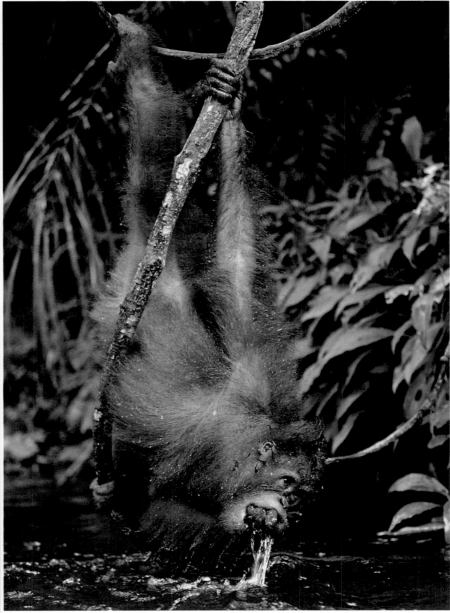

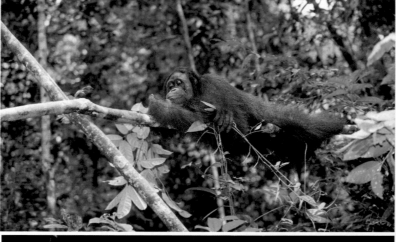

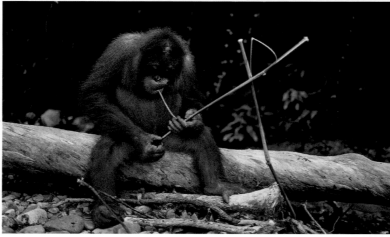

200 and 200-201 Bornean orangutans spend most of their time in the trees as their legs have not adapted to walking on the ground. Their preferred foods are fruit, leaves, bark, berries, and nuts.

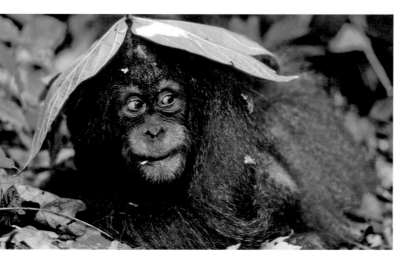

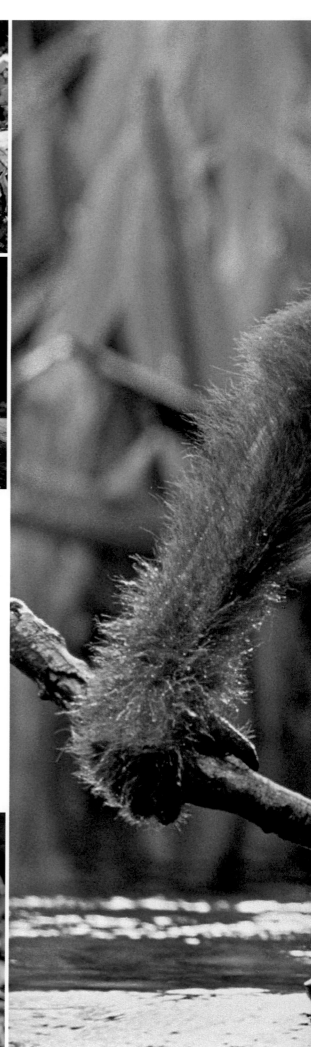

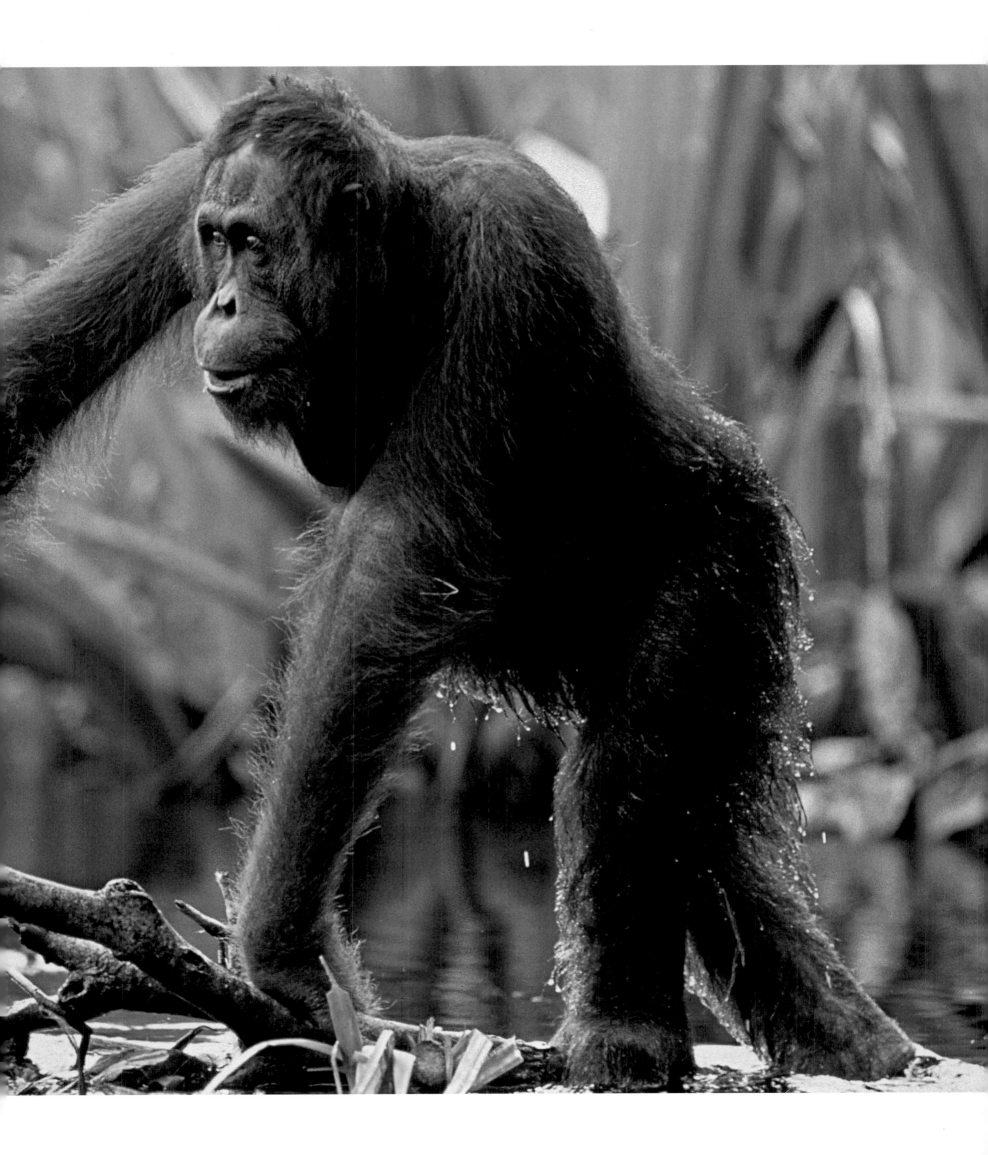

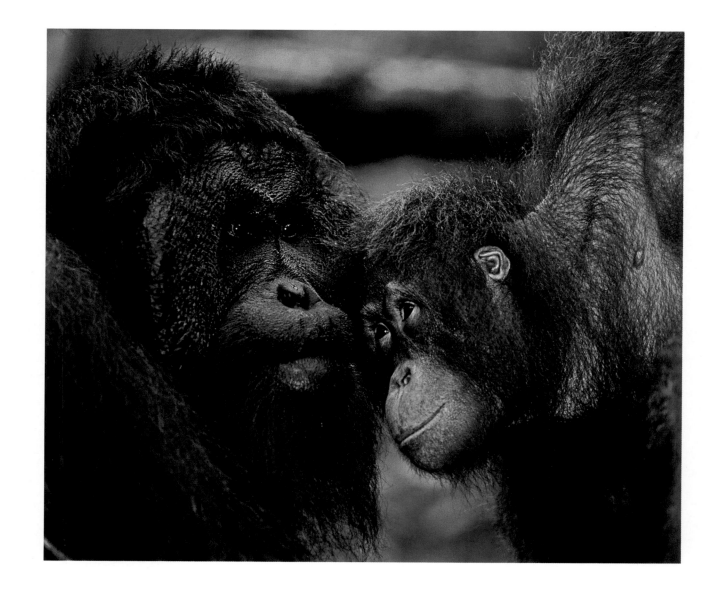

VANISHING ANIMALS

202 and 203 Bornean orangutans reproduce year round and their gestation period is generally 275 days. Orangutan babies are quite small at birth but still succeed in climbing up their mother's coat and they remain closely bonded to her.

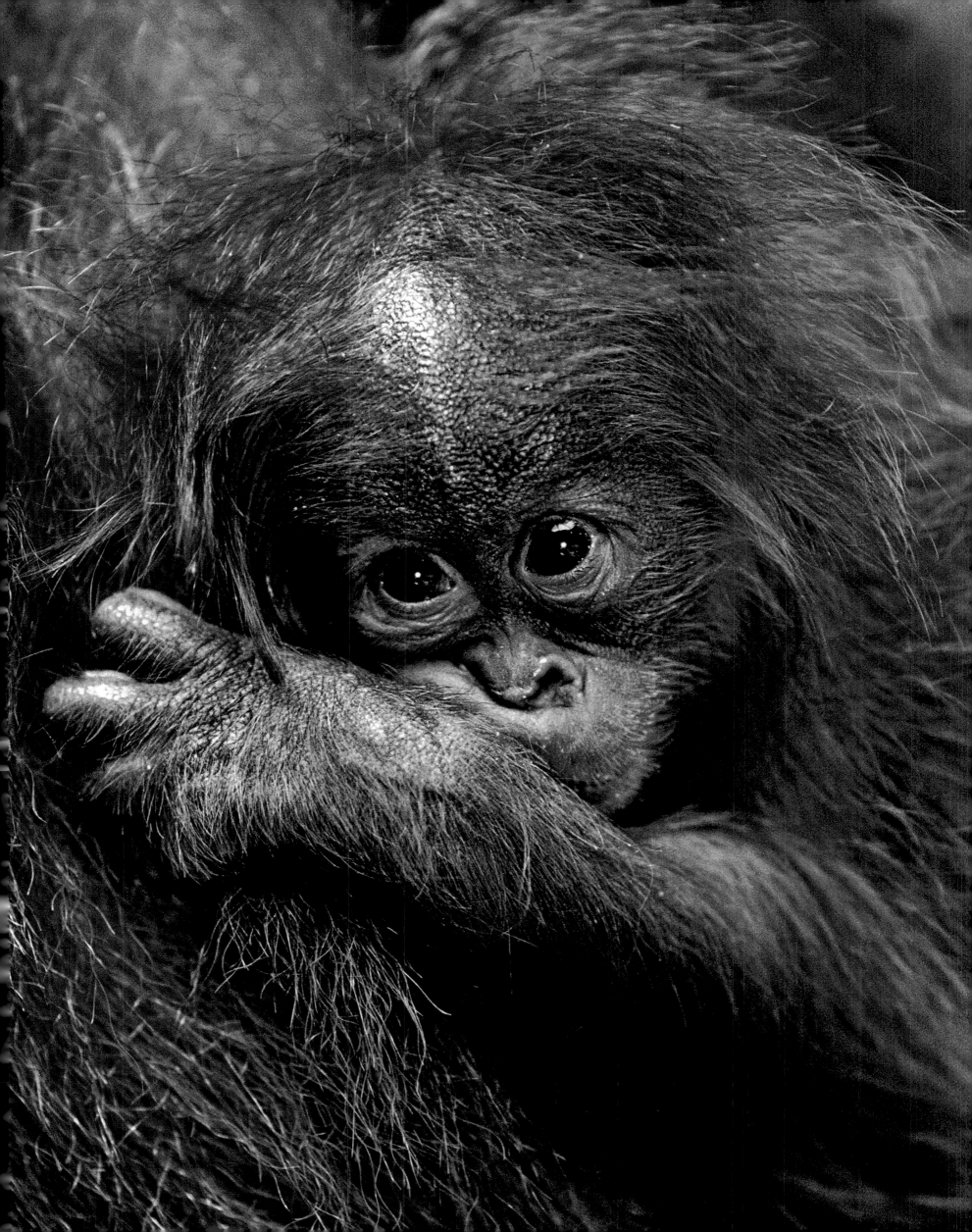

DOUC LANGUR

Pygathrix nemaeus

The small douc langur monkeys (*Pygathrix nemaeus*) are agile and rowdy, and they almost never descend to the ground but spend their whole lives high in the forest canopy. They are found in a region that acts as a watershed between Vietnam, Laos, and Cambodia. The most widespread species (*Pygathrix nemaeus*) is multi-colored, with a grey back, an orange muzzle, white neck, arms and tail, and a rust color on the backs of its other limbs. Of the other species, *P. cinerea* has gray hands and *P. nigripes* black ones. The douc langurs mainly feed on very carefully selected leaves and, to a lesser degree, on fruit, flowers, and berries. They live in family groups comprised of 4 to 15 individuals with one or more males and about two females per male, along with their offspring. Once, the small family groups joined together, creating complex social systems of up to 50 individuals. However, it is now rare to see so many langurs together, whether because the population declined to such an extent in the last century or because continuous removal from their natural habitat has made them more cautious. Although, it is said that their inquisitive nature means that they will stop and observe an impending threat, and have even done so in the presence of firearms and then instead of fleeing while companions are shot down, the tiny langurs stop and watch dumbfounded, becoming easy prey themselves. Even now when they are subject to legal protection, the brightly colored langurs are still constantly threatened by poaching, whether as a food source or for their bones which are used in preparing balms for use in traditional medicine. They are even sold as household pets, but they do not live for long because their special diet cannot be easily supplied in captivity. In addition, douc langurs are threatened by the steady destruction of the Annamite forests, which first began with the use of defoliants during the Vietnam War, then due to intense exploitation for wood products and the clearing of large areas for agriculture and settlements as a result of the rapidly increasing human population.

EN

204 and 205 In Vietnam, the survival of the red-shanked douc langur is primarily threatened by deforestation for the intensive cultivation of the coffee bean and also rubber plantations, as well as timber removal for commercial use. Douc langur have a slender build and long tails that they use to balance, unlike the prehensile tails of most other monkeys.

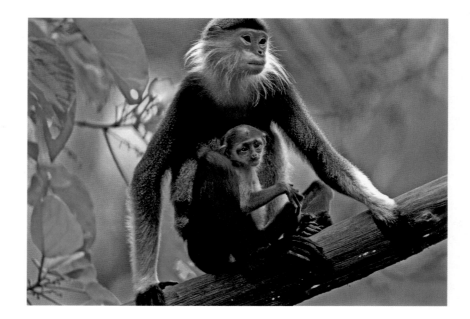

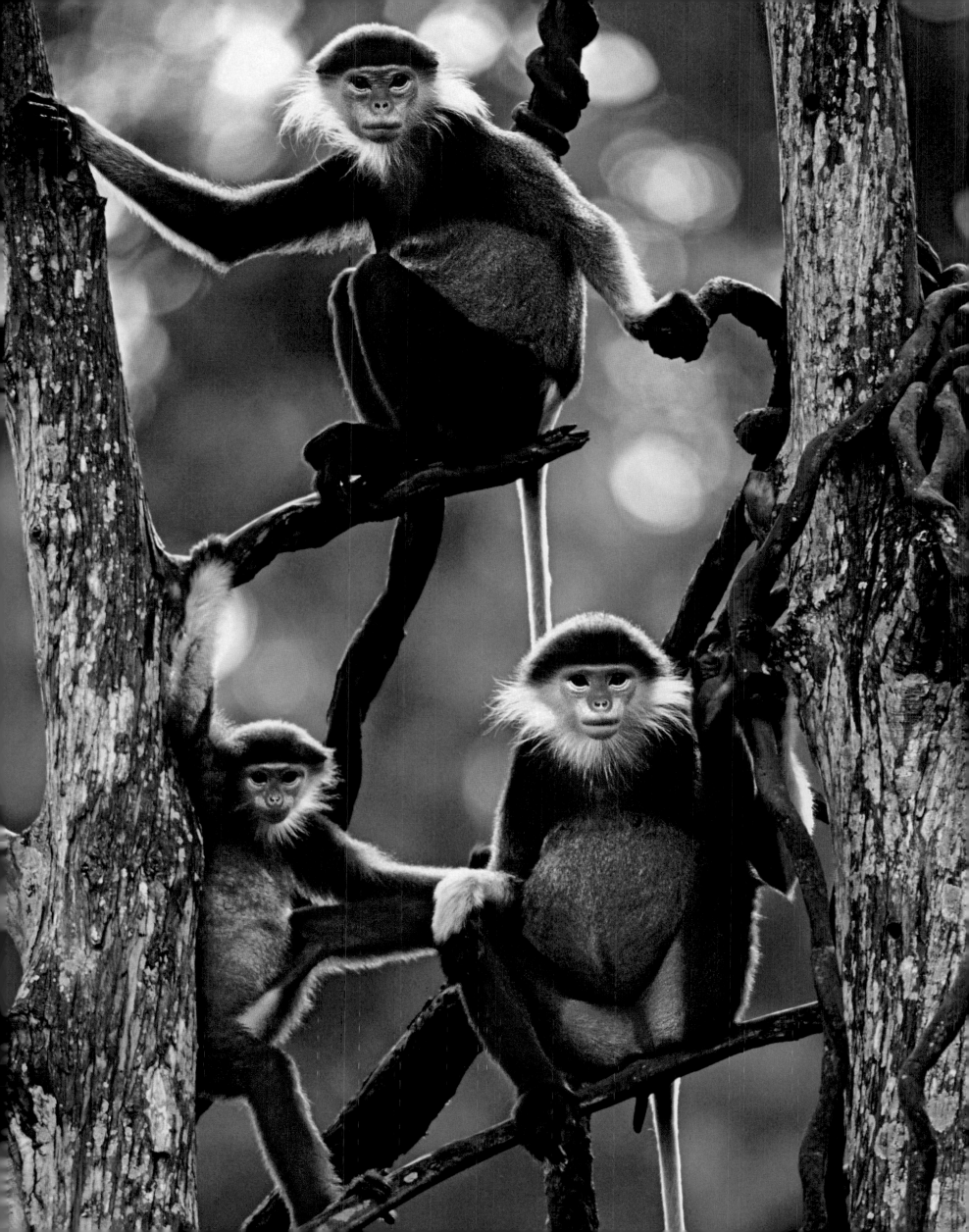

GIBBON

Hylobatidae

The gibbons (Hylobatidae) are among the species most threatened by extinction and yet are the least studied in the world. They are genetically very close to the anthropoid monkeys and therefore to humans. Gibbons are arboreal (tree) monkeys that live in the tropical rainforests of Southeast Asia, where they move with acrobatic grace from one tree to the next using a peculiar method of movement called "brachiation." In order to move rapidly through the foliage, gibbons mainly use their arms, which are the longest among all primates. This characteristic and a body weight that rarely exceeds 22 lbs (10 kg) makes them agile and light enough to pick fruit growing at the highest layers of the forest, where they sleep suspended from the branches and spend their whole lives. Gibbons form stable couples and defend their young and territory with characteristic long and modulated chants that resound throughout the vault of the forest. Unfortunately, these same chants, useful for the demographic study of natural populations, also indicate their presence to poachers. Every year, dozens of young gibbons are confiscated by the authorities and it is thought that for each juvenile taken, an adult is killed, probably the mother.

There are 14 species of gibbons, half of which are at risk of extinction. Some species, such as the Javan silvery gibbons (*Hylobates moloch*) that live only on the island of Java, or the crested gibbons (*Nomascus sp*.), spread throughout the Vietnamese and Laos forests, are particularly endangered. Deforestation for the commercial exploitation of timber, intense oil palm tree cultivation which replaces the original forests, illegal removal of live specimens, which are not just sold to local villages as household pets but more often supplied to a lucrative and illegal international market, and finally the growing demand for organs used in preparing balms for use in traditional medicine are all grave threats to the survival of the gibbon.

CR

207 The white-handed gibbon (*Hylobates lar*) is an animal that is typically diurnal and loves to live in the trees. It has a white ruff that surrounds its entire face and forehead, giving it the appearance of a mask. Its hands and feet are a greyish white color on the outside and black inside.

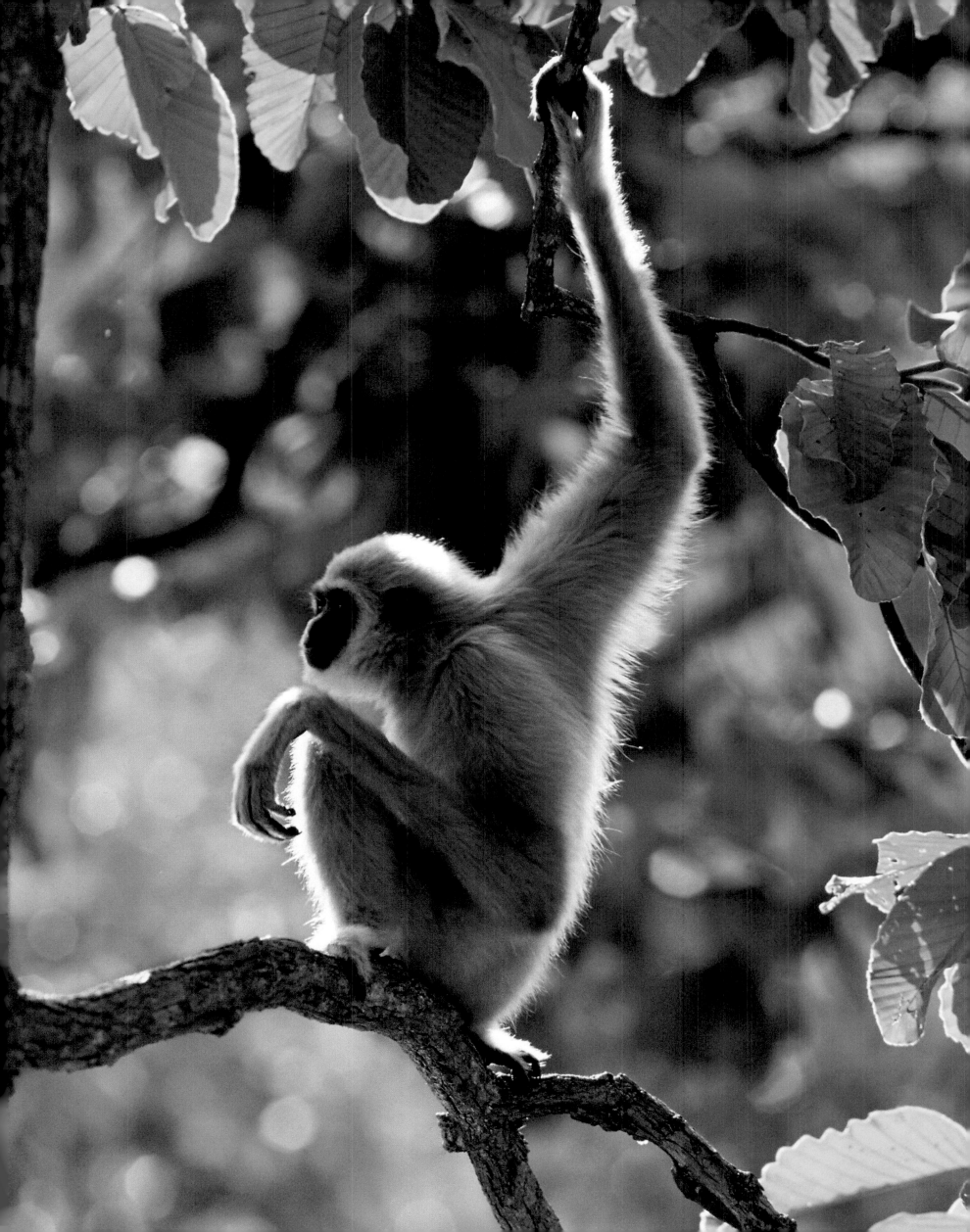

208 left There is little difference between the sexes with regard to weight or the development of canine teeth as is the case with other primates, but many differences may exist between males and females in the coloration of their coats.

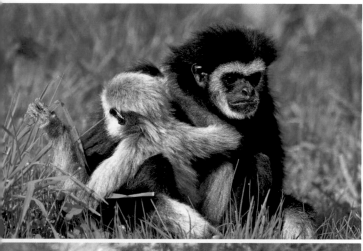

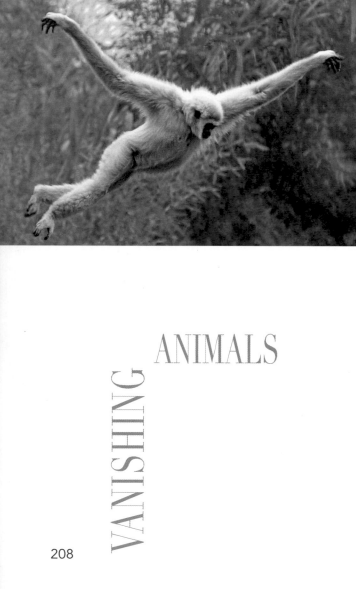

208 right Gibbons emit special vocalizations that may last up to 10 or 20 minutes depending on the species. In most cases, the male and female sing a duet, combining sequences of modulated chants based on rigid formats. In addition to claiming territory, these sounds serve to reinforce the bonds of the couple. The photograph to the right is a typical example of the Siamang gibbon (*Hylobates syndactylus*).

208-209 Considered the best acrobats in the forest, gibbons have the longest arms of all the primates, allowing them to swing great distances of up to 33 ft (10 m) from one tree to another.

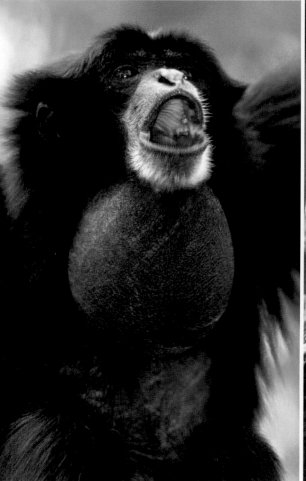

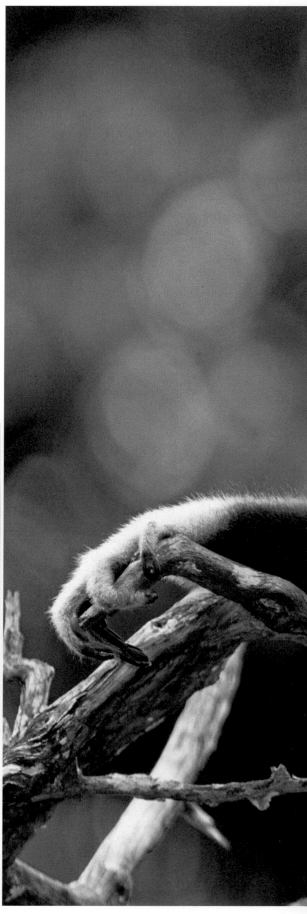

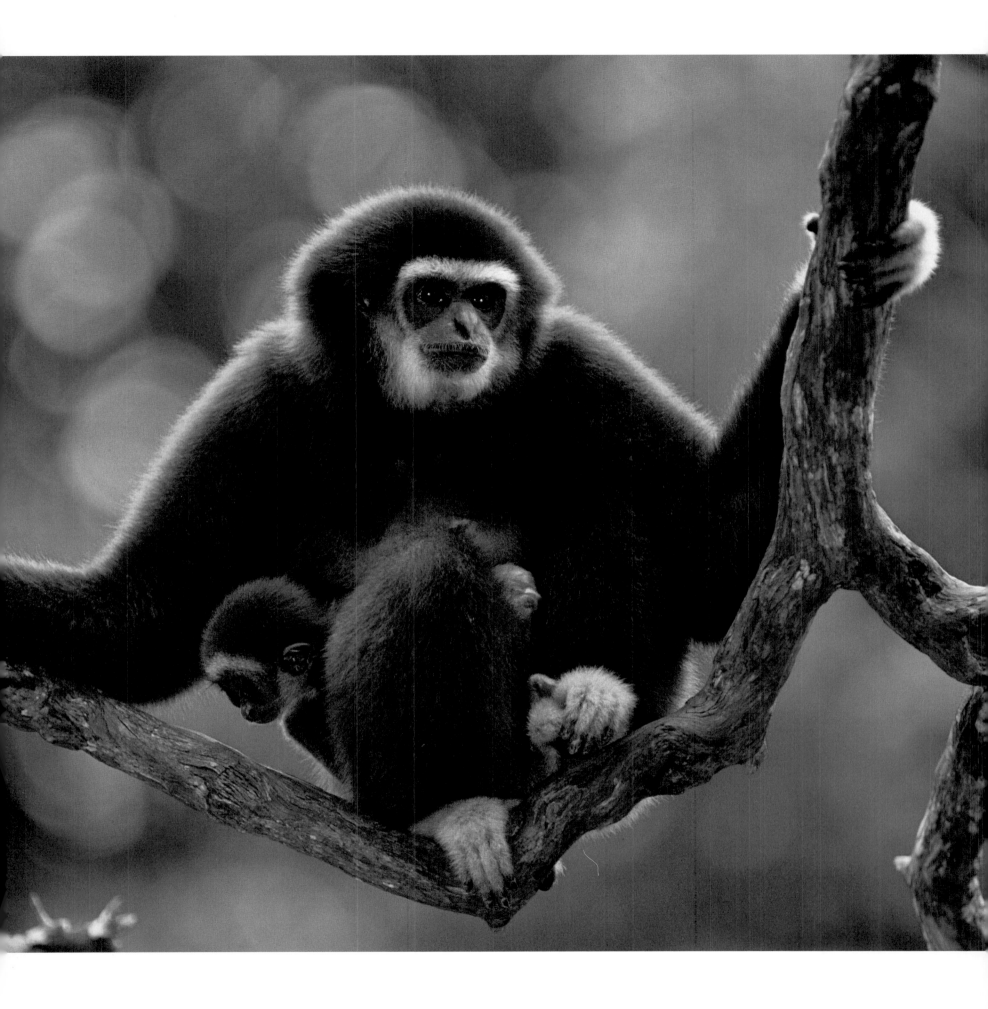

209

GIANT PANDA

Ailuropoda melanoleuca

The giant panda (*Ailuropoda melanoleuca*) symbolizes the 40-year global battle for conservation. Selected as the logo for the WWF because of its rarity, it is now associated throughout the world with the passionate desire to conserve the environment and to rethink our relentless consumption and exploitation of natural resources. The giant panda became known of in the West in 1869 when the naturalist, Father Armand David, had the skin and complete skeleton of one delivered to the Museum of Natural Sciences in Paris. Since that time this bear has been considered quite different from the seven other species that comprise the Ursidae family. In fact, it has even been debated whether or not it is correct to group it with the other modern bears.

The giant panda lives in the mountainous bamboo forests of southwestern China, in the provinces of Sichuan, Shaanxi, and Gansu, at altitudes between 5,900 ft (1,800 m) and 11,500 ft (3,500 m). It has always been considered a rare animal, increasingly confined to smaller territories and endangered because it depends entirely on certain species of bamboo for its food. If classified as a bear, the giant panda is different from its closest relatives because it is a herbivore, which means that it has to spend most of its time eating in order to consume enough calories to maintain its energy needs. Its dietary requirements are also connected with other aspects of its ecology, requiring it to have large enough territories to provide a sufficient supply of food which can only be provided by the bamboo forests. In the last several decades, these habitats have gradually disappeared due to human encroachment and the clearing of the bamboo for agriculture to sustain the constantly growing Chinese population.

EN

211 The giant panda leads a solitary life, encountering others of its species only occasionally. It can reach a height of up to 5 ft (1.5 m), weigh anything from 165 to 355 lb (75–160 kg), and on average lives for 10 to 15 years.

213 Panda cubs weigh 3.2–4.6 oz (90–130 g) at birth, but an adult can weigh more than 220 lb (100 kg). Their infant mortality rate is very high. A study of satellite images has indicated that the panda's specialized habitat has decreased by 50 percent over the last 15 years.

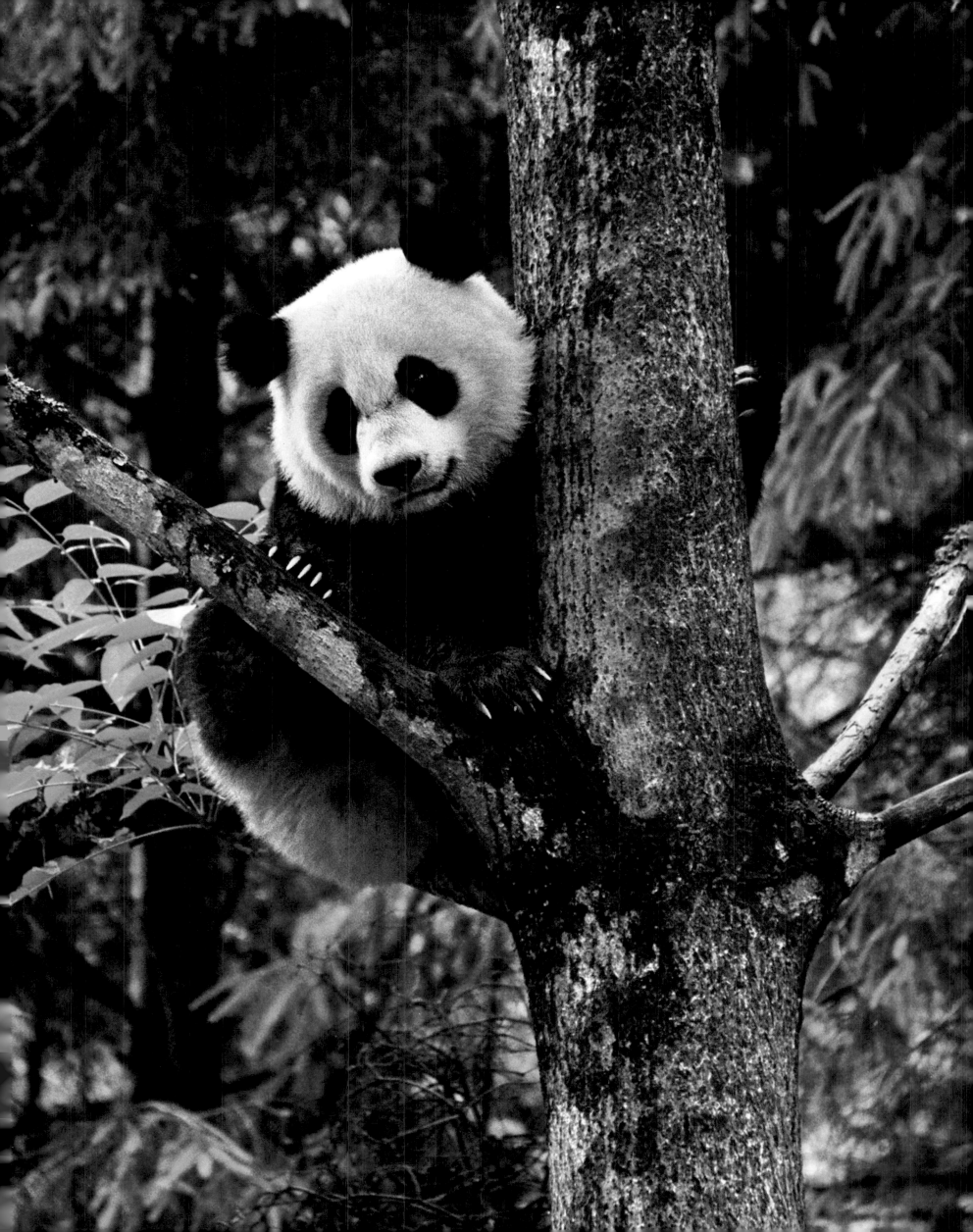

Protected areas and nature preserves
to safeguard the panda's habitat

The phenomenal rate of China's economic growth and modernization over the last 20 years has been welcomed as a great success and considered beneficial to its population. With an annual economic growth rate of 10%, there has been improvement in living conditions, even when an estimated l.8% out of a total 1.27 billion people still live beneath the poverty level. But if economic development continues at this pace, the country's natural resources will not be able to sustain it and the environment will succumb to pollution and excessive exploitation. So, the immediate challenges for today's China are to ensure sustainable development, maintain the essential preservation of natural resources, and achieve better living conditions (both economically and environmentally). The mountainous area of Minshan extends into the provinces of Sichuan and Gansu, and is home to the most stable population of giant pandas, while another established population, of approximatley 500, is in the area of the Qinling Mountains in Shaanxi province. The WWF was the first environmental association invited by the Chinese government to support their panda conservation program. From the institution of the first protected area in 1965, some 33 preserves have been created as well as the establishment of a conservation program that provides for more sustainable management of forest resources in the preserves. Some of the success of this program is attributed to the initiatives undertaken by the WWF with the local communities. In order to encourage farmers to diversify their activities and so safeguard their income, which would otherwise be threatened by the prohibition of deforestation of protected areas, the WWF has developed a wide-ranging training program for cultivating non-wood forest products, new breeding practices, beekeeping, and horticulture. The project has additionally facilitated the sale of the new agricultural products produced in the protected areas, such as the honey and herbs, by arranging supply agreements with companies that have extensive distribution networks. An economic mechanism has thus been created that, in addition to improving local farmers' income, has diminished the pressure on the giant panda's habitats, which were greatly threatened by unsustainable removal of timber and other forest byproducts. Also, in both the main population areas they are also instituting a sustainable tourism program, which involves local communities in widespread hospitality activities, horseback-riding trips, and trekking excursions to supplement their agricultural incomes. A major aim of these programs is, once again, to reduce the illegal removal of timber that once represented the principal economic activity. Even environmental restoration activities have become a source of income for local populations that are directly involved, because they are adequately compensated for any work they undertake that involves significant reforestation and renewal of the landscape.Conservation interventions on this scale inevitably and necessarily involve restrictions on the exploitation of natural resources that must be compensated for with alternative income-generating activities for the local populations. Otherwise the likely result would be economic hardship and impoverishment, the loss of local support for the conservation objectives, and renewed pressure on the delicate habitats. In the case of the giant panda, as for so many other animal species, further threat of territorial fragmentation would create isolated populations with increased vulnerability because of the resulting limited exchange of genes. Additional action to avoid this isolation of populations includes the creation of biological corridors for animals to move along, restoring some of the environments that have been destroyed, and facilitating the reuniting of populations that have become separated from one another.

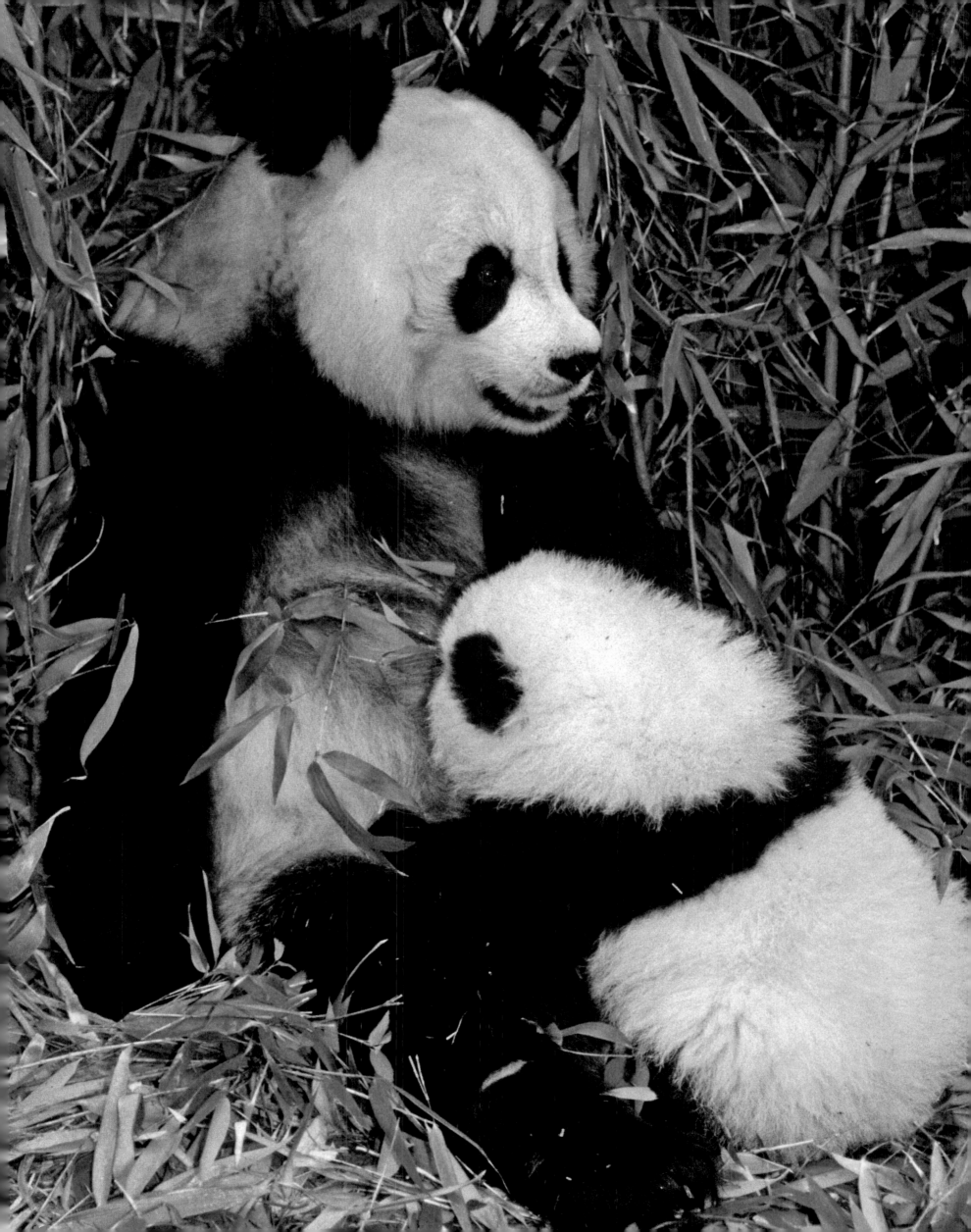

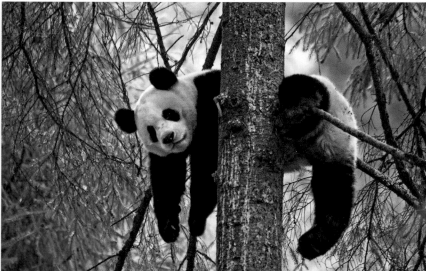

214 and 214-215 The giant panda goes up into the trees or withdraws into caves when looking for food or feeling the need for a nap.

VANISHING ANIMALS

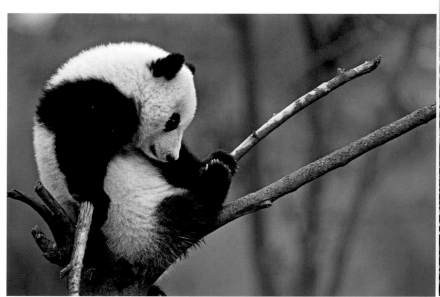

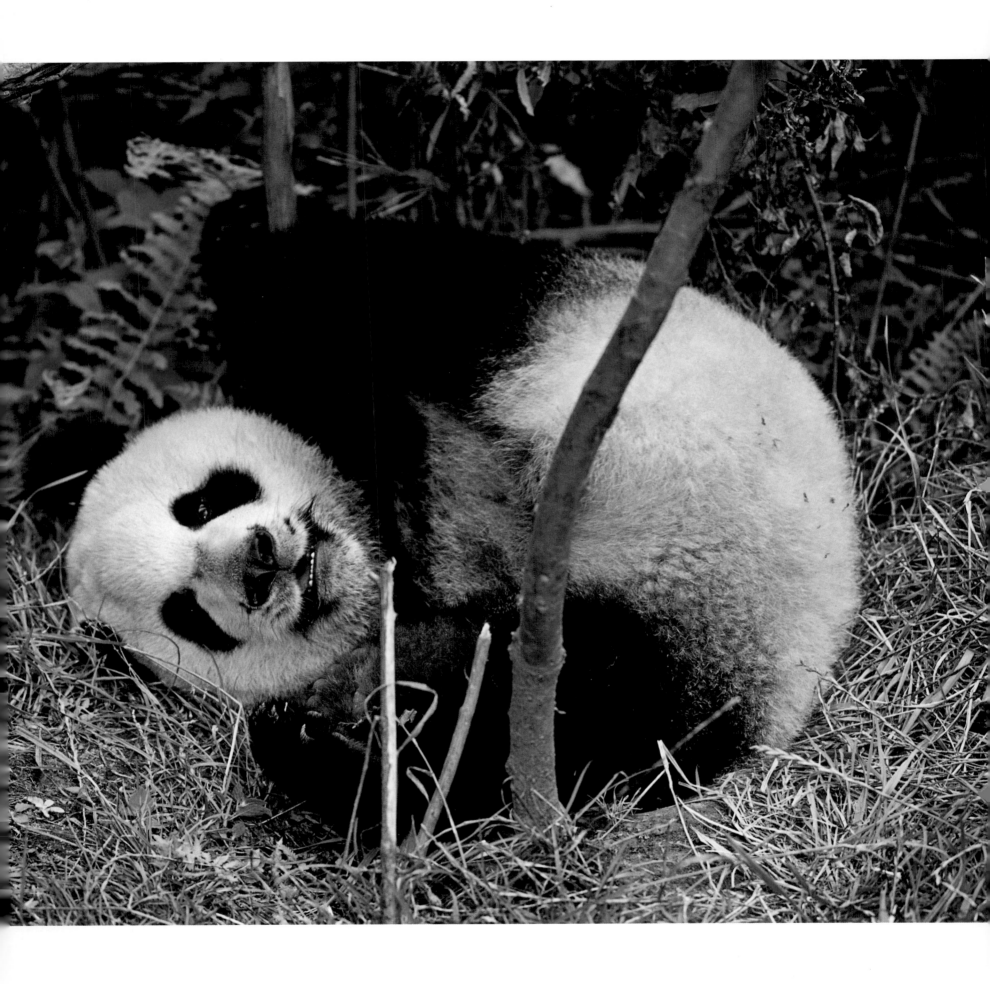

216 The giant panda has a digestive tract typical of carnivores, but over time it has also adapted to a vegetarian diet and now feeds almost exclusively on bamboo stems and leaves.

216-217 The giant panda only has two colors: black and white. Its muzzle is round and white, its ears and the areas around its eyes are black, as are its limbs and back.

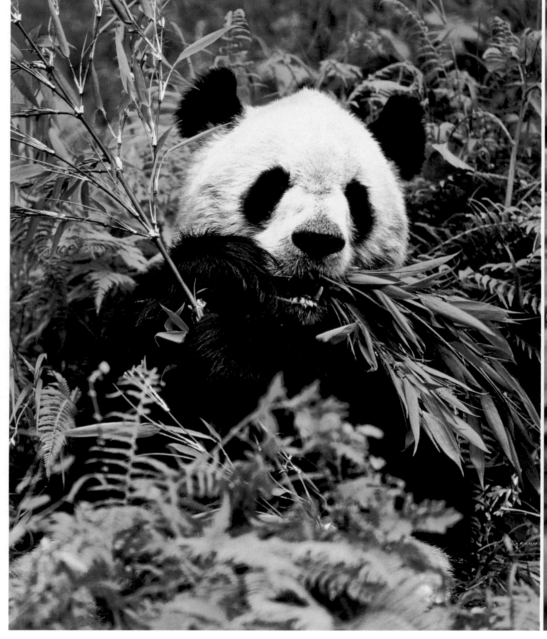

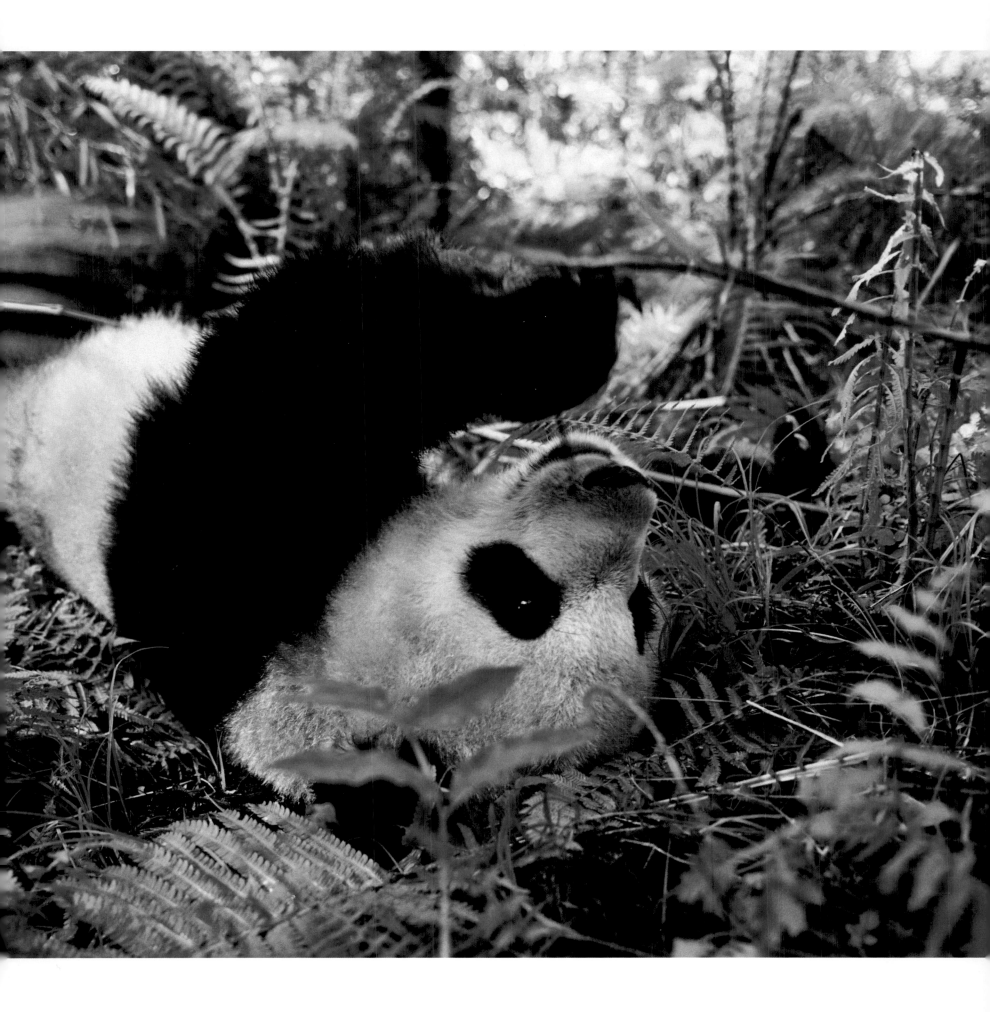

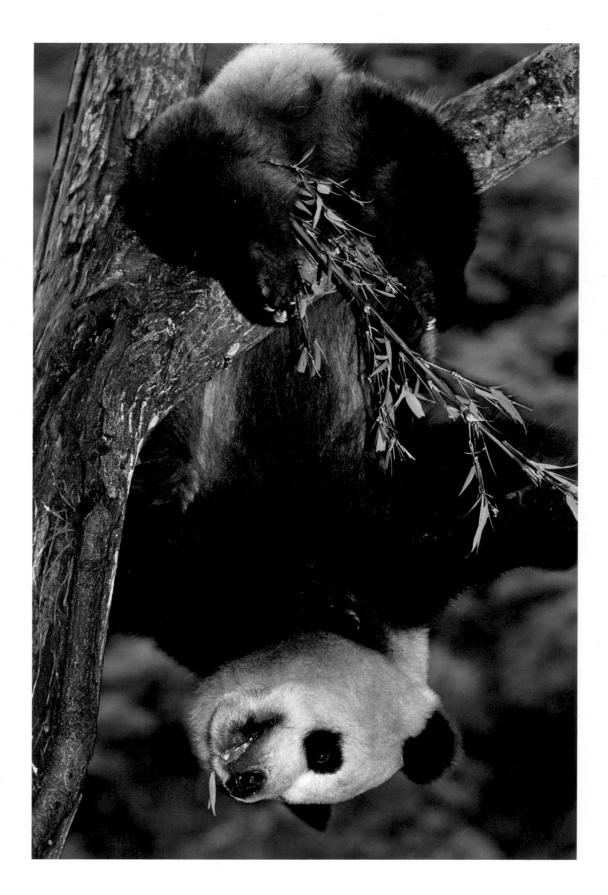

218 and 219 The giant panda spends most of the day, until 2 p.m., eating bamboo leaves. It eats a grand total of 25–30 lb (11–13 kg) of them everyday. In contrast to almost all other bears, the giant panda does not hibernate in winter. During the mating season, at the beginning of summer and in the late afternoon, males meet and compete for the females. The mating season lasts for about six weeks but each female is only in heat for two or three days.

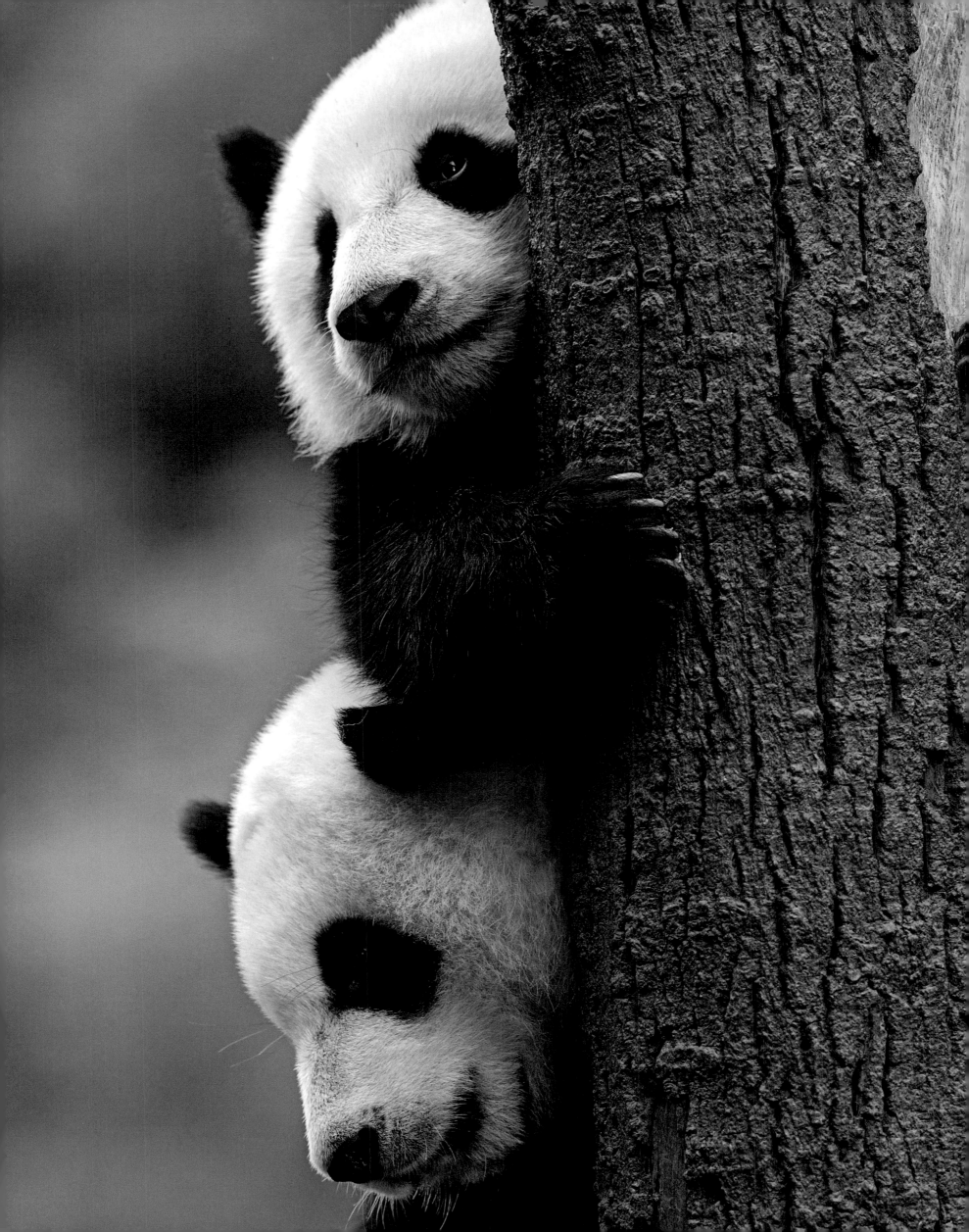

RED or LESSER PANDA

Ailurus fulgens

The lesser panda (*Ailurus fulgens*), also known as the red panda, is the only representative of the Ailuridae family. There are currently two distinct subspecies: *Ailurus fulgens fulgens* lives in the Himalayan forests of Nepal, Bhutan, and Sikkim, and also the northern regions of Burma; *Ailurus fulgens styani* lives in the Chinese provinces of Yunnan and Sichuan. The Chinese subspecies is distinguished from the Himalayan one by its darker coat. The lesser panda prefers medium to high altitude mountain environments characterized by an abundance of bamboo forests. It lives alone or at most in a pair and spends a large part of its time in the trees, feeding on bamboo shoots, succulents, roots, berries, fruit, and, if need be, eggs, small birds or mammals, and insects. Knowledge about its behavior in the wild is extremely limited. It has proven difficult to observe because it is cautious and shy and lives in such inaccessible regions. The lesser panda is quite sensitive to heat, so it seeks shelter from the rays of the sun, finding refuge in the dim light provided by the foliage, in tree hollows, or the clefts of rocks (adding to its elusiveness).

Unfortunately, this animal is now on the path to extinction because of steadily increasing and relentless human encroachment into its habitat. It is currently on the list of the 100 mammals considered seriously endangered. An experimental reintroduction project has been established in India in an attempt to halt the population decline. Lesser pandas equipped with radio-collars are released and monitored in order to better understand their habits and behavior. As a result, vital information will be gathered which will help in the struggle to save this splendid animal.

EN

220 The red or lesser panda usually eats during the night and sleeps during the day. It adopts a curious position when it sleeps, stretching out on a branch, allowing its arms and legs to dangle.

221 Also known as a "fire fox" in Chinese, the red or lesser panda has an impressive repertoire of sounds and a type of chattering that calls to mind the chirping of birds.

VANISHING ANIMALS

222-223 and 223 A mammal belonging to the Carnivora order, the red or lesser panda is a distant relative of the giant panda, lives in the forests, and usually marks its territory with secretions from its anal glands. Its gestation period lasts 130 days, followed by the birth of one to four cubs.

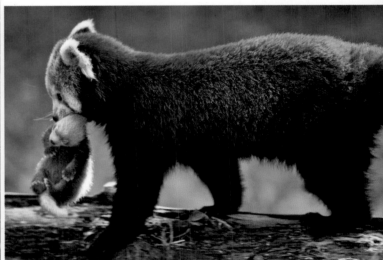

RED PANDA

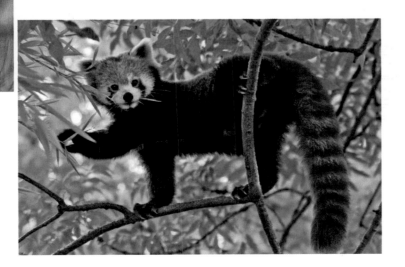

224 and 225 The red or lesser panda's coat varies in color from reddish to chestnut and is darker on its back. The thick fur that covers the underside of its front and back limbs is an adaptation to its slippery habitat.

226-227 The red or lesser panda may weigh 7–14 lb (3–6.35 kg) and measure, including the head, 20–25 inches (50–63 cm) in length. Its tail, which can be as long as 19 inches (48 cm), does not have pronounced ringed markings.

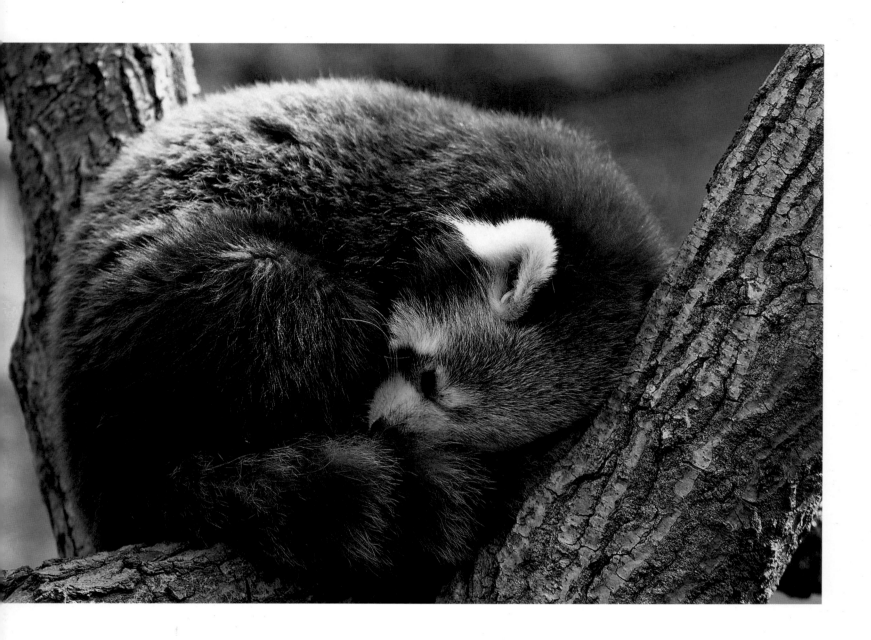

VANISHING ANIMALS

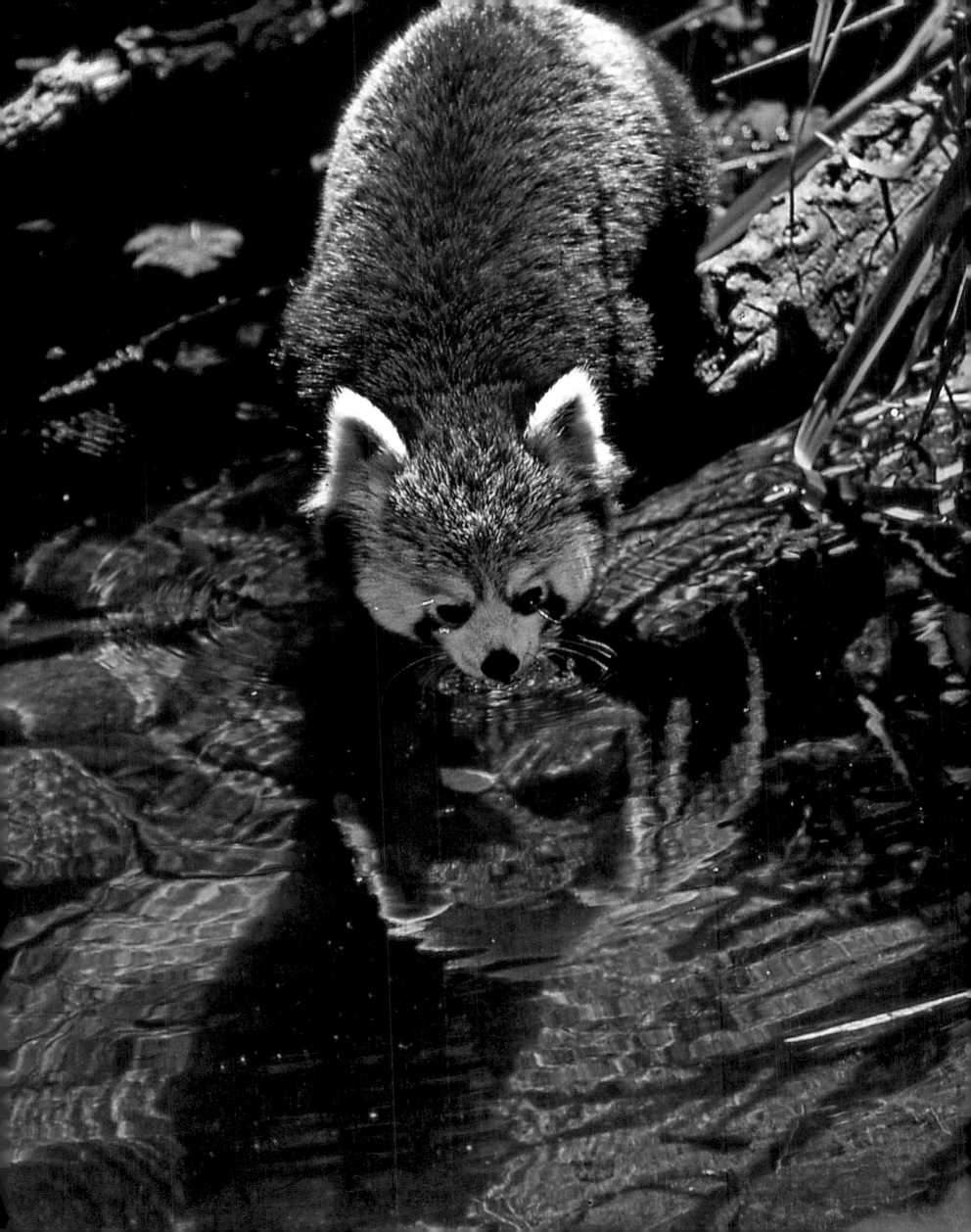

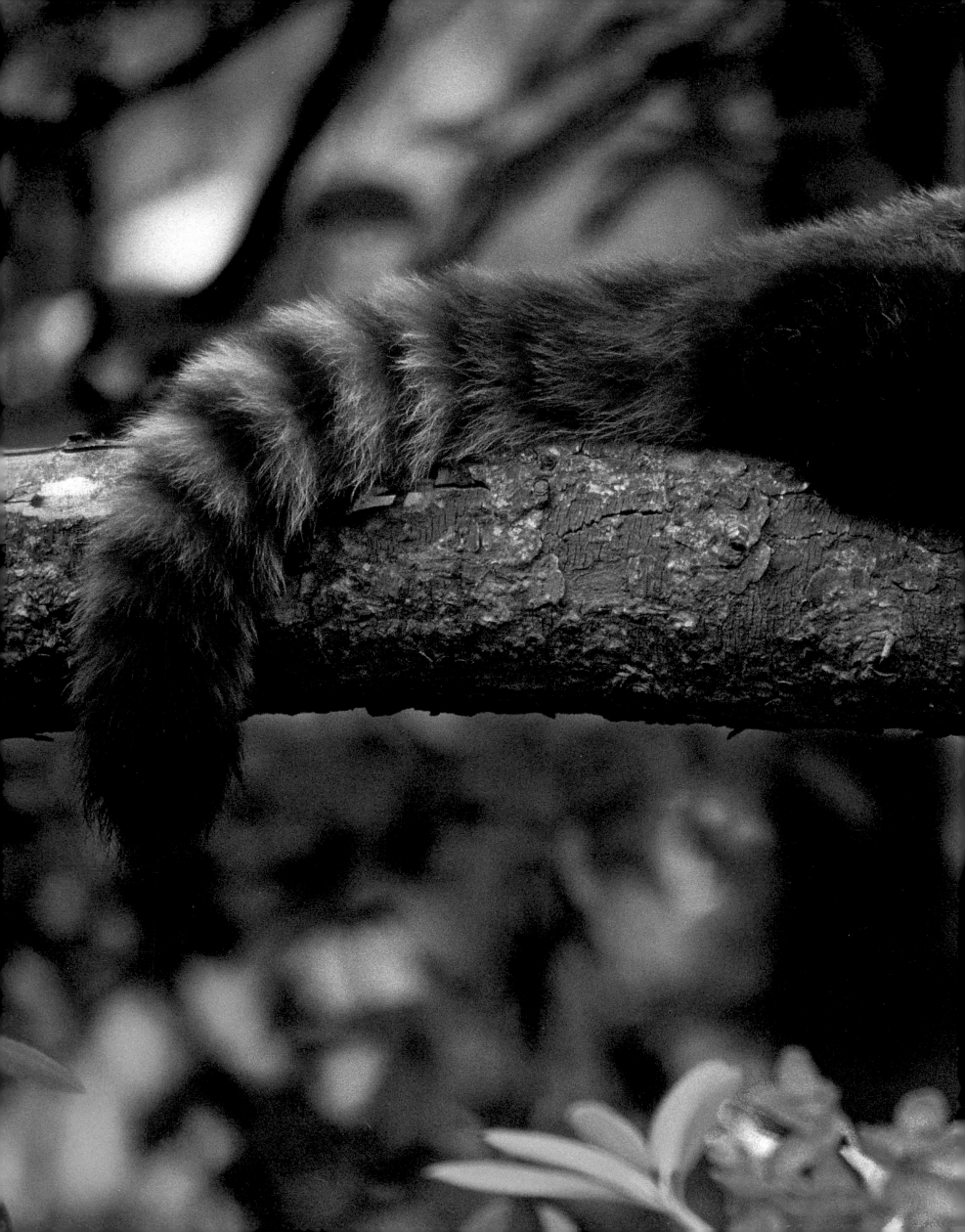

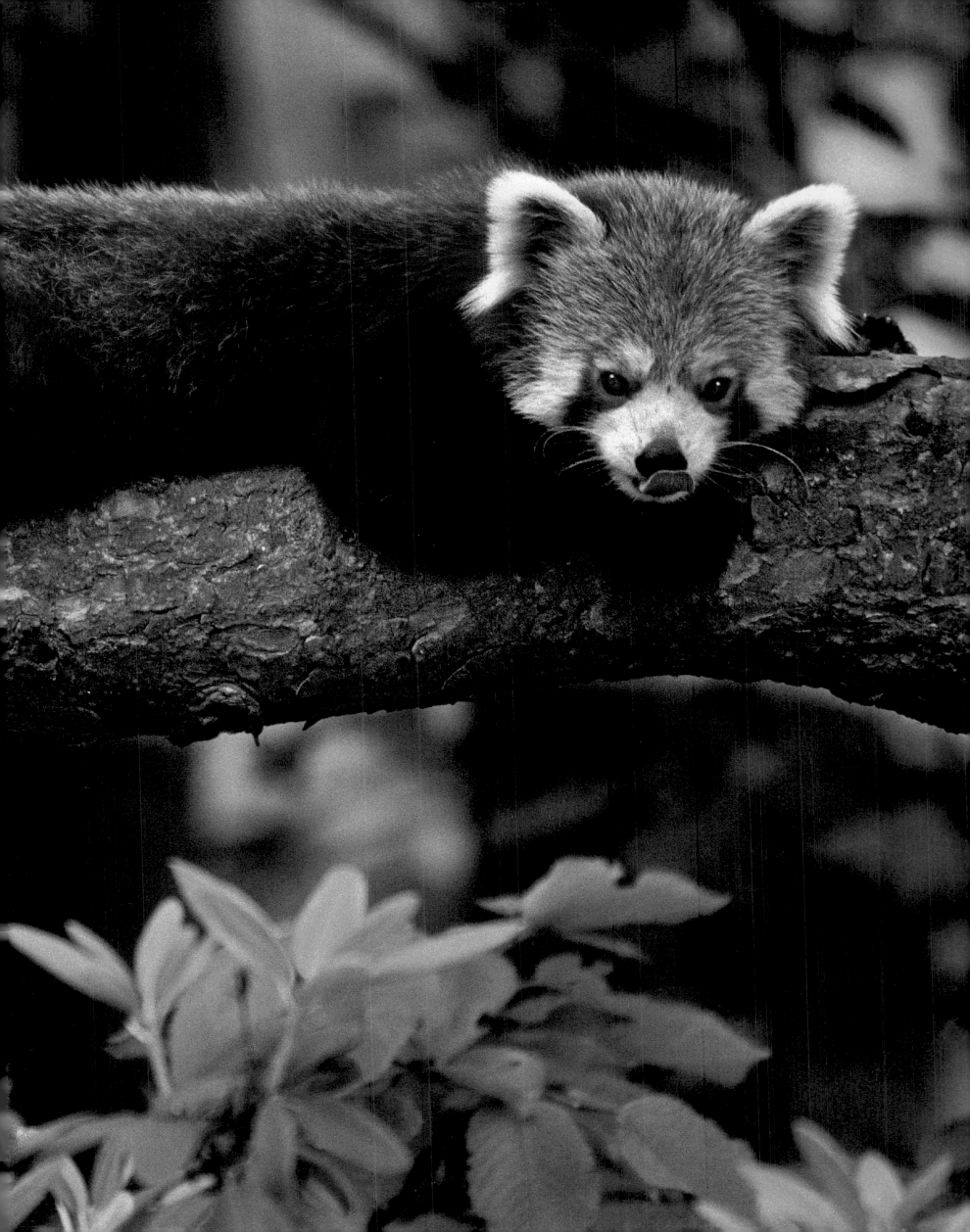

INDIAN GAVIAL or GHARIAL

Gavialis gangeticus

From time to time on the surface of the deep waters of the Ganges River a gavial, or gharial, (*Gavialis gangeticus*) falls asleep then becomes frightened by the passage of a boat and suddenly submerges with a resounding plop. A distant relative of the crocodile, the gavial spends most of its time floating in the water with only its eyes and nose appearing above the surface. This reptile lives mainly in the waters of the Ganges but can also be found in several rivers of Southeast Asia, such as the Brahmaputra, the Indo, and the Mahanadi. The name "gavial" derives from the corruption of the Hindi word, *gharya*," meaning crocodile. It is the only surviving representative of the Gavialidae family, distinguished from other crocodiles by its narrower head that extends into a very long muzzle. The shape of its mouth and jaws equipped with sharp and narrow conical teeth allow it to get a good grip on the slimy skin of the fish it enjoys as food, and its slender muzzle offers little resistance to water, allowing the sudden, rapid lateral movement it uses to capture prey.

Despite reaching almost 20 ft (6 m) in length, the gavial mainly feeds only on fish, frogs, and the occasional acquatic bird. Its appearance may be fearsome, but it is quite timid and defenseless when confronted with humans, so much so that people bathe peacefully near it in rivers and other bodies of water. It is extremely awkward and vulnerable on land, due to the stocky shape of its tail and particularly short limbs, which mean that is it not able to sustain its own body weight for long. In India, the gavial is a sacred animal to Vishnu, one of the three supreme Hindu divinities. Despite being respected, however, it has been the object of ruthless hunting by humans, to such an extent that it is now nearly extinct. Although a protected species since the beginning of the 1970s, it is still often poached for its valuable skin. According to the IUCN's (World Conservation Union) Red List, the gavial is considered a species at critical risk of extinction in the imminent future.

CR

228-229 The male Indian gharial or gavial has a potato-shaped growth on its nose, wich probably serves to amplify the sound of the male's call during the mating season. One male will have a harem of several females.

229 bottom The Indian gharial or gavial may reach almost 20 ft (6 m) in length and weigh up to 1,765 lb (800 kg). Despite its menacing appearance, it only feeds on fish and small prey, feeding frequently and competing with the local fishermen.

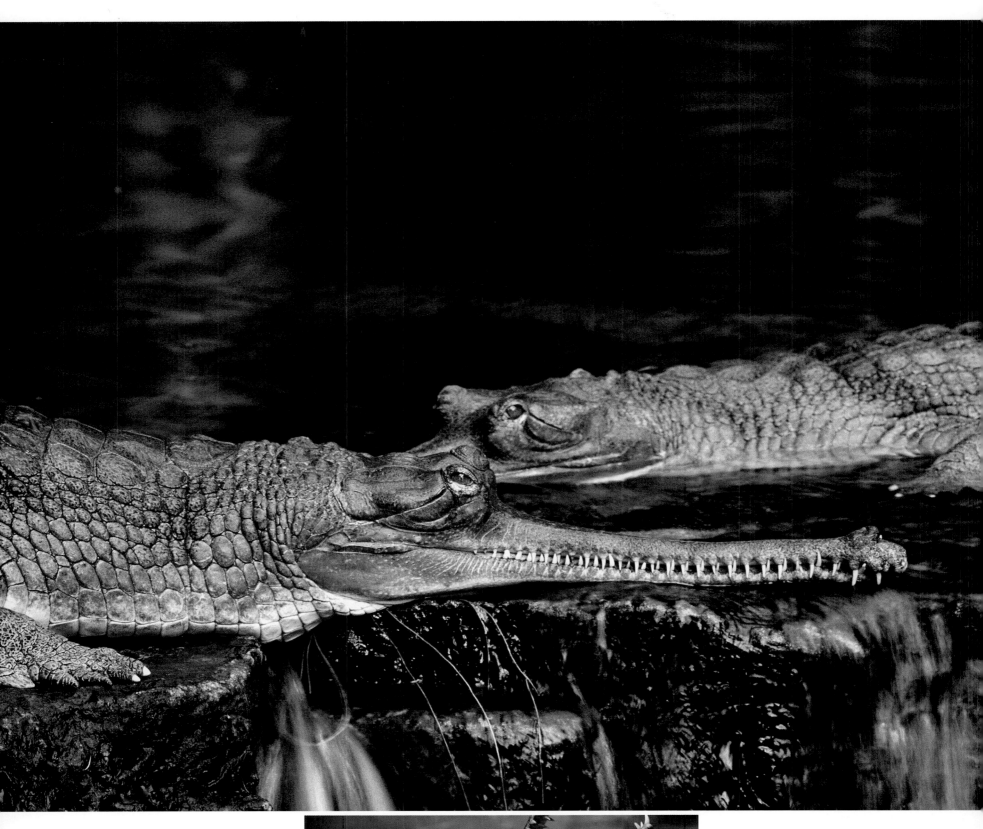

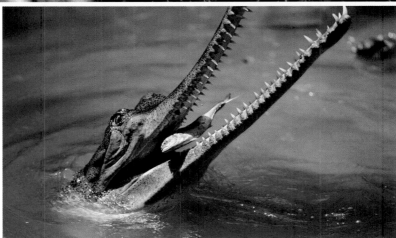

IRRAWADDY DOLPHIN

Orcaella brevirostris

River dolphins are among the most endangered marine mammal species in the world. They depend on extremely fragile habitats and also suffer from intentional or accidental killing by humans. In many cases, however, it is difficult to gather even small amounts of adequate information on the status of their populations. Information necessary to plan any effective conservation programs. This is certainly the case for the Irrawaddy dolphin *(Orcaella brevirostris)*, a small Delphinidae with sociable nature. Only rarely is one found alone because it prefers to live in small groups of up to a dozen individuals. It lives mainly in fresh water (it has been found up to about 870 miles (1,400 km) from the mouth of the Irrawaddy River in Burma) but also inhabits other environments, such as coastal waters where it feeds on fish and crustaceons. Consequently, it is also found in Southeast Asia, from the Bay of Bengal to New Guinea, and along the northern coasts of Australia. Despite its widespread range, its total population is small and the species is most likely in danger of extinction because of destruction of its coastal and river habitats, deforestation, and death due to fishing with nets or explosives. In fact, even when still found alive, some fishermen kill this dolphin for its meat. Others, mainly in Vietnam and Cambodia, fortunately hold these animals sacred and let them go. The collaborative relationship between fishermen and dolphins along the Irrawaddy is remarkable. The fishermen call the dolphins by beating the sides of their canoes and these animals respond by beating the water's surface with their tails, thus pushing the fish towards the fishermen's nets who then repay the dolphins with part of their catch. In this way, both humans and dolphins succeed in catching more fish and also make a key contribution to the conservation of many species. Yet another example of the benefits for humans as well as animals of living in harmony with nature.

DD

230-231 and 231 bottom The Irrawaddy or Mekong dolphin was discovered only in 1866. Several populations exist, geographically isolated from one another. Generally, these dolphins may weigh up to about 220 lb (100 kg) and can grow up to 9 ft (2.7 m) in length. Some Irrawaddy dolphin populations live only in fresh water, others live near the open sea, and a few even live in salt water.

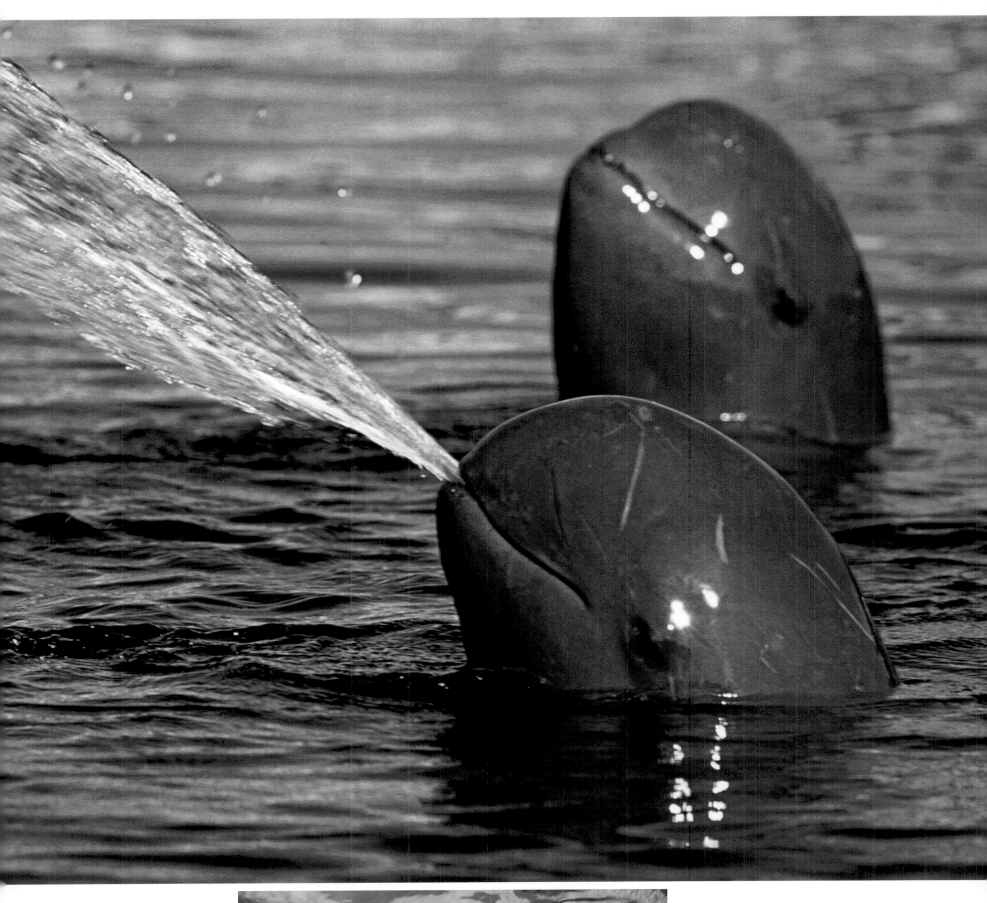

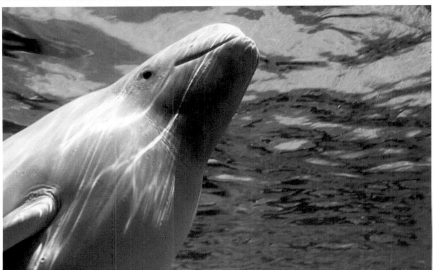

PHILIPPINE EAGLE

Pithecophaga jefferyi

The islands of Mindanao, Luzon, Samar, and Leyte are part of the Philippine archipelago (comprising 7,000 islands) and are the home of one of the largest eagles on the planet, the Philippine eagle *(Pithecophaga jefferyi)*. With a wingspan of almost 8.25 ft (2.5 m) and a head wreathed by a crown of feathers, the Philippine eagle is one of the rarest and most endangered animals in the world. Only about 250 survive in the wild. The reason for this small number is the destruction of its tropical forest habitat for its valuable timber and for agriculture in response to the ever-growing human population. Additionally, it has also been intensively hunted. The magnificent Philippine eagle has long been regarded as a prize trophy by hunters, who have their kills stuffed and exhibited in their homes.

Professor Dioscuro S. Rabor, a renowned scholar who has spent a good part of his life in the forests of the archipelago, first sounded the alarm in 1968 over the Philippine eagle's risk of extinction. Rabor's appeal was heard by one of the WWF's worldwide advisors at that time, Charles A. Lindbergh, the first pilot to fly over the Atlantic, who took the fate of the eagle very much to heart and went to the Philippines many times to promote its protection. In 1969, with financing from the WWF and the Frankfurt Zoological Society, the first investigation into the eagle's conservation requirements was begun. There has been little follow-up research, however. The last scientific information came from the work of Robert S. Kennedy, an American researcher who works within the conservation program promoted by government authorities in collaboration with the WWF. A recent documentary by Kennedy and his colleagues reveals the fascinating and secret habits of this very rare bird of prey.

CR

232 and *233* The scientific name, *Pithecophaga jefferyi* derives from the Greek terms *greci* and *pithekos* which mean "monkey" and "glutton," and from which the common name of monkey-eating eagle derived. The name was then changed to Philippine eagle following a decree by the government of the Philippine Republic in May 1978. Contrary to what was initially believed, monkeys only constitute a very small part of this bird's preferred diet. The Philippine eagle preys mainly on flying lemur, palm civets (or toddy cats), flying squirrels, rats and mice, and various species of bats, birds, and snakes.

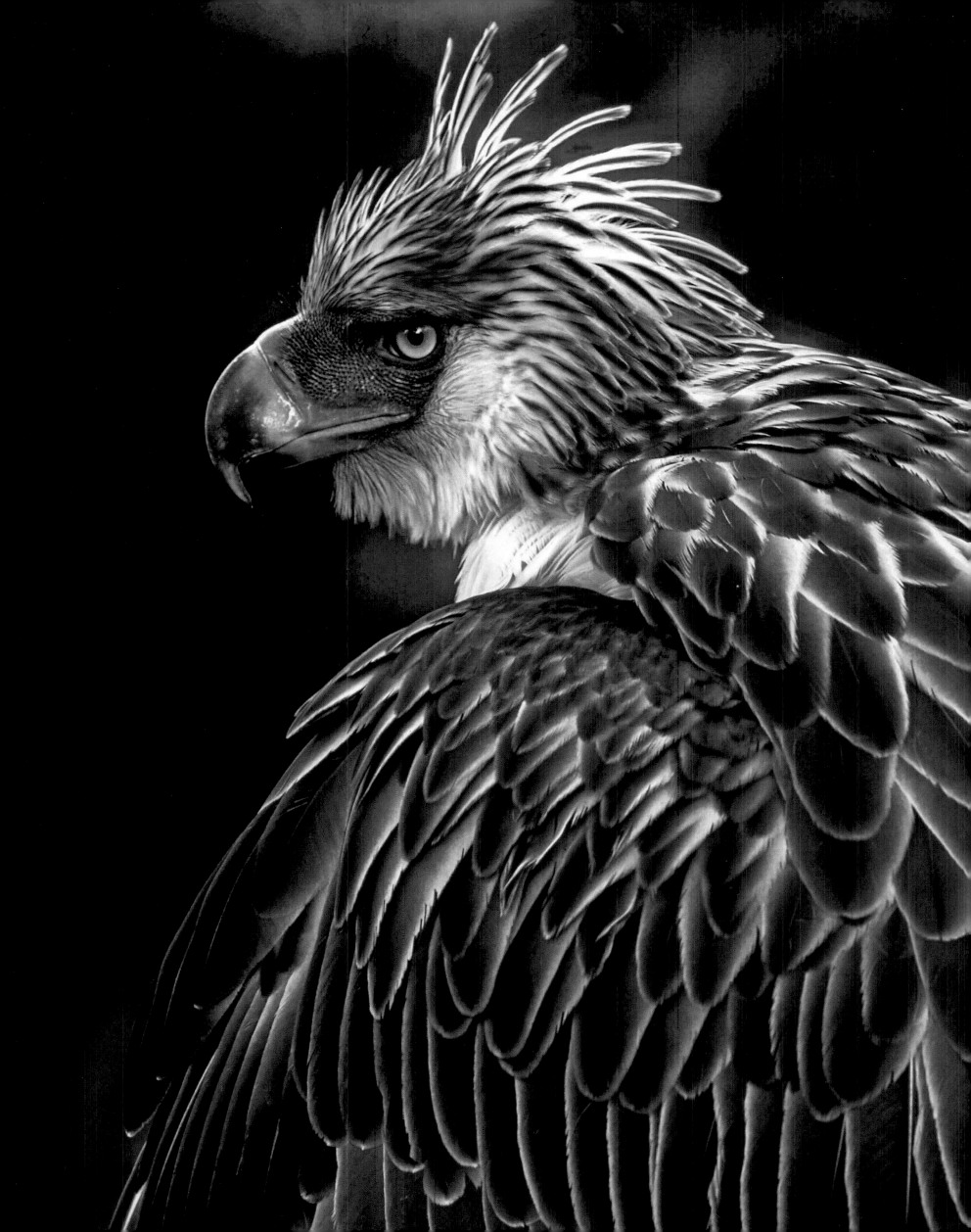

CITRON-CRESTED COCKATOO

Cacatua sulphurea citrinocristata

In 1981, when the scholar, William Doherty visited the Indonesian archipelago, he wrote that on the island of Sumba "among all the birds, the cockatoos were so numerous that I saw the trees turn white." He was referring to citron-crested cockatoos (*Cacatua sulphurea citrinocristata*), which are medium-sized parrots with bright white plumage and a small crest of bright orange feathers on their heads (the most widespread cockatoo subspecies being those with a yellow crest). The citron-crested cockatoo is endemic to the island of Sumba and nests in the natural hollows of old deciduous trees of the primary forest, laying just a few eggs in a pre-selected hollow. They feed on seeds, berries, and fruit found in the forest, but given the loss and fragmentation of their original habitat they often fly to agricultural areas, eating corn, bananas, mangos, and other cultivated fruit.

Until the 1970s, this species was quite common on the island but the population subsequently underwent a drastic decline mainly due to the sale of live specimens and the effects of deforestation. According to some estimates, in 1986 there were around 12,000 specimens in Sumba, with a density of eight per square kilometer (less than a third of a square mile or about 247 acres). Three years later, their estimated density was 1.8 specimens per square kilometer, a population loss of 80 percent. Every year, enormous quantities of birds are captured with nets or removed from their nests in order to satisfy a growing demand by collectors. Prices for this species have suddenly climbed at a pace equal with the decline in their population. The cost for one specimen was 25,000 rupies in 1987, and had already climbed to 100,000 by 1991. However, calculations show that in 1989 alone, 3,000 birds were still exported from Sumba. Upon arrival at Jakarta, the first leg of their journey to the collectors, one out of five specimens dies. In 2005, sales of this species were explicitly banned and they were included in Appendix I of the Convention on International Trade in Endangered Species of Wild Fauna and Flora (CITES), but illegal removal and deforestation still continue to endanger their survival.

CR

234

234 Although evergreen forests are common on the island of Sumba, it seems that citron-crested cockatoos prefer to lay their eggs in the hollows of large deciduous trees. The extensive felling of these tree species has seriously reduced the citron-crested cockatoo's ability to reproduce.

235 The citron-crested cockatoo can grow up to 16 inches (40 cm) in length and its base plumage is white, but its crest and cheeks have bright orange feathers. As with all cockatoo species, the citron-crested cockatoo forms tight family bonds and a couple may remain together for life.

OCEANIA

Oceania is the smallest and least-populated continent after Antarctica. Traditionally, it is considered to contain four regions: Australia and New Zealand, Micronesia, Polynesia, and Melanesia. Its largest countries are Australia, New Zealand, and Papua New Guinea, while the smaller ones are those comprised of the archipelagos of small coral or volcanic islands. It is the seas that surround all these nations that unifies this continent. The marine environments are particularly fragile, whether due to their isolation, creating conditions for the evolution of unique species of fauna and flora, or due to the ancient geological age of the Australian continent and the limited expanse of the islands, which have made their ecological balance extremely delicate. When the first European colonists reached Australia, they thought that the country was extremely fertile because of its dense forests with trees reaching over 390 ft (118 m). But after the deforestation of vast areas and attempts at cultivating the cleared land, the colonists discovered that Australian soil was especially infertile with a very high saline content. Essential irrigation brought salt to the surface, further aggravating soil conditions. The use of great quantities of fertilizer provoked still further pollution of the water table to the extent that 19,000 tons of phosphorous and 141,000 tons of nitrogen substances were discharged into the sea every year, representing a huge additional threat to marine ecosystems already suffering intense exploitation. In fact, it is estimated that in 2005 alone, the commercial fishing of at least 17 species exceeded the fish populations' capacity for regeneration. A vast arid region covers 70 percent of the central part of Australia, but the transformation of natural areas into agricultural cultivation and intense exploitation of them by livestock has tended towards increasing these desert territories to the detriment of green coastal areas. It is calculated that 13 percent of the original prairie land may have already been eliminated.

Australia is home to one of the highest number of endemic species in the world: 84% of

the mammal species, 45% of the bird, and 89% of the fish species are found only in Australia. This uniqueness is gravely endangered by the introduction of numerous foreign species from all parts of the world. The European colonists introduced dogs, cats, foxes, and rabbits, which adapted and multiplied rapidly as they were less specialized than local species and more anthropophilic (preferring humans), therefore easily coexisting with humans. These species introduced for various reasons then gradually increased in number and became a great threat to local fauna and flora. A typical example is the introduction of cane toads originating in South America. They were released to combat parasitic insects, multiplied rapidly and because they contain toxins now threaten the extinction of snakes, turtles, crocodiles, and small carnivorous marsupials that feed on them. Calculations show that 20 exotic species are introduced annually, sometimes accidentally, while 2,500 of the foreign species already present are invasive plants often originating from domestic gardens.

Similar problems also exist in many of the other nations in Oceania. In the Transfly and Sepik regions of Papua New Guinea, intense deforestation and the activities of the oil, gas, and mineral mining industries threaten one of the world's last tropical deciduous forests and one of the freshwater systems richest in endemic species. In New Guinea, exploitation of trees of the Aquilaria genus, which produce a scented essence called gahara highly sought after in Asia, is often accompanied by illegal logging and corrupt practices by the personnel charged with protecting this species. In all of the countries, deforestation, pollution, climatic change, invasive species, and indiscriminate capture of fauna threaten the survival of indigenous species. Additionally, uncontrolled sales of invertebrate animals and fish from coral reefs as household pets, fishing with dynamite, and unprincipled tourists jeopardize the survival of species living in the marine environments of Oceania.

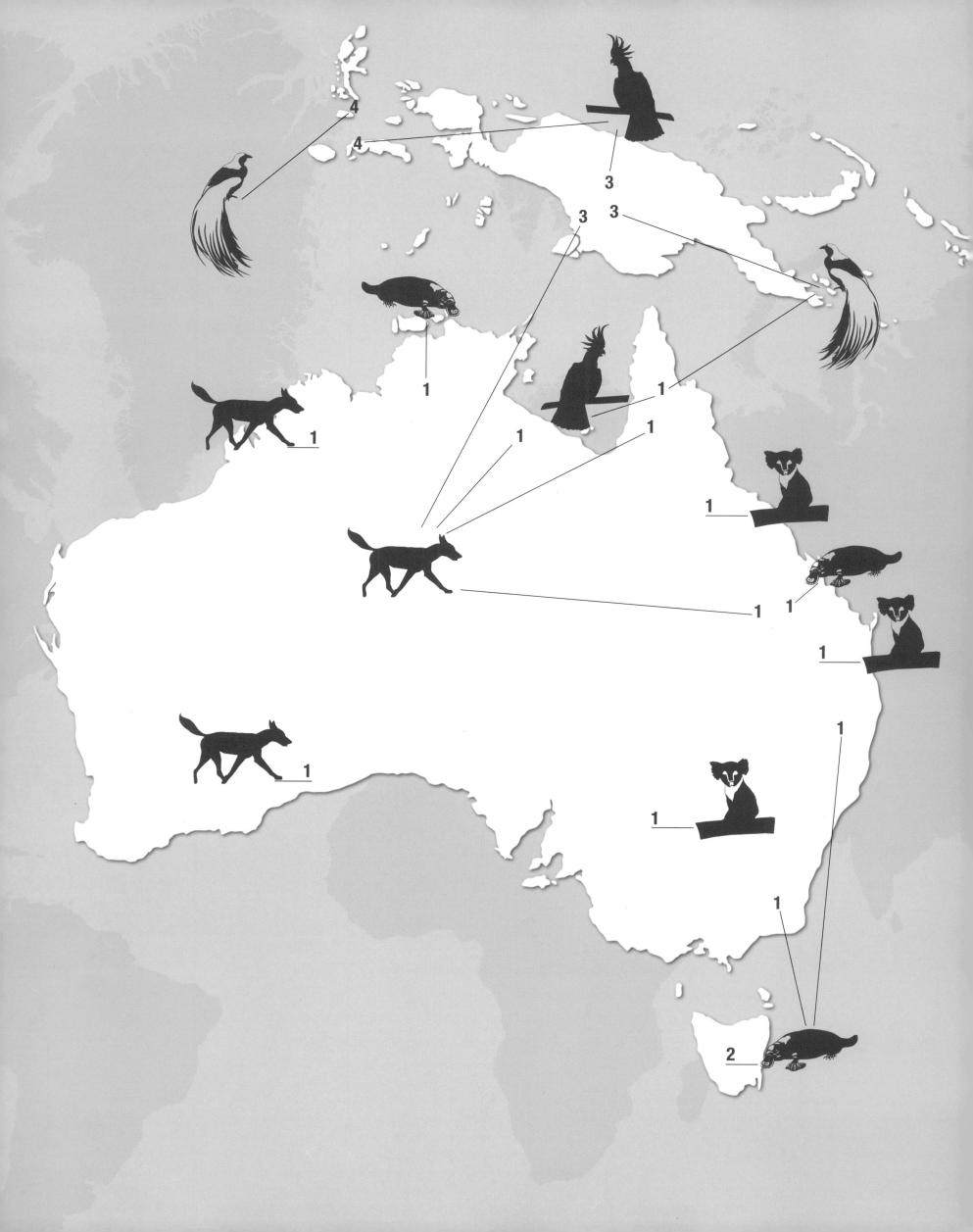

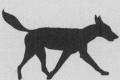

KOALA

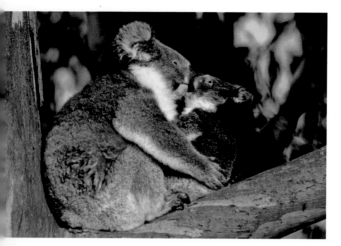

Phascolarctos cinereus

In old Daruk language, a now defunct Australian dialect, the koala (*Phascolarctos cinereus*) was called "gula," meaning "the one who never drinks." In fact, this animal does not need to drink water, but extracts necessary fluids from the leaves it feeds on. Sitting in the crook of a eucalyptus tree, the koala spends several hours of the night slowly chewing this plant material until it is reduced to a fine pulp. Eucalyptus leaves are rich in fiber and poor in protein, contain tar phenols and terpenes that are toxic for many species, but not for the koala as its liver is able to defuse their damaging properties so it can utilize them. Fully integrated into the eucalyptus forest system, the koala exploits the toxicity of substances produced by these trees. In fact, pests stay away as the koala's coat is always soaked with the tree's essential oils that give off an anti-parasite odor. Active for not more than five or six hours per day, the koala descends to the ground only occasionally to change trees or encourage digestion by swallowing soil, tiny pebbles, and bark. Similar to a bear cub, the koala is the only Australian marsupial mammal in the Phascolarctidae family, or climbing marsupials.

Despite its pleasant appearance and gentle nature, the koala is not a household pet and law prohibits keeping it as a domestic animal in Australia. During the first half of the last century, koalas in southern Australia were subject to intense hunting for the beauty of their coat. In the last 60 years, however, suspension of hunting activities has allowed them to repopulate this region, which has also benefited from the introduction of specimens from other areas of the continent. Currently, fires that devastate entire stretches of forest represent a major threat to this species. According to the IUCN (World Conservation Union), the koala now runs a moderate risk of extinction.

NT

240 The koala, also called "koala bear," has primarily nocturnal habits, spending about four hours every night eating the leaves of the eucalyptus tree, where it spends the majority of its life.

241 The koala is a marsupial mammal whose scientific name, *Phascolarctos cinereus*, derives from the Greek words *phaskolos* (marsupial) and *arktos* (bear) and from the Latin, *cinereus* (gray).

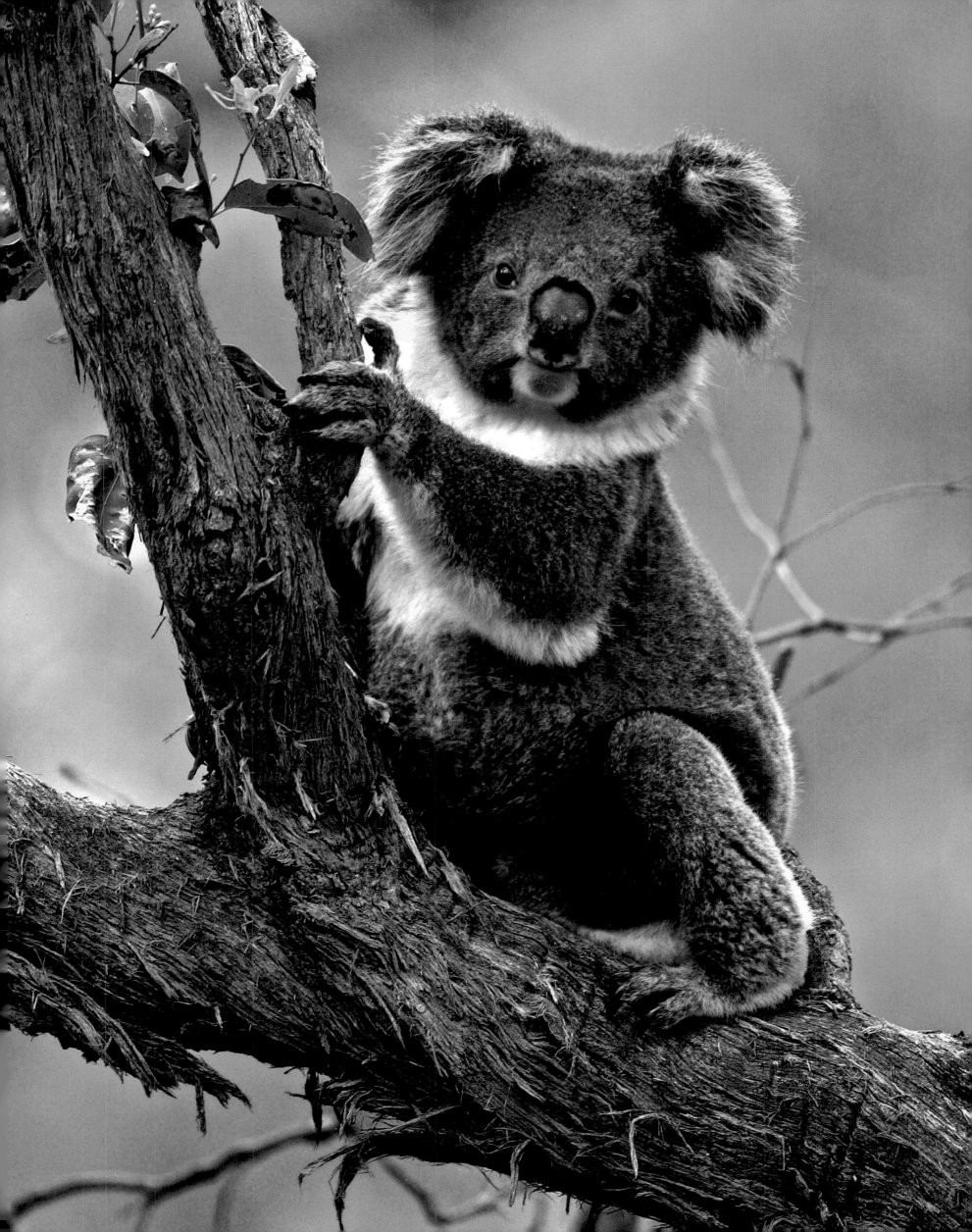

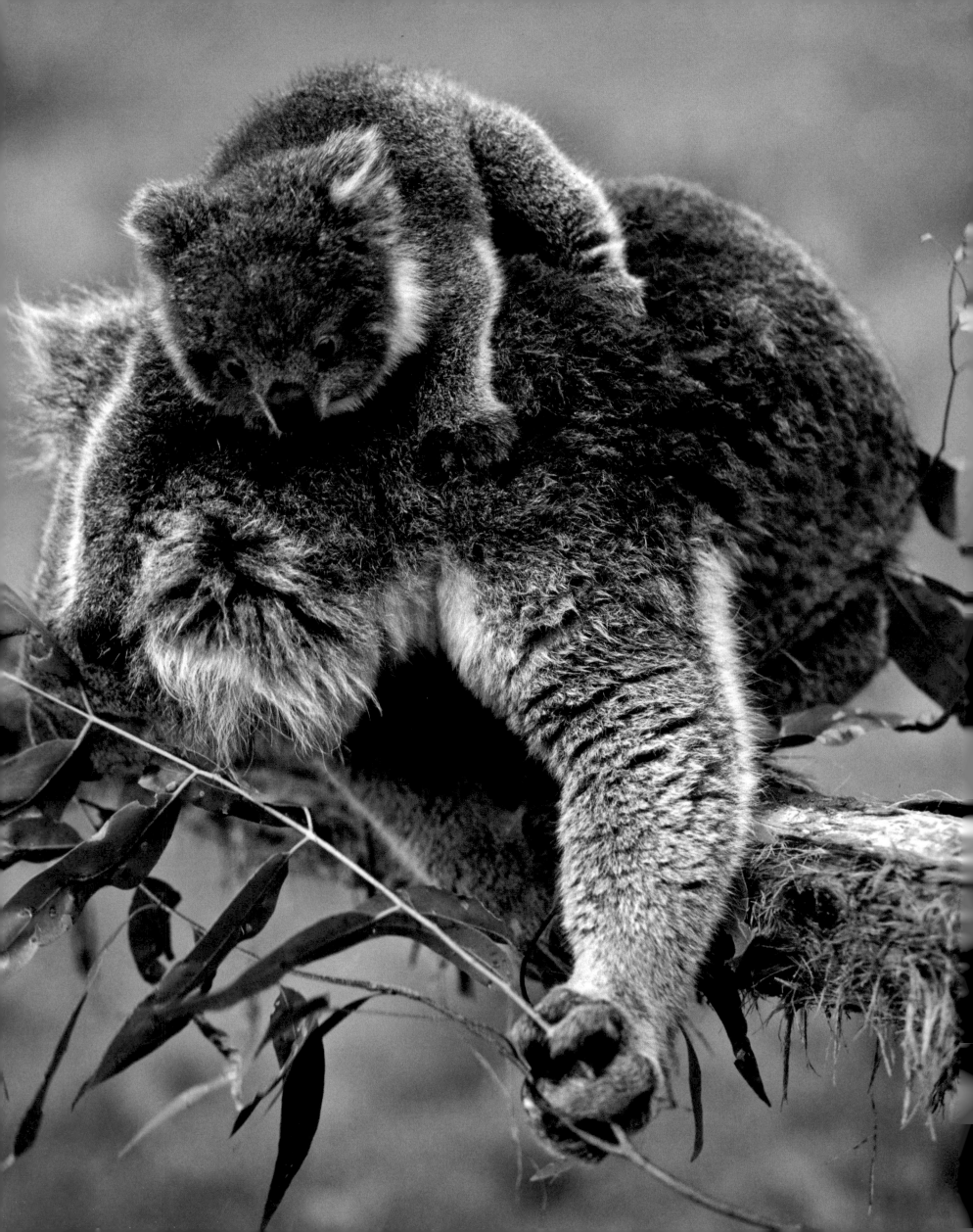

242 Koalas reach sexual maturity when they are three or four years old. Females give birth to one offspring at a time and two would be a rare exception. Once it leaves the pouch, the newborn koala clings to its mother's back and remains there until reaching one year of age.

243 left An adult koala is 23–33.5 inches (58–85 cm) in length and lives a maximum of about 20 years. It has small sharp nails that allow it to easily climb trees in which it spends most of its time dozing among the branches.

243 right The koala has a thick and generally grayish coat, varying in shades from individual to individual. Its upper body is ash gray and its abdomen is yellowish white. Its fur is long, soft, and wooly, and has the odor of eucalyptus.

243

PLATYPUS

Ornithorhynchus anatinus

When the first platypus pelt arrived in Great Britain in 1798 from the Australian colonies, it was thought that a taxidermist was playing a practical joke by sewing different animal parts together: a duck's bill, a beaver's tail, and the body of an otter. In the end, they accepted the idea that the platypus (*Ornithorhynchus anatinus*) was a real animal, but classified it as a new bird species, because of its beak and oviparous reproduction, until discovering that females suckled their young, which is a characteristic that distinguishes mammals from other animals. Due to the rarity of the species, in 1905 the Australian government decided to prohibit the slaughter of platypus which had previously been hunted for their valuable coats, but the decline in numbers of these animals still continued for another half-century. In the 1950s, a slow recovery of the population finally began thanks to the implementation of conservation measures. The platypus is now again present throughout its historical range, that is, the western strip of the Australian continent where it is considered common in some areas.

Unfortunately, there are still many threats that cloud the future of the platypus: the gradual fragmentation of its habitat, water pollution by pesticides and liquid sewage, refuse in rivers, such as cans and bottles that trap or wound them. But, these are not the only problems. Fishing activities can cause death by suffocation when these small mammals get entangled in fishing hooks, lines, and nets. Additionally, the presence of non-indigenous plants and animals pose further threats to this delicate and highly specialized species. For example, the planting of poplar trees instead of native species along riverbanks absorb more oxygen from the water than native eucalyptus trees, making rivers uninhabitable for the invertebrates on which platypus feed. The introduction of exotic fish species has created new competition for food in the rivers populated by the platypus and, finally, cats and foxes often prey on this delightful animal.

LC

244 The platypus hunts under water usually for about two minutes but can stay under for up to ten. When it returns to the surface it takes its food into its mouth whole, without swallowing, and stores it in pockets located inside its cheeks.

245 The platypus has a tapered hydrodynamic body and webbed hands and feet. During the night, it combs riverbeds in search of small invertebrate animals, aided by the electroreceptors situated inside its beak.

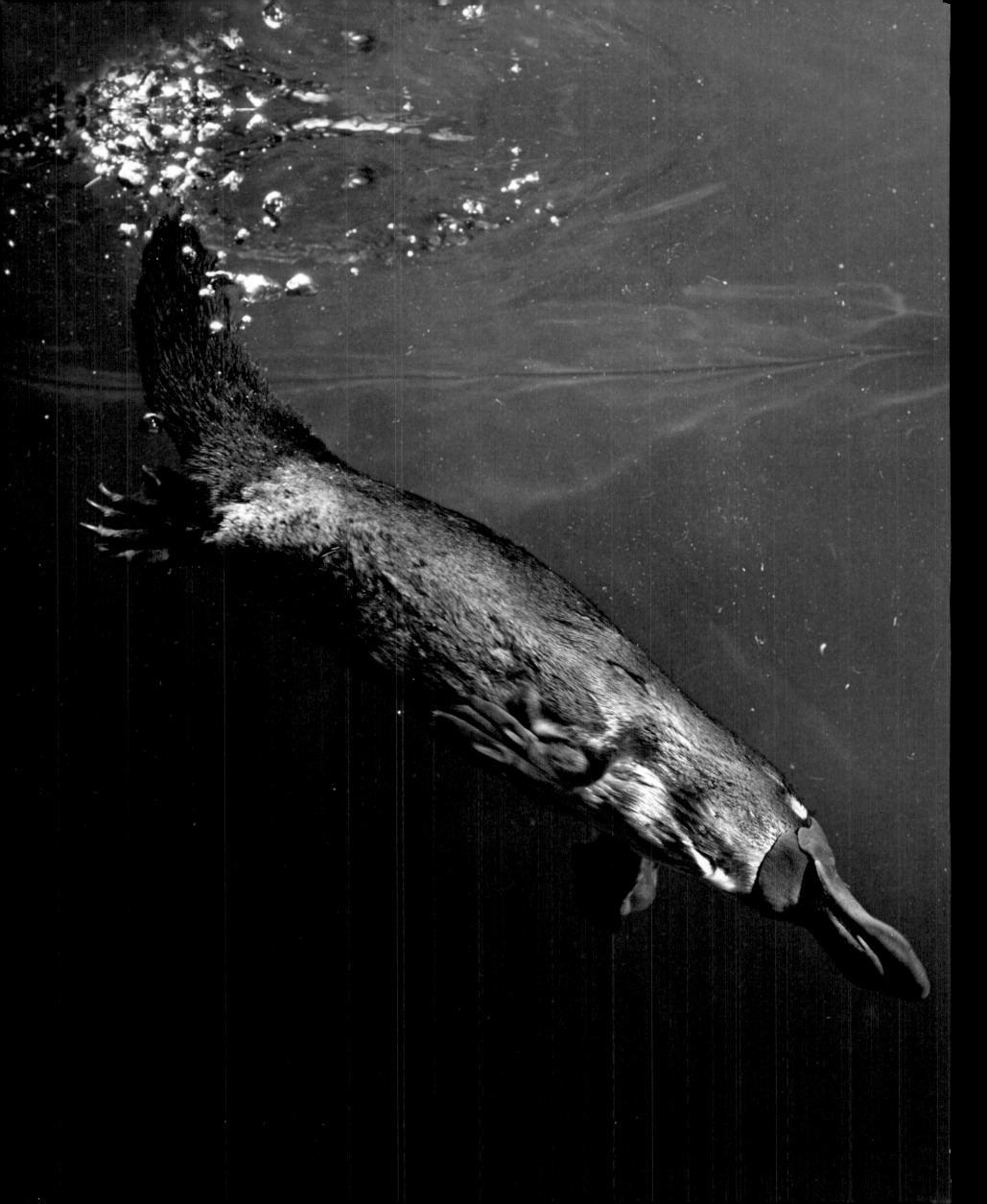

BIRDS of PARADISE

Paradisaeida

The Paradisaeidae family, spread throughout Papua, New Guinea and Australia, includes about 40 species of songbirds and perching birds known for their magnificent plumage and the complex mating rituals of the males, involving elegant exhibitions of color and movement that seem like dance in its purest form. Unfortunately, because of their beautiful plumage, birds of paradise have suffered and still do suffer intensely at the hands of hunters, particularly the males, as the faded colors of females are more adapted to camouflaging them from their natural enemies and protecting their brood. Local tribes have for centuries used the feathers of these birds for decorating traditional clothing, however, a drastic reduction in their population occurred between the 16th and 20th centuries when animals were also skinned completely, the skin was then re-covered with colored feathers and exported to Europe in great quantities. Most of the feathers once used for deocration came from the lesser bird of paradise (*Paradisaea minor*), but feathers from the king bird of paradise (*Cicinnurus regius*), the Wilson's bird of paradise (*Cicinnurus respublica*), and the greater bird of paradise (*Paradisea apoda*) were also used.

Currently, three species are considered vulnerable, the black sicklebill (*Epimachus fastuosus*), the blue bird of paradise (*Paradisaea rudolphi*), and the Wahnes's parotia (*Parotia wahnesi*), which was discovered in 1906. All three species live in the mountainous forests around Papua on the island of New Guinea, hunting insects and other small arthropods among the epiphyte plants, also sometimes feeding on fruit. Threats burdening the birds of paradise populations are diverse: the capture of live specimens destined for captivity within their original terrain, international sales, hunting as a food source, deforestation of woods constituting their primary environment, fragmentation and decline of its natural habitat, and human population expansion requiring new space for agriculture and settlement.

LC

246 The black sicklebill owes it Latin name, *Epimachus fastuosus,* to its especially curved beak that is reminiscent of a sickle. The word *Epimachus* originates in the Greek language, where *makhaira* means curved sword.

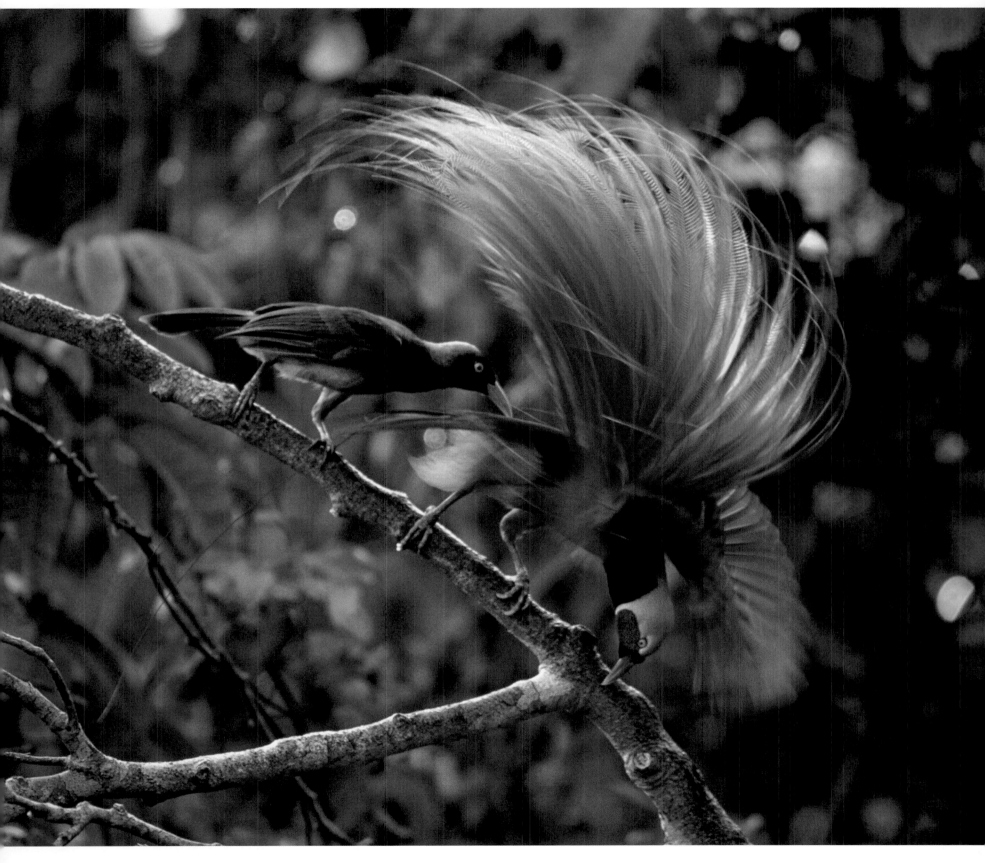

246-247 For birds of paradise, the choice of location where to display themselves is of vital importance to attract the greatest number of females. The horizontal or slightly sloping branches of the Albizia trees and shrubs seem to be much sought after as suitable spots for their displays.

248 left The *Paradisaea rubra* (red bird of paradise) assumes acrobatic positions on branches that it has exfoliated in order to be seen more clearly during its courting displays.

248 right Birds of paradise are endowed with a vast vocal repertory, which

is necessary to make themselves heard and recognized in the often dense and impenetrable vegetation.

249 Eye color is a characteristic that distinguishes the species and age of birds. In certain birds of paradise species the males have different colored eyes to the females.

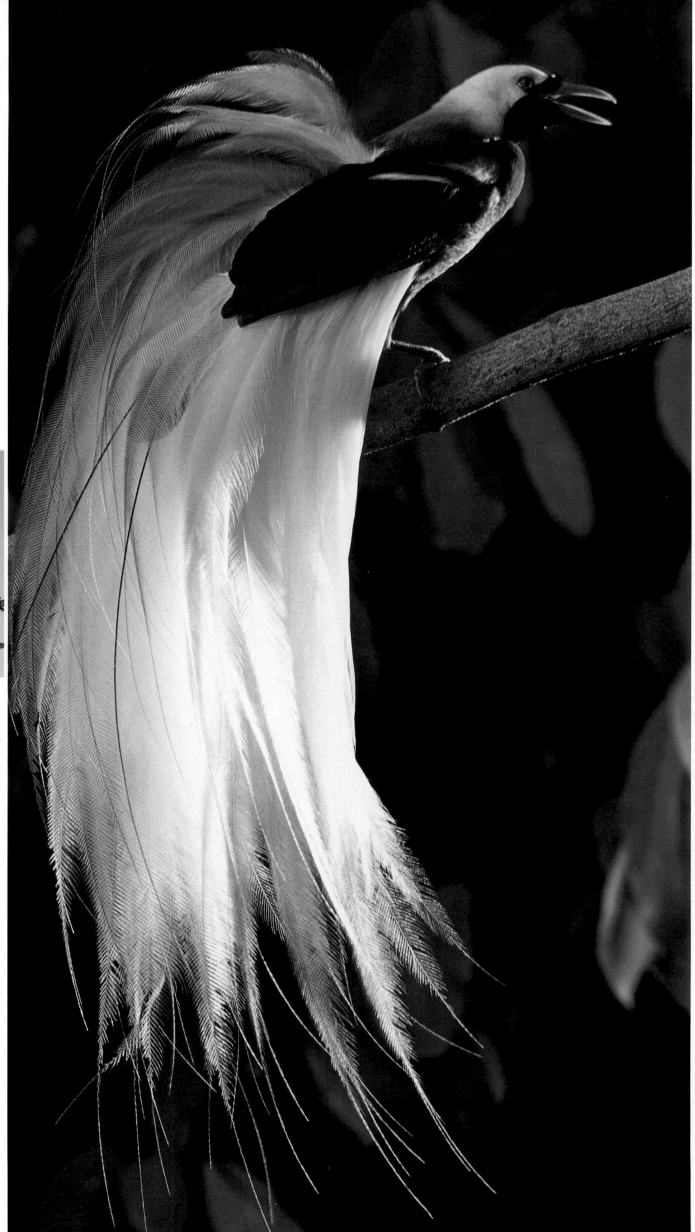

248

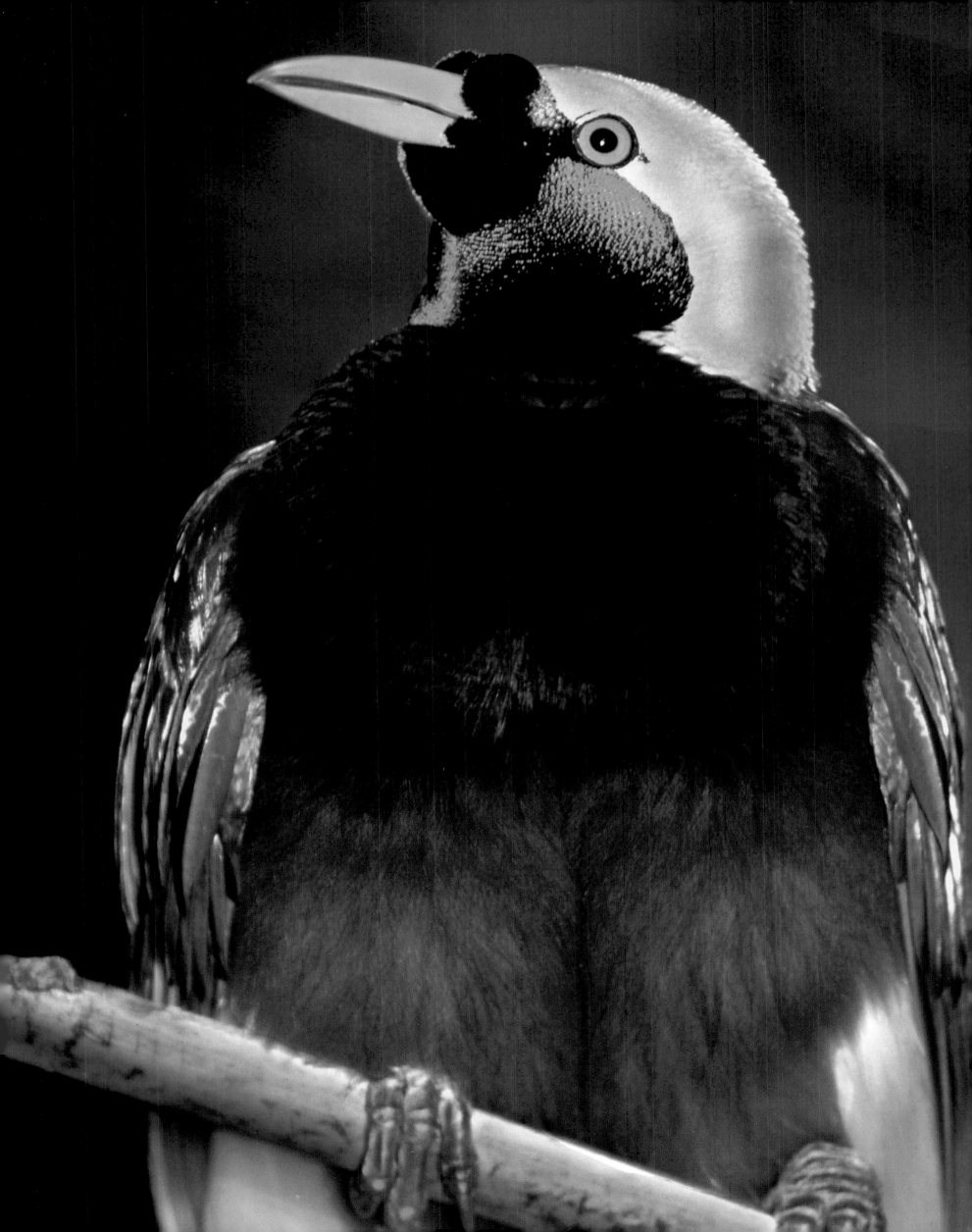

PALM COCKATOO

Probosciger aterrimus

Almost 28 inches (70 cm) long, the palm cockatoo (*Probosciger aterrimus*) is the largest existing cockatoo. Different from the other multicolored species, it has a prominent upright crest and black colored plumage from which bare crimson cheeks stand out. The bright red of its tongue with a black tip makes this parrot all the more fascinating. Only three subspecies of palm cockatoos exist, *P. aterrimus*, *goliath,* and *stenolophus*, with only slight morphological differences and sharing the same ecological niche. All of them prefer to live in areas bordered by dense savannah and/or forests. This typical preference makes them particularly vulnerable to the fragmentation of their habitat, a serious issue in the forests of southeastern Asia. Indeed, the primary cause of decline throughout most of the parrot population is frequently due to the deterioration of habitats, even when many of the species adapt to these changes over time. Currently, many populations survive in remarkably modified environments.

However, other factors also represent an increasing threat to their survival. In particular, the constant loss of specific nesting sites (hollow tree trunks), hunting, and capture of live specimens for sale as household pets. Despite the current existence of stable populations of *Probosciger aterrimus* in Australia, Papua, New Guinea, and in the eastern Malaccan Islands, including the islands of Aru and Misool, the palm cockatoo is still in decline because of the destruction of its habitat. This means a decrease in the nesting sites where it may protect the single egg it lays over the course of one year and increased competition for food resources with other seasonal animals. The Convention on International Trade in Endangered Species of Wild Fauna and Flora (CITES) has included this species in Appendix I, prohibiting its sale. Nevertheless, poaching continues to be a serious threat to its existence. One specimen, born and raised in captivity, may be sold for upwards of $15,000.

LC

250

250 The palm cockatoo is the largest existing cockatoo. It can reach almost 24 inches (60 cm) in length and weigh up to 3 lb (1.3 kg). Its plumage is bright red on the cheeks with a long feathered crest that crowns its head.

251 The palm cockatoo is omnivorous and loves to eat seeds, fruit, berries, shoots, buds, and coconuts, which are consumed mainly in the trees. It uses its very strong beak to crack open a coconut, and can also use it to catch insects and larvae.

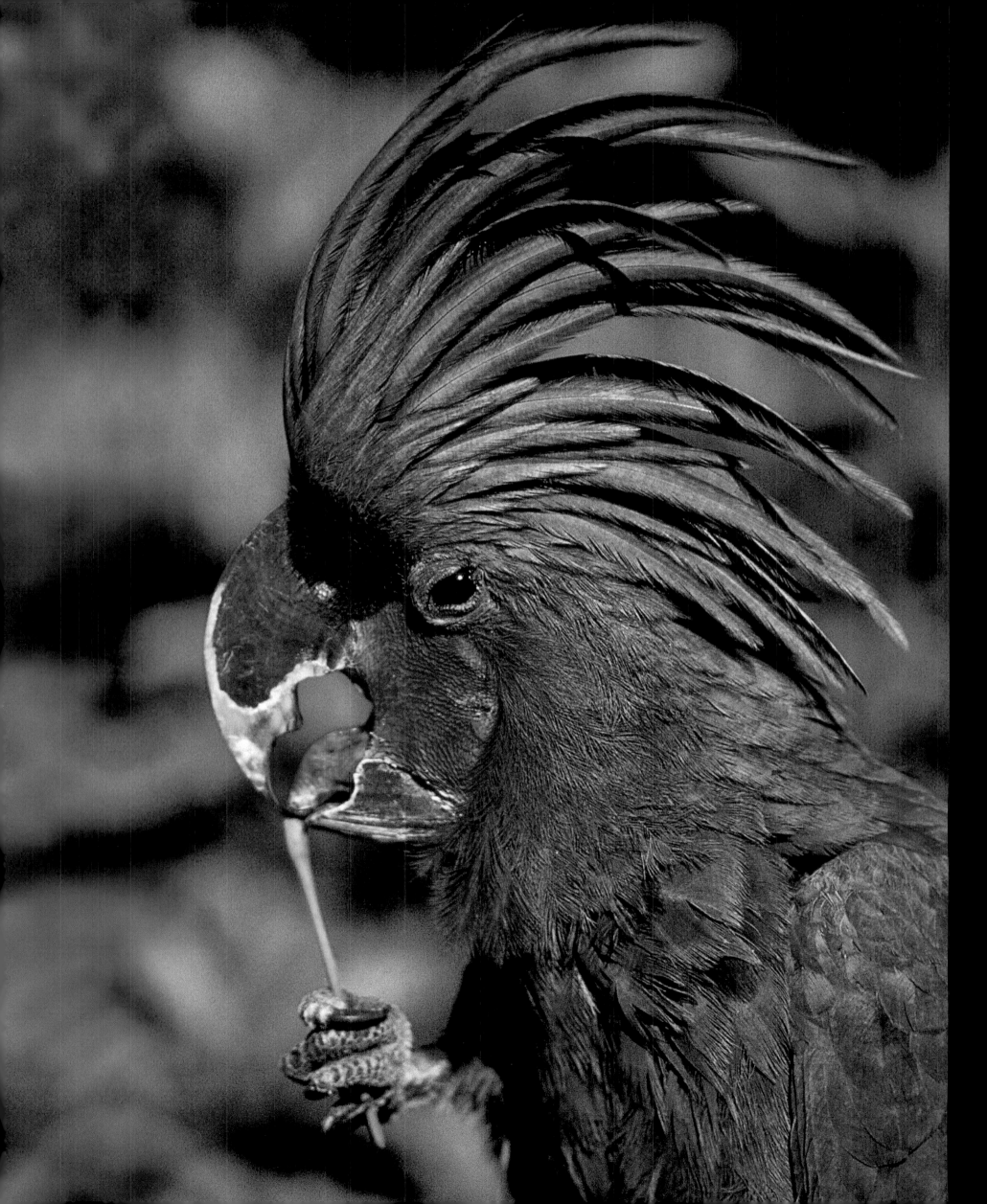

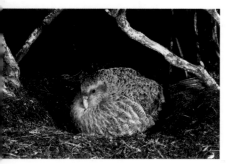

KAKAPO PARROT

Strigops habroptila

Potentially representing a link between nocturnal birds of prey and parrots due to its facial disc typical of owls, the kakapo (*Strigops habroptilus*) shares little with the rest of the Psittacidae family. There are currently only 86 kakapo and a variety of initiatives for the protection of this singular parrot have been pursued since 1950. Indigenous populations, the Maori in particular, started the decline in their numbers as they plundered the birds for their meat and colorful feathers, which were used as head ornaments. Subsequently, the European colonization of New Zealand caused a drastic decrease in kakapo numbers with the introduction of foxes, martens, dogs, and weasels. These have always been deadly predators of the kakapo who is skillful at climbing but inept at flying, with small wings used for the most part as parachutes to glide from one tree to another and so had little chance of escaping. Despite its coloration utilized for camouflage, the species' vulnerability is compounded by the fact that the kakapo is a crepuscular and nocturnal bird, active during the same hours as its unnatural predators that easily locate it due to its unmistakable musk odor. The kakapo's preference for plant food has put it in competition with flocks of grazing sheep and wild herbivores. Among the latter, deer especially contribute to the destruction of the kakapo's ideal habitat, trampling over delicate galleries of undergrowth through which it nimbly moves in search of berries, fruit, shoots and small branches from the New Zealand broom tree to suck on. The kakapo parrot survives today thanks to the conservation projects that care for two populations in the sanctuaries on Codfish and Chalky islands, where there are no predators but are only large enough to accommodate about 100 individuals, the minimum necessary for the survival of a viable population.

CR

252

252 The kakapo is the heaviest parrot in the world and is the only one that does not fly, because it does not have a streamlined breastbone. Its wings are used as a rudder for balance, to break its fall from trees, or to glide from one tree to another. Studies on the biology of this species of the *Strigops* genus continue in order to understand the reasons why it reproduces so rarely.

253 Kakapo in the Maori dialect means "nocturnal parrot" and, indeed, it only becomes active at sunset, searching for plants, rhizomes, and tubers. A large and massive bird, the kakapo measures up to 2 ft (60 cm) in length and weighs 6–9 lb (2.5–4 kg). Its very soft feathers are moss green in color but darker on the back.

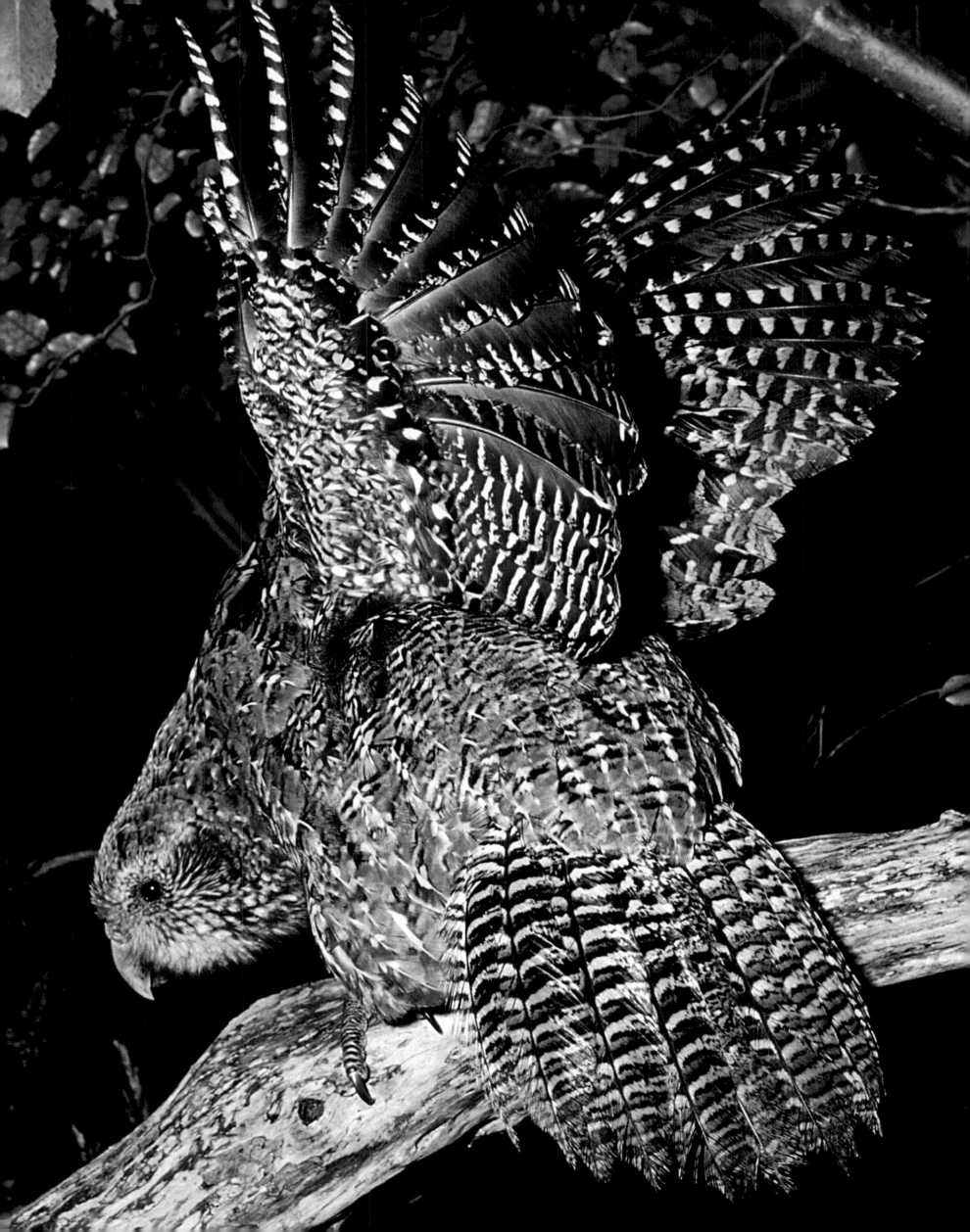

DINGO

Canis lupus dingo

Agile, slender, with a pointed muzzle and cinnamon-colored coat, the dingo is the legendary wild dog of Australia. Recent studies based on fossil remains indicate that the dingo's ancestors were spread throughout the southern hemisphere, where they lived first with groups of nomadic hunters then within farming communities. Dingoes reached Australia with Asian navigators about 4,000 years ago. Wild dogs similar to the dingo are still present in Thailand, where they seem to have maintained their purebred characteristics, as well as in Cambodia, China, India, Indonesia, Laos, Malaysia, Burma, the Philippines, and Vietnam. The "New Guinea singing dog," initially described as *Canis hallstromi*, the "Carolina dog," discovered in the 1970s in the southeastern United States, the "Basenji", an African breed, and the Indian "Pariah dog" are all surviving forms of the primitive dog whose taxonomic identity has yet to be adequately investigated.

The IUCN (World Conservation Union) considers all populations of wild dogs in the Far East and Pacific regions as vulnerable. Dingoes are protected in Australia in national parks and Aboriginal preserves, but throughout most of their range are considered pests and are persecuted by livestock breeders that use poisons, firearms, and traps to get rid of them. In some Australian regions, killing a dingo gives people the right to collect a bounty. In southeastern Australia where most of the large pastures with flocks of sheep are located, dingoes have been exterminated and the creation of a fenced-off area more than 3,480 miles (5,600 km) long discourages their resettlement of this zone. In addition to the conflict with livestock breeders, the largest threat to the survival of this wild canid is hybridization with modern-day domestic dogs. It is calculated than more than one third of Australian dingoes are hybrids. Quite often, even the desire to conserve dingoes causes enormous damage to their populations. "Dingo farms" that aim to protect and reproduce this breed, build their reproductive stock on specimens that have not always been genetically managed. Moreover, the demand for dingoes as household pets increases the risk of producing specimens with characteristics that diverge from their original traits. The danger of hybridization also exists in all of the populations in the Asian countries, where dingoes do not enjoy any legal protection. Also, in these countries dingo meat is very popular and commonly sold in markets.

VU

255 The dingo can be found in all types of habitat, from forests to tropical marshes, to alpine regions over 12,450 ft (3,790 m) above sea level in Papua New Guinea. It is often solitary, but reunites during the mating season with its small pack in which males and females have separate hierarchies.

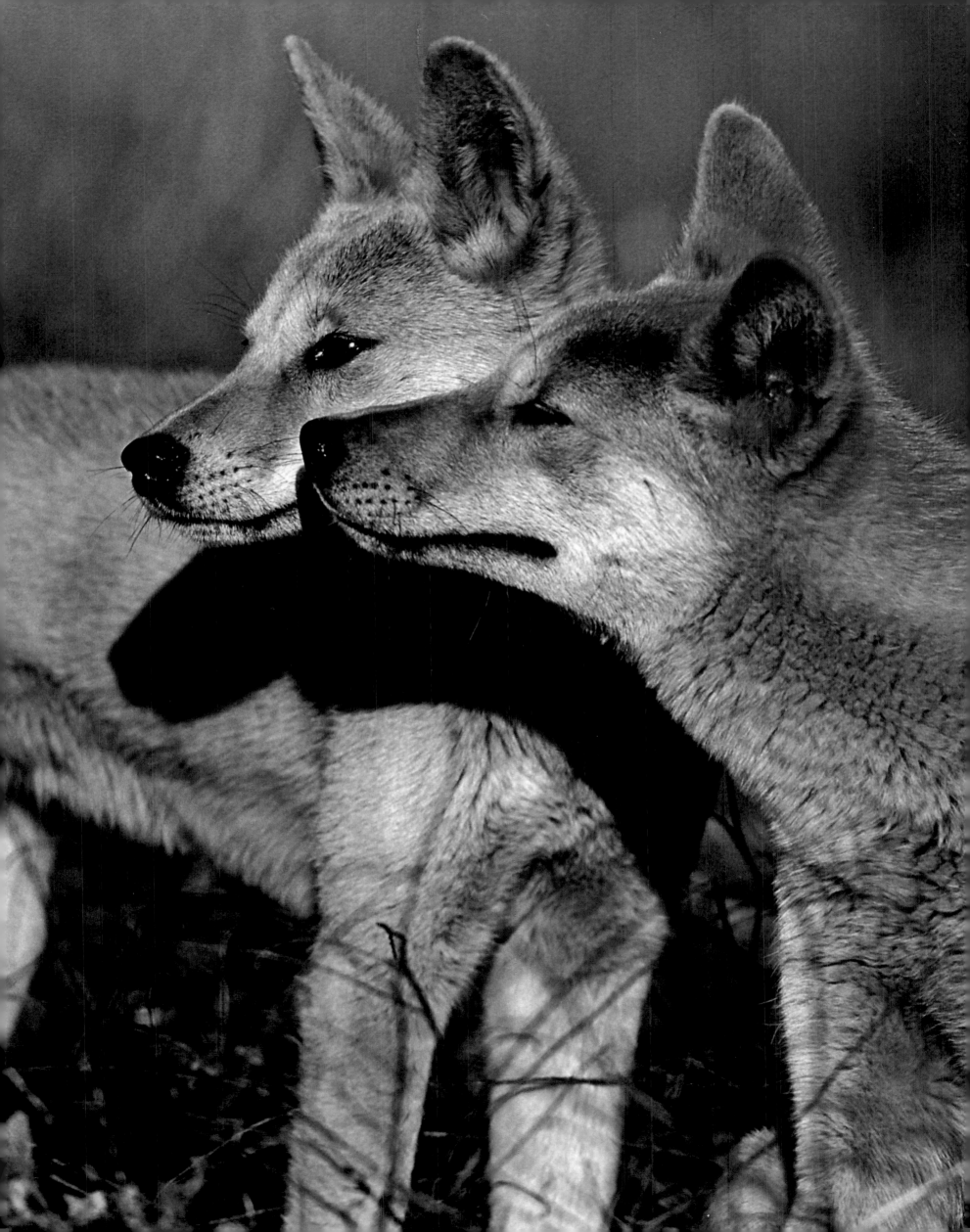

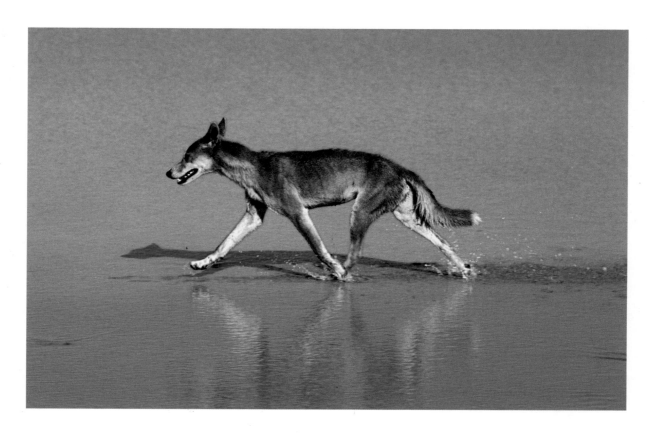

256 The dingo weighs 17–46 lb (8–20 kg), is 15–26 inches (38–66 cm) high at the withers, and 28–44 inches (70–110 cm) in length from its head to the base of its tail. Males are larger than females.

257 The dingo is an opportunistic carnivore and its diet includes more than 170 species, from insects to a buffalo. It can be a solitary hunter or join small groups where all the individuals cooperate fully amongst themselves.

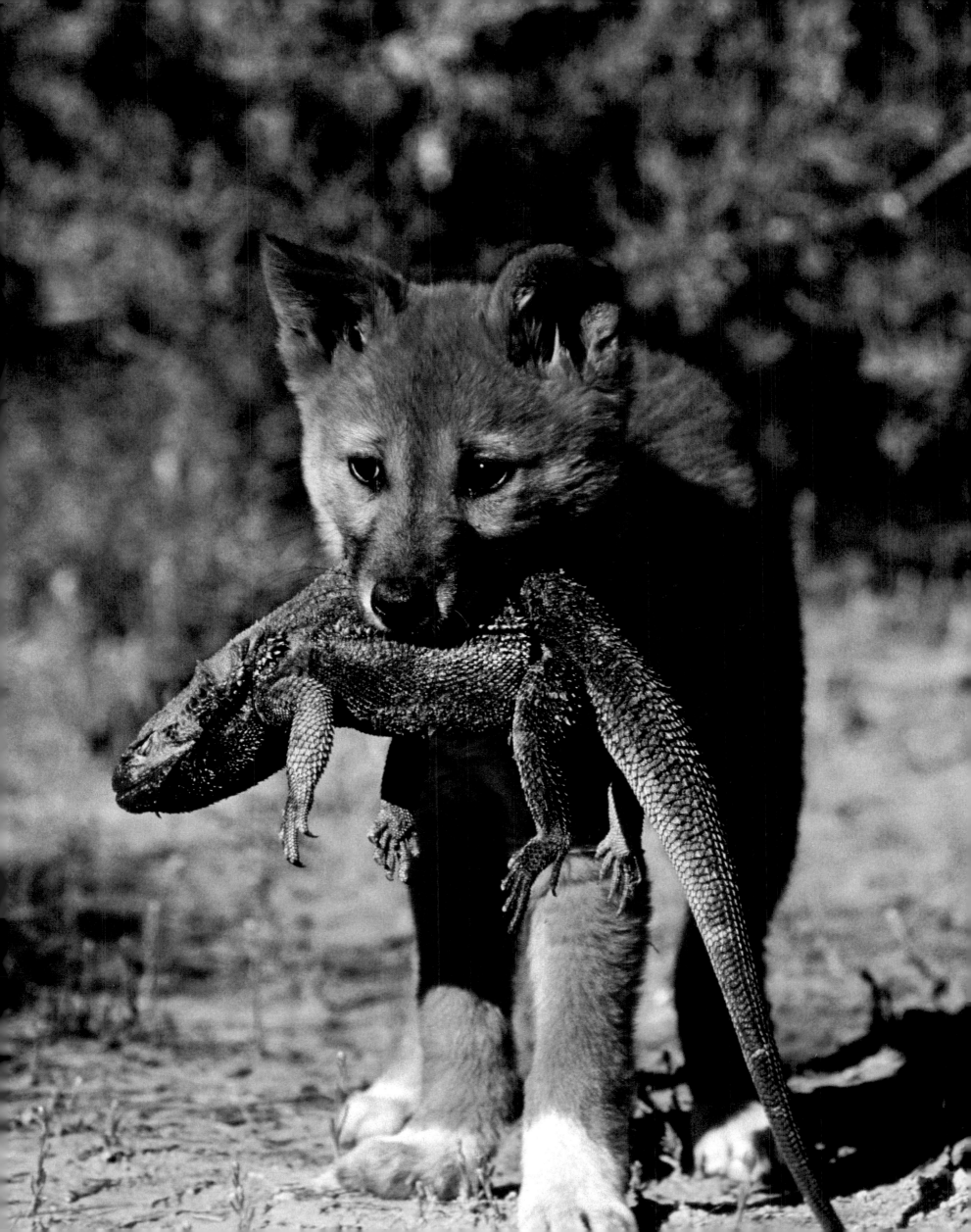

OCEANS AND SEAS WORLDWIDE

For a long time, the sheer vast expanse of the oceans, covering almost 71 percent of the planet's surface, and the land-bound existence of human beings meant that the marine ecosystems were left undisturbed. However, the relatively recent increase in human populations has had a profound impact upon them. The oceans and seas were for a long time crudely exploited for their resources with inefficient fishing techniques limited by and large to coastal areas, with an almost insignificant effect on marine habitats. Over the last 100 years or so, however, due to effective new fishing technology, humans have been able to radically alter and more extensively plunder the marine environments. We currently know a great deal about the ecology of the habitats on land and how to combat the threats against them, but we know too little, as yet, about the worlds beneath the seas and our commitment to their conservation still lacks urgency. Human activity jeopardizes the continued existence of many species and risks transforming if not destroying ecosystems even before they are discovered. Increasingly, intensive fishing has brought about the decline of many populations of commercially popular fish species, and frequently also that of secondary species (by-catch), and threatens also the habitats that support them. Trawling nets as well as extraction and removal of materials for construction or other industrial activities, destroy the seabeds and communities of invertebrate animals living there. Dumping of refuse, fertilizers and pesticides from agricultural areas, industrial waste such as chemicals and heavy metals, as well as the accidental and deliberate discharge of petroleum from tankers, all substantially alter the delicate physicochemical balances, food chains, and biodiversity of the seas.

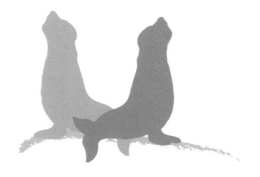

Many still see oceans and seas as unexplored and unknown space, and perhaps because of this they also consider them as having a limitless capacity for our waste and are capable of diluting and disposing of any sort of discarded item, from a simple plastic cup to radioactive material. Unfortunately, this is not so. Toxic chemical substances, such as DDT, accumulate in the oceans and are ingested by marine animals, moving up the food chain until they are "returned" to us on our plates. Because of the numerous means of transport available to humans, many species belonging to specific ecosystems are conveyed to other habitats that can be destabilized by these foreign species which unnaturally modify the ecological balance. To all of this, we should add the unpredictable but inexorable effects of climate change, which will undoubtedly bring fundamental and potentially disastrous alterations to the planet's natural systems. Among the consequences of these changes are the retreat, fusion, and disappearance of glaciers, rising sea levels, and considerable increases in average global temperatures. The growing phenomenon of bleached coral reefs due to the loss of symbiotic coral algae resulting in its eventual death may be due to the general increase in temperature over the whole Earth's surface. It is sadly undeniable that the oceans and seas suffer the effects of the so-called "tragedy of the commons." In other words, individuals consider the exploitation of a common resource as advantageous, even to the extent of its complete destruction, inasmuch as if one individual does not use up this resource then another will have the opportunity to consume it instead. Therefore, it is evident that in addition to adequate consideration of marine ecosystems and our impact on them, we must also take direct responsibility for them, which still has not yet occurred thus far.

L E G E N D

WHALES
(NORTH ATLANTIC RIGHT WHALE)
page 262

1 North Atlantic Ocean

WHALES
(ANTARCTIC BLUE WHALE,
FIN WHALE)
page 262

2 Mediterranean Sea

SHARKS
(BASKING SHARK, MOBULA,
SPINY DOGFISH)
page 274

2 Mediterranean Sea

SHARKS
(GREAT WHITE SHARK)
page 274

2 Mediterranean Sea

DUGONG
page 280

3 Red Sea, **4** Indian Ocean, **5** Pacific Ocean

MONK SEAL
page 284

2 Mediterranean Sea, **6** Black Sea,
7 Atlantic Ocean (Mauritanian Coast)

SEA TURTLES
page 288

2 Mediterranean Sea

WHALES

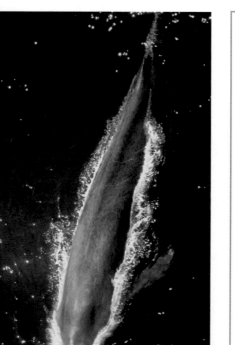

Mysticeti

Despite always having commanded respect and even veneration from those people that traditionally hunted them, whales have also been subjected to reckless hunting, leading many species to the brink of extinction during the last two centuries. Today, some whale populations are numbered in the hundreds and struggle to recover despite no longer being hunted. This is the case for the North Atlantic right whale (*Eubalaena glacialis*) and the Antarctic blue whale (*Balaenoptera musculus*). But hunting still represents a serious threat to some populations, even after the International Whale Commission (IWC) established the 1986 global moratorium on hunting for commercial purposes. In fact, around 30,000 whales, belonging mostly to five species, have been killed since then on the dubious pretext of scientific research. Additionally, hunts carried out by countries such as Japan, Iceland, and Norway, increase yearly and the IWC's fundamental role becomes twofold: prevent any return to large-scale whale-hunting and work to overcome the other dangers threatening these animals. For example, about 300,000 sea mammals, including whales, dolphins and porpoises, currently die entangled in fishing equipment intended for the capture of other pelagic (deep sea) species. What proves to be the most damaging for these species is the large-scale drift net, a vertical barrier that is hundreds of feet wide, countless miles long, and invisible to sea mammals.

Five whale species have been identified in the Mediterranean Sea, even though the fin whale (*Balaenoptera physalus*) is the only species present with a consistent number of specimens and a stable population. In order to contribute to the conservation of whales and other sea mammals, the "sea mammal sanctuary" was established, which is an internationally protected marine area of almost 39,600 sq miles (102,000 sq km) between France, Italy, and the principality of Monaco.

EN

262 Whales are sea mammals divided into the two suborders of Mysticeti and Odontoceti which comprise 14 species, many of which have diverse subspecies. This photograph is of a splendid Antarctic blue whale (*Balaenoptera musculus*).

263 The Antarctic blue whale is the largest animal ever observed. It can reach a length of more than 100 ft (30 m) and weigh more than 150 tons (135 tonnes), or the weight of more than 30 elephants, three of the largest dinosaurs that ever existed, or 2,000 people.

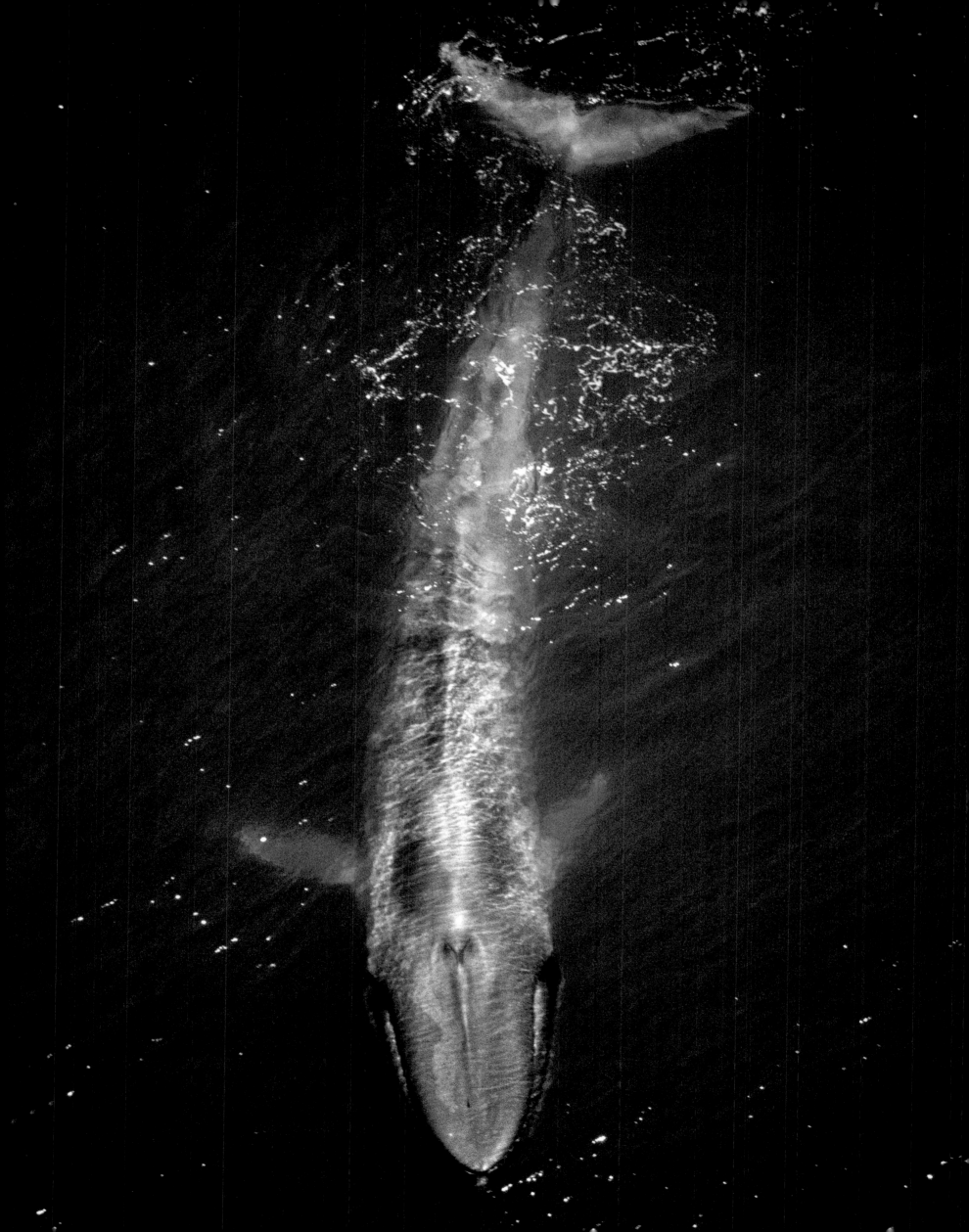

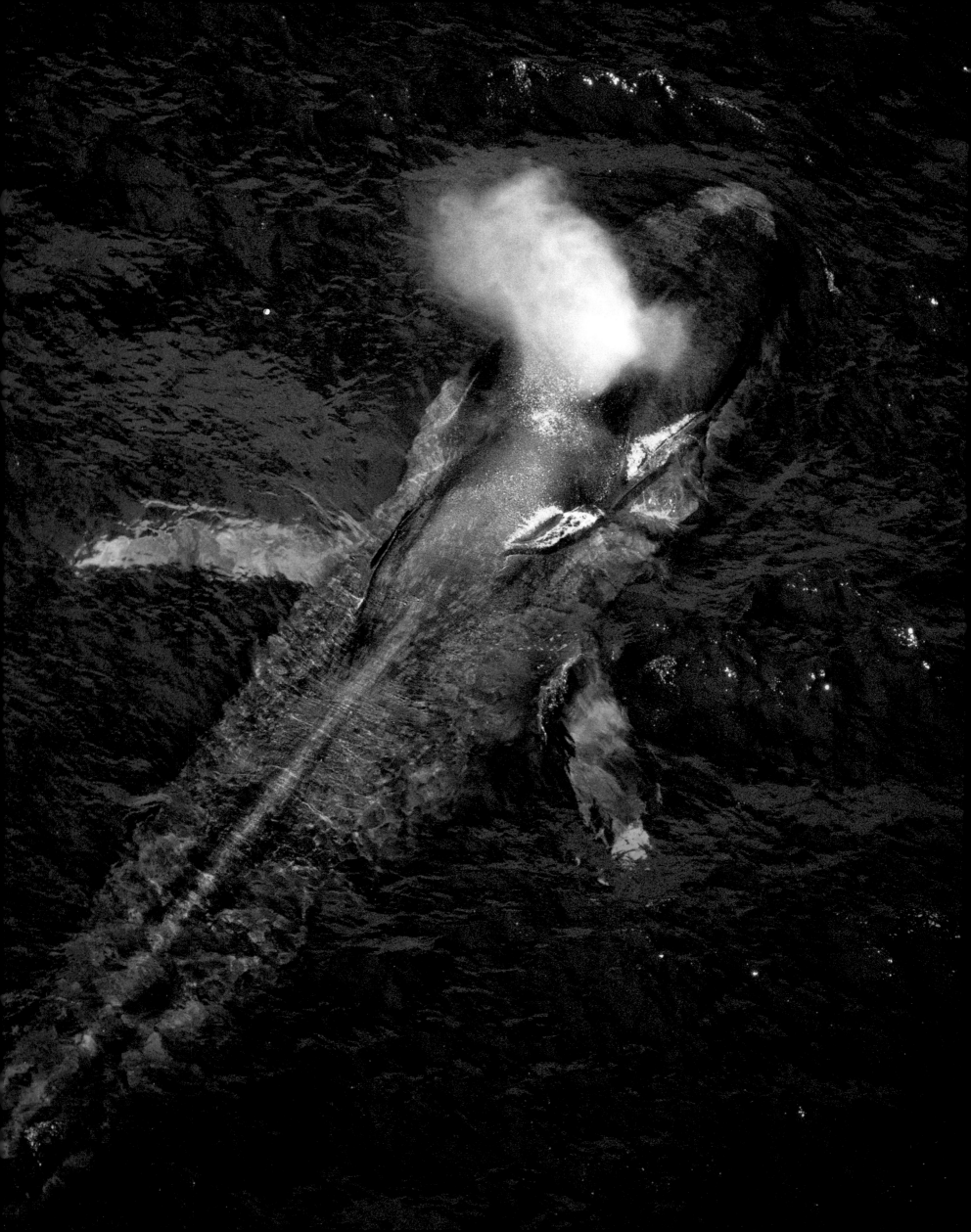

264 Every 10 to 15 minutes the Antarctic blue whale rises to the surface to breathe. The spray of steam created by the contact of its hot breath with fresh air reaches a height of almost 30 ft (9 m). Generally, it breathes from three to eight times before plunging back under the water.

265 Preferred by the whale-hunting fleets of the first half of the last century, the Antarctic blue whale was almost exterminated but has been protected since 1967. Today, the total population is estimated to be between only 2,500 and 5,000.

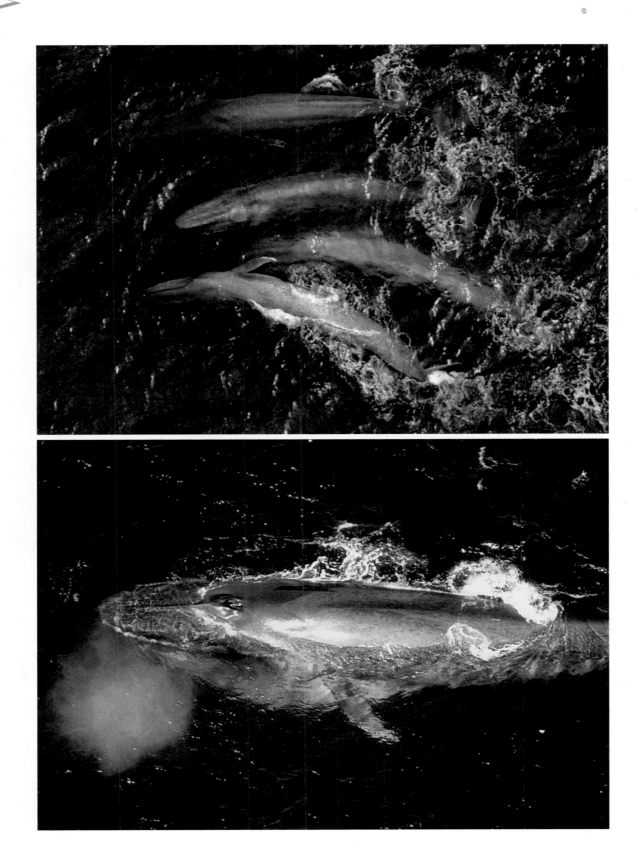

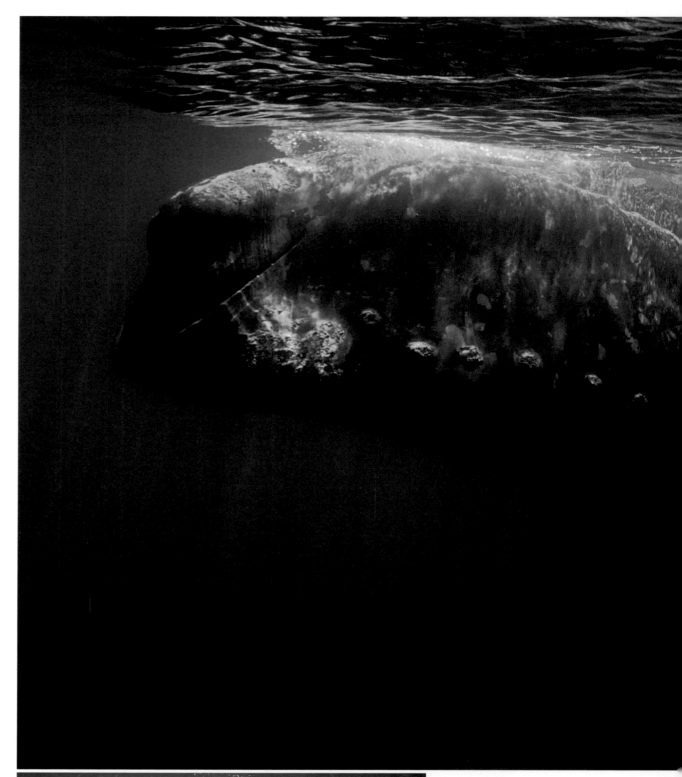

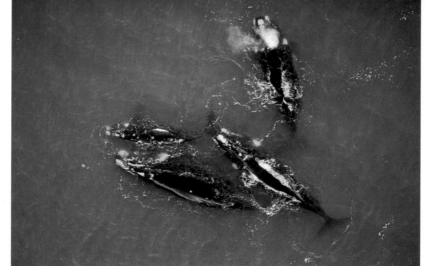

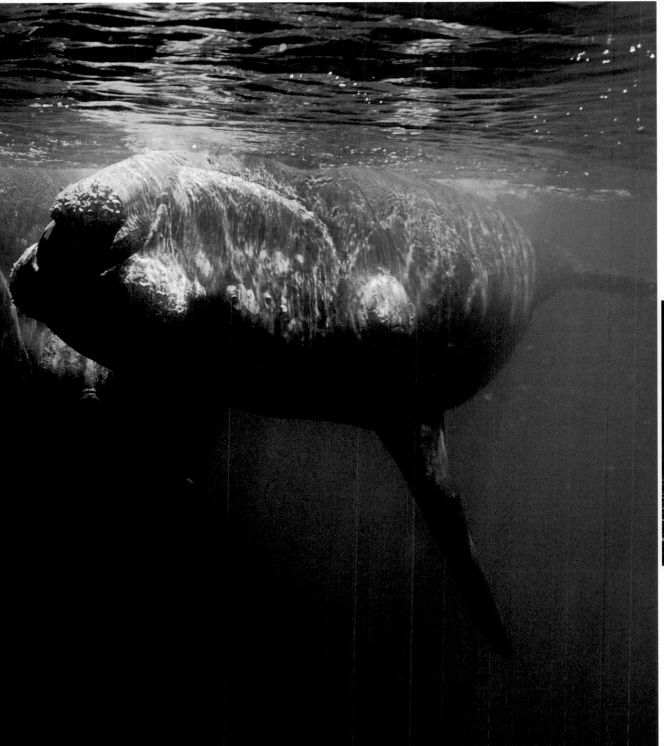

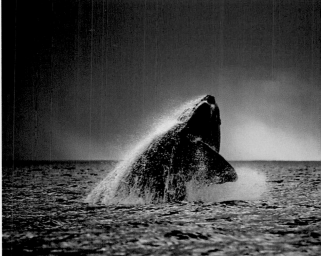

267 The southern right whale is black with white spots scattered haphazardly all over its body and does not possess any dorsal fins.

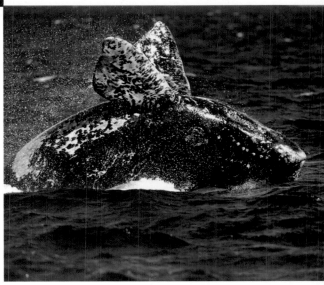

266-267 and 266 bottom Whales have a long maturation period (four to ten years) and females give birth to one offspring at a time. A lot of time is therefore required for populations to recover before the species is no longer classified as endangered. Distributed mainly in subantarctic waters, the southern right whale (*Eubalaena australis*) is almost extinct in the northern hemisphere.

268 The southern right whale has calluses on its head, which are nothing more than growths of hardened skin, varying in position from individual to individual.

268-269 The southern right whale can grow to about 60 ft (18 m) and weigh more than 50 tons (45 tonnes).

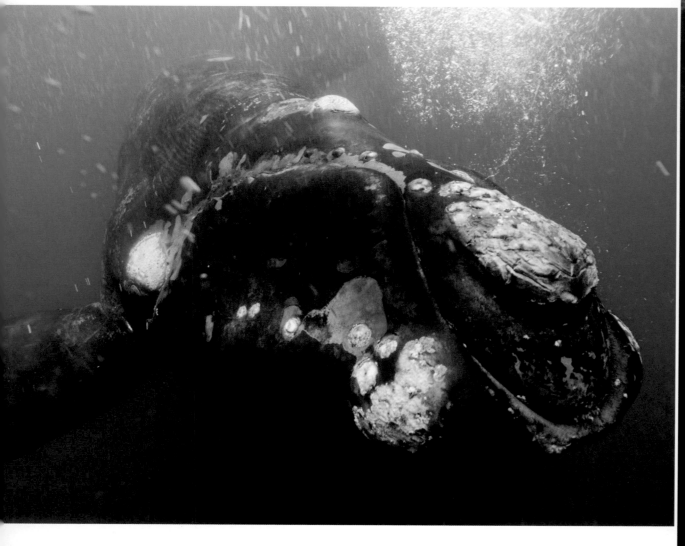

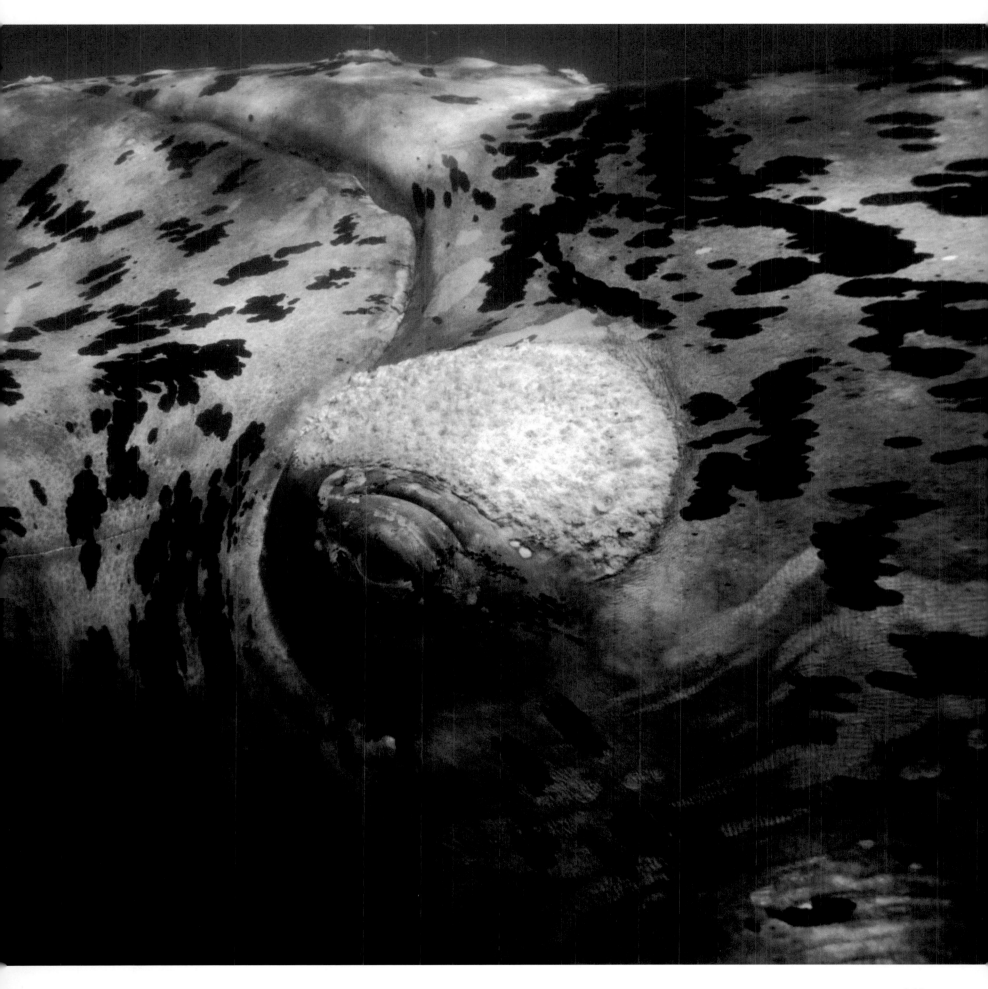

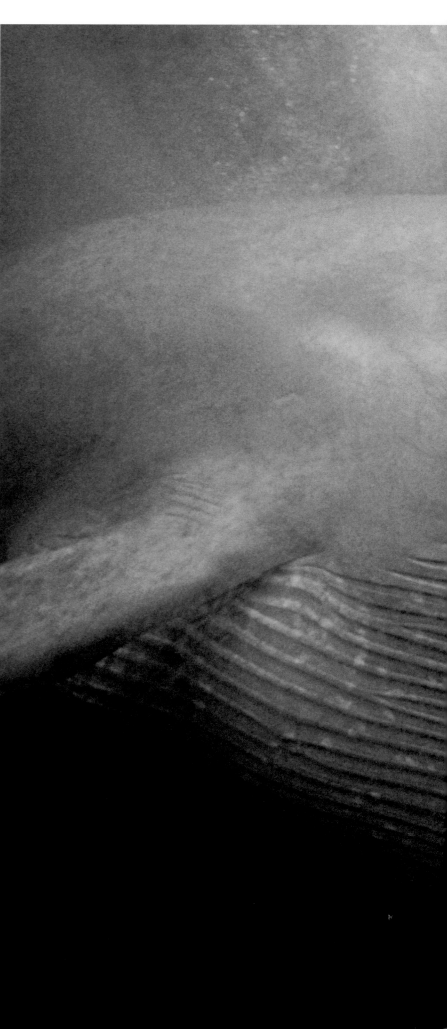

270 and 270-271 Balaenoptera means a whale with wings. The Antarctic blue whale's (*Balaenoptera musculus*) front fins are in fact quite long and have two primary functions: as a stabilizer and as a rudder to help it change direction. Its tail is also very powerful and allows it to travel at almost 13 mph (21 km/h; 11 knots). Among the Antarctic blue whale's most distinctive characteristics are its 50 skin folds distributed along its throat and chest, allowing it to enlarge its mouth to engulf huge quantities of water rich in plankton.

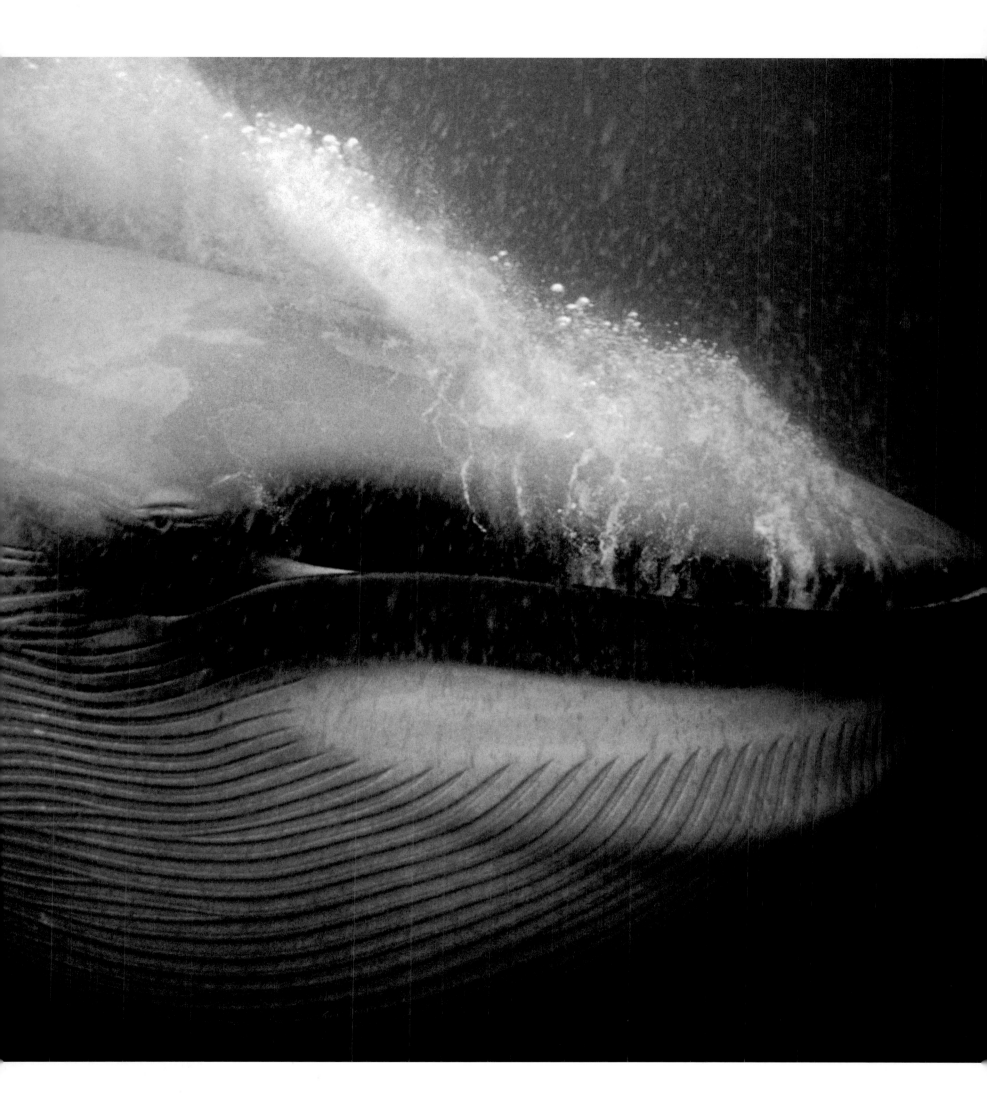

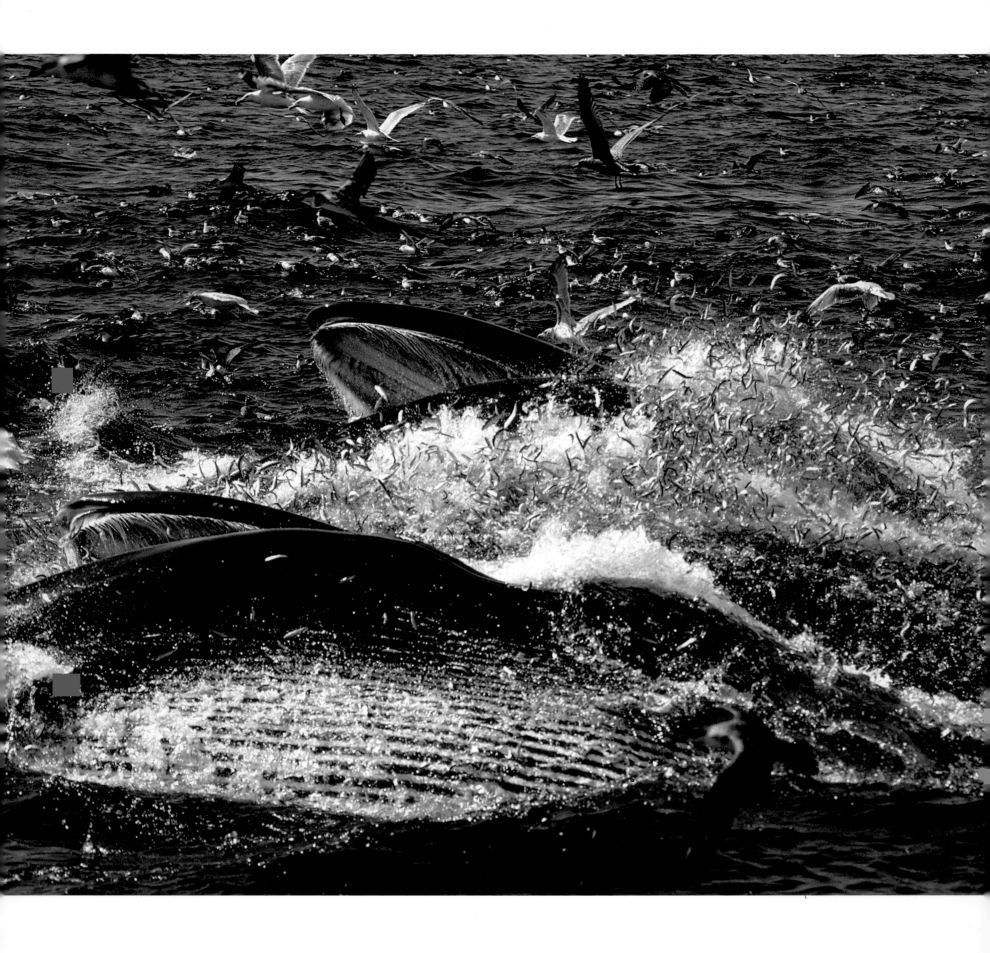

272-273 The fin whale (*Balaenoptera physalus*) is the second largest animal in the world and can reach up to 89 ft (27 m) in length and weigh 80–90 tons (72–80 tonnes).

273 *top* The fin whale dives to depths of more than 660 ft (200 m) and usually returns to the surface about every 15 minutes.

273 *center* The fin whale was once one of the most common whales on the planet, but many years of ruthless hunting has drastically reduced its population, and today just a few specimens survive.

273 *bottom* Also called the "greyhound of the ocean" because of its speed, the fin whale is one of the fastest swimming whales and can exceed 23 mph (37 km/h; 20 knots).

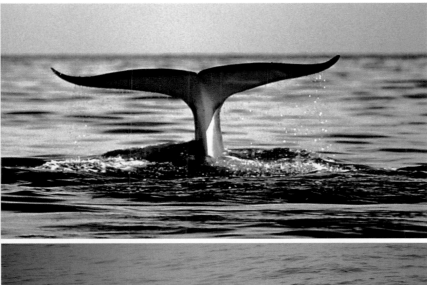

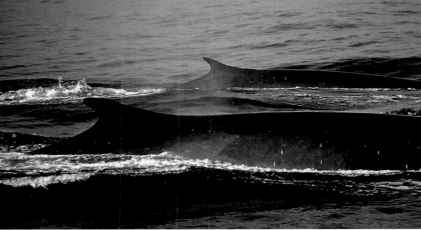

VANISHING ANIMALS - WHALES

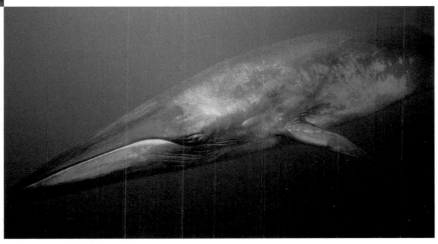

SHARKS

Chondrichthyes

Sharks are defined as cartilaginous fish because of their physical makeup (*Chondrichthyes*) and are an evolutionarily conservative and greatly successful group. This success has allowed their diffusion throughout just about all of the marine ecosystems. They appeared some 400 million years ago, with around 1,200 currently known species differentiated over time, adapting themselves to diverse ecosystems. However, today many human activities threaten their survival and some populations have even decreased by up to 99 percent. Many species were relentlessly hunted for sport and commercial fishing, which became so intense that many populations could no longer survive. Such practices were as damaging as they were brutal, particularly "finning" that consisted of cutting off the animals' fins (two to five percent of total body weight), then throwing their now dying bodies back into the sea, destined for certain death. Tens of millions of sharks are still killed every year, decimating their populations. They also get caught during the fishing for other species (the so-called "by-catch") and it is suspected that this may cause even more deaths than direct fishing. This is the case with the drifting long line used for deepsea tuna, one of the most widespread fishing methods, as well as trawling, which occurs nearer the coast. Sharks are also in decline due to the loss of their habitats, such as those along coasts, caused by development, fishing, chemical pollution, deviations in bodies of water, and refuse. Many of their species have already been classified in danger of extinction and included on the IUCN's (World Conservation Union) Red List. In every probability, others are equally in danger, even when the necessary information to determine their status is lacking. For example, the basking shark (*Cetorhinus maximus*), the great white shark (*Carcharodon carcharias*), and the giant devil ray (*Mobula mobular*) are already protected in the Mediterranean Sea. This could also be necessary for other shark species while for some, such as the hammerhead shark, there is an urgent need to acquire more information on the status of current populations.

Cetorhinus maximus VU, *Mobula mobular* EN, *Hylobates moloch* VU

274 and 274-275 Sharks are accumulators of polluted substances. High levels of mercury have been found in the spiny or piked dogfish (*Squalus acanthias*) seen below. The basking shark, almost 40 ft (12 m) long, is the second-largest fish in the world.

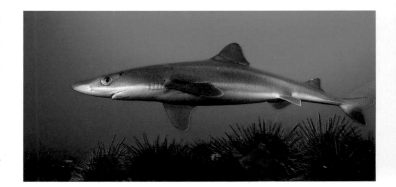

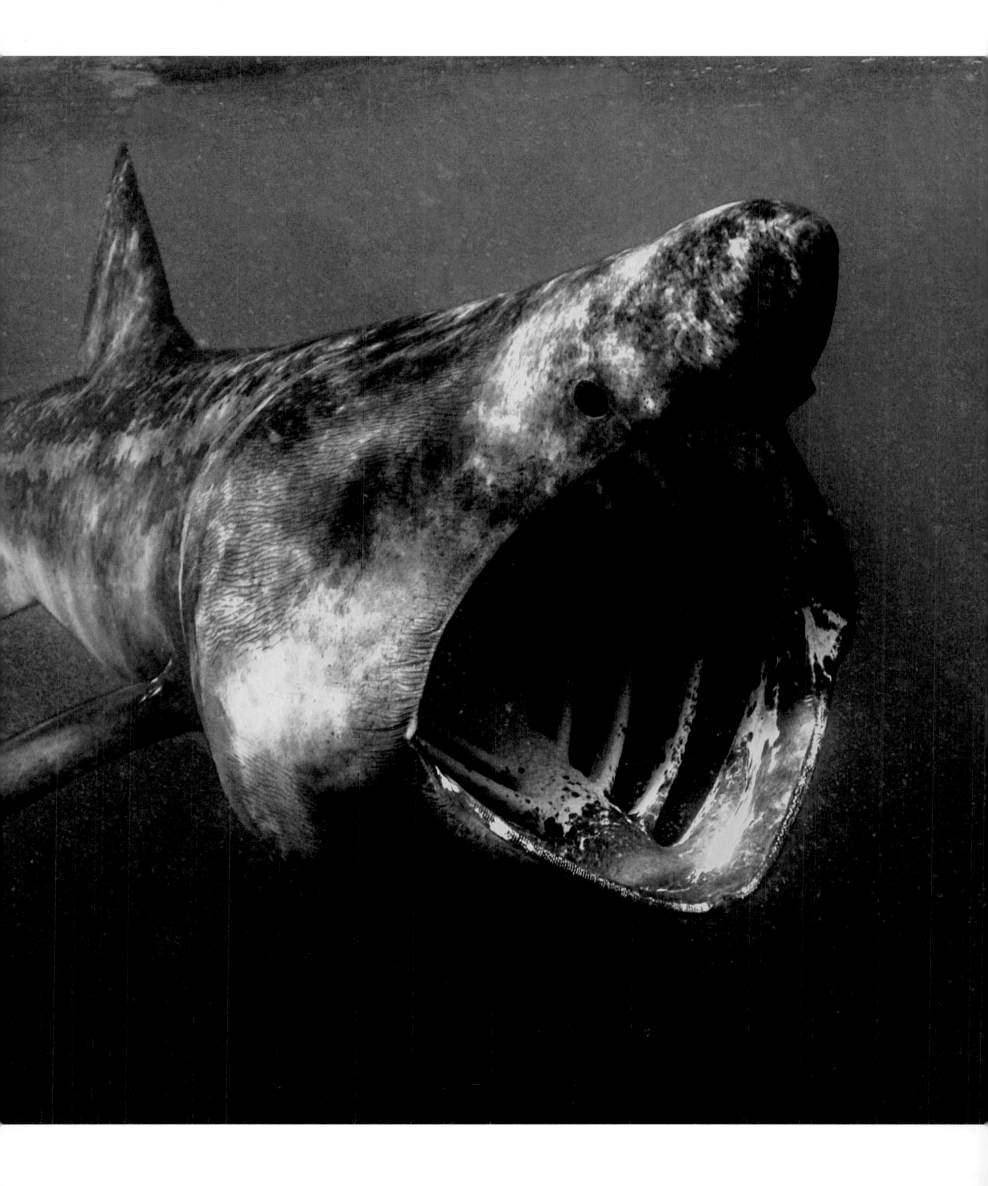

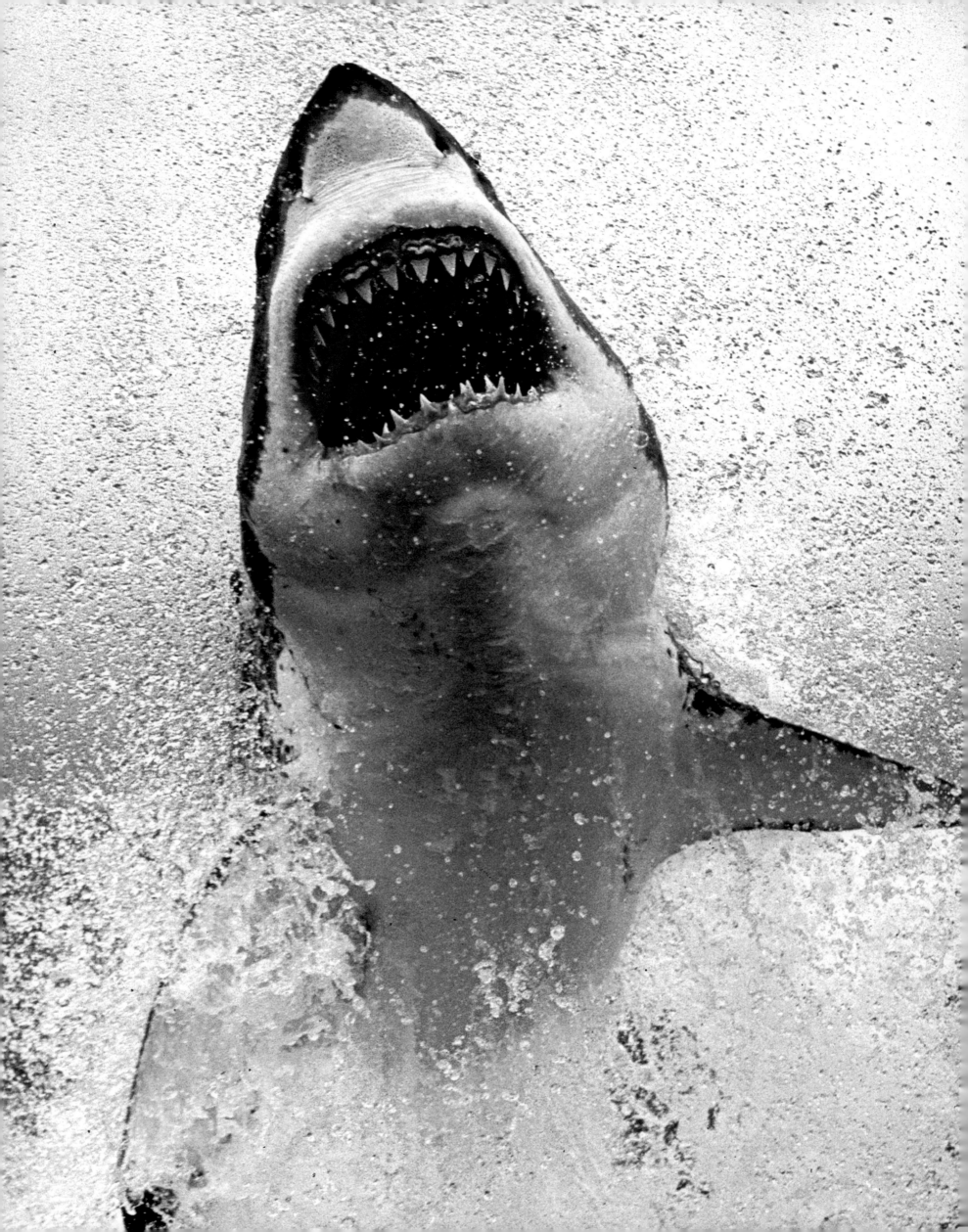

276 and 277 The largest fish predator on the planet is the great white shark (*Carcharodon carcharias*), which is distributed throughout the cold and temperate deep oceans and only occasionally moves nearer the coastline. Seals, tuna, swordfish, sea turtles, dolphins, as well as other sharks are its main prey species. Attack is the great white shark's preferred hunting technique. It does not surround its prey by encircling it, but surprises it by attacking from below.

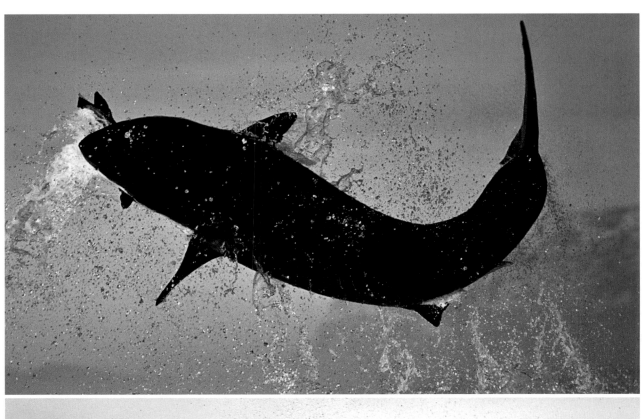

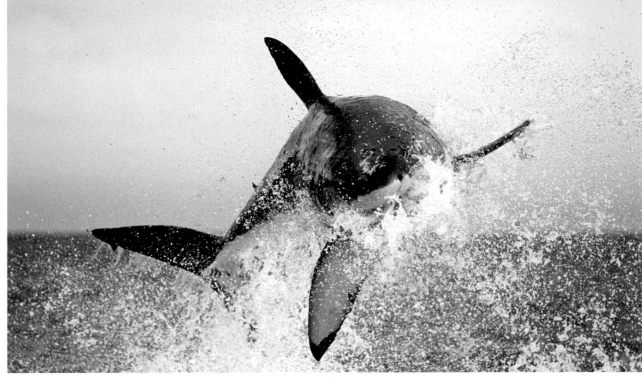

VANISHING ANIMALS

278-279 Sharks are highly specialized and particularly adaptable animals. For example, the great white shark maintains a higher body temperature than that of the water where it swims, allowing it to be more efficient.

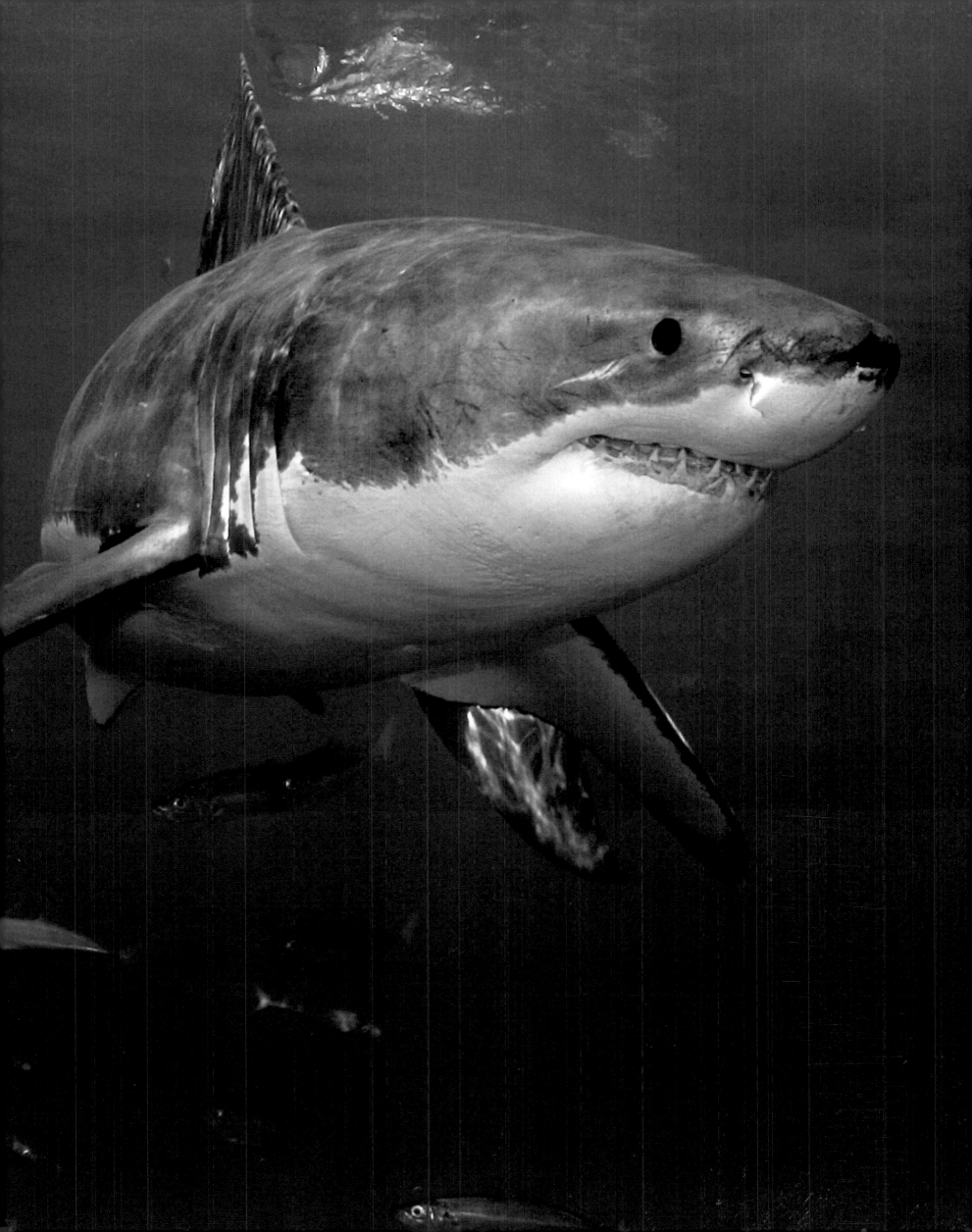

DUGONG

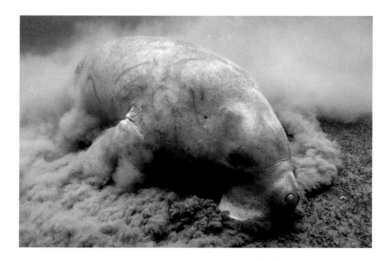

Dugong dugon

At a depth of just 10 ft (3 m) below sea level, holding their breath for many minutes, the dugong (*Dugong dugon*) slowly graze the vast sea-grass beds, looking for plant rhizomes (rootstock) to feed on. The dugong are vegetarian mammals, so thoroughly adapted to aquatic life that they never abandon the seas where they swim, helped along by their large bilobed tails and prehensile fins, which are also used for grasping and holding objects. It is unusual to see more than two or three dugong together. Generally, a pair would be a mother and her young one who will be suckling for the entire period of 18 months. It was perhaps the dugong that gave rise to the legend of the siren (mermaid), half-fish and half-woman, which gave the name, Sirenia, to their order. Another species of "sea cow," as dugong are also known, also belongs to this same order. The Steller's sea cow (*Hydrodamalis gigas*) was hunted for its meat and oil, and became extinct in 1768, less than 30 years after its discovery. The dugong inhabit the shallow and tranquil bays of the Red Sea, of the eastern coasts of Africa and Southeast Asia, islands in the Pacific Ocean, and Australia. The largest population of dugong seems to be concentrated in the Australian state of Queensland. A census of specimens is difficult and is performed over specific reconnaissance areas. Throughout the rest of their range, the population is in decline, fragmented and divided by vast stretches of coast where the dugong is now absent. In addition to traditional hunting for meat and oil, for hides, teeth used as amulets, and for bone that is pulverized and considered an aphrodisiac, the dugong's survival is threatened by many accidental deaths due to trawling or large topside chafer nets used for shark fishing in which the dugong get entangled and die from suffocation. The primary threat, however, is really due to the transformation and degradation of its natural environment. New tourism-oriented construction and development along the coasts, the emission of agricultural chemical products, and industrial and mining waste into the seas all negatively affect the growth of sea-grass beds. Finally, the loss of coastal mangrove forests, the type of forest most in decline over the last ten years, also contributes to a reduction in habitat and the possible future extinction of the dugong.

VU

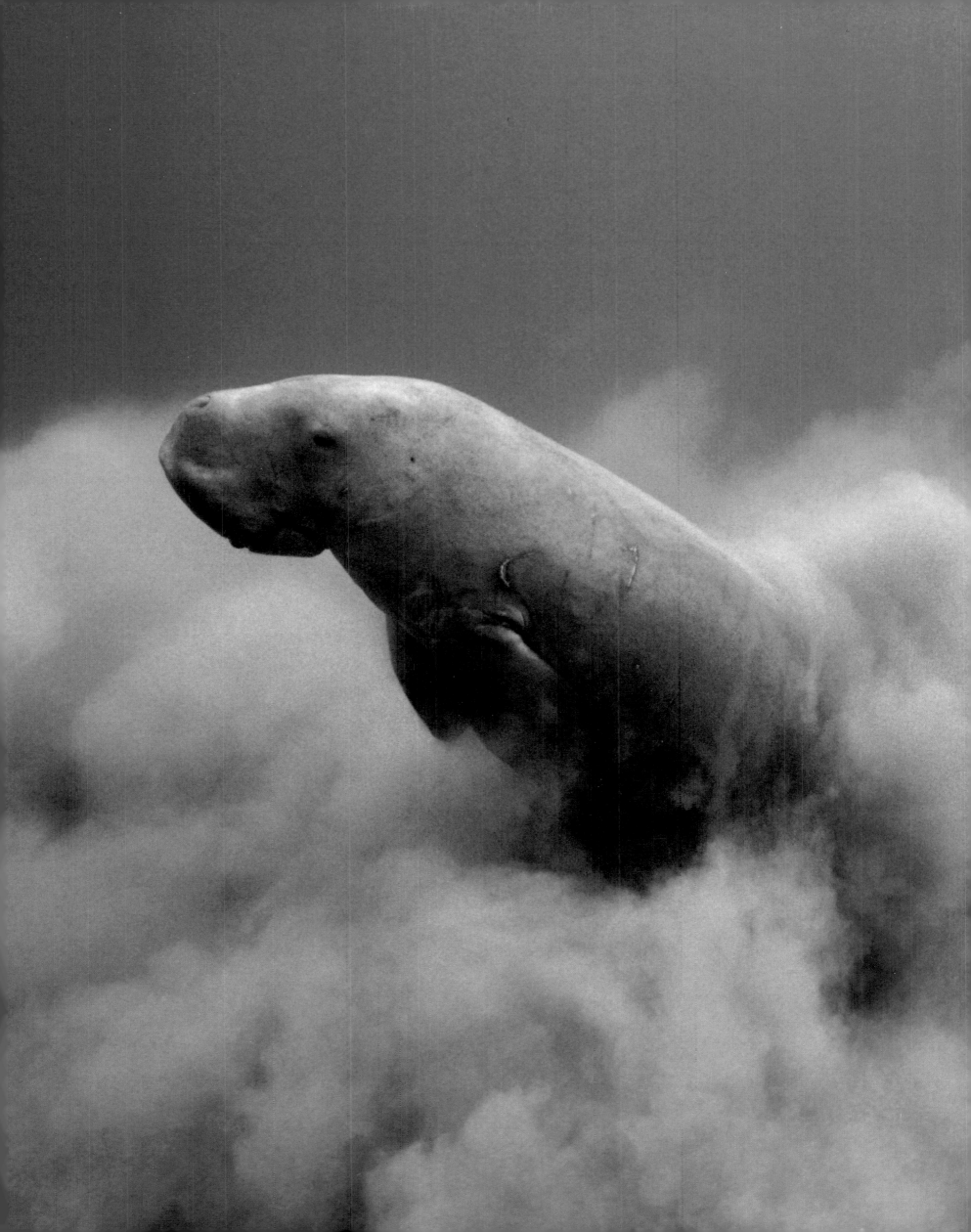

When national development strategies consider both humans and animals

In conjunction with the institution of the first dugong sanctuary, the WWF has developed a major project for persuading the government and local authorities in the Philippines to pursue marine and fishing strategies that would reduce poverty and at the same time conserve the marine ecosystem. In fact, fishing represents an important component of Philippines agriculture, contributing 4.3% of the gross domestic product, supporting about 1 million people, and employing 5% of the national workforce. Fishing constitutes around 50 to 60% of the population's protein diet and fish exports reach up to 172 billion tons every year. As a result, excessive and illegal fishing, decline in marine habitats, and poverty are the main challenges that the Philippines must confront. The current situation shows that fishing revenues are not sufficient to guarantee the profitability of a large number of small fishing businesses, but a general plan based on specific objectives regarding sites for management of fish and natural resources could be the solution to this critical problem. Beyond any specific measures to move fishing towards a sustainable future (for example, potential per capita fishing quotas, license distribution, fishing controls), the critical issue is that the reduced quantity of fish available requires a decrease in fishing activity whether by the fishermen or by those who sell fish. Therefore, to combat poverty, a plan that involves other business sectors in addition to fishing would be essential, assuming it is multi-dimensional and addresses economic, social, demographic, and cultural factors. The WWF has taken account of these factors and, in addition to establishing its own projects, has worked over the years to motivate the Philippine government to implement long-term plans for creating the infrastructure that would help the poorest people and involve all the appropriate institutions so that the best conditions for investment and small enterprises are created to benefit the less fortunate. For example, if aquaculture is to be seen as a potentially rewarding new business venture, then the country could help by reviewing business sector policies based on the cumulative experience with the issues of over-breeding, high demand for food sources from the wild fish stock, pollution, and the impact on coastal zones and relocation of small fish.

280 Once also distributed throughout the Mediterranean Sea, the dugong is the only strictly herbivorous marine mammal and it chooses its habitat according to the season and its activities.

281 Dugong may live for over 70 years. Females start reproducing at around ten years of age and, after a gestation period of 13 to 15 months, give birth to one offspring at a time that it suckles for 15 to 18 months.

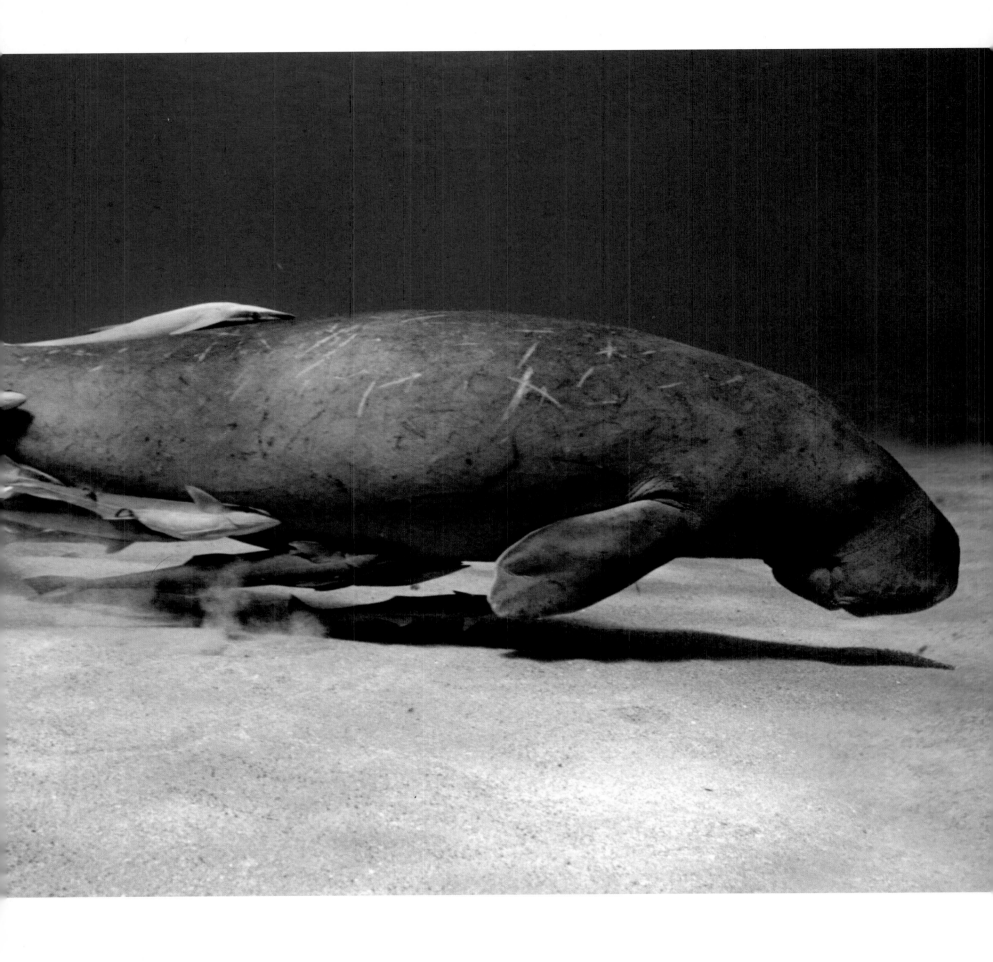

282-283 The dugong's fertility is quite sensitive to the consistent quantity and quality of its diet, which comprises mainly the leaves and roots of aquatic marine plants. When the dugong does not have enough to eat, it postpones reproduction for better times. The conservation of the dugong's natural environment is a critical factor to the survival of this species.

MONK SEAL

Monachus monachus

The presence of the monk seal (*Monachus monachus*), glimpsed moving sinuously through the waves, is linked to the myth of the mermaids, legendary half-women, half-fish creatures of the sea. With their "voices of honey," the mermaids bewitched sailors who would jump into the waves to find them. In Homer's epic poem *The Odyssey* (8th century BC), Ulysses tied himself to the main mast of the ship so as to not give in to temptation as he listened to their seductive song and become their victim. Once widespread throughout the Mediterranean Sea, the Black Sea, the Atlantic coasts of Spain, Portugal, Morocco, Mauritania, Madeira, and the Canary Islands, the monk seal is now one of the most endangered animals on the planet. The species has been reduced to less than 400 specimens and is distributed in small groups throughout the Mediterranean Sea and along the coasts of Mauritania. The surviving nuclei are principally concentrated among the Greek islands and the Mediterranean coasts of Turkey and the Black Sea. According to the IUCN's (World Conservation Union) estimates, the monk seal is at critical risk of extinction and the species has also been inserted into Appendix I of the Convention on International Trade in Endangered Species of Wild Fauna and Flora (CITES).

The monk seal is extremely sensitive to the presence of humans. Direct hunting by fishermen because the monk seal can damage their nets, the excessive exploitation of fisheries which has reduced the available food for seals, and the difficulty in finding isolated and undisturbed caves where they can give birth to their young have brought this species to the threshold of extinction. In Italy in 1997, the WWF established a special work group called the Gruppo Foca Monaca (Monk Seal Group) that has experimented with using infrared TV cameras to monitor the sites frequented by monk seals. Thanks to the collaboration between Italy and Turkey, WWF researchers have observed the activity of seals inside a cave on a small, uninhabited island north of the Gulf of Izmir, 24 hours a day for an entire month. According to the latest research, the monk seal does not exclusively frequent the shallower sea beds near coasts, but travels dozens of miles every day and readily submerges to depths of up to 300 ft (90 m).

CR

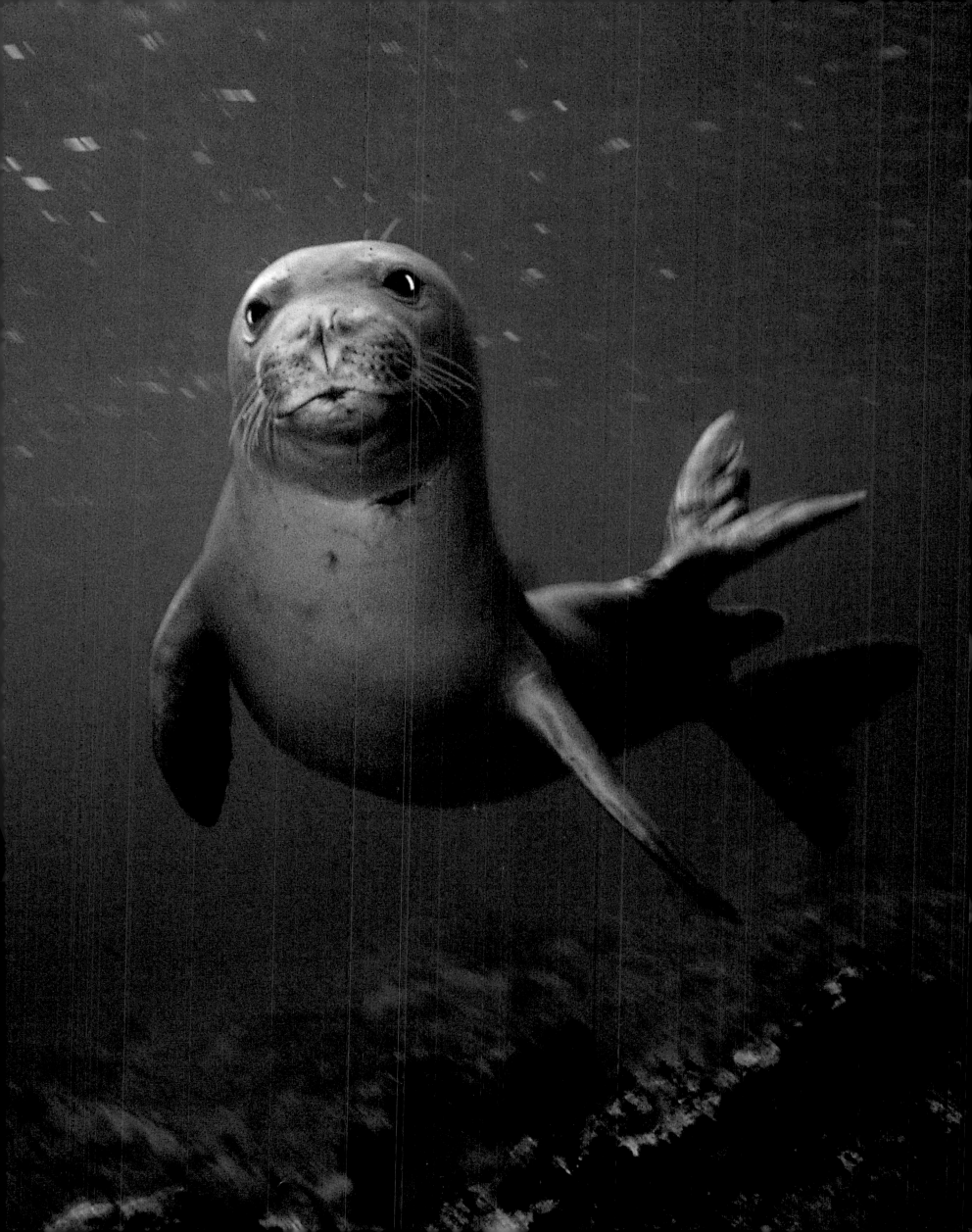

Government commitment and responsible fishing to maintain the precious marine ecosystem intact

Mass tourism and development in coastal areas seriously places the survival of this wonderful marine mammal in danger. The WWF collaborates with and encourages the governments of Greece, Turkey, and North Africa to protect those stretches of coast that are still relatively intact, and protests against tourism development projects and coastal infrastructure construction that seriously endanger the strips of beach where monk seals may reproduce. The institution of protected marine areas cannot just remain a formality of law or a small spot of a different color on tourist maps. Efficient sea surveillance that enforces the prohibitions of motorboat use, controls on fishing activity, and observers to watch for any abuse by developers along the coast are all required. The protection of the last uncontaminated areas of the Mediterranean Sea is a commitment that all relevant governments must make together by collaborating and supporting common initiatives to safeguard this enormous cultural heritage of biodiversity. In addition to supporting these initiatives, the WWF has committed to pursuing information campaigns in many countries directed at small coastal fishing operations. Unlike other marine mammals and sea turtles, this pinniped is rarely the victim of drift nets, but more frequently the object of direct elimination as the monk seal is still perceived as a competitor to fishermen who do not hesitate to kill it when finding it entangled in their nets. In all of the countries around the Mediterranean basin where the monk seal is present, the WWF provides environmental education programs in schools so that future generations are aware of the importance of respecting and protecting coastal areas, and of the opportunities that all the activities of sustainable tourism and responsible fishing offer by maintaining a marine ecosystem that is among the most valuable in the world.

284 and 285 Monk seals are from 31 inches (78 cm) to almost 8 ft (2.5 m) long and the males may reach about 705 lb (320 kg) in weight, while the females are smaller. They generally live to between 20 and 30 years of age. This mammal has transformed its limbs into fins. Adult monk seal females live in family groups comprised of other adult females and young seals.

286 and 287 The monk seal is characterized by a tapered body, covered by an adipose layer (fat tissue) with short waterproof hair that is black or brown in color. Its head is small in dimension and a bit on the flat side. Its ears are not equipped with external ear flaps and its muzzle has long and stiff "moustache" whiskers.

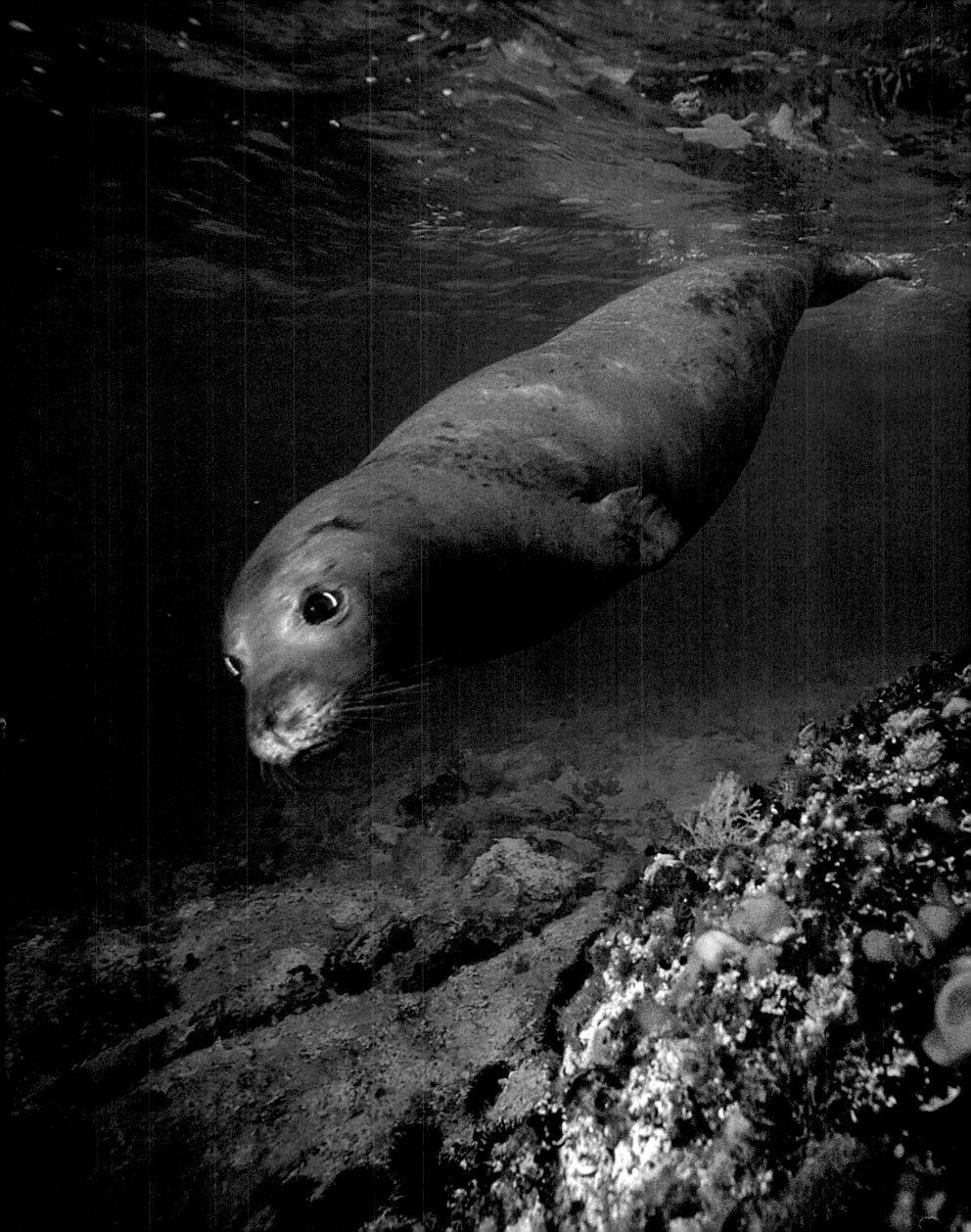

SEA TURTLES

Chelonioidea

Sea turtles have inhabited the Earth for more than 150 million years. Over this long period of time different species have existed, varying in number or their ability to adapt to marine life with one important exception: in contrast to other great marine reptiles of the past, sea turtles were never completely separated from the dry land to which they still returned to lay their eggs. Currently, only seven species of sea turtles exist in the world, a low number when compared with other periods, and this number risks further reduction because of human activity. Some species are quite the generalists. The *Caretta caretta*, for example, is the most common in our seas and lives either in offshore pelagic (deep sea) environments or in shallow sea beds near the coast, feeding on any prey it encounters, whether pelagic or benthic (living on the sea bed). Other species are largely specialized, such as the *Chelonia mydas* that feeds on marine plants, or the *Eretmochelys imbricata* that feeds on sea sponges. However, an even higher level of specialization is observable in the *Dermochelys coriacea* that, distinct from other terrestrial, marsh, or marine animals with chelae (claws), has a leathery carapace (shell), whereas the large dermal bones of the shell of other species have undergone a remarkable reduction and fragmentation. Until recent times, sea turtles had an ecologically important role, but in some cases, human-induced impact has resulted in a reduction in their numbers of more than 95 percent. In fact, these species are threatened by various human activities. From the direct collection of eggs or removal of specimens for food or commercial purposes, to indirect threats such as death due to accidental capture in fishing equipment, tourist traffic on beaches where the turtles nest, to pollution and climate change. Sea turtles are present in the Mediterranean Sea, and all those bodies of water around Italy, such as the Adriatic Sea, the Ionic Sea, and particularly in the Strait of Sicily. Their principal nesting sites are in Greece, where the WWF and Archelon have protected the beaches on Zakynthos Island for years, and especially in Akyatan, Turkey, Cyprus, and Libya, where the WWF has also looked after many beaches.

EN

289 The green sea turtle's distribution (*Chelonia mydas*) is quite widespread and includes both tropical and subtropical seas. However, it is estimated that currently about 100,000 green sea turtles are killed every year in the Indo-Australian archipelago alone.

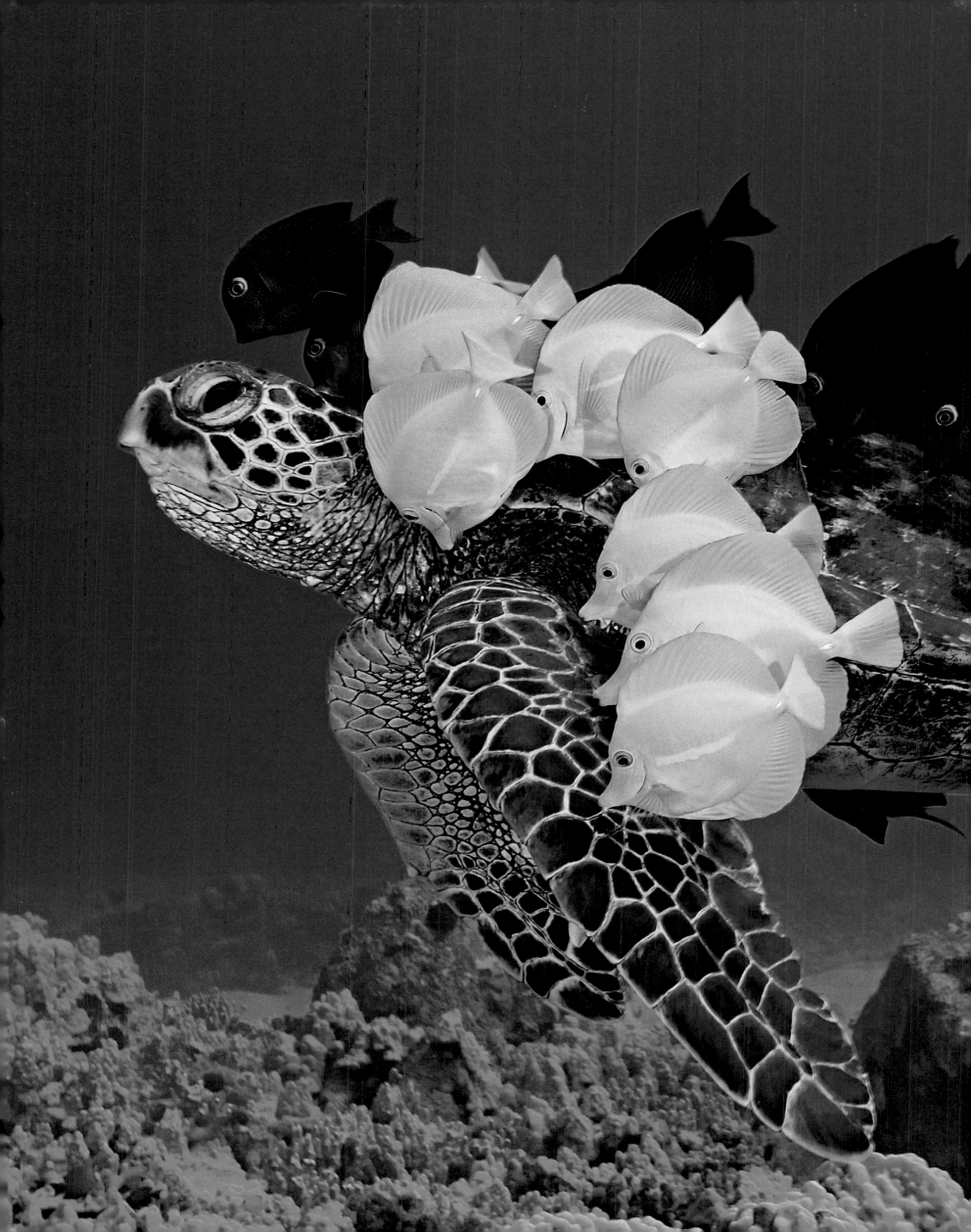

WWF projects for the conservation of marine and coastal resources

Sea turtles have for centuries been an important resource for coastal communities of quite a few countries in tropical and sub-tropical regions. However, lately there has been a rapid decrease in their populations largely due to human activities, including excessive exploitation for international commerce, the destruction of reproduction sites, and damage to the species caused by the fishing industry, which still has difficulty in adopting more selective fishing equipment that would prevent accidental capture and death from ingesting fish hooks or suffocation in nets. The reduction and disappearance of turtle populations is occurring in the coastal areas of mainly developing countries. The WWF has made the protection of sea turtles one of their global conservation priorities by developing and supporting numerous integrated management projects of marine and coastal resources. These projects involve local communities in the safeguarding of reproduction sites, in the control of the species, creation of sustainable tourism activities, and environmental education.In Kenya, for example, a project on Lamu Island near the Somalian border has been in operation since 1996. In this area, the Kiunga Marine Preserve has been established for the protection of five out of seven known sea turtle species. From the start, the WWF has involved the local communities here in an extensive program of protection and sustainable management of marine resources that employs especially women and young people in a variety of direct and indirect conservation activities. The nests are protected from prey by covering them with mesh crates that allow the coming and going of young sea turtles. If necessary, the nests are relocated to more secure places in order to avoid rough inshore seas destroying their precious contents. Surveillance teams work in the reproduction areas, checking on the nests, and updating a census of laid eggs. A wide-ranging environmental education program involves the evaluation and collection of refuse on the beaches that may pose an obstacle to nesting, and this also provides the local people with some economic benefit from the collected refuse. The women gather colored plastic materials, recycle them, and transform them into a great variety of interesting objects which are sold as souvenirs. Great effort is also being dedicated to the training of communities in the sustainable management of natural resources, particularly with regard to sustainable fishing and the dangers resulting from the removal of timber from coastal mangrove forests. All of these interventions have created a basis for developing ecotourism activities that are directly managed by the local communities in one of the most uncontaminated areas on the eastern coast of Africa.

290

290 The green sea turtle lives in quite shallow and warm water, rich in algae and marine plants.

291 The green sea turtle is recognizable by the greenish brown coloration of its shell.

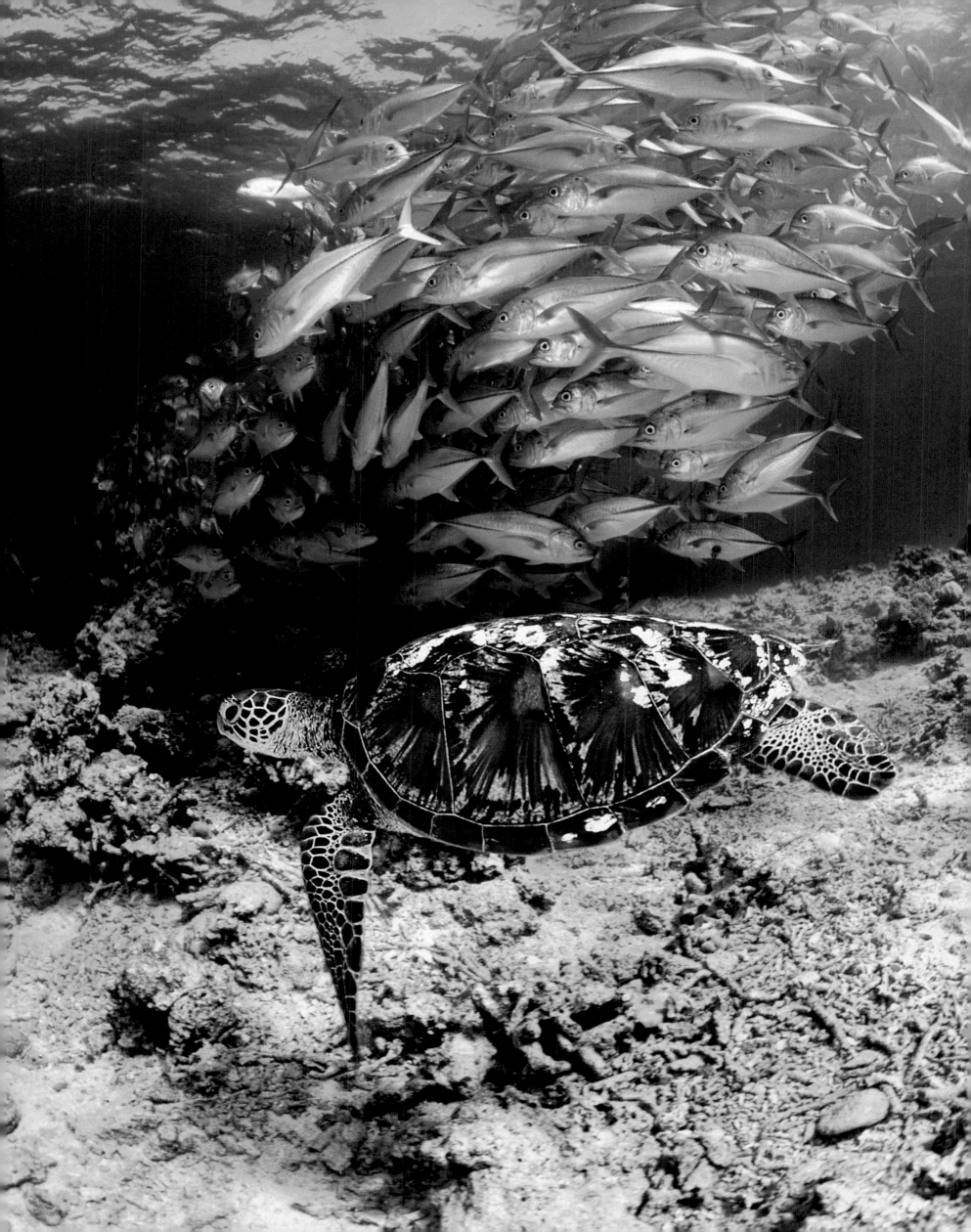

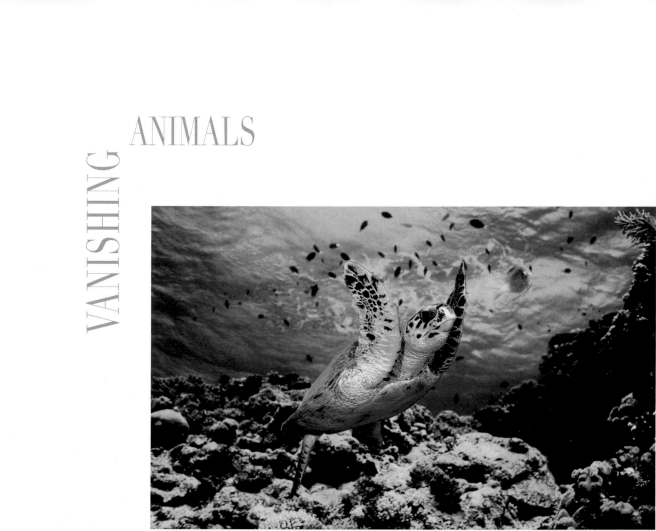

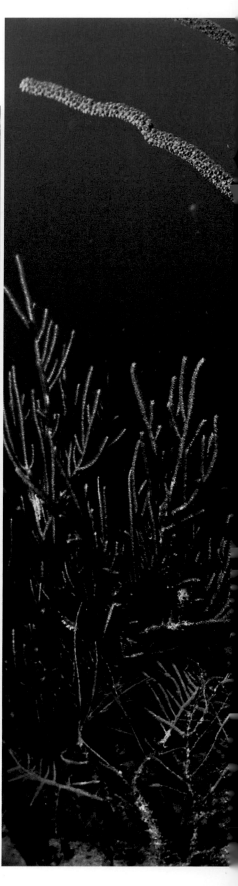

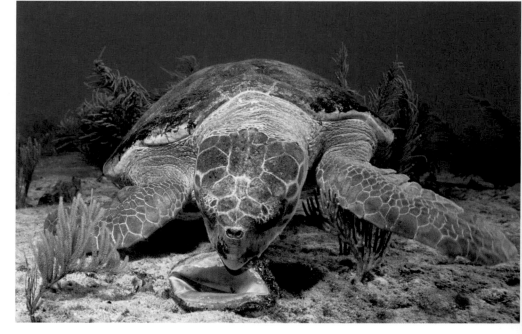

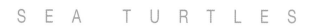

SEA TURTLES

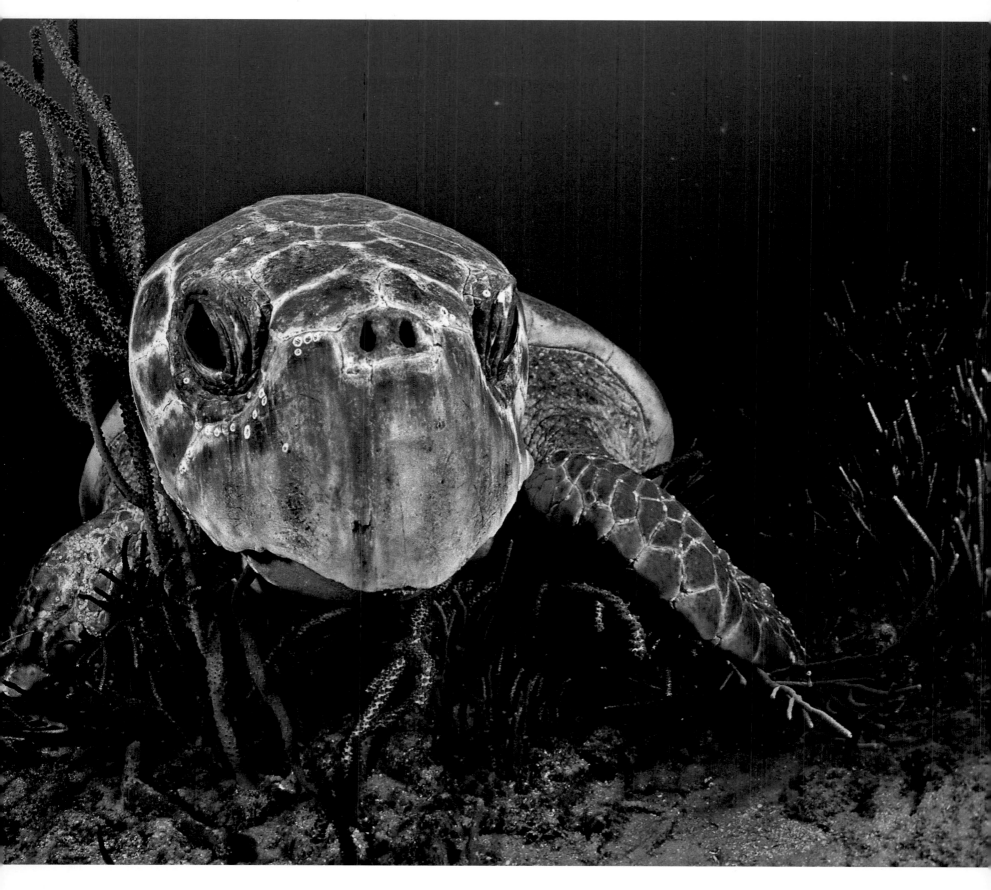

292 top An essentially tropical animal, the hawksbill turtle (*Eretmochelys imbricata*) is about 3 ft (90 cm) in length and weighs up to about 132 lb (60 kg). This turtle's prey of choice are invertebrate animals and sea sponges.

292 center, bottom and 292-293 With a reddish brown shell, the loggerhead sea turtle (*Caretta caretta*) is the most common sea turtle species in the Mediterranean Sea but is also frequently found in the Pacific, Indian, and Atlantic oceans, and also the Black Sea. Although it does have a widespread distribution, very little is still not known about it, which does not bode well its future survival.

VANISHING ANIMALS

294-295 When the newborn logger-head sea turtle hatches from its egg, it quickly leaves the nest to reach the sea nearby. Generally, the right time to do this is at night when subdued light from the moon attracts less bird and mammal predators, and the newborn is able to recognize the wa-ter because it is more reflective than the sand.

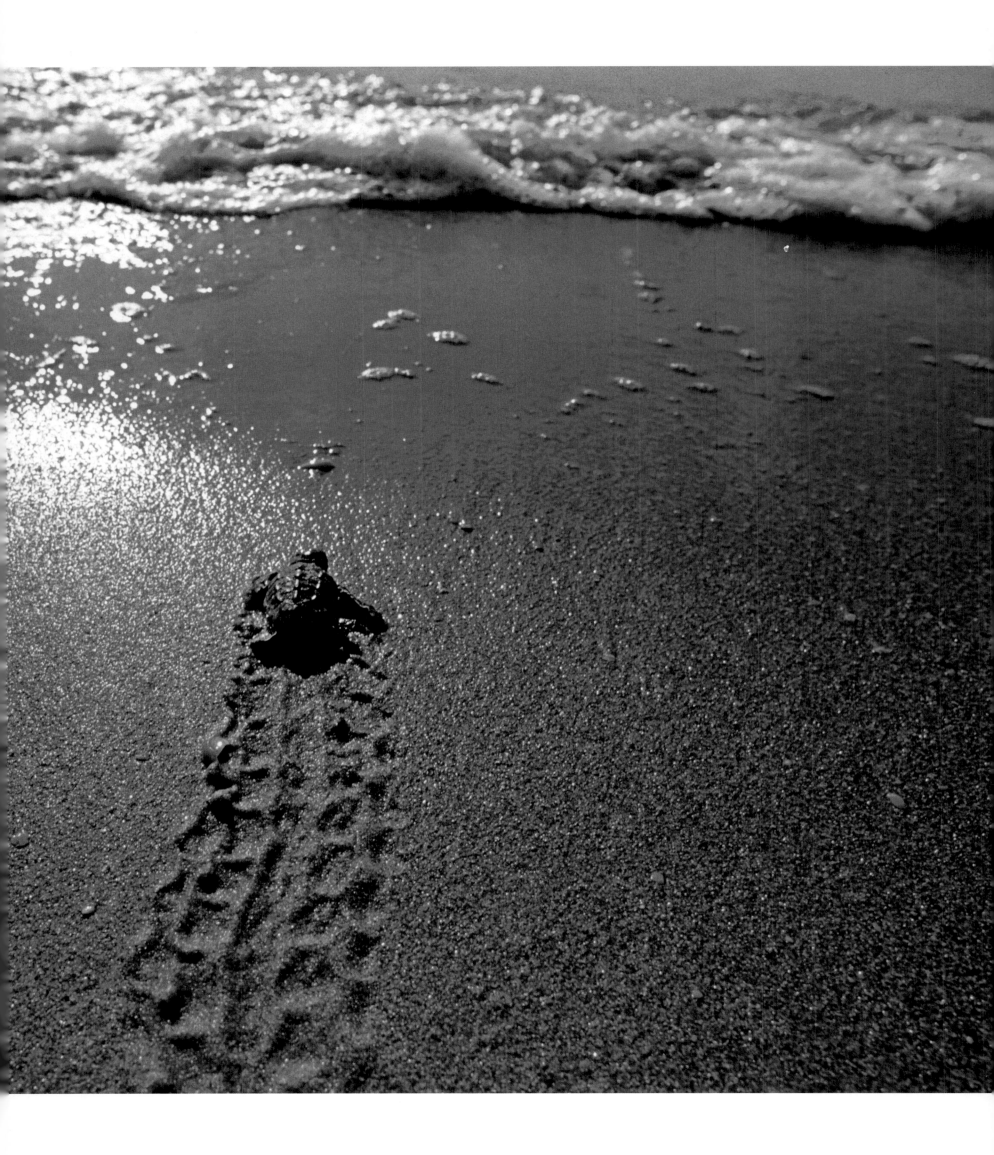

Red Wolf (*Canis rufus*)

The red wolf is one of the rarest canids in the world because of direct persecution and disease from and hybridization with domestic dogs. The species was declared extinct in nature in 1980 when the last 17 individuals were captured and put into a captive breeding program. In 1987, the first reintroduction was accomplished in North Carolina. Currently, the wild population has reached 100.

Saola or Vu Quang Ox (*Pseudoryx nghetinhensis*)

The saola, which officially entered the zoological world in 1993, lives in the humid forests of Southeast Asia. Today, it is considered one of the most endangered mammals in the world. It is estimated that there are only about 200 in Vietnam and less than 100 remaining in Laos. Besides its natural predators (tigers, leopards, wild dogs), it is threatened by human interference, particularly deforestation and hunting.

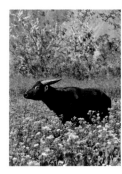

Tamaraw (*Bubalus mindorensis*)

The population of this small buffalo has been in constant decline since the start of the 20th century. The greatest threat is the loss of its territory due to increasing human encroachment, indiscriminate hunting, deforestation, and agricultural conversion of habitats. Today, it is estimated that less than 300 tamaraw survive on the island of Mindoro, Philippines. A captive breeding program was established a few years ago, but the species is still critically endangered.

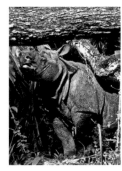

Javan Rhinoceros (*Rhinoceros sondaicus*)

This species was once the most common of the Asiatic rhinoceroses, but it is currently considered one of the most endangered large mammals in the world, with only a few residual micro-populations remaining. The Vietnam War began its decline and now the greatest threat is attributed to hunting for its tusks which are highly sought after. Despite its protected status, poaching still continues and the survival of this species is in doubt.

Marbled Cat (*Pardofelis marmorata*)

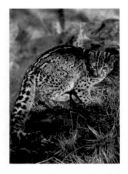

There is little information about this species. Its rarity even in apparently intact environments, and difficulty of breeding it in captivity, makes this cat vulnerable and exposes it to increasingly unpredictable risks. It is unintentionally caught in traps laid for other animals, but its destiny depends on the survival of its forest habitat, which is rapidly being destroyed by humans for the timber and to make way for agriculture.

Addax (*Addax nasomaculatus*)

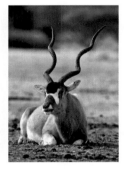

Well known by the ancient Egyptians, these white antelopes have almost disappeared now and are severely threatened with extinction. Their population has undergone a decline of more than 80 percent in the last decade alone. It is estimated that less than 500 currently exist in the wild between Niger and Chad. Illegal hunting, off-road vehicles, desertification, drought, and agriculture are the factors that most endanger the survival of the last remaining addax.

Saiga (*Saiga tatarica*)

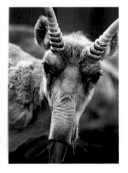

Because of the great demand for the horns from the male saiga, the population of this antelope has been drastically reduced. Until 15 years ago, one million saigas roamed the Eurasian steppe. Currently, the Russian subspecies includes 50,000 specimens, 750 of which belong to the Mongolian subspecies. As a whole, the saiga species is threatened by intensive poaching, selective removal of males, degradation of its habitat, and competition with domestic livestock.

Musk Deer (*Moschus moschiferus*)

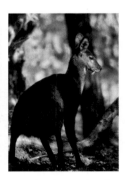

This deer lives in the forests of Asia and eastern Russia. Since 3500 BC, the waxy secretion and musk essence produced by this deer has been used in traditional Chinese and Indian medicine. Every year, more than 660 lbs (300 kg) of musk are sold, costing the lives of 24,000 musk deer. This species is on the threshold of extinction. However, the Traffic organization proposes the production of synthetic musk in laboratories or extraction only from captive-bred deer.

Markhor (*Capra falconeri*)

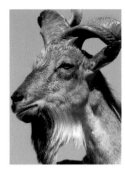

A symbol of Pakistan the markhor is hunted for its meat and spiral horns, which are a prized trophy to hunters that collect them, or they are used in traditional Chinese medicine. Although it is protected throughout almost all of its range, the markhor is still threatened by poaching and the decrease and fragmentation of its habitat by deforestation and increased livestock breeding. Today, there are estimated to be only 5,500 left.

Bactrian Camel (*Camelus bactrianus*)

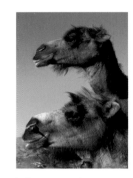

Domesticated as early as 2500 BC, the wild population of this species is currently on the threshold of extinction. It is estimated that there may be around 200 in China and not more than 700 in Mongolia. According to the Zoological Society of London, based on the criteria of evolutionary uniqueness and scarce population, the Bactrian camel is one of 100 mammal species at major risk of extinction.

Indri or Babakoto Lemur (*Indri indri*)

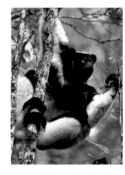

According to ancient belief the largest living prosimian, the indri, is the "man of the woods," father to all lemurs and ancestor of humans. In Madagascar, killing or eating an indri is still illegal today and the species is traditionally considered the protector of the forests. Despite that, its population is in decline because of the reduction of its forest habitat. According to estimates, the number of specimens has been almost cut in half in the last ten years.

Muriqui or Woolly Spider Monkey (*Lagothrix lagothricha*)

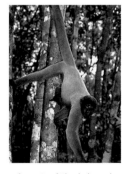

Because of a lack of documented sightings, these primates were considered extinct from 1926 to 1974 when they were rediscovered in the Andes. Today, they are threatened by hunting and destruction of the Amazon Rainforest. The capture of part of their local populations takes place for commercial and nutritional purposes, and their skin is used for various things, while living specimens are considered good household pets

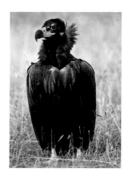

Monk Vulture or Black Vulture (*Aegypius monachus*)

Negli ultimi due secoli questa specie ha subìto un grave declino per la caccia degli esemplari, la meccanizzazione dell'agricoltura, il disboscamento, la cattura dei pulcini dal nido per il collezionismo e l'utilizzo di esche avvelenate impiegate dall'uomo per contrastare lupi, volpi e altri animali sue prede. Nel XX secolo le popolazioni di avvoltoio monaco si sono estinte in molti Paesi europei, ma oggi la specie è in lenta ripresa in Spagna, Grecia, Turchia e Cipro.

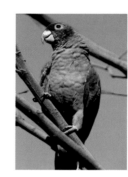

Red-tailed Amazon (*Amazona brasiliensis*)

This Brazilian parrot has a red and blue head, a body covered with green feathers, and a red-tipped tail. It is gravely threatened by the destruction of its natural environment, by the collection of its eggs, and by illegal commercial hunting. It is estimated that 90 percent of the chicks taken from their nests die before arriving in foreign markets and that only one adult out of five survives the stress of capture.

Philippine Cockatoo
(*Cacatua haematuropygia*)

Until 50 years ago this bird was present on at least 52 of the Philippine islands, but it was found on only eight of them between 1989 and 1999. The decline in this species' population has proceeded at the same rate as deforestation and the human population explosion. The real threat to its survival is illegal capture of live specimens, primarily chicks, for collecting purposes. It is estimated that about half of captured nestlings die briefly thereafter.

Sawfish (*Pristidae*)

An endangered species, the commercial fishing of sawfish was prohibited in 2007. They are still subject to indiscriminate fishing and this could reduce their population to the point where recovery is impossible. Sadly, they are highly sought after as every part of their bodies may be used in some way. Sawfish skin can be processed into leather, their mouths manufactured into a votive object, and their meat and fins are a popular food in Southeast Asia.

Common Sturgeon (*Acipenser sturio*)

All 27 species of sturgeon are subjected to intense exploitation for their meat and eggs (caviar). Once distributed throughout the seas, rivers, and lakes of Europe, the common sturgeon is now quite rare everywhere due to intensive fishing during the 20th century. The Gironda River (France) is the only site known where these animals spawn. Other sites were abandoned due to deterioration in the quality of their waters, the presence of dams, and other infrastructure.

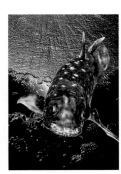

Coelacanth (*Latimeria chalumnae*)

The major threat to the coelacanth population is its accidental capture in the nets of commercial fishermen. Because of rapidly declining fish stocks, fisherman actually cast their nets increasingly lower into the sea where the coelacanth live. Even the loss of just a few pregnant females may threaten the long-term survival of the coelacanth. Strict prohibition against sale of this species is enforced.

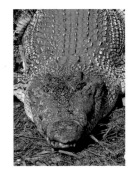

Siamese Crocodile (*Crocodylus siamensis*)

This formidable predator has lived on the Earth for about 200 million years. Existing only in Cambodia and some captive breeding areas, the Siamese crocodile is now threatened by ruthless hunting. Its skin is used to produce purses, shoes, and other accessories, excretions from its glands are used to produce perfume, and crocodile eggs are considered a delicacy in some countries.

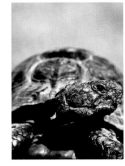

Egyptian Tortoise (*Testudo kleinmanni*)

This turtle is one of the most endangered tortoise species. It lives on the Mediterranean coasts of Egypt and Libya. In the last 30 years its population has declined from 55,000 to just 7,500. This is due to the destruction of its habitat for cattle breeding, automobile traffic, and indiscriminate capture for illegal commercial use. Captive breeding of this tortoise is absolutely banned as is its removal from its natural habitat. The Egyptian tortoise risks extinction in the next 20 years.

Madagascar Radiated Tortoise (*Geochelone radiata*)

The existence of this species is threatened by fires that have destroyed a large part of the indigenous vegetation of Madagascar, hunting as a source of food, and illegal commercial use. Fortunately, captive breeding centers have achieved a high rate of success in breeding these animals, and it is estimated that most existing radiated tortoises are located in these facilities.

c = caption
nn = dedicated chapter

© 2008 White Star S.p.A.
Via Candido Sassone, 22/24
13100 Vercelli, Italy
www.whitestar.it

TRANSLATION: ERIN JENNISON

ISBN 978-88-544-0397-0

REPRINTS:
1 2 3 4 5 6 12 11 10 09 08

Color separation Areagroup media, Milan
Printed in Italy by G. Canale & C., Turin

This book is printed on FSC-certified paper
(Forest Stewardship Council)